Yale French Studies

SPECIAL ISSUE

Contexts: Style and Values in Medieval Art and Literature

NANCY FREEMAN
REGALADO 1 Introduction

I. *Images, Texts, and Contexts*

WALTER CAHN 11 Medieval Landscape and the
Encyclopedic Tradition

LINDA SEIDEL 25 The Value of Verisimilitude in the Art of
Jan van Eyck

KEVIN BROWNLEE 44 The Image of History in Christine de
Pizan's *Livre de la Mutacion de
Fortune*

ERIC HICKS 57 *Le Livre des Trois Vertus* of Christine de
Pizan: Beinecke MS. 427

II. *Romanesque Middle Ages?*

EUGENE VANCE 75 Style and Value: From Soldier to Pilgrim
in the *Song of Roland*

MARGOT FASSLER 97 Representations of Time in *Ordo
representacionis Ade*

SANDRA HINDMAN 114 King Arthur, His Knights, and the
French Aristocracy in Picardy

STEPHEN G. NICHOLS 134 Marie de France's Commonplaces

III. *Gothic Middle Ages?*

MICHAEL CAMILLE 151 Gothic Signs and the Surplus: The Kiss
on the Cathedral

CLAUDE THOMASSET 171 Toward an Understanding of
"Truthfulness" in the French Version
of the *Pratique* by Maître Bernard de
Gordon

BEVERLY J. EVANS 183 Music, Text, and Social Context:
Reexamining Thirteenth-Century
Styles

CLAIRE NOUVET 196 Dangerous Resemblances: The *Romance
of the Rose*

ANNE BERTHELOT 210 The Other-World Incarnate: "Chastel
Mortel" and "Chastel des Armes" in
the *Perlesvaus*

IV. *Baroque Middle Ages?*

JACQUELINE
CERQUIGLINI-TOULET
224 Fullness and Emptiness: Shortages and
Storehouses of Lyric Treasure in the
Fourteenth and Fifteenth Centuries

SYLVIA HUOT
240 The Daisy and the Laurel: Myths of
Desire and Creativity in the Poetry of
Jean Froissart

MARGARETE NEWELS
252 From Narrative Style to Dramatic Style
in *Les Moralités*

MICHEL ZINK
269 The Time of the Plague and the Order of
Writing: Jean le Bel, Froissart,
Machaut

DANIEL POIRION
281 Afterword

PQ
153
.C64
1991

Yale French Studies

Daniel Poirion, Nancy Freeman Regalado,
 Special editors for this issue
Liliane Greene, *Managing editor*
Editorial board: Ora Avni (Chair), Sahar
 Amer, Peter Brooks, Shoshana Felman,
 Denis Hollier, Didier Maleuvre,
 Christopher Miller, Kevin Newmark,
 Eliza Nichols, Charles Porter, Allan
 Stoekl
Staff: Cynthia Mesh, Kathryn Oliver
Editorial office: 82-90 Wall Street
Mailing address: 2504A-Yale Station,
 New Haven, Connecticut 06520.
Sales and subscription office:
 Yale University Press, 92A Yale Station
 New Haven, Connecticut 06520
 Published twice annually by Yale
 University Press.

Designed by James J. Johnson and set in
Trump Medieval Roman by The
Composing Room of Michigan, Inc.
Printed in the United States of America by
the Vail-Ballou Press, Binghamton, N.Y.

ISSN 0044-0078
ISBN for this issue 0-300-05034-8

NANCY FREEMAN REGALADO

Introduction

How shall we consider medieval texts and paintings that have survived
to our day but that were conceived, produced, and first received within
a culture far removed from our own? Our very distance from the Mid-
dle Ages requires attention to our perspective as beholders of that
world of space and time, to the critical concepts we use to look towards
the past. Many of our current terms tend to obscure the true relations
of artistic works to each other and to their culture: they may refuse
alterity by subjecting texts to atemporal grids of abstract analysis; they
may flatten individual works against broad categories of periodization;
they may deform them *allegorice,* by applying codes of interpretation
derived from other genres, other times. We need perspectives that can
reveal the place of each artistic object within its cultural landscape; we
need concepts that can enable us to discover medieval expectations
and intentions while acknowledging our own.

The articles collected here demonstrate that style and values offer
such perspectives. The terms proposed for this issue provoked sus-
tained and comprehensive exploration that focuses sharply both on
accurate description of particular artistic works and also on historical
issues that delineate the special place of each work within its particu-
lar cultural framework. The analyses of style and values in this volume
show to what degree the unique qualities of a work are disclosed pre-
cisely by such evaluation of its relation to its context.

By their very definition style and values lead to full consideration of
aesthetic and cultural dynamics at work within a culture as well as in
the production of each work of art. While the notion of style has notori-

YFS Special Edition, *Contexts: Style and Values in Medieval Art and Literature,*
ed. Daniel Poirion and Nancy Freeman Regalado, © 1991 by Yale University.

ously resisted abstract definition,[1] every reader and viewer readily perceives stylistic qualities in artistic and textual objects. This is because style is, by its very nature, particularizing, distinguishing, identifying. The style of any work is best defined by a contrastive and contextual analysis which will always be more substantive than any general classification. Perception of style is thus inseparable from the comparison of one work to another, from observation of difference and change—from individual to individual, place to place, century to century. In the words of Josephine Miles, "Style is what it is; what it is has deep involvement with what, linguistically, artistically, evaluatively, individually, it is not."[2] It characterizes the work of individual creators and of groups of artists within what Ortega called their *circunstancia*, all that is around them. To ask about style is thus to move to a vantage point from which we see the special qualities of each work as well as its position relative to other works and the full cultural context. Style is, in short, a dynamic conception of artistic forms that considers aesthetic shaping from the spatiotemporal perspective of contexts.

Where style orients our critical inquiry along historical lines of time and place, the notion of values shifts our attention to vertical hierarchies of preference. Values express human judgments on the world of experience; values sort and class every aspect of reality. Hierarchies of value and preference can extend along many vectors: they can be moralized into categories of good or bad, aestheticized as beautiful or ugly, high or low style; they may be contrasted economically as costly, valuable or worthless, politically as weak or powerful. Moreover, value often posits the notion of exchange. Jacqueline Cerquiglini-Toulet describes the system of supply and demand for Froissart's lyric garlands and poetic caskets in "Fullness and Emptiness: Shortages and Storehouses of Lyric Treasure in the Fourteenth and Fifteenth Centuries." Linda Seidel demonstrates in "The Value of Verisimilitude in the Art of Jan van Eyck" how the painter's compelling realism may allude to the transaction by which an artistic production is undertaken and received, an exchange that defines a play of values and that establishes a contractual relationship with the viewer.

The critical concept of values is thus not taken here to mean merely

1. See *Style in Language*, ed. Thomas Sebeok (Cambridge, MA, MIT Press, 1960) and its more successful sequel *Literary Style: A Symposium*, ed. Seymour Chatman (Oxford: Oxford University Press 1971) as well as the work in progress on style by Gérard Genette, subject of a graduate seminar at New York University (Spring 1990).
2. *Literary Style*, ed. S. Chatman, 28.

evaluation, i.e., judgments of preference about medieval works.[3] Instead it serves to ask what value preferences motivate medieval authors, artists, and their patrons. What desires, aims, and beliefs inform the selection and ordering of those elements writers and artists take from a common material base of language and medium? Values and preferences express what Fustel de Coulanges named *croyance*, what we now call *mentalités*, the beliefs and mental habits of individuals and of cultures. But these studies demonstrate that like style values must be seized within relations of comparison in motion, in context; for values too shift over place and time. They are "an uneasy sea . . . full of cross currents and counter-pressures."[4]

When style and values are conjugated, as they are here, new questions emerge: how do values determine specific stylistic choices of form and matter? How does a style reveal, express or even affect cultural values at a given moment and in a particular place? We will not reduce each demonstration to a summary, for this would betray the very purpose of our inquiry. Taken together, however, the articles gathered here suggest an analytic methodology firmly based on style and values. These analyses cluster around three broad axes of description and interpretation: the relation of a work to dominant formal and cultural traditions; its expressive formulation of mimesis or representation of the world of history; and its construction of meaning.

The axis of tradition requires that we consider the twin poles of reference and transformation, that we examine both how a work alludes to a tradition, to its own past, and also how it appropriates or recasts it. No image in these articles speaks more eloquently of the long concatenations of tradition behind every work than Kevin Brownlee's portrait of Christine in "The Image of History in Christine de Pizan's *Livre de la Mutacion de Fortune.*" As she contemplates Fortune's great painting of universal history in her *Mutacion*, Christine recalls Lancelot's paintings of his adventures undertaken for Guinevere in the *Prose Lancelot*, images inspired by the sight of yet another artist painting "an ancient tale" upon the walls of Morgan's palace, the story of Aeneas who gazes at his own history painted on the

3. See Barbara Hernstein Smith, "Value/Evaluation," *Critical Terms for Literary Study,* ed. Frank Lentricchia and Thomas McLaughlin (Chicago: University of Chicago Press, 1990).

4. Ralph Barton Perry, *Realms of Value, A Critique of Human Civilization* (Cambridge, MA: Harvard University Press, 1954, [rpt. New York: Greenwood Press] 1968), 71.

Temple of Juno which is represented in the *Aeneid*. Christine thus confronts the dominant models of medieval textuality—those of classical antiquity, of clerical Latinity, of theological vision and of chivalric, masculine romance—which she rewrites through her feminine persona.

Tradition derives from *traditio:* "tradition," but also "surrender." The models bearing the forms and themes that constitute tradition both convey and betray it, for tradition is a formal and cultural vehicle that is constantly reconstructed as it moves forward in time. While each work refers, it also rewrites, repaints what it takes from a literary or artistic tradition. Authors use what they choose from the repertory of continuously evolving linguistic and literary forms, artists what they select from available media, technologies and modes of representation. Some new forms and motifs appear as easy and harmonious extensions of tradition. Sylvia Huot shows how Froissart adapts Ovidian models to the social values and literary tastes of his public, forming new myths that express with elegant seriousness his identity as scholar-cleric and lover as well as the political relations of poet and aristocratic male patron ("The Daisy and the Laurel: Myths of Desire and Creativity in the Poetry of Jean Froissart"). Beverly J. Evans emphasizes the multiple concordances created in the thirteenth-century motet through the polyphonic dialogue of incongruous religious and secular motifs and of Latin and French texts ("Music, Text, and Social Context: Reexamining Thirteenth-Century Styles"). Anne Berthelot reveals how a new romance construction—the Grail castle—is built up out of chivalric additions to old theological models of Heaven and Hell ("The Other-World Incarnate: "Chastel Mortel" and "Chastel des Armes" in the *Perlesvaus*"). The significance of some changes may escape our modern eye at first glance: Michael Camille demonstrates the unexpectedly radical consequences of the simple substitution of a naturalistic sculptured kiss for an emblematic image of lust ("Gothic Signs and the Surplus: The Kiss on the Cathedral"). However, other transformations of tradition—particularly those involving women— are still felt today as broadly transgressive: Eric Hicks emphasizes Christine's extraordinary access to the means of production of her own texts ("*Le Livre des Trois Vertus* of Christine de Pizan: Beinecke MS. 427); Stephen G. Nichols stresses how Marie de France manipulates and regrounds rhetorical commonplaces through "barbarisms" and "metaplasm" ("Marie de France's Commonplaces").

Metamorphoses of form, transgressions of generic lines, new poly-

phonic combinations and juxtapositions—all disclose the structures of tradition as they rebuild them. These articles tell us that out of the medieval shifts between the learned and the vernacular, between discursive and pictorial traditions, the spiritual and secular, emerge new forms that may appear monstrous or pathological relative to the past or the present context of a work. But such transformations of tradition— that refigure iconographic practices, that reground commonplaces within *ydioma*[5]—appear fertile and significant relative to a future we see from our perspective: elements that are marginal to Latin and clerical culture—women, the vernacular, the natural world, the marvelous—move towards the center and expand their territory.

No axis of description and interpretation in these articles tells us more about style and values than the way authors and artists perceive and represent their world. Mimesis is always partial, always selective. Its arrangements of representation therefore reveal the innermost workings of genre structures and the central preoccupations of a cultural milieu. These articles probe deeply into mimesis and its uses. Broadly speaking, many comment on the growing tendency in medieval representations towards mimetic naturalism. Walter Cahn describes progress towards naturalistic representation by showing how the solo landscape emerges from the encyclopedic tradition to become an independent genre. Claude Thomasset's "Toward an Understanding of 'Truth' in the French Version of the *Pratique* by Maître Bernard de Gordon" and Linda Seidel's "The Value of Verisimilitude" both speak of representations that aim towards verbal or pictural *denominations* that can encompass outer reality; but the text of Maître Bernard attempts to bring together *pratique* and written authority from the past while the paintings of Van Eyck aim to bond representation with the viewer's present reality. This tendency increases the stylistic significance of every shift away from representations marked by realistic effects. Claire Nouvet's "Dangerous Resemblances: The *Romance of the Rose*," tells of a work that recedes away from mimesis through words and images towards fantasy, dream and silence, where seductive relations of resemblance may lead to the cutting off of representation, to a vision of mute signs moving toward speech and song. In Margarete

5. "John of Garland . . . formulates the term *ydioma* to designate the relationship that must prevail between social status and speech decorum." Wlad Godzich and Jeffrey Kittay, *The Emergence of Prose* (Minneapolis: University of Minnesota Press, 1987), 93; cf., *The Parisian Poetria of John of Garland*, ed. Traugott Lawler (New Haven: Yale University Press, 1974), book 1, sect. 375, 102.

Newels's "From Narrative Style to Dramatic Style in *Les Moralités*," however, fantasy—again in the form of other-worldly personification allegory—serves a sturdy moral purpose of catechizing the reader-spectator with ethical and religious considerations.

Representations may thus both display and override mimetic, creatural naturalism. In Margot Fassler's "Representations of Time in *Ordo representacionis Ade*" we find a cosmic "all time" of salvation which overtakes chronological progression through the liturgical calendar and from Old Testament to New. Michel Zink's "The Time of the Plague and the Order of Writing: Jean le Bel, Froissart, Machaut," illustrates vividly how even in works committed to social history, representations of natural chronology or causal order of events are arranged according to different models or hierarchies of political and poetic values, or again, with Machaut, in favor of heightened attention to the perceiving subject.

Issues of mimesis lead thus to consideration of how representation undertakes to negotiate the shifting social values of a culture. Eugene Vance suggests that the cult of relics in the early twelfth century *Roland* marks an ethical disjunction with a warrior-crusader ethos and favors an imperial ideology ("Style and Value: From Soldier to Pilgrim in the *Song of Roland*). Sandra Hindman, in turn, asks how specific selections of miniatures illustrating Chrétien's romances reflect choices that may reveal the anxieties and aspirations of the thirteenth-century Picard nobles who read and reread the manuscripts made for them ("King Arthur, His Knights, and the French Aristocracy in Picardy"). Like Cerquiglini-Toulet and Seidel, Vance and Hindman show us signifying, powerful forms encased in stories, tombs, objects, parchments, paintings, reliquaries, and collections that express or compel relationships with real readers and viewers in the world of history.

It is these very issues of mimesis that point to the third axis of analysis of style and values: the construction of meaning. The solo landscape, the sculptured kiss, the signs of disease on the body, paintings visually contextualized in the world of a particular viewer—such illusionism releases the grip of moral definition upon representation. It permits dangerous likenesses that destabilize and multiply meanings: where the old image of *Luxuria* bitten by serpents unequivocally condemns the vice it represents, the ambiguously seductive kiss upon the cathedral of Amiens described by Camille offers a *surplus* of uncontrollable semiosis. Sophisticated secular milieus find refined plea-

sure in interplay of meanings: Sylvia Huot shows us a poet—Froissart—eager to layer up significant associations on images like the *marguerite* ("daisy; pearl") for an aristocratic public adept in interpretation. Other representations move against this trend and seek to reassert particular cultural values through moral definitions, through words inscribed in paintings, through description of signifying images in texts. Representations may thus be reemblematized by writing on swords, by proliferating allegorical *moralités*, by strange new symbolic implements of virtue such as those which Hicks explains in Christine's *Mirror of Honor*.

Like the works discussed, the studies gathered in this volume also rewrite their own critical traditions, reconfigure a relation to the artistic works they represent, formulate new constructs of meaning. The familiar periodic classifications—romanesque, gothic—have not lost their question marks, for they prove finally less pertinent than precise descriptions of stylistic features of individual works. Each is to be considered in terms of how it recasts a tradition, represents the world, responds to conditions of production and patronage, projects a definition of values and meaning. Our distant perspective serves to bring out large-scale cultural and artistic movements: the punctual eruption of written vernacular in the twelfth century and of prose in the thirteenth that gradually floods almost every discursive space; the swiftly flowing fashions of distinctive stylistic features versus the slower currents of shifting values; the eternal materials of stone and paint versus the technology of writing that vaults from song to book to print; the sudden figure of one woman writer, then another, appearing in a crowd of men. Finally inquiry into style and values favors an intensively descriptive mode that emphasizes formal features that engender interpretation rather than a synthesizing but metatextual hermeneutics. The closed critical circle of self-reflexivity within which texts and images whisper only of themselves opens to vigorous, even noisy dialogue with the world of history, to polyphonic concordances of form and moral vision, of images and ideologies, of social structures and signs, of the contexts of style and values in medieval art and literature.

I. Images, Texts, and Contexts

WALTER CAHN

Medieval Landscape and the Encyclopedic Tradition

An esteemed colleague recently told me of his irritation that speakers at learned conferences now always seemed to feel the need to begin their papers with an abstract disquisition on questions of method, in which they paraded before the listener the complexity of their subject, and of course, their own learning and subtlety. I was inclined to agree and sympathize with my friend's complaint until I began to work on this paper, which seemed to cry out for just such an exercise. The reason for this is easy to appreciate. Landscape in the Middle Ages is a topic that is heavily, even essentially, marked by historical reflection of more recent times. But, one might reasonably ask, is it a topic at all in any meaningful sense? Scholars who from the nineteenth century onward sought to chart the history of a concern with landscape in art and literature were struck first and foremost by the silence of the Middle Ages on this score, by absence, in other words, or at any rate, by the apparent lack of a concrete expression in the medieval period of anything resembling a conception of the natural world in our sense of the term. This absence was for them a defining feature of the Middle Ages, and conversely, the appearance of landscape painting as a distinct genre in the Lowlands during the early decades of the sixteenth century marked the onset of a radically new sensibility, and could be said to constitute the harbinger of the modern era.

The history of landscape (or *Landschaftsgefühl*, as our German colleagues like to say) has thus been constructed as an account of the birth and the ensuing progression in the mastery of the means of naturalistic representation, accompanied over time by a correspondingly

YFS Special Edition, *Contexts: Style and Values in Medieval Art and Literature*, ed. Daniel Poirion and Nancy Freeman Regalado, © 1991 by Yale University.

successful assertion of art's autonomy from didactic or moralizing concerns.[1] This account, which takes us from Patenier to Constable and Monet, from the Renaissance Pastoral to Wordsworth's lyrical meditations, is certainly not unimpeachable. Naturalism and land-scape do not always coincide, as the paintings of Turner, to take only one example, demonstrate. The representation of nature is not invariably freighted with feeling (Gombrich, *Renaissance Theory,* 118). The distinction between pure landscape, which is my particular concern here, and the "impure" variety, that is to say landscape harboring elements of anecdote or more or less literal messages, has also proven more difficult to maintain than was formerly assumed. Scholars now routinely seek to recover religious or political significance where only a poetic distillation of nature was once suspected. Nevertheless, the scenario that I have outlined has a certain broad persuasiveness, which is abetted by one's sense that it is congruent with larger patterns of historical change.

For the question of medieval landscape, this situation has inspired two kinds of responses. Some students have sought to explain why an independent landscape painting altogether failed to develop in the Middle Ages, giving such reasons as the reign of an otherworldly spirit, or the exclusive place that this spirit gave to man's destiny and the consequent disinterest in nature that it fostered. The first chapter of Kenneth Clark's widely read *Landscape into Art,* where this issue is considered, indicts "the symbolizing faculty of the medieval mind" which in his view, transformed all natural objects into signs for higher things. Thus, when medieval artists turned to nature, their vision was transfixed by "the icy winds of doctrine," and flowers and trees lost their lively quality to become prototypes of the divine.[2] Max J. Friedländer cites the tendency of medieval artists to render physical appearance as a sequence of sharply bounded objects, a habit fostered by the practice and prestige of sculpture. This tendency made it impossible to suppress the particular in favor of the whole, and to achieve the informal, hazy or indistinct effect required for a successful illusion of

1. Ernst H. Gombrich, "The Renaissance Theory of Art and the Rise of Landscape," *Norm and Form. Studies in the Art of the Renaissance* (London: Phaidon Press, 1966), 107–21. Julius Böheim, *Das Landschaftsgefühl des ausgehenden Mittelalters* (Beiträge zur Kulturgeschichte des Mittelalters und der Renaissance, 46) [Leipzig and Berlin: B. G. Teubner, 1934]. Owing to space constraints, bibliographic citations are limited to essential titles. Henceforth cited in text.

2. Kenneth Clark, *Landscape into Art* (London: J. Murray, 1949).

the natural world.[3] Friedländer was perhaps thinking here of the landscapes of the Impressionists, but his observation intimates shrewdly enough that the medieval propensity to convert everything into allegory had as a counterpart the equally debilitating character of the pictorial language at the artist's disposal, which denied the viewer any chance of mistaking the image before him as a trustworthy replica of the natural world and nothing more.

Other scholars, who find this hieratic and drastically simplified picture of the Middle Ages either wrong or at least one-sided, have disputed this view and sought to arrive at a more accurate and differentiated image of medieval attitudes toward nature. Some emphasize the continued practice or revival of ancient rhetorical techniques in the evocation of the landscape, and others find in the art of the later Middle Ages much that foreshadows or prepares the ground for the apparent innovations of the Renaissance.[4] The historiography that has accumulated around the figure of Saint Francis of Assisi over the past hundred years has been one of the focal points of this discussion, and of the attempt to uncover medieval roots for a sensibility attuned to nature in its most manifold and quotidian aspects.[5] It identifies the phenomenon not with observation or the mind's striving for order and control over our physical surroundings, but with a novel strain of religious feeling, with mysticism, and with poetry. My own subject, the encyclopedic landscape, engages other interests, that might be called descriptive or classificatory at heart. But where an understanding of the basis of *Landschaftsgefühl* in the medieval setting is concerned, it does not seem very helpful to divide science from poetry, as we, who are tributary to other and more recent modes of thought, now commonly do.

What can be called encyclopedic forms an enormous body of writing whose models were of ancient origin, and which medieval authors were conscious of revising, expanding or condensing, but not ever wholly setting aside.[6] To a greater or lesser extent, they were con-

3. Max J. Friedländer, *Essays über die Landschaftsmalerei und andere Bildgattungen* (The Hague: A. A. A. M. Stols 1947), 16ff.

4. See, for example, Otto Pächt, "'La Terre de Flandres'," *Pantheon*, 36, (1978): 3–16.

5. Edward A. Armstrong, *Saint Francis: Nature Mystic. The Derivation and Significance of the Nature Stories in the Franciscan Legend* (Berkeley: Los Angeles and London, University of California Press 1973), is a recent contribution in this vein.

6. An overview is found in Maurice de Gandillac *et al.*, *La Pensée encyclopédique au moyen âge* (Neuchâtel: La Baconnière 1966).

cerned to shape this vast treasure of information into a meaningful whole, endowing it with a hierarchical structure and moral perspective. On the other hand, much encyclopedic writing about the natural world is mere enumeration and description, leavened by etymological word play, and conceived as an inventory of the Lord's creation, a more or less systematic supplement to the record of the divine work given in the opening verses of Genesis. Bartholomeus Anglicus, about whom I shall have more to say later on, claims in his treatment of the regions of the world that he will deal only with those that are mentioned in the Scriptures, but in actual fact, he cites and describes many that are not, and his reference to the geographical lore of the Bible serves only to legitimize his descriptive appetite.

This descriptive interest is a fundamental trait of the images on which I shall comment. Those that are to be considered first also make apparent certain stresses within the genre to which the painters were in various ways responsive. One stems from the collection of *Marvels of the East*, here represented by the oldest known illustrated copy, an Anglo-Saxon manuscript tentatively dated in the second quarter of the eleventh century.[7] The marvels in question are for the most part monstrous creatures, but four items in the collection concern fabulous trees or plants. One (Fig. 1) is the so-called balsam of balm tree, also celebrated in other *mirabilia* collections, and described as follows: "In that place grow trees that are similar to the laurel and the olive. They produce balsam, and the place where they are found measures 151 *stadia*, which makes fifty leagues and a thousand paces." The artist has given us what is essentially a portrait of these exceptional plants: the trees are pushed forward—there are three of them in order to account for the plural of the text—and anything extraneous to that purpose is omitted. I shall, nonetheless, venture the thought that the sinuous, billowing foliage, barely contained within the frame, might be read as an evocation of the plant's miraculous powers of germination. The sense of space that is built into the illustration perhaps also means to translate into visual terms the notion of a distinctive setting or place, stipulated in the text by the phrase *in hoc loco*.

In the first book of his *Institutions*, Cassiodorus gives a description of his monastery at Vivarium, and this celebrated passage in the work inspired visual reconstructions, one of them found in a south Italian

7. London, Brit. Lib. Cotton Tiberius B. V. Montague R. James, *Marvels of the East*, Roxburghe Club, Oxford, 1929, 19–21, nos. 20, 25, 32 and 34.

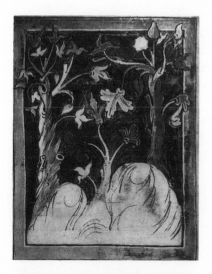

1. Balsam Tree, from *Marvels of the East* (London, Brit. Lib. Cotton Tiberius B.V, fol. 83) (British Library)

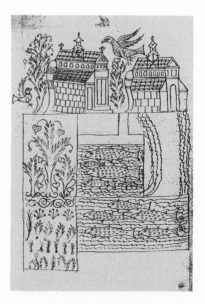

2. The Monastery of Vivarium, from Cassiodorus, *Institutiones* (Kassel, Hess. Landesbib. Ms. theol. 2° 29, fol. 26v) (after Milkau, *Festschrift Kuhnert*)

manuscript of the eighth century, the other in a copy of the text made in Germany around the year 900 (Fig. 2).[8] I quote this description, which is cast in the style of the rhetorical evocation of the pleasance, or *locus amoenus*, in the translation of Leslie Webber Jones: "The site of the monastery of Vivarium invites you to prepare many things for strangers and those in need, since you have well-irrigated gardens and, close beside them, the waters of the River Pellena, which abounds in fish—a river which should not be considered dangerous because of the greatness of its waves or contemptible because of their smallness. It flows into your grounds, skillfully directed wherever it is considered necessary, adequate for your gardens and your mills alike. It is indeed present when it is wanted, and when it has satisfied your wishes it goes far away; thus, being dedicated to definite service, neither is it dangerously rough nor can it be lacking when it is sought. Seas too are so near you that they are accessible for various kinds of fishing, and, when

8. Kassel, Hess. Landesbib. Ms. theol. 2° 29. Fritz Milkau, "Zu Cassiodor," *Von Büchern und Bibliotheken. Festschrift Ernst Kuhnert*, ed. G. Abb (Berlin: Von Struppe and Winkler, 1928), 23–44.

it pleases you, a fish once caught may be shut up in the fish ponds. For there, with the help of the Lord, we have made pleasant ponds, where a multitude of fish may drift beneath the faithful monastery; the situation so much resembles the caves in mountains that the fish in no way realizes that it is a captive, and it is free to acquire food and hide itself in the solitary caverns."[9]

The German artist's picture of Vivarium differs from the illustration of the *mirabilia* just mentioned in that it is not a circumscribed portrait of a fabulous object, but a panoramic view which assembles the various features of the site enumerated or merely alluded to by the text. The vertical panel along the left side of the composition evokes for us the well-tended gardens of the monastery, which we are invited to imagine as stocked with every variety of plant species. The area to the right depicts the carefully policed river and the different places where fish can be found. The trees and flying birds in the upper part of the drawing are not mentioned by Cassiodorus, but they are in medieval landscape description or rhetoric the almost inevitable pendant of marine life, as when, meaning to embrace the natural world in its entirety, we say "the birds in the air and the fish in the sea."

Considering this ample but orderly panorama, we are made mindful of just this issue—the nature of the image's dependence on the text. This is an issue that, on the whole, presents itself in a more straightforward way in the case of historical or narrative illustration, endowed with an action or plot of which the image appears to give us a more or less reliable counterpart. In the case of landscape description or poetry, the relation between word and image is looser, and it would be difficult to recover from the miniature something closely resembling Cassiodorus's description.[10] I want to discuss some additional aspects of this question in relation to an illustration that I had recently occasion to treat in another context. It is a composition found in a French paraphrase of parts of the books of Daniel and Macchabees contained in a manuscript made in northeastern France around the year 1300.[11]

9. Cassiodorus Senator, *An Introduction to Divine and Human Readings*, ed. Leslie W. Jones (New York: Columbia University Press, 1946), 131. On rhetorical descriptions of landscape, see Ernst R. Curtius, *European Literature and the Latin Middle Ages* (New York: Pantheon Books, 1953), 193ff.

10. The question deserves a full airing, along the lines of the recent treatment of ancient landscape representation in art and literature by Eleanor W. Leach, *The Rhetoric of Space. Literary and Artistic Representations of Landscape in Republican and Augustan Rome* (Princeton: Princeton University Press, 1988).

11. The Hague, Royal Library, Ms. 131 A 5. Walter Cahn, "Moses ben Abraham's 'Chroniques de la Bible'," *Artibus et historiae* 16, (1987): 55–66.

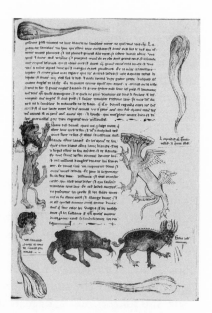

3. Daniel Vision, from Moses ben Abraham, *Chroniques de la Bible* (The Hague, Royal Lib. Ms. 131 A 3, fol. 26) (The Hague, Royal Library)

My illustration (Fig. 3) concerns Daniel's vision of the four beasts (7:1–27) that in the interpretation furnished to the prophet by the Lord himself, adumbrate the succession of the four world empires. The four huge creatures, depicted here along the lateral and lower margins of the text column, are said to have emerged out of the sea, churned up by mighty winds, four in number (*ecce quatuor venti caeli pugnabant in mari magno*). The dramatic but very cursory description of the physical setting of the vision does not play a significant role in the exegesis of the prophecy, though artists of the earlier Middle Ages who occasionally take the vision as their subject do seek to come to terms with it. They do so, as a rule, with the help of the conventional personification of the winds borrowed from ancient art, a hirsute and winged mask spewing air.[12] The French paraphrase of Daniel dispenses with these anthropomorphic winds, and we find in their place a sort of graphically mimetic ideogram, tear-shaped and shaded with linear striations and flourishes.

This case reminds us that the rendering of nature in the ancient world and in the Middle Ages is often made by way of personifications, not only of winds, but of other entities like rivers, the earth and *natura* herself. Did the artist in this instance fear that in giving his winds the

12. Thomas Raff, "Die Ikonographie der mittelalterlichen Windpersonifikationen," *Aachener Kunstblätter* 48, (1978–79): 71–218.

appearance of monstrous creatures, he would be risking a confusion with the four beasts of the prophecy? However this may be, the shift from an anthropomorphic to a mimetic interpretation of natural phenomena that confronts us in the French manuscript has some important implications for the development of landscape representation. It is not, of course, the case that the wiggly and striated blobs give us a more plausible image of a wind than the grotesque bearded masks with wings. But a survey of the art of the high and later Middle Ages that might be fruitfully undertaken would show up other examples of the substitution of the former for the latter, and of a more general tendency at this time for personifications of nature to disappear in favor of landscape constructed by purely formal means. The reasons for this change involve large-scale speculations that I shall avoid, since they would take me far from my subject. But in the case at hand, a more immediate consideration presents itself: the translator renders the rather lapidary Latin *venti* into the much more vivid French phrase *tourbillons de vent*, and *tourbillons*, I suggest, are what we have in the margins of the manuscript. In a more general way, one might also hazard the suggestion that personifications must have seemed naturally suited to the loftier and literary Latin, while the vernacular could more easily accommodate itself without them.

The encyclopedia which is most closely identified with the depiction of landscape is Bartholomeus Anglicus's *De proprietatibus rerum*. What we know of this author comes to very little. Perhaps of English origin, he was a Franciscan friar active at the University of Paris around the second quarter of the thirteenth century, before being called to take up the direction of the Minorite *studium* in the new province of Saxony. His success as an author owes much to this Parisian connection. He lived at a moment when the production of books by lay and professional scribes and illuminators in the growing capital had become a vigorous and well-organized industry. His work was thus absorbed into the circuit of recommended or approved books for students, and judging by the number of surviving copies, became something of an academic best-seller. Its only serious rival in this respect among medieval encyclopedias was Isidore of Seville's *Etymologiae*, whose vogue, however, was essentially limited to the early Middle Ages, and whose diffusion and reception involved rather different factors. In his own time, which is customarily regarded as the great age of encyclopedic enterprises. Bartholomeus's chief competitor was of course Vincent of Beauvais, whose *Speculum majus* indeed towers over his work through its sheer enormity and all-encompassing ambition, as over just about

everything else on the thirteenth-century literary landscape. But just this fact, I think, prevented it from achieving a comparably large diffusion, since the production of a complete copy of the work, to say nothing of fully illuminated copies, would have put both producer and buyer under some strain. It is therefore only the first section, the *Speculum historiale*, of which we encounter copies in any number.

De proprietatibus rerum is a more compact work, normally complete in one volume. It owes this more manageable quality to the fact that, as indicated by the title, it concerns the physical world and the properties of things, omitting sacred and secular history altogether.[13] The work comprises nineteen books, whose topics are arranged in a hierarchical order beginning with God (1), followed by the angels, the parts of man and of the cosmos. The books that engendered the landscapes that I shall briefly discuss come afterward, and concerns matter and form (10), the birds (12), the earth (14), the provinces of the world (15), precious stones and metals (16), trees and plants (17), and the different kinds of animals (18). At the end, Bartholomeus furnishes a long list of authorities whose works he claims to have drawn on. For the books which interest us, it is primarily Isidore, and to a lesser extent, Pliny and Orosius that are cited. Whether the manuscripts of these authors that he and his contemporaries were able to consult also contained images that might in some fashion have entered into the fabric of his work is doubtful, at least in regard to the second and third of these authors, whose works were only very sparingly illustrated in the Middle Ages. For Isidore, the matter is somewhat less clear-cut. The manuscripts of his *Etymologiae* contain as a rule only diagrams in relation to the teachings of the author on geometry and the degrees of kinship. But there is a twelfth-century copy of the work from the south German monastery of Zwiefalten in which the subject of the respective books of this encyclopedia are identified in more or less literal fashion by lively, if highly abbreviated images set within the initials. For *De montibus* in Book 14, we thus have a wavy peak sprouting verdure and trees (Fig. 4); for Book 15, *De civitatibus*, a view of a walled and turreted city (Fig. 5).[14]

This is the system that the books of the thirteenth-century en-

13. The latest and most comprehensive treatment of the author and the work is that of Heinz Meyer, "Bartholomäus Anglicus, 'De Proprietatibus Rerum'. Selbstverständnis und Rezeption," *Zeitschrift für deutsches Altertum und deutsche Literatur* 117 (1988): 237–74.

14. Stuttgart, Württemb. Landesbib. Ms. Poet. 2° 33. Karl Löffler, *Schwäbische Buchmalerei in romanischer Zeit* (Augsburg: Benno filser Verlag, 1928, 69.

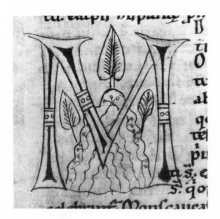

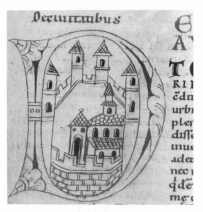

4. Mountain and Trees, from Isidore of
Seville, *Etymologiae* (Stuttgart, Würt-
temb. Landesbib. Ms. Poet. 2° 33, fol.
125v) (Bildarchiv Marburg)

5. Cities, from Isidore of Seville, *Ety-
mologiae* (Stuttgart, Württemb. Lan-
desbib. Ms. Poet. 2° 33, fol. 127)
(Bildarchiv Marburg)

cyclopedists, Bartholomeus included, adopted and made thoroughly
familiar. The early copies of the *De proprietatibus* are rather modest
productions with respect to decoration, and a full sequence of illustra-
tions seem only to have been introduced in connection with the
French translation of the work, made by Jean Corbechon in 1372 at the
behest of the bibliophile king Charles V, at a time when independent
vignettes, permitting a more extended and spacious pictorial treat-
ment, had very largely supplanted the older historiated initial in Pari-
sian book illumination. Corbechon's original presentation copy of the
Propriété des choses is lost, but its cycle of illustrations survives in
thirteen copies of the later fourteenth and early fifteenth centuries,
among them a manuscript now at Iena, which is the source of the
images to which I shall refer.[15] The landscapes that precede Book 12 on
the variety of birds and Book 17 on the different plants and trees (Fig. 6)
are rather calculated, not to say artificial compositions, a trait that we
are most likely apt to find unsympathetic. It results, of course, from

15. Iena, Universitätsbib. Ms. El. f. 80. Irmgard Kratzsch, *Über die Eigenschaften
der Dinge. Die Enzyklopädie des Bartholomeus Anglicus in einer illuminierten fran-
zösischen Handschrift der Universitätsbibliothek der Friedrich-Schiller Universität
Jena* (Jena: Die Universitätsbibliothek, 1982). On the illustrated manuscripts of Cor-
bechon's translation of the late fourteenth and early fifteenth century, see Donal Byrne,
"The Boucicaut Master and the Iconographical Tradition of the 'Livre des Propriétés des
Choses'," *Gazette des Beaux-Arts* 92, (1978): 149–64, and idem, "Rex Imago Dei:
Charles V of France and the *Livre des Propriétés des Choses*," *Journal of Medieval
History* 7, (1981): 97–113.

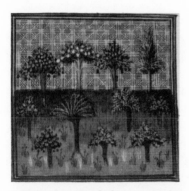

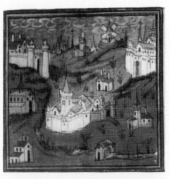

6. Trees, from Bartholomeus Anglicus, *Propriété des Choses* (Iena, Universitätsbib. Ms. El. f. 80, fol. 261v) (after Kratzsch, *Eigenschaften*)

7. Provinces, from Bartholomeus Anglicus, *Propriété des Choses* (Iena, Universitätsbib. Ms. El. f. 80, fol. 217v) (after Kratzsch, *Eigenschaften*)

the painter's desire to do justice to the individual characteristics of each of the species, while simultaneously seeking to persuade us that they informally inhabit a piece of the natural world. The composition that introduces Book 15, which concerns various lands and provinces has, on the other hand, a different and much more novel character (Fig. 7). The artist had to combine here not easily circumscribed entities like birds and trees, but subdivisions of the world with particular geographic and cultural identities. The subject of the painting is thus landscape itself, or as the text invites us to say, a view of a *province* or *pays*, to become in later parlance a *paysage*. This is reflected in the painting, which is much more casually composed and spatially fluid than the rendition of the author's catalogue of trees, and dispenses as well with the flat, ornamented backdrop in favor of a bluish sky activated by white linear flourishes simulating cloudlets.

Bartholomeus's treatment of the *pays et provinces* is of special interest, as Leopold Delisle noted in a fundamental essay devoted to the *Propriété des choses* published just over a century ago.[16] Book 14 of Isidore's *Etymologiae* is Bartholomeus's basic source here, but Isidore is much more cursory in his characterization of the different parts of the world, and since he was dependent on Greek and Roman sources, his nomenclature of the provinces has a distinctly Mediterranean coloration. In the territory that would now be included in western Europe, he lists outside of Italy only *Germania, Gallia, Belgae* and *Hispania*.

16. Leopold Delisle, "Traités divers sur les propriétés des choses," *Histoire littéraire de la France* 30, (1888): 353ff.

For Bartholomeus and his readers, this was no doubt a serious short-coming, and his discussion of the same subject includes entries for the major territorial subdivisions of France, Germany and Spain, taking note also of England and Ireland.[17] He is also more expansive than his predecessor on the distinctive features of each province, including here and there an appreciation of its inhabitants and local customs. The description of Flanders, which is particularly acute, thus registers the importance of the cloth industry, and the inhabitants' reliance on peat fuels dug up from marshes in order to palliate the shortage of wood. We are made aware by the churches, castles, windmills, and other structures in the painting of the Iena manuscript that the *pays* as it is conceived by Bartholomeus is not a raw slice of geography but a piece of nature that has been socially invested and structured in particular ways by implicit human agents.[18]

After this initial Paris-centered production of illustrated copies of the *Propriété des choses*, roughly spanning the reigns of Charles V and Charles VI, the initiative seems to have passed to provincial centers of the kingdom, following in this respect a general trend. There is in these somewhat later copies of the work a remarkable further elaboration of landscape representation, which would deserve closer scrutiny. A manuscript thought to have been written and illuminated around 1440 in a center of western France, perhaps Angers, transforms the author's list of precious stones and metals (Book 16) into a dramatic panorama of rocky peaks and ravines (Fig. 8).[19] The extraordinary painting in a copy of the work made in the southern Netherlands and perhaps attributable to the painter of Valenciennes Simon Marmion is attached to Bartholomeus's explanation of the four basic elements constitutive of man (Book 4), normally depicted in schematic or allegorical form, and not easily imaginable as the subject of a landscape.[20] The painter's attempt to treat the interplay of fire, air, water and earth as a purely sensory spectacle is *Landschaftsgefühl* in an almost excessive sense, and can hardly be said to have been provoked in a literal fashion by the

17. In his *Imago mundi* (1410), Pierre d'Ailly also complains about the virtual silence of Orosius, Isidore and other ancient writers on geography for their near silence on the provinces of Gaul and Flanders. See on this Bernard Guenée, *Entre l'église et l'état: Quatre vies de prélats français à la fin du moyen âge* (Paris: Gallimard 1987), 265.

18. Matthias Eberle, *Individuum und Landschaft. Zur Enstehung und Entwicklung der Landschaftsmalerei* (Giessen: Anabas-Verlag, 1980), 15ff., stresses the socially constructed nature of landscape representation.

19. Paris, Bibl. Nat. fr. 135–36. Otto Pächt, *Terre de Flandres*, 7ff.

20. London, Brit. Lib. Cotton Aug. A, VI, fol. 52v. Color reproduction in Pächt, *Terre de Flandres*, 7, pl. II. Henceforth cited in text.

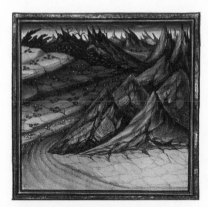 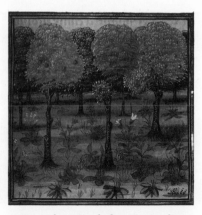

8. Precious stones and metals, from
Bartholomeus Anglicus, *Propriété des
Choses* (Paris, Bibl. Nat. fr. 136, fol. 73)
(Bibliothèque Nationale)

9. Trees, from Bartholomeus Anglicus,
Propriété des Choses (Paris, Bibl. Nat. fr.
134, fol. 281) (Bibliothèque Nationale)

sober science of the text. A painting in a manuscript perhaps made at Bruges around 1470–1480 fuses the author's methodical enumeration of trees into a convincing forest (Fig. 9).[21] Toward the end of the fifteenth century, the landscapes of Bartholomeus's *Propriété* also wandered into other contexts. A historical chronicle concerned with Flanders excerpts Bartholomeus's description of that province, and with it, a deep prospect in which the land, perhaps a shade too amiably, exhibits the marks of cultivation and industry for which it was already famous (Br. L., Cotton, Aug. A. V., fol. 345v. Pächt, 7, pl. 2). A spacious and crisply delineated landscape divided by a meandering stream announces the chapter on islands (*Des isles de grand mer qui avironnent le monde*) in Jean de Vignay's translation of Vincent de Beauvais's *Speculum historiale* contained in a Flemish manuscript of ca., 1475 (Fig. 10).[22] I must leave aside the printed editions of the *Propriété des choses*, often accompanied by wood engravings, of which there were to be no less than fifty-five in various languages between the late fifteenth and the early seventeenth century.[23]

21. Paris, Bibl. Nat. fr. 134. On the localization of the manuscript, Georges Dogaer, *Flemish Miniature Painting in the 15th and 16th Centuries* (Amsterdam: B.N. Israël, 1987), 124.

22. Malibu, The J. Paul Getty Museum, Ms. 83 MP.148. Anton von Euw and Joachim M. Plotzek, *Die Handschriften der Sammlung Ludwig*, III (Cologne: Schnütgen Museum, 1982), 243–49.

23. The printed editions are inventoried in Edmund Voigt, "Bartholomaeus Anglicus, De Proprietatibus Rerum. Literarhistorisches und Bibliographisches," *Englische Studien* 41 (1910): 337–59.

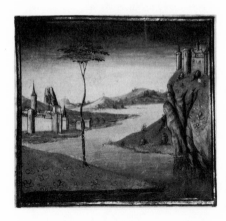

10. Islands, from Vincent de Beauvais, *Speculum historiale* (Malibu, The J. Paul Getty Museum, Ms. 83 MP.148, Vol. I, fol. 61) (The J. Paul Getty Museum)

In his characterization of meadows (*De prato*), Bartholomeus, as rendered in Corbechon's translation, writes as follows: "Les pres donnent confort a la veue par leur verdure et au nez par leur ondeur et prouffitent aux gens par leur saveur." That meadows, whatever might be their purpose, interested the eye in the first instance, was a small but far-reaching perception.

LINDA SEIDEL

The Value of Verisimilitude in the Art of Jan van Eyck

Verisimilitude, the appearance of truth, was the quality most praised by Bartolommeo Fazio in his midfifteenth-century discussion of Jan van Eyck's painting. In a description of a triptych by Jan, the Genoese humanist noted an Angel Gabriel "with hair surpassing reality," and a donor lacking "only a voice;" Jerome, probably painted on one of the wings, looked "like a living being in a library," and the viewer had the impression when standing a bit away from the panel that the room "recedes inwards and that it has complete books laid open in it. . . ." Fazio remarked that a viewer could measure the distance between places on a circular map of the world that Jan painted for the Duke of Burgundy; on another painting, the viewer could see both a nude woman's back as well as her face and breast through the judicious placement of a mirror. Indeed, Fazio noted, "almost nothing is more wonderful in this work than the mirror painted in the picture, in which you see whatever is represented as in a real mirror."[1] Although none of the paintings Fazio described has survived, no one doubts or discounts the substance of his praise. Tiny panels of Saint Jerome and of a nude woman bathing, known in possibly abbreviated versions from the

1. Michael Baxandall, "Bartholomaeus Facius on Painting; A Fifteenth-Century Manuscript of the *De Viris Illustribus*," *Journal of the Warburg and Courtauld Institutes* 27 (1964): 90–107; the English translation of the entry on Johannes Gallicus, from which the quotations are excerpted, appears on p. 102. In his article, Baxandall uses an early manuscript source, Vat. lat. 13650, to establish a new text for Fazio's chapter on Painters previously known only from a Florentine publication of 1745 by Lorenzo Mehus. Fazio, secretary to Alfonso of Naples, wrote the work in 1456. His treatise is distinguished by its inclusion of painters and sculptors among the more familiar groups of orators, lawyers, princes, and physicians.

YFS Special Edition, *Contexts: Style and Values in Medieval Art and Literature,* ed. Daniel Poirion and Nancy Freeman Regalado, © 1991 by Yale University.

hands of Jan's followers, provide unambiguous support for the points he made; and the celebrated works by Jan that have come down to us and which are scattered among a handful of primarily European museums indisputably attest to the perspicacity of Fazio's remarks.[2]

Although Fazio in these cases, as Baxandall notes, has clearly transferred to Jan's painting familiar expectations for poetry, recognition of Jan's *naturalism* is a consistent response to his art, not a relative judgment. Yet, Panofsky observed, the sense that his works "confront us with a *reconstruction* rather than a mere *representation* of the visible world is more difficult to rationalize" (Panofsky, Early Netherlandish Painting, 181; emphasis mine). In this paper, I shall scrutinize Jan's use of descriptive details in his construction of individual physiognomy and environmental topography; I seek to inquire whether, and if so how, a record of such kind might have laid claim to higher truth. For, if the verisimilitude that Jan's art displays had rhetorical pretense, then his style, not just the subject matter of his paintings, raises the issue of art's capacity to stand as witness to the events it portrays.

Concern about the role of art as record arises initially in the context of Jan's *Arnolfini Portrait* in London, in which reflections in a mirror appear to document the otherwise unobserved attendance of witnesses at a marriage (fig. 1). Jan's multifigured devotional panels in Ghent, Bruges and Paris, in which "living" donors coexist with long deceased saints in a space which Jan has created, develop this theme. Through the manipulation of both shadows and reflections, Jan makes the painted setting appear to be an extension of our own. Jan's construction of concrete relationships between the "real" viewer of his paintings and the objects and settings he portrays on his panels implicates viewers in inextricable ways in the act of looking at his art. Insofar as Jan appropriates us as authorities into his painting, verisimilitude is not merely an aesthetic option for him or for us: it is a strategy of power.[3]

2. For Jan's *oeuvre* in general see Max J. Friedlaender, *Early Netherlandish Painting*, 1. The van Eycks—Petrus Christus, preface by Erwin Panofsky, trans. Heinz Norden (Brussels: Sigthoff, 1967); publication of the original German edition began in 1924. More recent comprehensive studies of Jan's work include those by Erwin Panofsky, *Early Netherlandish Painting: Its Origins and Character*, 2 vols. (Cambridge, Mass., Harvard University Press, 1953), 1:178–246, and Elisabeth Dhanens, *Hubert and Jan van Eyck* (New York: Alpine Fine Arts Collection, 1980). The color plates and details in Dhanens' book are particularly helpful tools in studying Jan's work.

3. Some of these points were raised toward the end of my article "'Jan van Eyck's Arnolfini Portrait': Business as Usual?" *Critical Inquiry* 16 (Autumn 1989): 54–86, to which the reader is referred for extensive bibliographic references on Jan's art.

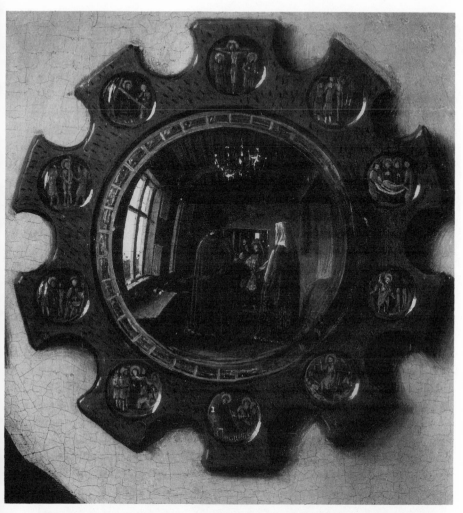

1. Jan van Eyck, *Portrait of Giovanni Arnolfini and Giovanna Cenami*. The National Gallery, London; detail of the mirror. Photo: Courtesy of the Trustees, the National Gallery, London.

More than half of Jan van Eyck's extant works are portraits of his contemporaries seen either as busts in small scale or full length and in a somewhat larger format, though not life size. Four works, all painted in the early 1430s, belong to this latter group. The celebrated panels of *Chancelor Nicholas Rolin and the Virgin* in the Louvre (fig. 2), *Canon van der Paele with the Virgin and Saints George and Donatian* in the Stadelijk Museum, Bruges (fig. 3), and Joos Vijd and his wife on the

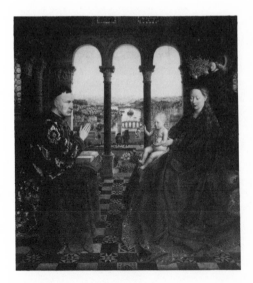

2. Jan van Eyck, *Chancelor Nicholas Rolin and the Virgin.* Musée du Louvre, Paris. Photo: Archives photographiques.

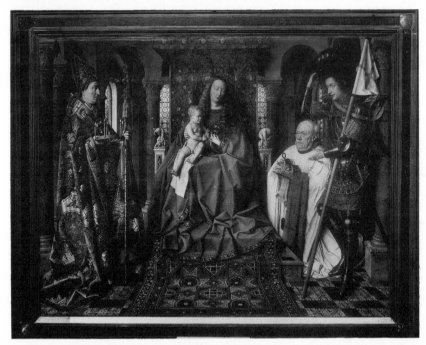

3. Jan van Eyck, *The Virgin with Canon van der Paele, Saint Donatian and Saint George.* Stadelijk Museum voor Schone Kunsten, Bruges. © A.C.L.-Brussels.

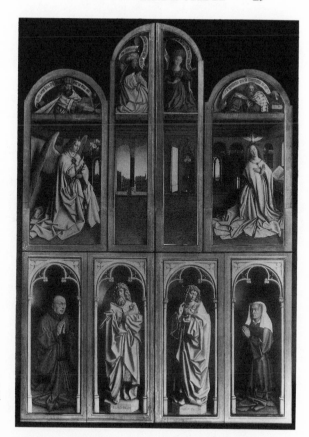

4. Jan van Eyck, *The Ghent Altarpiece*, exterior: the donors and statues of their patron saints; the Annunciation; Sibyls and Prophets. Cathedral of Saint Bavo, Ghent. © A.C.L.-Bruxelles.

wings of the multipaneled *Altarpiece of the Mystic Lamb* in the Cathedral of Saint Bavo (fig. 4) (originally Saint John's) in Ghent, show powerful court and civic dignitaries in consort with the Virgin and or saints. Why these individuals should have hired the Duke's artist to make these works and why Philip might have allowed his *varlet de chambre* to "freelance" for them are questions that have not been addressed. The compelling double portrait in the National Gallery, London, believed to present the marriage of Giovanni Arnolfini and Giovanna Cenami and dated 1434, is conventionally discussed in art historical literature as part of this group: an image of real people participating in a sacramental event. In fact it presents a well-to-do but as yet obscure young merchant couple, unattended by holy companions, in the austere splendor of their private dwelling; as such, it is an ostensibly anomalous adherent to the group of devotional works. Yet, in each of these four paintings, Jan uses veristic details of one sort or another to

trap his viewers into a significant relationship with the panel, one that involves intellectual activity and not merely aesthetic pleasure. This strategy of representation, which is an essential component of Jan's style, demands further consideration.

For example, in the *Ghent Altarpiece*, Jan matches the implied source of light used to model figures on the outer wings with the actual source of light that would have illuminated the chapel for which the painting was made and in which it was intended to be seen. By suggesting through paint that the frame of the painting casts shadows on the panels it encloses, the artist has implied that the spaces in which the portrayed events take place are extensions of those in which the viewing occurs. The claim is restated when the wings of the altarpiece are opened even though representations of celestial thrones and distant landscape, which are juxtaposed on the interior panels, disrupt the logic of constructed space that pervades the exterior. On the panel of singing angels in the upper register to the left of the central scenes, one of the figures wears a gleaming brooch on which the artist has simulated reflections of light shining through gothic lancet windows. These "reflections" result from a source of daylight that is imagined to fall from the right, the direction of the choir chapel's actual south windows. Such effects contextualize Jan's paintings in particular environments and implicate the viewer's presence under the same conditions as well. In that way, Jan fixes the connection between viewer and painting in a present of infinite duration.

On the van der Paele panel in Bruges, Jan composed "reflections" in order to incorporate within his painting otherwise unseen figures, individuals who can only be understood rationally as onlookers. On the shield of Saint George, patron of the aged kneeling canon, a distorted depiction of a man in turban and tunic is discovered amidst the myriad glistening illuminated facets of the armor and gilded metal that crowd the right edge of the panel; fragments of two additional forms can be made out as well. Through these obscure, simulated, mirrorlike images, Jan creates an external audience of perpetual viewers for his multifigured painting.[4] This entrapment of imagined or invented onlookers within the viewing space of the painting of course recalls Jan's invention of the conceit in his London double portrait.

The most celebrated example of reflection in art, not only in Jan's

4. On this reflection see David G. Carter, "Reflections in Armor in the Canon van de Paele Madonna," *Art Bulletin* 36 (1954): 60–62 and David Farmer, "Further Reflections on a van Eyck Self-Portrait," *Oud Holland* 83 (1968): 159–60.

work but in all of painting, occurs in the mirror of the *Arnolfini Portrait*, a work that was most likely known to another master of reflection, Velasquez, since Jan's panel was in Spain from 1556 on and was part of the royal collections.[5] In Jan's work, the mirror attests to the presence of two onlookers in the space in front of the painted couple, the zone the "real" viewer imagines herself as occupying. The presence of these depicted parties is consequential to all readings of the panel however divergent those accounts may be. Whether the figures are understood as attendants or witnesses depends upon the interpretation of the ceremony that is being enacted; it may be more accurate to say that assumptions about the role the figures play determines understanding of the rest of the panel.[6]

Jan also employed focused light sources in this painting, one indicated in the window, the other implied in the foreground; together, these construct the characteristic twin-windowed brick residence of middle-class, medieval Bruges. The house in Damme, the port suburb of Bruges, where, in 1430, Philip the Good exchanged marriage vows with Isabella as she stepped off the boat from Portugal, provides a close comparison. Guided by the circumstances Jan is known to have constructed in his other multifigured panels, the viewer is encouraged to fit together the information here provided with what is known from personal experience. It is possible to imagine that the *Arnolfini Portrait* was hung on the rear wall of a chamber like the one represented on its surface. There the conditions of illumination—lateral light shining through paired mullioned windows—would coincide with the experience of viewing. The precise characterization of the furnishings of that depicted room would not, I think, have repeated the actual objects of the viewing chamber, at least that is not the way in which Jan's paintings of this type seem to have been assembled. Jan's panels instead constructed for viewers a plausible space beyond the frame, one which connected with but did not repeat the actual environment's architec-

5. For a review of recent interpretations of Velasquez's masterpiece, along with new suggestions concerning its meaning, see Joel Snyder, "*Las Meninas* and the Mirror of the Prince," *Critical Inquiry* 11 (Summer 1985): 539–72. Foucault's comments on the painting are central to the argument about Jan's work I develop here. See Michel Foucault, "Las Meninas," *The Order of Things* (New York: Vintage, 1970).

6. On interpretations of the *Arnolfini Portrait,* see most recently David Carrier, "Naturalism and Allegory in Flemish Painting," *Journal of Aesthetics and Art Criticism* 45 (1987): 237–49; Mark Roskill, *The Interpretation of Pictures* (Amherst, Mass., 1989), 61–72; Craig Harbison, "Sexuality and Social Standing in Jan van Eyck's Arnolfini Double Portrait," *Renaissance Quarterly* 43 (1990), 249–91.

tural definition. In this way, Jan bonded together, in a coordinated unit, his representation with the viewer's reality.

I wonder, therefore, whether the painting might not have been hung in an antechamber of a house in which location the activity we see taking place in the picture could have been understood as occurring in an adjacent room, beyond the doorway that frames the individuals depicted in the mirror (and who ostensibly stand in our space). Such an arrangement of rooms is shown in a miniature of the third quarter of the century in which Duke Philip is seen visiting the scribe David Aubert at work;[7] beyond the room in which they meet lies the calligrapher's personal bedchamber. The *Arnolfini Painting* may have been envisioned by its maker as hanging on the boundary wall between such working and living spaces.

At the moment at which Jan draws us into carefully constructed, extended environments, he shifts our attention from the seen to the known, from what we may call eyewitness to third-person testimony. In addition to his accumulation of topographical reference, Jan introduces language into nearly all of his works as inscription, as speech and as text, either on the frames or on the surfaces of his paintings, as an additional way of obligating the viewing public to his work. On the Arnolfini panel, an inscription in a fastidious diplomatic hand boldly announces that Jan was (but is no longer) here. The words inform an elite viewer that the absent artist has relinquished responsibility for the image; that role has reverted to the current "reader" of record. In the *Ghent Altarpiece,* the dedicatory inscription on the frame places the painting under the protection of the viewer; the words here echo the language of the foundation charter of the chapel in which the painting was intended to reside.[8] In that text, the donor implores the

7. The illumination is illustrated and discussed in the exhibition catalogue *Charles le Téméraire. Exposition organisée à l'occasion du 5e centenaire de sa mort.* Bibliothèque Royale Albert Ier, ed. P. Cockshaw, C. Lemaire, A. Rouzet (Brussels 1977), cat. 6, 82–83.

8. The inscription, a quatrain, was discovered during a cleaning in 1823. Although Paul Coremans registered doubt as to its originality, he observed that "la non-originalité n'a cependant été prouvée de façon certaine. . . ." *Les Primitifs flamands. Contributions à l'étude des primitifs flamands. L'Agneau mystique au laboratoire* (Antwerp: de Sikkel, 1953), 120–22. Dhanens argues that the paleography and style of the quatrain are both original. *Van Eyck: The Ghent Altarpiece* (New York: Viking Press, 1973), 26–31. The text, which appears on the lower frames of the bottom row of panels on the outer wings has been transcribed as follows: PICTOR HUBERTUS EEYCK. MAIOR QUO NEMO REPERTUS INCEPIT. PONDUS. QUE JOHANNES ARTE SECUNDUS

servers of his chapel to remember him, his childless wife and their ancestors. Jan's image instructs the viewer in the way in which Joos and his spouse are to be recalled: at daily devotion before their patron saints, ever present for participation in holy communion. The coin purse at Joos's belt evokes the substantial donation he made to the cathedral, as recorded in the charter, so that masses at this altar would be said in his memory, at regular intervals, well into the future. The painting functions then as part of the contract between Joos and the church, establishing the viewer as guarantor of its fulfillment.

Jan employed a different strategy of written words to engage a viewer in the painting now at the Louvre. Text, written in gold around the twisting hem of the Virgin's mantle and partly legible, contains fragments of the Little Office of the Virgin.[9] These words locate her presence and our viewing of her in a particular liturgical context. The letter D, for Domine, on the book that is opened in front of the Chancelor, initiates the regular morning devotion; the viewer then completes Nicholas's action through the reading of the textual remnants on the Virgin's garment. While Rolin may conjure up Mary as the focus of his devotion (indeed, no one suggests that she is to be thought of as present before him in the flesh), it is the viewer, through his or her decoding of inscribed texts—a decoding that takes place through remembered readings of the offices—who substantiates Rolin's operation.

Viewers are the agents through whom the implications of Jan's art are realized; they have no capacity to reject that responsibility. Jan so embeds each element of his painting in a web of contextualizing reference that the viewer is instantly trapped in the role of obligatory participant; the act of looking at Jan's paintings fulfills the claims they make. In the van der Paele panel, the setting in which the canon is seen very likely invoked the church of Saint Donatian to which he was attached and in which he intended to have himself remembered

(FRATER) PERFECIT. JUDOCI VIJD PRECE FRETUS. VERSU SEXTA MAI VOS COLLOCAT ACTA TUERI. The foundation charter of 13 May 1435, obligates the clergy who served the chapel to take care of it. Ibid., 22–24.

9. The texts on the Virgin's robe, reconstructed by Heinz Roosen-Runge, Die Rolin-Madonna des Jan van Eyck (Wiesbaden: L. Reichert, 1972), 29–32. have been discussed in detail by Anne Hagopian Van Buren, "The Canonical Office in Renaissance Painting, Part 2: More About the Rolin Madonna," Art Bulletin 60 (1978): 617–33, with illustrations.

through the foundation of chaplaincies; the inscription on the frame of the panel proclaims this.[10] The building was destroyed, however, and survives only in archaeological fragments across from the town hall in Bruges; thus we are unable to reconstruct the precise conditions of viewing in which the painting was intended to be seen. We acknowledge, nonetheless, that we see the canon at prayer conjuring up the Virgin in the company of his church's patron and his own; the latter both presents and represents him. The former, Archbishop Donatian, understood as standing in the sanctuary of his own shrine, represents his own relics. These provided the dedication of the building; they were also the focus of a spectacular celebration on his feast day.[11] The lighted candles in the wheel the saint holds attest, according to legends, to the location of his final resting place; they are guarantees of his authenticity and authority. Van der Paele is inserted by Jan into this sequence of holy figures, each of whom obligates service from a faithful viewer. The canon's desire to be in the company of distinguished patrons is thus realized through the attention the viewer gives to his donation in the chapel for which it was painted. Viewer and artist collaborate in the fulfillment of the patron's wishes.

Such connections between Jan's panels and the physical experience of looking fuse the desire of the patron with the reality of the viewer. What is wished for and prayed for (be)comes true in the eyes of the beholder. Jan's paintings in this sense do not record events: they are parts of ongoing transactions in which we are intimately implicated as parties to their claims. In such a way, the issue of Mrs. Arnolfini's purported pregnancy can be addressed. She is shown as women were always shown by Jan, Virgin saints like Catherine in the wing of the Dresden altar as well as Eve before the Fall on the Ghent polyptych. As represented, each woman embodies the possibility of generation; each is inseminated, so to speak, through the engendering activity of (male)

10. The inscription reads: HOC OP(US) FECIT FIERI MAG(ISTE)R GEORGI(US) DE PALA HUI(US) ECCLESIE CANONI(CUS) P(ER) JOHANNE(M) DE EYCK PICTORE(M) -ET FUNDAVIT HIC DUAS CAPELL(AN)IAS DE GR(EM)IO CHORI DOMINI and the date 1436. Since van der Paele founded only one chaplaincy in 1434, and another in 1441—the year of Jan's death, it is likely that some adjustment was made to the inscription early on. *Les Primitifs flamands. Corpus de la peinture des anciens Pays-Bas méridionaux au quinzième siècle. 1. Le Musée communal de Bruges*, by A. Janssens de Bisthoven and R. A. Parmentier (Antwerp: De Sikkel, 1951), 41.

11. For a discussion of the important celebrations at St. Donatian's involving the procession of the saint's relics, see Reinhard Strohm, *Music in Late Medieval Bruges* (Oxford: Oxford University Press, 1985), 16–17 as well as 10–13.

viewers. For Jan, viewing is not an accident of possession; it is a condition of production.

Mrs. Arnolfini is part of another transaction as well, something I read in economic terms. She is being handed over in this painting as token of the dowry her father transfers to her husband at the moment of the consummation of their union. I believe that this is presented here as Jan presented the Virgin on the Louvre and Bruges panels, as the man's wish which, through the artist's meticulous representation, the viewer experiences as reality. But insofar as the desire that is represented in this painting has significant economic consequences—her father was a distinguished banker, her husband started out selling hats—the value of Jan's rendering has more than metaphoric implications. Indeed, the resituation of discourse, from the economy of salvation in the case of van der Paele, Rolin and Joos Vijd to that of the market place in this instance is signified by the green dress Giovanna wears, the color of the cloths that licensed bankers placed over their tables and on which they transacted their business. Quentin Massys conveniently showed us this quite explicitly in a painting of the early sixteenth century in the Louvre in which a banker and his wife weigh money on a green covered bench. We know that the custom was in use in Tuscany, from whence the subjects of Jan's painting came, by the late fourteenth if not the early fifteenth century.[12]

The kind of meticulous description that secured credibility in the realm of the real for religious representation is thus employed in the London painting to provide confirmation of what may, at first sight, seem to be more pedestrian activity. I do not wish to suggest, however, that economic transactions were then, or are now, without a theology of their own. The relocation of discourse that occurs in the *Arnolfini Portrait* invites us to inspect other sorts of transactions of a kind that we might not otherwise feel impelled to inquire into when discussing works of art. One of the issues thus foregrounded concerns the relationship between materials and production: in Jan's and Giovanni Arnolfini's merchant economy, credit and advances were routinely used for the purchase of raw materials; these were then converted into goods for exchange. Art, too, may have functioned as a commodity in this

12. *Florentine Merchants in the Age of the Medici: Letters and Documents from the Selfridge Collection of Medici Manuscripts*, ed. Gertrude Randolph Bramlette Richards (Cambridge, Mass., Harvard University Press, 1932), 38–39. For the Massys painting, see Larry Silver, *The Paintings of Quinten Massys* (Montclair, N.J., Allanheld and Schram, 1984), 136–38 and 211–12.

context. It has not been difficult to visualize or conceptualize a painting as fulfilling wishes in the context of the church; but can it be understood in the same way in the commercial quarters of the real world? How can or did art's authority in one sphere translate into another? It is my claim that Jan's style facilitated the transfer of art's promissory authority from the church to the "street" because it had already assimilated the language of contractual practice; with appropriation came the power of those conventions.

Images of artists being visited in their studio provide the closest visual parallels I know to the interior encounter we discover in the London panel. These illuminations, which date for the most part from the second half of the century, do not constitute precedents or sources for Jan's work. They represent conditions of production that constrained individuals in ways that are frequently outlined in guild regulations and in *ordonnances* that various Burgundian administrations produced to control a variety of activities. But insofar as the *Arnolfini Portrait* adheres to the pictorial genre of artist-at-work, it too may tell us about producer-patron relations.[13]

Artistic enterprises were governed by their own contracts or by their contractlike situations. Perhaps the reason we have almost no documentary evidence indicating what work Jan did for the Duke has to do with the verbal understandings that often guided such exchange. We know what the Duke paid Jan and the currency in which it was paid, a matter of particular consequence until 1434, the date written on the *Arnolfini Portrait*, when Burgundian currency was both devalued and stabilized.[14] It may not have been necessary to make any further record since Jan's paintings visually inscribed within themselves the reciprocal strategy of the contract, the notion of exchange. Additionally, the attention Jan gave to material richness and his simulation of splendid working of raw matter served to equate the worth of

13. There are additional manuscript illuminations in the catalogue *Charles le Téméraire* cited in n. 7 above. For the administrative regulations, see the essay by Pierre Cockshaw, "Les Manuscripts de Charles de Bourgogne et de ses proches," ibid., 3–19. Contemporary guild practices are discussed in detail by Lorne Campbell, "The Art Market in the Southern Netherlands in the Fifteenth Century," *Burlington Magazine* 118 (1976): 188–98 and "The Early Netherlandish Painters and their Workshops," in *Le Dessin sous-jacent dans la peinture. Colloque III: Le problème Maître de Flemalle—van der Weyden*, ed. Dominique Hollanders-Favart and Roger van Schoute (Louvain-la-Neuve, 1981), 43–61.

14. Peter Spufford, *Monetary Problems and Policies in the Burgundian Netherlands, 1433–96* (Leiden: E. J. Brill, 1970), 1.

his product with the value of its workmanship, a theme that we find stated in countless medieval writings.[15]

In Glasser's study of artist's contracts of the fifteenth century, she observes that, in some cases, the transfer of raw material constituted a pact between artist and patron without benefit of a written document. It was the artist/craftsman's responsibility to fashion and finish a product, and, only when it was completed to satisfaction, was full payment made to him. In particular, artisans in metal, wood, embroidery, painting and weaving took responsibility for the raw matter, obligating themselves through receipt of the materials to the work to be done. As we read so often in the texts on art of the Middle Ages, the workmanship was expected to surpass the materials, something Jan surely achieved in the bravura passages of his paintings: the metalworking of the Virgin's crown in the Paris painting and the chandelier in the London one—objects which confer rank or authority on the event into which they are incorporated; stone carving and luxury weaving on the Bruges panel, glass grinding there and in the Arnolfini—where it is juxtaposed with mirror making. Painters and mirror makers belonged to the same guild in the late middle ages, enacting a rivalry between their trades that went back to antiquity, when Narcissus's reflection was identified as the origin of painting.[16] Immediately above the mirror on Jan's panel, the vanished artist's signature absorbs the mirror into his production.

Another painting by Jan done in connection with a marriage undeniably acted as part of a contract. Jan van Eyck went to Iberia in 1428 as a member of a ducal delegation, which included Baudouin de Lannoy, to negotiate a marriage for Philip the Good with a princess of the House of Portugal. A contemporary account of the voyage survives; in it we read of a series of contractual maneuvers to arrange the alliance.[17] At the point at which a preliminary agreement was drawn up with the princess's father, Jan painted a portrait of the bride-to-be to accompany the document on its voyage to Philip for his approval. Scholarship romanticizes the painting as a "photo" of the princess for her future

15. Hannelore Glasser, *Artists' Contracts of the Early Renaissance* (Columbia University doctoral dissertation, 1965), 5–20; and Meyer Schapiro's survey of earlier texts in "On the Aesthetic Attitude in Romanesque Art," *Romanesque Art* (New York: G. Braziller, 1977), 1–27.

16. Heinrich Schwarz, "The Mirror in Art," *Art Quarterly* 15 (1952): 110.

17. C. A. J. Armstrong, "La Politique matrimoniale des ducs de Bourgogne de la Maison de Valois," *Annales de Bourgogne* 40 (1968): 41–44, for a detailed analysis of the transactions.

husband's sanction.[18] Instead it should be seen as corroboration of the contract: eyewitness testimony to the person of the princess so that when she arrived in Burgundy, provided that the deal went through, there would be independent proof of her authenticity through the matching of her image to her person. In fact, when the messengers to Philip's Court returned to Portugal, carrying signed proof of the Duke's agreement to the terms of Isabella's father's offer, they brought with them halves of certain gold coins in which the Duke stipulated that her dowry should be paid. By matching up the King of Portugal's halves with those the Duke retained, the fulfillment of the monetary value of the contract would be demonstrated.[19]

The matching of panels to authenticate an event or image portrayed on them, in the manner by which contracts could be validated, may be a useful way to understand some of the miscellaneous panels that have survived; it may also expand our thinking about diptych construction. The painting of a nude woman bathing, which is known in two examples after a lost fifteenth-century original (fig. 5 and fig. 6), has been linked in the literature to the *Arnolfini Portrait*, although only with difficulty because of the seemingly divergent genres of representation to which the panels belong.[20] On a tiny copy of the "lost" painting, the woman, accompanied by a clothed female, is shown in a chamber that

18. For the most recent restatement of this position see Diane Wolfthal, *The Beginnings of Netherlandish Canvas Painting: 1400–1530* (Cambridge: Cambridge University Press, 1989), 10, where she cites an earlier authority: "As Crowe and Cavalcaselle note, 'The prince was to reserve for himself the right of breaking off the negotiation if Isabella's charms should appear to him less attractive than he had fancied them to be.'"

19. Armstrong, "La Politique matrimoniale," 42. On the payment of the dowry, see the second part of Armstrong's paper in *Annales de Bourgogne*, 40 (1968): 128–29.

20. The most detailed study of this no longer extant painting suggests that it may have had something to do with prosaic prenuptial marriage rituals. Julius Held, "Artis Pictoriae Amator. An Antwerp Art Patron and His Collection," in *Rubens and His Circle: Studies by J. S. Held*, ed. Anne W. Lowenthal, David Rosand, and John Walsh, Jr. (Princeton: Princeton University Press, 1982), 35–64. Peter Schabacker identified the subject as *Judith Beautifying Herself*, following a little-known and otherwise unillustrated biblical text ("Jan van Eyck's Woman at her Toilet; Proposals Concerning its Subject and Context," *Fogg Art Museum Annual Report, 1974–75, 1975–76* [Cambridge, Mass., 1979], 56–78). Robert Baldwin absorbed the picture into a totalizing sacramental reading of the London panel ("Marriage as a Sacramental Reflection of the Passion: The Mirror in Jan van Eyck's Arnolfini Wedding," *Oud Holland* 98 [1984]: 66). Max Friedlaender, the ultimate authority on matters Netherlandish, first observed that the painting seems to have been approximately the same size as the Arnolfini Portrait (*Early Netherlandish Painting*, 1: 67–68). Panofsky detached discussion of the lost panel from that of the Arnolfini Portrait and buried reference to it in an early footnote (*Early Netherlandish Painting*, 1: 3, n. 1).

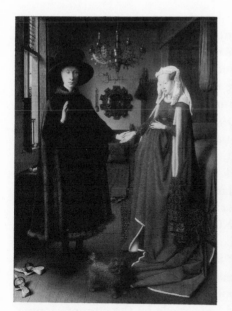

5. Jan van Eyck's Arnolfini Portrait, see. Fig. 1.

6. *Toilet Scene;* fifteenth-century copy after a lost van Eyck. The Harvard University Art Museums. Photo, courtesy of the Museums.

is astonishingly similar to the one that is portrayed on the London panel. The dog, the bed, the chest, the mirror, even the discarded wooden slippers all attest to the connections between the representations. Perhaps the value of the lost painting, independent of its erotic content or precisely through it, resided in the proof it secured, not just of the woman but of the event portrayed, the consummation of a marriage. This activity, according to Tuscan practice of the time, was the condition for receipt of the dowry. Thus, if the London portrait had been painted for the wall of Giovanna Cenami's father's house where she would have seen it in the years between her betrothal and her marriage,[21] then, perhaps, the erotic half, which is known only indirectly, may have been given to her future husband as guarantee of what

21. In the article cited in n. 3, I speculate that the painting represents the viewer with the future, wished-for marriage of Giovanna and Giovanni, and not the completed event. In hypothesizing an installation for the painting in Giovanna's childhood home, I am effectively extending and downplaying Joel Snyder's suggestion, put forward in the context of his study of "Las Meninas," that a painting could be the " . . . equivalent of a manual for the education of a princess." "*Las Meninas,*" 564.

he was promised. The presence of pattens in the lower left corner locates the site of that panel's controlling gaze and aligns it with the mirror's reflection of the woman's naked body; together they identify Giovanni as onlooker to the scene.[22] Both "halves" of such an Arnolfini diptych transform a future transaction into an occurring one; art would here record as reality a promise rather than the performance.

In such a way then, the *Arnolfini Portrait* may be regarded as a constitutive part of a contract, analogous to the Ghent Altarpiece's relationship to Joos Vijd's foundation or the Bruges panel's to van der Paele's donation. Although we lack the certifying text in this case, the visual record is undeniably similar.[23] Jan, we know, was a well-paid employee. Ducal documents indicate that Philip made a special point of directing his administrators NOT to tamper with Jan's pension when he cancelled those of other court members during times of stringency.[24] Evidence of Jan's "price" is represented in his panels by the meticulous working of splendid materials; this would have indicated to his contemporaries, in the unspoken language of artisanal contracts, that a significant investment had been made by the commissioning party, whether that was van der Paele, Rolin or Joos Vijd in behalf of the future repose of their souls, or the "patron" of the London panel.

To be sure, it is not easy to imagine who the latter was anymore than it is a simple matter to ascertain why that painting was made. But

22. Men ogle nude women in a number of works of art of the time. The story of Griselda stripped bare, illustrated on painted marriage chests, offered one opportunity for such imagery. See Christine Klapisch-Zuber, "The Griselda Complex: Dowry and Marriage Gifts in the Quattrocento," *Women, Family and Ritual in Renaissance Italy,* trans. Lydia Cochrane (Chicago: University of Chicago Press, 1985), 213–46. The undersurfaces of lids of marriage chests, the groom's gift to his bride in Italian custom, are also known to have borne images of reclining nude women. See Harald Olsen, "A Florentine Cassone Workshop," *Idea and Form: Figura* n.s. 1 (1959): 68–75 and Ellen Callman, *Apollonio di Giovanni* (Oxford, 1974), 27–28. For the tradition of the *cassone*, see Brucia Witthoft, "Marriage Rituals and Marriage Chests in Quattrocento Florence," *Artibus et Historiae* 5 (1982): 43–59. For Flemish and French examples, see Harbison, "Sexuality and Social Standing."

23. According to a Spanish inventory of 1700, the original frame of the *Arnolfini Portrait* was inscribed with verses from Ovid "y los versos declaran como se engañan el uno al otro." (J. Allende-Salazar, "Don Felipe de Guevara, coleccionista y escritor de arte del siglo xvi," *Archivo Español de Arte y Arqueologia* 2 [1925]: 191). Dhanens' translation of this as "And the verses explain how they plight their troth," is misleading (*Van Eyck,* 197). A more accurate translation might read: ". . . the verses explain how they deceive one another," a more appropriate reading in light of the professed Ovidian source and my own interpretation.

24. For documents about Jan at the Court of Burgundy, see W. H. J. Weale, *Hubert and John van Eyck, Their Life and Work* (London, J. Lane Company, 1908), xxvii ff., as well as Friedlaender's comments, *Early Netherlandish Painting,* 1: 36, op., cit.

if we bear in mind that Jan incorporated into his multifigured panels both the sense of a transaction with a viewer as well as a contract with a donor, and that he distinguished these relationships, then we may be able to differentiate the parties and infer who each might have been. The activity depicted in the London panel, the handing over of the bride, signifies the transfer of money from Signor Cenami to Arnolfini. Viewers of the painted transaction would thus attest to the disposition of the dowry, a matter of consequence should either the groom or the bride die before there were any offspring. Such "viewing" would have served the interests of Giovanna's father whose money was at stake in his daughter's betrothal; it would have verified his exchange with Arnolfini. At the same time, the splendor of the panel, with its imitation of sumptuous fabrics and rich metals, evokes the conditions of a more purely commercial contract, one which involved an advance of credit or materials in exchange for work. Insofar as the artist and the male subject of the panel both had commercial dealings with the Duke, the panel may represent a recirculation of money and labor: payment owed to the court "haberdasher" transmitted through or exchanged for work performed by the court painter. The former, the cloth merchant Arnolfini, may then have turned the panel over to his father-in-law as worthy evidence of his receipt of another cash advance of significant commercial potential: Giovanna's dowry. The woman is absent in each of these exchanges between father and son-in-law, spouse and parent, artist and employer.

Jan's style, I have argued, makes a claim on viewers' vision and experience. His paintings contract us to be eyewitnesses to the events the artist has portrayed; in doing so, they charge the issue of visual versus verbal testimony with new potency. Another painting, from the hand of a contemporary of Jan's, supports this observation (fig. 7). Roger van der Weyden's panel of Saint Luke making a likeness of the Virgin exists in several versions; the one in Boston is considered by connoisseurs to be closer to an original than any of the others. Roger may have painted it for the altar of the chapel of the Painters' Guild in Brussels, using his self-portrait for the saint's face; possibly it was his qualifying panel in which he signalled his promotion from apprentice to master. In representing Luke, patron saint of the Painters' Guild, Roger makes a stunning claim for the power of his profession.[25]

25. See Walter Cahn, *Masterpieces; Chapters on the History of an Idea* (Princeton: Princeton University Press, 1979), for a wide-ranging essay on the subject. For Rogier's painting, the best resources are Max J. Friedlaender, *Early Netherlandish Painting*, 2. "Rogier van der Weyden and the Master of Flemalle," op. cit., 18, 20, 81–82 and pl. 118;

7. Rogier van der Weyden, *Saint Luke Drawing the Virgin*. Museum of Fine Arts, Boston. Photo, courtesy of the Museum.

Luke renders what he sees; he presents himself as eyewitness to an event, the visit of the Virgin, about which the couple outside his room has no knowledge. In his burgher's studio, with a pet ox playfully untangling a scroll beneath a lectern in the side room, Luke, like Jan's Rolin, seems to be entertaining a vision of Mary. Her sudden appearance, which has caused Luke to turn abruptly from his reading (or writing), has been accommodated by the installation of a folded fabric to make a canopy. Perhaps Luke didn't have time to mix his paints: he works with metalpoint, scratching on prepared paper in a virtuoso test of his skills, one that allows no error. The drawing he produces will be solitary and unmistaken testimony to the validity of what he sees, more authoritative than the open book, presumably the Gospels, that

Les Primitifs flamands. I Corpus de la peinture des anciens Pays-Bas méridionaux au quinzième siècle. 4. New England Museums by Colin T. Eisler (Brussels: Centre national de recherches des primitifs flamands, 1961), 71–93; and Martin Davies, *Rogier van der Weyden. An Essay with a Critical Catalogue of Paintings assigned to him and to Robert Campin* (London: Phaidon, 1972), 204–05 and pl. 76. My claim expands on Erwin Panofsky's remark that "In representing St. Luke portraying the Virgin, the art of painting renders account of its own aims and methods." (*Early Netherlandish Painting*, 1: 253), and departs from Rona Goffen's observation that, for Rogier, "the depiction of the Madonna is a kind of prayer, the act of painting an act of devotion." ("Icon and Vision: Giovanni Bellini's Half-Length Madonnas," *Art Bulletin* 57 (1975): 507).

lies abandoned in shadow to the right. On the Boston panel we see Luke's representation—the silverpoint sketch—appropriated into Roger's; in a similar way in the London painting, the mirror is incorporated within Jan's greater production. In each instance, a "reflection" of nature that the viewer corroborates is at the core of the panel's construction; there it eloquently testifies to the definition of the artist's enterprise and to the supremacy of vision within that activity.

Seeing in these paintings is presented as a contractual relationship. The creation of a beautiful, independent, carefully wrought object marks the artist's fulfillment of his part of an agreement. Through his construction of a distinct, recognizable environment, one that is filled with concrete and splendid things, the painter obligates the viewer to the other half of the bargain: certification of the validity of the event, the people and the materials portrayed. In an arena of multiple discourses, the new style of fifteenth-century Burgundian painting, especially as practiced by Jan van Eyck, stakes out its claim to authority and power.

KEVIN BROWNLEE

The Image of History in Christine de Pizan's *Livre de la Mutacion de Fortune*

Christine de Pizan's *Livre de la Mutacion de Fortune*[1] (completed in 1403) is a universal history framed by a personal history. The structure of the work involves an extended presentation of human history as a function of the operations of Fortune, in seven parts. Parts 2, 3, and the beginning of Part 4 present a detailed "anatomy" of Fortune in allegorical terms; the conclusion of Part 4, as well as Parts 5, 6, and 7, contain a universal history, from the creation of the world down to the establishment of the Roman Empire, with an epilogue which considers contemporary medieval Europe. This universal history is preceded in Part 1 of the *Mutacion* by a personal history: an allegorical autobiography in miniature which traces Christine's development into the author of the present book. At the very end of Part 7, we return once again to this portrait of Christine as author-figure, which serves to effect closure for the work as a whole. The plot structure of the *Mutacion* thus involves a first-person configuration which both "explains" how Christine-protagonist became Christine-author, and represents her—figures her—in the very act of writing, of transcribing history.

The construct that makes this possible involves a double mimesis of history. At the beginning of Part 4, Christine initiates her description of the interior of Fortune's Castle (*donjon*, l. 7061), whose external appearance and whose inhabitants she has just treated in detail in Parts 2 and 3. Within, there is a "marvelous hall" (*une sale merveilleuse*, l. 7069)—round in shape, enormous in size, beautiful in appearance. The

1. All citations are from *Le Livre de la Mutacion de Fortune par Christine de Pisan*, Suzanne Solente, ed. (Paris: Picard, 1959–66). Translations are mine.

YFS Special Edition, *Contexts: Style and Values in Medieval Art and Literature,* ed. Daniel Poirion and Nancy Freeman Regalado, © 1991 by Yale University.

rest of the *Mutacion* will be situated, diegetically, inside this hall, for its walls are painted with all the events of human history:

> Si sont la escriptes les gestes
> Des grans princes et les conquestes
> De tous les regnes, qu'ilz acquistrent . . .
> La est la vie de chacuns
> Empereurs et princes et roys,
> Et leurs estas, et leurs arrois
> Pourtraict, et leurs propres figures,
> Et trestoutes les aventures,
> Qui en leur vies leur advint . . . [Ll. 7107–09; 7114–19]

There were written the deeds of the great princes, and the conquests of all the kingdoms that they acquired. . . . There was portrayed the life of every emperor and prince and king, their condition, their behavior, their very appearance, and every single adventure that befell them during their lives.

It is Fortune herself who controls these lives: "Et, quant les princes, qui la servent . . . / sont trespassez, lors, pour memoire, / elle fait pourtraire l'istoire / d'eulz (ll. 7141; 7143–45) [And when the princes who serve Fortune . . . die, then, to preserve their memory, she has their stories portrayed (on the walls)].

This visual depiction of human history is presented by Christine-author as part of her first-person experience as protagonist of the *Mutacion:*

> Si nommeray les creatures,
> Dont je vi la les pourtraitures,
> Non pas de tous, car trop seroie
> Lonc, quant trestout deviseroye,
> Mais des principaulx grans seigneurs . . .
> Si com vendra a ma memoire. [Ll. 7153–57; 7162]

And I will name the people whose portraits I saw there—not every one, for it would be too long if I described everything, but the most important great lords . . . as my memory recalls it.

At the diegetic center of the *Mutacion de Fortune,* we have, then, the following construct: a woman in the past (Christine-protagonist) who looked at a series of wall paintings depicting, comprehensively, all the great events of human history; and that same woman in the present (Christine-author), who remembers her past experience of this visual mimesis of history, and translates the visual images into verbal im-

ages, a process which necessarily involves a rigorous selectivity. In this essay, I would like to explore three interrelated aspects of this construct: First, the ways in which it utilizes, combines, and transforms a set of key model texts: in particular, the *Aeneid* and the *Roman de la Rose*, but also the *Prose Lancelot* and the *Divine Comedy*. Second, the ways in which it is used to structure the vast historical subject matter of the *Mutacion*. And third, the implications this construct has for both the identity and the authority of Christine the inscribed author-figure. In terms of the topic of the present volume, what is at issue in each case is a particularly striking example of the interdependence of "style and value," image and text, that is central to the entire enterprise of the *Mutacion de Fortune:* the fundamental relationship between Christine's imaging of history and her authorial self-representation.

The *Mutacion de Fortune*'s central construct of a protagonist reading a sequence of wall paintings is informed by a series of key model-texts. First and foremost, there is—as Suzanne Solente, the work's modern editor, suggests—the famous scene from the beginning of Guillaume de Lorris's *Roman de la Rose* in which Amant comes upon the walls which enclose the Garden of Deduit and the God of Love:[2]

> Quant j'oi un poi avant alé,
> Si vi un vergier grant et lé,
> Tout clos d'un haut mur bataillié,
> Portrait defors et entaillié
> A maintes riches escritures.
> Les ymages et les paintures
> Le mur volentiers regardai;
> Si conterai et vous dirai
> De ces ymages les semblances,
> Si cum moi vint en remembrances. [Ll. 129–38][3]

When I had gone ahead thus for a little, I saw a large and roomy garden, entirely enclosed by a high crenelated wall, figured [*portrait*] outside and inscribed with many fine writings. I willingly looked at the images

2. As Solente suggests. See *Mutacion*, 1.xl and 2.351. In this context it is worth recalling a significant textual detail. In the opening description of the exterior wall of Fortune's Castle, at the beginning of *Mutation* 2, there is a brief mention of a series of (undescribed) portraits (ll. 1577–86), which function to lure people inside (i.e., in a contrary manner to those on the exterior wall of Deduit's Garden).

3. All citations are from *Le Roman de la Rose*, ed. Daniel Poirion, (Paris: Garnier-Flammarion, 1974). Translations are mine.

and paintings on the wall, and I shall recount to you and tell you the appearance of these images as they occur to my memory.

What Amant proceeds to describe are ten portraits of personifications of the vices or undesirable qualities that are excluded from the courtly world of the Garden.[4] He concludes by explaining: "Ces ymages bien avisé / qui, si comme j'ai devisé, / furent a or et a asur / de toutes pars paintes ou mur (ll. 463–66) [I carefully looked at these images, which, as I have described, were painted in gold and azure all along the wall].

The *Mutacion*'s recall of this moment in the *Rose* sets in motion a series of important contrasts between the protagonists of the two works that serves to define Christine—here, as so often in her œuvre[5]—in contradistinction to the author-figures of the dominant vernacular model-text of the late French Middle Ages. First, the wall paintings of Deduit's Garden are on the outside, while those on Fortune's Castle are on the inside. This contrast involves two extremes in terms of the "experience" of the first-person protagonist in the two works. For the *Rose*'s Amant, the encounter with the wall paintings is the beginning of his initiation into the world of the Garden, i.e., the world of erotic love under the auspices of the Dieu d'Amours. For the *Mutacion*'s Christine, the encounter with the wall paintings is the final stage of her long initiation into the world of Fortune's Castle, an initiation that began in earnest only after she had passed beyond erotic love, i.e., only after the death of her husband and the beginning of her widowhood, as elaborately described in Part 1 of the *Mutacion*.[6]

4. These negative qualities that are excluded from Guillaume de Lorris's courtly *vergier* are an integral part of history under the control of Fortune, as depicted in the *Mutacion*—including the history of Christine's own life. Cf., e.g., her treatment of widows' financial problems (ll. 6983–7052).

5. For Christine as polemical reader of the *Rose*, see Kevin Brownlee, "Discourses of the Self: Christine de Pizan and the *Roman de la Rose*," *Romanic Review* 79 (1988): 199–221.

6. The plot line of Part 1 has Christine's mother (Nature, l. 366) first place her in Fortune's service as she emerges from childhood, when she is a *grant pucelle* (l. 470; see ll. 469–89ff.). Fortune then "arranges" her marriage, sending her by ship to the city of Ymeneüs, where she lives for ten years, happily married to her "si loyal ami" (l. 995). Envious of Christine's happiness (ll. 1168–69), Fortune terminates her marriage by recalling her to her court: her husband is presented as drowning during this "return voyage" and Fortune then transforms the newly widowed Christine into a man in order to enable her to take charge of her captainless *nef* (ll. 1237; 1410) and avoid shipwreck. Christine is thereby able to arrive for the second time at Fortune's Castle (ll. 1409–106), which she now can fully understand (ll. 1417–21). It is this "second stage" of Christine's entrance into Fortune's service that is presented as her true initiation.

Furthermore, the "static" personification allegories painted on the exterior walls of Deduit's Garden offer a striking contrast to the "dynamic" historical narrative depicted on the interior walls of Fortune's Castle. In this context, it is important to note that Christine-author very explicitly digresses in order to present—as a kind of prelude to the historical narrative paintings—a different and complementary set which figure allegorically the intellectual qualities and disciplines required in order both to transcribe and to interpret the events of human history: "an intellectual hierarchy, headed by Philosophy."[7]

On the one hand, this scene recalls and rewrites the opening of the *Consolatio Philosophiae*, both linking Christine to and distancing her from the Boethian model. Lady Philosophy is here a portrait, a text to be read, rather than a full-fledged personification character who intervenes actively in the allegorical narrative to instruct the protagonist. On the other hand, the *Mutacion*'s personification portraits of (positive) intellectual qualities provide a symmetrical contrast with the *Rose*'s personification portraits of (negative) affective and physical qualities, and thus emphasize the difference between Guillaume-protagonist as Male Lover and Christine-protagonist as Female *clerc*.

The second major subtext for this scene in the *Mutacion* is the *locus classicus* of ekphrasis for the Latin Middle Ages: the moment in *Aeneid* 1 (ll. 455–93) when Aeneas, newly arrived at Carthage, sees depicted on the Temple of Juno the history of the Trojan War, including his own participation in it (ll. 488–89).[8] Aeneas's reaction is twofold: on the one hand, he feels relief and a proleptic sense of safety, because of the esteem and sympathy for the Trojans implicit in the Carthaginian representation of their suffering and heroism.[9] On the other hand, Aeneas feels great sadness at this mimetic evocation of past losses, at once public and personal: " . . . animum pictura pascit inani / multa

7. Nadia Margolis, *The Poetics of History: An Analysis of Christine de Pisan's "Livre de la Mutacion de Fortune."* Diss. Stanford, 1977, 183; see also, 184–98. For the *Mutacion*'s "static" ekphrasis of Philosophy, the seven liberal arts, etc., see especially ll. 7173–86; 7195–98; 7203–08.

8. For an important study of the key ekphrastic moments in the *Aeneid* and the *Rose*, see Stephen G. Nichols, "Ekphrasis, Iconoclasm, and Desire" in *Rethinking the "Romance of the Rose,"* ed. Kevin Brownlee and Sylvia Huot (forthcoming). Nichols shows how Guillaume de Lorris rewrites Virgil in terms of the mimetic tension between history and desire.

9. For the limitations of Aeneas's perception and the ironic distance thus created between reader and protagonist, see R. O. A. M. Lyne, *Further Voices in Vergil's "Aeneid"* (Oxford: Clarendon, 1987), 209–10; and W. R. Johnson's *Darkness Visible. A Study of Vergil's "Aeneid"* (Berkeley/Los Angeles: University of California Press, 1976), 99–105.

gemens, largoque umectat flumine vultum" (*Aen.* 1.464–65, ed. Austin) [with many tears and sighs he feeds his soul on what is nothing but a picture; trans. Mandelbaum].

A reading of the key ekphrastic moment of *Mutacion* 4 against that of *Aeneid* 1 emphasizes the following contrastive features which serve in part to define Christine as protagonist and as author vis-à-vis Aeneas as hero and Virgil as historian. First, Christine-protagonist, unlike Aeneas, sees a public history that is not her own. The story of her life has already been recounted in Part 1 of the *Mutacion*, and is separate from (though, perhaps, in a sense, parallel to) the political and military past events which constitute the principal subject matter of Parts 4–7. Christine's personal history thus "prepares" her to be a *reader* of public history at the level of plot. Second, Christine's reaction does not involve personal affect the way Aeneas's did. She is not moved to cry but rather to recount. In this sense, her personal history "prepares" her to be a *writer* of public history at the level of composition. Third, the historical narrative that Christine will go on to recount is universal rather than "merely" Trojan. Indeed, it will contain the history both of the Trojan War and of Aeneas's founding of Rome. Finally, a significant contrast obtains between the two protagonists in terms of narrative context. Aeneas's confrontation with ekphrastic history occurs immediately before his first encounter with Dido. It is, in a sense, a prelude to the extended erotic engagement between Aeneas and Dido that will be fully developed in *Aeneid* 4. Significantly, Aeneas's account of his own past in Books 2 and 3 will be prompted by the amorous Dido's request, i.e., at the level of plot, it is motivated by the power of eros, which is about to make itself felt in his "biography" in *Aeneid* 4. By *Mutacion* 4, Christine's "autobiography," by contrast, has already progressed to a point definitively *beyond* the "stage" of personal erotic love. It is Christine's widowhood that has effected this progression, and this suggests, I submit, an interesting comparison with Dido. For Christine may be seen as a Dido made good in the literary sphere—a Dido, that is, who becomes not a tragic victim of erotic passion on the stage of political history, but rather, a female Virgil, a poet who recounts *historia*.

In terms of the models of the *Rose* and the *Aeneid*, what emerges is a contrastive self-representation of Christine de Pizan which serves to guarantee her authority as author of the *Mutacion*: radically detached from direct involvement in either the erotic or in the political, she appears neither as lyric lover (like Guillaume), nor as narrative hero

(like Aeneas). Rather, the events of Christine's "personal" life are presented as having transformed her into a new kind of *clerc:* a learned woman poet of history—the author of the *Mutacion.*

In this connection, I would like to turn briefly to two other model-texts that inform the scene in which the protagonist of the *Mutacion* confronts the visual mimesis of history on the interior walls of Fortune's Castle. The first comes from the *Prose Lancelot,* and is evoked by a negative comparison that immediately follows Christine's very first mention of Fortune's *sale merveilleuse* (l. 7069):

> Oncque en la Garde Perilleuse,
> Dont dit le rommant Lancelot,
> Qui sienne, quant conquise l'ot,
> Fu, n'ot autretant de merveilles
> Comme il ot la . . . [Ll. 7070–74]

There were never so many marvels in the Garde Perilleuse which the romance says belonged to Lancelot after he had conquered it.

The primary reference here is to the Castle of the Douloureuse Garde, the conquest of which constituted Lancelot's first great exploit (and resulted in his learning both his own and his father's name [Sommer, ed., 3.152]). Christine conflates the Castle of the Douloureuse Garde with the Forest Perilleuse (Sommer, ed., 5.243–52).[10] This negative evocation of Lancelot as model serves to differentiate Christine, once again, from a famous male protagonist motivated by erotic desire, at a liminal moment in his "biography." Christine's diegetic status as "posterotic" is thus reemphasized. At the same time, of course, Christine's experience as reader and writer is implicitly presented as a superior version of chivalric romance: her *aventure* will be to view and to describe the wall paintings which figure history.

In this context, I would like to mention, somewhat speculatively, a further suggestive detail with regard to Lancelot as (negative) model for Christine: the scene in which Lancelot, a prisoner in Morgan's castle, paints on the wall of his room the story of his life, and in particular, of his love for Guenevere. As Michel Zink has observed in a recent study of this passage, "the function of the frescoes painted by Lancelot is thus to compensate him as much as possible for the absence of the queen. For want of seeing her, he feasts his eyes on her por-

10. As noted by Solente, ed., 2.351. For the "geography of the *Lancelot,*" see Charles Méla, *La Reine et le Graal: La Conjointure dans les romans du Graal, de Chrétien de Troyes au Livre de Lancelot* (Paris: Seuil, 1984), 362–63.

trait . . . Likewise, for want of having new adventures, he paints and contemplates those that he has already experienced, which were all motivated solely by his love for the queen" (54–55).[11] In addition, Lancelot conceives the idea of this compensatory mimesis when he sees through his window a man painting on the walls of Morgan's palace "une anciene ystoire" (Sommer, ed., 5.217)—the story of Aeneas ("cestoit [lestoire] deneas comment il se parti de troies [& sen ala en exil]") [it was the story of Aeneas: how he left Troy and went off into exile]. Lancelot's wall paintings are thus presented as an "imitation" of Aeneas, but one that is profoundly eroticized—as if Aeneas had undertaken all his exploits for the sake of Dido.

This overwriting of political by personal history—and its attendant dangers—are of course quite relevant to the concerns of the Mutacion, and particularly so in the context of visual mimesis. Again, Lancelot would constitute a negative exemplum for the first-person protagonist of the Mutacion. This is all the more striking in that King Arthur's later discovery of Lancelot's wall paintings (in La Mort le Roi Artu, ed. Frappier, 61–64) provides him with the conclusive evidence of the adultery between his wife and his knight that leads to the ultimate destruction of the Arthurian world. This episode thus emblematizes the bivalence of this mimetic art in terms of the tension between private eroticism and public history. In a private erotic context (i.e., as "first-person" history), Lancelot's mimetic art has a positive valence— it comforts him for the absence of Guenevere. In a public historical context, this same mimesis (as "third-person" history) has a negative valence: it reveals a political transgression—royal adultery—that will destroy the polis. In the Mutacion, by contrast, the mimesis of an exclusively public—"third-person"—history on the walls of Fortune's Castle enlightens Christine-protagonist and empowers Christine-author.

The last of the model ekphrastic texts I would like to consider involves yet another liminal moment: Dante-protagonist's experience on the First Purgatorial Terrace,[12] after he has just passed through the

11. Michel Zink, "Les Toiles d'Agamanor et les fresques de Lancelot," Littérature 38 (1980): 43–61.

12. Solente suggests Purg. 12.16ff. as a source for Mutacion, ll. 7107ff. in ed., 1.xlvii and 2.351. Christine explicitly mentions "Dante de Florence, le vaillant / Poete" in ll. 4645–46 and in l. 4663, which introduces her citation in French of Inferno 26.1–5, in the context of her condemnation of the Guelf/Ghibelline wars in Italy. For the classic study of the presence of the Commedia in the Mutacion, see A. Farinelli, Dante e la Francia dall' erà media al secolo di Voltaire (Milan, 1908), 2 vols. especially 1.37, 166, 180–90

Gate into Purgatory proper. It is on this initial Terrace that the positive and negative *exempla* of Pride—the first sin to be purged[13]—are presented ekphrastically, in a series of portraits of which God is the *fabbro* (*Purg.* 10.99) [craftsman].[14] Dante first encounters three "stories" illustrating humility on the wall formed by the "encircling bank" [*ripa intorno, Purg.* 10.29] of the Mountain, which is here made of pure white marble and "addorno / d'intagli sì, che non pur Policleto, / ma la natura lì avrebbe scorno" (*Purg.* 10.31–33) [adorned with such carvings that not only Polycletus but Nature herself would there be put to shame]. The initial story is that of the Annunciation; then comes David dancing before the ark; finally, Trajan and the widow—this last, an interesting presence in light of Christine's self-presentation as widow in the *Mutacion*. In each case, this divine mimesis involves a miraculous fusion of visual image and verbal expression, which Dante terms *visibile parlare*—"visible speech" (*Purg.* 10.95).

As he is leaving the First Terrace, Dante sees twelve examples of pride humbled, each one "figured" [*figurato, Purg.* 12.23] on the floor of the pathway he is following around the Mountain. We begin with the fall of Satan, and end with the fall of Troy.[15] The series as a whole presents history as *exemplum* and *exemplum* as history. History originates with the first instance of pridefulness, Lucifer's rebellion; the subsequent series of historical events are simultaneously repetitions of Lucifer's master model, and require to be read as such, that is, both figurally and didactically.

What makes such a text and such a reading possible—indeed, necessary—is the power of God as a mimetic artist:

> Qual di pennel fu maestro o di stile
> che ritraesse l'ombre e' tratti ch'ivi
> mirar farieno uno ingegno sottile?

and 2.287. See also Solente, ed., 1.xlvi–xlviii. The epic journey of Dante-protagonist in the *Commedia* is explicitly presented as a model for that of Christine-protagonist in the *Livre du Chemin de Long Estude,* an allegorical autobiography dating from 1402–03, whose title is derived from *Inf.*1. 83–84 (see ed., Püschel, ll. 1125–70).

13. All citations are from the text of Giorgio Petrocchi as found in Charles S. Singleton, *Dante Alighieri. The Divine Comedy,* (Princeton: Princeton University Press, 1970–75), 6 vols. Translations are by Singleton, selectively emended.

14. For the ways in which *Purg.* 10 treats the problems of mimesis, see Nancy J. Vickers, "Seeing is Believing: Gregory, Trajan, and Dante's Art," *Dante Studies* 101 (1983): 67–85.

15. The final three of these *exempla* (Cyrus, Holofernes, and Troy) can be read as theologically contextualized instances of the "mutacons de Fortune," and are, indeed, treated in Christine's narrative from the perspective of human history.

Morti li morti e i vivi parean vivi:
non vide mei di me chi vide il vero,
quant' io calcai, fin che chinato givi. [*Purg.* 12.64–9]

What master was he of brush or of pencil who drew the forms and lineaments which there would make every subtle genius wonder? Dead the dead, and the living seemed alive. He who saw the reality of all I trod upon, while I went bent down, saw not better than I!

Several important parallels and contrasts are at issue here in terms of the *Commedia* and the *Mutacion.* First, there is the relationship between history and self. In both works, the mimesis of history and the protagonist's experience of this mimesis on the level of plot constitute a key stage in the story of the literary vocation of the first-person protagonist, in the way in which Dante and Christine each represent their development from past acting self into present writing self. For Dante-protagonist, however, the diegetic experience of historical mimesis in *Purg.* 10 and 12 is simply one episode—albeit a very important one—among many. For Christine, this experience at the level of plot is presented as the basic authorization for her role as historian.

Second, there is a contrast in terms of the status of historical mimesis. The divine mimesis of history in *Purg.* 10 and 12 involves an explicit fusing of image and word, in a manner possible only for God. The "human" mimesis of history on the walls of Fortune's Castle in the *Mutacion* is sequential rather than simultaneous: the terminology of the image and of the word are thus used interchangeably to describe it. The deeds of history that Christine sees are from the beginning described both as *pourtraitures* (1. 7154) and as *escriptures* (1. 7203). It is as if the mimesis of history experienced by Christine-protagonist were being presented both as a series of wall paintings and as a book; or rather, as a master set of illuminations with written commentary underneath.

Third, there is a striking contrast in the relationship between personal and public history in the *Commedia* vis-à-vis that in the *Mutacion.* The personal history that Dante tells is presented as literally true, i.e., it is true in the same way as public history is true. Christine's personal history in the *Mutacion* is told as allegory, i.e., it is in a qualitatively different discourse from that used by Christine as "public historian."

In this connection, it is important to recall the distinction between Dante's *exile* and Christine's *widowhood* as the key biographic events in the respective lives of the two authors as presented in the *Com-*

media and in the *Mutacion*. First, there is the important correspon-
dence between history and gender: Dante's exile is public and political;
Christine's widowhood is private and personal. In addition, there is a
key temporal difference: Dante's exile is in the diegetic future, that is,
it will come after the personal revelation—and after the direct experi-
ence of history—which the *Commedia*'s plot line recounts. Chris-
tine's widowhood is in the diegetic present, that is, it precedes and,
indeed, initiates her "indirect" experience of history at the level of the
Mutacion's plot. Both Dante's otherworldly journey and his exile
(which is linked to the composition of the poem that records the jour-
ney) are presented as interventions by *God* in Dante's life. Christine's
"otherworldly journey" is presented as an allegory of her unfolding life
on earth. And her widowhood—directly linked to her clerkly and writ-
erly vocation—is presented as the intervention of *Fortune* in that life.
The final authorial self-portrait that emerges from the *Commedia* is of
an inspired male poet chosen by God; in the *Mutacion*, we have a
woman historian chosen by Fortune.

It is in this context that the model provided by the *Commedia* for
Christine-protagonist's experience of the ekphrasis of history in *Muta-
cion* 4 is related to the three other models we have been considering:
the *Romance of the Rose*, the *Aeneid*, and the *Prose Lancelot*. The
central construct of an ekphrastic mimesis of history in the *Mutacion*
involves the self-presentation of Christine-protagonist as fundamen-
tally separated—detached—from history: she is not a direct partici-
pant. This detachment is an essential component both of her identity
and of her authority in the *Mutacion*,[16] and is reinforced by the re-
peated use of the construct at important structural moments in the
Mutacion's historical narrative.

Three examples are particularly pertinent to the present argument.
The first comes at almost the precise midpoint of the *Mutacion* and
serves to mark the transition from ancient Near Eastern history to
ancient Greek history. Christine-author intervenes in the text in order
to situate this structural division within the plot-line experience of
Christine-protagonist: "Toutes ces choses, que j'ay dictes, / furent en

16. For Christine's transformation into a man—at the level of plot—in order both to
read and to write history (in *Mutacion* 1), see Kevin Brownlee, "Ovide et le moi poétique
«moderne» à la fin du moyen âge: Jean Froissart et Christine de Pizan" in *Modernité au
moyen âge: Le Défi du passé*, ed. Brigite Cazelles and Charles Méla (Geneva: Droz, 1990),
153–73, and Nadia Margolis, "Christinè de Pizan: The Poetess as Historian," *Journal of
the History of Ideas* 47 (1986): 367–70.

la paroit escriptes / de la sale ou Fortune maint . . . / et plusieurs autres, dont diray / partie . . . " (ll. 11729–31; 11733–34) [All the things that I have recounted were inscribed on the walls of the hall where Fortune lives . . . along with many other things which I will recount in part].

A similar kind of link between author and protagonist in terms of the "experience" of history serves as the introduction to the single longest segment in Christine's historical narrative, the story of the Trojan War (ll. 14059–18244):

> En la sale, que j'ay descripte,
> Vi l'istoire de Troye escripte;
> Et d'or et d'azur les ymages
> Bien pourtrais . . .
> Tres tout devisoit l'escripture,
> Qui estoit soubz la pourtraiture.
> Si la deviseray en brief . . . [Ll. 14059–62; 14065–67]

In the hall which I have described, I saw the history of Troy inscribed; and the images were well portrayed in gold and azure. . . . Everything was described by the writing which was below the paintings, and I will now describe it in abridged form.

The very last section of the *Mutacion*'s historical narrative (ll. 23301–594) treats contemporary Europe, i.e., the one part of universal history that Christine de Pizan lived through, knew from personal experience. Yet even this is presented, within the plot structure, as part of the experience of Christine-protagonist by means of the "double mimesis" construct (ll. 23277–300). Christine-protagonist therefore appears as a detached reader even of contemporary European history, which is represented in the text as part of the wall paintings in Fortune's Castle.

This extended use of inscribed ekphrasis to present and to authorize Christine-protagonist's relation with history thus leads directly to the *Mutacion*'s final lines in which Christine concludes her monumental work by means of a self-presentation as author figure:

> Or ay je devisé assez
> De ce que tous mes jours passez
> Ay trouvé, veu, et cogneu,
> Ou lieu qui a pluseurs a neu . . .
> Et, pour ce que partout Meseur
> Frequante, pour avoir moins noyse . . .

> J'ay choisie pour toute joye
> (Quelqu'aultre l'ait), telle est la moye,
> Paix, solitude volumtaire,
> Et vie astracte [et] solitaire. [Ll. 23595–98; 23630–31; 23633–36]

I have thus described enough of what—during my past life—I have found and seen and known in the place which has harmed many [=Fortune's Castle]. . . . And because Misfortune is everywhere, in order to have less trouble . . . I have chosen for my entire joy (whatever others may have, this is mine): peace, voluntary solitude, and a retiring, solitary life.

By way of conclusion, however, I would like to stress that the *Mutacion*'s treatment both of authorial self-representation and of the imaging of history represent "provisional solutions" to problems that Christine was to redefine in the *Cité des Dames* (completed two years later, in 1405). In both books, works of art are used to represent history. The plot line of the *Mutacion* shows us the first-person woman historian as a detached spectator who observes and records a past that, in many important respects, is not her own. At the same time, the *Mutacion*'s construct of historical ekphrasis presents the "book" of history as antedating Christine's book—as an already "completed" painting. At the beginning of the *Cité des Dames*, by contrast, the "book" of history is represented as "incomplete," as a series of "beautiful stones"—each the story of an exemplary woman—which must be put together into a new building, an architectural metaphor that is used throughout the work to figure the writing of the *Cité des Dames* itself. Christine the first-person protagonist is directly engaged, at the level of plot, in the rereading of history, as she builds the City of Ladies from the ground up, stone by stone. At the level of composition, the *Cité*'s author is a first-person woman historian who is directly engaged in the rewriting of history, the composition of the book.

In the *Cité des Dames*, therefore, Christine de Pizan represents herself as actively participating both as protagonist and as author in the construction—the reconstruction—of history as narrative. In the *Cité* her identity as woman will provide her—**not,** as in the *Mutacion de Fortune*, with a radical detachment from the historical mainstream—but rather with a privileged link to the history of women which it is her calling to write into the canon—in the process, appropriating the status of a canonical author for herself.

ERIC HICKS

Le Livre des Trois Vertus of
Christine de Pizan: Beinecke MS. 427

Christine de Pizan was born in 1364 in Venice and died in 1431 at the Dominican convent of Poissy. This is not an original statement to make, although it is probably true; it is however unusual to be able to make a statement of this kind in the field of medieval literary history. We know very little about the concrete existences of most medieval writers, and such knowledge as we do have—for example, that the author of the *Romance of the Rose* lived on the Rue Saint-Jacques—is generally not too enlightening. For most medieval writers, anonymity is the rule, probably because type took precedence over existence, and the individual was subsumed in paradigm. The life of Christine de Pizan is, on the other hand, inscribed in her work, as her work in her life, in ways that cry for attention, and which need not espouse, although they need not exclude, traditional biographical criticism.

Christine is the first woman writer to have lived demonstrably from her trade. This is doubly significant. There was, first of all, a Christine *product:* a kind of work which typified her name; secondly, Christine would normally have been excluded from the milieux in which such products circulated. Being a female was conducive to a rare kind of authenticity, for there was no authorial type to which Christine could readily conform, no place for a *femme savante* in the clerical order of things. It is thus that Christine may be dubbed, as Daniel Poirion has pointed out, the first real author of France:[1] professional in

1. Daniel Poirion, *Le Moyen Age* (Paris: Arthaud [Coll. *Littérature française*, 2], 1971), 206.

YFS Special Edition, *Contexts: Style and Values in Medieval Art and Literature,* ed. Daniel Poirion and Nancy Freeman Regalado, © 1991 by Yale University.

a way most others were not, and obliged, as an excluded *other*, to live with her own authenticity.

Much, as often, lies in a name. Christine was the daughter of "Thomas de Pizan" or "de Bologne,"[2] who enjoyed a reputation as the finest astrologer of his day. He seems to have had ideas on the education of women well in advance of his time, and Christine speaks with fondness of his attitudes, contrasting them with those of her mother, who would have confined her to spinning.[3] The family came to the court of Charles V when Christine was a child.[4] At the age of fifteen she was married to a young nobleman of Picardy, a secretary in the Royal Chancery. She thus lived in an environment where the earliest figures of French humanism were flourishing. She bore children, and lived happily for ten years. Ill fortune then took her husband, leaving her with a household to support. She apparently knew something of writing, and took to the craft she knew: first in short lyrical pieces, then in longer treatises of a didactic and moral cast. She speaks of her solitude, a source of comfort and despair: regretting that fate had exchanged her marriage for literature and dispatched her along the long road to learning. As Jacqueline Cerquiglini aptly puts it: *"calame, calamité"*[5]—pen and pain.

Common sense and Levi-Strauss have taught us that one of the constants of writing, wherever it appears, is its rapid appropriation by

2. The French forms, somehow, seem appropriate. On Tommaso de Pizzano, see Charity Cannon Willard, *Christine de Pizan, Her Life and Works* (New York: Persea, 1984), 17–23; ead., "Christine de Pizan: the Astrologer's Daughter," in *Mélanges à la Mémoire de Franco Simone: France et Italie dans la culture européenne, 1: Moyen Age et Renaissance* (Geneva: Slatkine ["Bibliothèque Franco Simone", 4], 1989), 95–111.

3. "Your father . . . did not believe that women were worth less by knowing science; rather . . . he took great pleasure from seeing your inclination to learning. The feminine opinion of your mother, however, who wished to keep you busy with spinning and silly girlishness, following the common custom of women, was the major obstacle to your being more involved in the sciences. But just as the proverb . . . says, 'No one can take away what Nature has given,' . . . " Christine de Pizan, *The Book of the City of Ladies*, trans. Earl Jeffrey Richards (New York: Persea, 1982), 154–55.

4. "The wife and children of your beloved philosopher, Thomas, my aforementioned father, were grandly received upon arriving in Paris. That most gracious, wise and gentle king [Charles V] was anxious to see them and to rejoice in their welcome. And so it was done, shortly after their arrival, with them still clad in their Italian finery, studded with jewels and adorned according to the fashion of noble women and children. It was in the month of December, with the king residing at the Louvre in Paris, that wife and family, along with a worthy suite of parentage, were presented to the court and received by the king with joy and generosity." My translation; cf. *Avision*, quoted in S. Solente, ed., *Livre des Fais et bonnes meurs du sage roy Charles V* (Paris: Champion, 1934), v.

5. Jacqueline Cerquiglini "L'Étrangère," *Revue des Langues Romanes* 92 (1988): 248.

power. It follows that control over writing, access to the channels of expression in the most obvious concrete way, is necessary to any new configuration of power. Much of what Christine had to say concerned power and its uses: this is true of the engagement of her pen by the powers that were; it is also true of her engagement in the cause of helping women to wield such power as they had. For such, in short, is the subject of the *Livre des Trois Vertus.*[6]

Many modern readers, particularly those ready to marshal the past in favor of present quarrels, have been struck with the timeliness of what Christine had to say. I personally am struck by the sad and tiresome timeliness of what her adversaries had to say, for the old saws of misogyny still cut deep. If feminism is, as Sally Alexander has said, "the awareness of the difference between women's need to be treated as equals, and the fact that they are treated otherwise than as equals, and differently from men,"[7] then Christine was a feminist, in a logical, formal sense of the word. What is remarkable, then, about Christine's engagement, whether singly against ordinary misogyny[8] or in her practical advice to the women of her day, is less that a fifteenth-century female could have had such ideas, than the fact that she had at her disposal the means to express them.

For express them she did, and much more. In their study of Christine's manuscript production, Gilbert Ouy and Christine Reno[9] speak of some forty original manuscripts, and judging from the introductions of critical editions, probably just as great a number have not survived. Near the end of her *Livre des Trois Vertus*, Christine speaks of the plans she entertains for the work she has just completed: "I [the servant of the Three Virtues], though in no way adequate to the task, intend, as always has been my habit, to devote myself to promoting their welfare. Therefore, I thought I would multiply this work throughout the world in various copies, whatever the cost might be, and pre-

6. Christine de Pizan, *Le Livre des Trois Vertus*, ed. Charity Cannon Willard and Eric Hicks (Paris: Champion ["Bibliothèque du XVᵉ Siècle, 50], 1989).

7. Quoted in J. Sayers, *Sexual Contradictions: Psychology, Psychoanalysis and Feminism* (London: Tavistock), 99.

8. Eric Hicks and Thérèse Moreau, trans. Christine de Pizan: *La Cité des Dames* (Paris: Stock/Moyen Age, 1986), 14–15. See also my "Femme auteur et auteur femme: Christine de Pizan et la question féministe," in *La Femme et l'art au Moyen Age* (Lausanne: German Department, 1984: brochure, summarized and reviewed by Rosalind Brown-Grant, *Revue des Langues Romanes* 91 [1987]: 139–44).

9. "Identification des autographes de Christine de Pisan," *Scriptorium* 34 (1980): 221–38. The authors graciously remember my own contribution to the subject (résumé in *Manuscripta* 20 (1976): 14–15).

sent it in particular places to queens, princesses, and noble ladies. Through their efforts, it will be the more honored and praised, as is fitting, and better circulated among other women. I already have started this process; so that this book will be examined, read and published in all countries, although it is written in the French language."[10] The author's knowledge of the book trade, her control over her own information, has immediate and far-reaching consequences for manuscript scholars, in particular for the editors of her works. In order to appreciate these consequences, it is necessary to digress for a moment on critical method, for our knowledge of medieval literature ultimately derives from the use or misuse of printing in the transmission of a medium essentially foreign to it, the handwritten book.[11]

No copy is entirely like any other, and all manuscripts except first drafts are copies. The modern editor of pre-Gutenberg texts essentially makes a new copy, which if all goes well, will be the best of all *possible* copies. For every manuscript, as anyone who has ever written can attest, contains mistakes. The editor's aim is usually to correct errors in the original material without introducing new ones. And this is no easy task.

One school of textual criticism, associated with the name of Joseph Bédier and still dominant in France, holds that the lesser of all evils is to choose the best available manuscript and to reproduce it as exactly as one can. This approach suggests that a medieval scribe will usually prove more competent than a modern philologist—on the face of it, a fairly safe bet. The best of all possible copies will thus be, at worst, an authentically medieval version of the text. As far as errors are concerned, it is ultimately the reader's task to deal with them. The method has had the unfortunate and perhaps unexpected result of reifying the text as printed, that is, of excluding from the pale of legitimate reading all other authentically medieval versions. Thus the Oxford *Roland* has been read, in France at least, to the exclusion of all other *Rolands*, as if the other versions were but degraded states of a perfect original. Bédier's method does suppose that the best manu-

10. Christine de Pizan, *A Medieval Woman's Mirror of Honor: The Treasury of the City of Ladies*, translated, with an introduction by Charity Cannon Willard, edited, with an introduction by Madeleine Pelner Cosman (New York: Bard Hall Press/Persea Books, 1989), 224.

11. An extensive modern bibliography might be compiled on the literary aspects of the question, but the interested reader is referred to the remarkable little book by H. L. Chaytor, *From Script to Print* (Cambridge: Cambridge University Press, 1945) which has rarely been surpassed for clarity and sound thinking.

script is always closest to *some* original. It suggests, by the same token, that originals are not perfectible. If this were so, the original version of Flaubert's *Sentimental Education* would turn out to be the last version written—exactly the opposite of an original in any ordinary sense of the word. The creative process runs counter to chronology, and Bédier's method implicitly denies that this is so.[12]

As is often true with new epistemologies, Bédier's approach stemmed from his failure to apply to his (or anyone else's) satisfaction the methodology then in favor. Put succinctly, if flippantly, "if you can't join 'em, beat 'em!" The approach Bédier rejected is associated, for better or for worse, with the name of the German philologist Karl Lachmann. This method is based upon *mistakes*, rather than upon an intuitive judgment of *excellence*. The aim is to divide manuscripts into families by the errors they have in common, then to establish a kind of family tree that will allow a choice between readings and reconstruct the lost original. The basic assumptions of the method are two, one of which is usually stated, one of which is not, and both of which are tenuous. It is first assumed that two scribes will not make the same mistake at the same place; it is secondly assumed that enough data exist to establish significant relationships. There are however inherent ambiguities in language and orthography which *do* create the same errors in the same places: the tendency to write "four" for "for" on the part of native speakers of English could easily be quantified, and predicted. Such preconditioned mistakes tend to blur the lines between manuscript groupings. It is probably more serious that there is no way of determining how many manuscripts are unaccounted for. Since the desire to draw conclusions is usually independent of the amount of one's knowledge, this is a fact that tends to be overlooked. The method therefore runs the risk of generating an artificial text bearing little resemblance—like certain architectural constructions of Violet-le-Duc—to what may have existed. (The best example of this is thought to be Gaston Paris's *Vie de saint Alexis:* fake as it may seem or be, it is still a fine piece of writing . . . [13])

For all its problems, traditional philological method does have the advantage of portraying the text as process. It also attempts to exclude value judgments, and this is generally counted among its advantages.

12. For a more theoretical discussion, see my "De l'individu et du collectif dans les manuscrits," in *La Naissance du Texte*, collection gathered by Louis Hay (Paris: Corti, 1989), 121–31.

13. "On s'y croirait presque," as the late Bernard Guyon once said to me.

Yet it is for this very reason that the so-called Lachmann method excludes authorial process: as Bédier pointed out, the editor has no objective criteria for revisions. This would result in characterizing the last version of Flaubert's *Sentimental Education* as spurious, since revisions are summed as mistakes. Authors being the people most likely to have an interest in disseminating their works, it would be unwise to dismiss revisions as unlikely. Conversely, an author working as a scribe also functions as a scribe, that is to say he—or she, for we are now approaching Christine—will tend to make mistakes.

With a minimum of chronology and a great deal of taste, James Laidlaw has recently sketched Christine de Pizan's progress as both editor and author of her own lyrical poetry.[14] The question may thus be raised of a genetic approach to her texts based on codicological data, similar to the methodology being applied to modern authors in the I.T.E.M. circle around Louis Hay in Paris. Medieval codicology probably does not lend itself entirely to so "hard" a methodology (although this remains to be seen); still, Christine scholars are clearly more fortunate than most.

It has been some time since the dean of American research in the field, Charity Cannon Willard, suggested that a copy of Christine's *Epistre a la Reine* was in fact in the author's own hand.[15] More recently, in the well-documented study mentioned above, Gilbert Ouy and Christine Reno have supported Professor Willard's hypothesis, describing three hands appearing in early Christine manuscripts. The argument for identifying one of these hands as the author's is based upon textual grounds: one of the scripts associated with this hand—labeled X for unknown or χ for Christine—appears in marginal notations which are incorporated into a new preface to the work the manuscript contains, the *Avision Christine* which Professor Reno is preparing for publication. In the above illustration (a composite from the Ouy-Reno article) there are several specimens of writing which (ought to) appear different, even to the uninitiated: those of the three scribes of course, but the various samples of the X/χ hand as well. The latter are separated by time, rather than identity: the writer has aged. What bears emphasis is that although not identical, the samples are

14. James Laidlaw, "Christine de Pizan—an Author's Progress," *Modern Language Review* 78 (1983): 532–50: "Christine de Pizan—A Publisher's Progress," *Modern Language Review* 82 (1987): 35–75.

15. Willard, "An Autograph Manuscript of Christine de Pizan?" *Studi Francesi* 27 (1965): 452–57.

Jtem parﬁ & Jeuneﬁe
ﬁnt par ﬁﬁnæ & Dieu er faﬁn'

et Sertuouﬁe h nmiﬁte que ﬁ

Fig. 2: Main «R» (ms. Vatican, Reg. lat. 920, f.1ʳ et 3ʳ)

Le ﬁure du dit De poyﬂ?

Fig. 1: Main «P»(ms. Paris B.N. Fr. 835, f. 85ᵛ et 86ʳ)

Do ﬅre tre ﬁumble ober ﬁant
Creature cpﬂue de pizan·

d lamentaion opﬂue depijon c

axpé apauis par moy opﬂue de pizā

Fig. 3: Main «X» (1) Paris B.N. Fr. 580, f. 54ᵛ: *5 octobre 1405* ;
2) 24864, f. 14ʳ: *1410* ; 3) 24786, f. 96ʳ: *20 janvier 1418* (n.st.)

9:ﬅ prﬅplamﬀ & prﬅﬁmr

Fig. 6: Main X'. Note «*des pestilances de present*»
(ms. Phillipps 128, f. 14ᵛ, marge inf.)

Fig. 9: Note hâtive (ms. Phillipps 128, f. 17ᵛ)

similar to the eye in a global sort of way; it is not so much the letters
that define the hand as a kind of rhythm—the ways the letters com-
bine and flow. Now it is a fairly easy matter to define letters, and many
of the programs for optical character recognition on scanned computer
materials could be put to this end, a positive end, I believe. The feel for
rhythm is, however, an entirely different matter, and a problem for
which I can propose no methodology which could not be criticized as

intuitional. Indeed this has at times been said of medieval manuscript attribution in general. But still it moves, and rhythmically so: the χ hand corrects the others, the others do not correct χ. In examining an early copy of the *Cité des Dames*, I recently came upon the light cursive hand identified as χ by Ouy and Reno: it generally gives indications for chapter headings, which were, according to usual practice, inked in red after the completion of the text. There are other marginal notations next to passages which have been scratched out (or more precisely, *off*) and corrected in the χ. book hand over "*P*" script. These marginal notations have been scratched out as well, but can be read under favorable light: they are identical with the text as corrected. A comparison of these readings with an earlier copy, shows that χ is revising the earlier text. We read for example in the former: "Jean André le sollempnel legiste," corrected to "le sollempnel docteur," or: "ilz font en leur ordonnances," corrected from "leurs conseils." These are not scribal errors but the workings of an intention, and the sort of thing editors might note in distinguishing the text as process, as opposed to what might be termed the text as *entropy*, the inevitable degradation of copy by copy.

As coeditor of the *Livre des Trois Vertus*, it would be fair to ask me if this advice has been followed. The answer is no. While much of Christine's writing was constantly revised, this does not seem to be true of the *Livre des Trois Vertus*. Moreover, none of the copies appear to be originals—in the sense that they bear evidence of having been prepared under Christine's supervision—and practically all are late. The copy which seems closest to the products of the author's scriptorium is now in the Boston Public Library. This is the base manuscript of the edition which has just been published, an edition more in the spirit of Joseph Bédier than the I.T.E.M., and with good cause, alas! For this case is one in which the available evidence points to the unavailability of sufficient evidence.

What may have happened to the original copies is a matter of conjecture. First copies are usually not the best illustrated, and illustrations are a major factor for survival. There is a kind of Gresham's law for manuscripts: lavish books are hoarded and replaced by ordinary ones; these in time drop out of circulation like so many bad coins. Then too, the *Trois Vertus* went through three printings in the Renaissance, and it was common practice for printers to sacrifice old manuscripts in the process of preparing them for publication. Again, if

Christine did try, as she assures us, to disseminate the work as widely as possible, the copies were probably ordinary, and ordinary articles have a way of being washed away by the tide of history.

The Beinecke copy is a lavish one: of the twenty-one known surviving manuscripts, it is one of the nine with miniatures. Its text is eminently readable, with clearly defined letters and few abbreviations. It is one of the four control manuscripts used in our edition, and tends to align itself with a copy now at Oxford, written in an English hand, and to form a triad, with either the Brussels copy—once in the collections of the Duke of Burgundy—or (exclusive of this manuscript) with a Paris copy once in the possession of Jeanne, Duchess of Bourbon. This may reflect, rather than a grouping of families, the state of the original text, for the "best text," i.e., Boston, is not perfect, even if at times we may have treated it as such. All of which is consistent with Professor Willard's assessment of the manuscript tradition in an early article, published in the *Boston Public Library Quarterly:*[16] the manuscripts can be divided as to provenance, one group originating in Paris, the other in Burgundian circles. It is to the latter group that the Beinecke copy belongs.

The recent history of the manuscript is well known and has been traced by Barbara Shailor, in her excellent catalogue to the Beinecke collections.[17] MS 427 was purchased at Galliéra in 1968 by H. P. Kraus and given to the library by Edwin J. Beinecke. Previously, the manuscript had been in the Rothschild family. It would have been acquired with its present binding, which bears the arms of Pajot d'Ons-en-Bray. The Ons-en-Bray were a branch of the Crèvecoeur, a fact that is not without interest. The oldest indication of provenance is a coat of arms painted over the first initial: X-rays by the Beinecke staff have not revealed any other coat-of-arms beneath these (in the language of heraldry, three *chevrons, or* on *gueules*). The arms were borne by at least ten families, including a certain Mathews of New York, and of course the Crèvecoeurs. This is a family associated with the regions of Artois, Lorraine, and Beauvaisis. Art historians have attributed the manu-

16. "The 'Three Virtues' of Christine de Pisan," *Boston Library Quarterly* 2 (1950): 291–305; ead., "The Manuscript Tradition of the *Livre des Trois Vertus* and Christine de Pisan's Literary Audience," *Journal of the History of Ideas* 27 (1966): 443–44. Cf., edition, xviii.

17. Barbara Shailor, *Catalogue of Medieval and Renaissance Manuscripts in the Beinecke Rare Book and Manuscript Library, Yale University* (Binghamton: New York [Medieval & Renaissance Texts & Studies], 1984, 1987 . . .).

script's four miniatures to the "Master of Amiens 200," who worked in the North of France in the midfourteenth century.[18] This is certainly consistent with other codicological data: script, borders, spellings, decoration. An oral tradition among Christine scholars, going back to L. M. J. Delaissé, (see edition, xx) points to similarities between this manuscript and certain others prepared for Jean de Créquy, a bibliophile known at the court of Philippe le Bon. What relationships, if any, there may have been between the Créquy family and the Ons-en-Bray, I am not prepared to say.

It is difficult, nay impossible, to speak of *Les Trois Vertus* (which I will henceforth refer to as *A Medieval Woman's Mirror of Honor*, following the title of the recent English translation), without reference to the earlier *Book of the City of Ladies*. This is particularly true of the program of miniatures, since the allegorical figures are a common point of reference in the two books. The *City of Ladies* is ostensibly a book spawned by a book. Alone in her study, Christine falls upon a volume placed in her trust, the *Lamentations de Mathéole*, which may best be described as a compendium of misogynist clichés. Since Christine believes in the written word, this volume, albeit of farcical intent, calls up in her a profound sense of alienation: "But just the sight of this book, even though it was of no authority, made me wonder how it happened that so many different men—and learned men among them—have been and are so inclined to express both in speaking and in their treatises and writings so many wicked insults about women and their behavior. . . . They all concur in one conclusion: that the behavior of women is inclined to and full of every vice. . . . To the best of my knowledge, no matter how long I confronted or dissected the problem, I could not see or realize how their claims could be true when compared to the natural behavior and character of women. Yet I still argued vehemently against women, saying that it would be impossible that so many famous men . . . could have spoken falsely. . . . And I finally decided that God formed a vile creature when He made woman, and I wondered how such a worthy artisan could have deigned to make such an abominable work which, from what they say, is the vessel as well as the refuge and abode of every evil and vice" (Richards, 3–5). Three Virtues thereupon appear to Christine to counsel and console her: they

18. John Plummer, *The Last Flowering: French Painting in Manuscripts, 1420–1530* (New York: The Pierpont Morgan Library/London: Oxford, 1982), 14–15; see also W. Cahn and J. Marrow, "Medieval and Renaissance Manuscripts at Yale: A Selection," *Yale Library Gazette* 53 (1978): 243–45, plate 24 (first folio miniature).

are Reason, Righteousness (or Rectitude in the Richards translation) and Justice. Each will find for Christine, in the field of literature, examples of justly famous good women: their lives are to be the stones with which Christine will build a city—or citadel, as the word is ambiguous in the French of the time—to protect women from future slander. The metaphor is taken from Augustine's *City of God*, translated in 1371 by Raoul de Presles. The Beinecke library has a copy of this work, slightly later than the composition of Christine's *City*, with the figure of the citadel clearly depicted in the volume's first "histoire" or miniature (MS. 215, Shailor, 1,000; Cahn and Marrow, 217–18).

There can be little doubt that Christine oversaw the painting in her own manuscripts. This is a fact long suspected, but now finally well established, with a wealth of illustration, in a recent book by Sandra Hindman emphasizing the didactic import of miniatures in the *Epistre Othea*.[19] In the *City of Ladies*, however, Christine portrays the allegorical figures as foreign to any established visual code: meaning flows from text to image, rather than the reverse. Her vision astounds her, and she is at a loss to decipher the visual emblems such as allegorical beings can carry. There is an affinity between the elucidation of allegory and the unraveling of a mystery: even in the presence of conventional attributes, the effect sought is one of progressive demystification, resulting in a kind of baffled recognition. One can experience something similar in reading the commentary on the painting over the circulation desk at the Sterling Memorial Library, or, when in Paris, in unraveling the manifold mysteries of the Sorbonne mural by Puvis de Chavannes. "Dear daughter," the first of the three figures begins, "know that God's providence, which leaves nothing void or empty, has ordained that we, though celestial beings, remain and circulate among the people of the world here below. . . . Thus it is my duty to straighten out men and women when they go astray and to put them back on the right path. And when they stray, if they have enough understanding to see me, I come to them quietly in spirit and preach to them. . . . Since I serve to demonstrate clearly and to show both in thought and deed to each man and woman his or her own special qualities and faults, you see me holding this shiny mirror which I carry in my right hand in place of a scepter. I would thus have you know truly that no one can look into this mirror, no matter what kind of creature, without achiev-

19. Sandra Hindman, *Christine de Pizan's "Epistre Othéa": Painting and Politics at the Court of Charles VII* (Toronto: Pontifical Institute of Medieval Studies, 1986).

ing clear self-knowledge. My mirror has such great dignity that not without reason is it surrounded by rich and precious gems, so that you see, thanks to this mirror, the essences, qualities, proportions, and measures of all things are known, nor can anything be done well without. And because, similarly, you wish to know what are the offices of my other sisters whom you see here, each will reply in her own person about her name and character . . . " (Richards, 9; see illustration). There follows a development on what we have called Christine's alienation, then the charge to construct the citadel; it is only after this symbolic business is attended to, several pages below, that the allegory reveals her name: "I am called Lady Reason; you see that you are in good hands." (ibid., 12).

A Medieval Woman's Mirror of Honor develops the images first set forth in the *City of Ladies:* it is because the Three Virtues reappear to Christine that the book bears their name. This is also why Christine is asleep in the first miniature of Beinecke MS.427: "My body was exhausted by such long and sustained effort, and I was resting, idly, when suddenly the three radiant creatures appeared to me once more, saying: 'Studious daughter! Have you spurned and silenced the instrument of your intellect? Have you let your pen and ink dry out? Have you given up the labor of your hand which usually delights you? Are you willing to listen to the seductive song which Idleness sings to you? . . . Do not be distracted in the middle of your long journey! Shame on the knight who leaves the battle before the victory! Only those who persist deserve the laurel crown. Now up, up! Lend a hand! Get ready! Stop crouching on this dust heap of fatigue! Obey our words, and your work will prosper.' " (Willard, 69.) It is interesting to note that these figures are described as virtues, rather than as the specific instances of virtue suggested by the names Reason, Righteousness and Justice. This is a tendency already present in the *City of Ladies:* it is not always clear why one famous life should be placed under the patronage of Reason, while others, patently just as reasonable, are subsumed under Righteousness. That the lives of the Saints be exclusively the province of Justice seems to escape logical necessity, even if we make allowances for Justice as Divine Justice, and Divine Justice alone. More significantly, the general tenor of the work is that of a *utopia,* and as such oriented toward abstraction, whether the abstraction of dialogue on the issue of what should be, or the categorization of lives, as instances of what has been. If the Three Virtues return to wake Christine, it is to appear in a different light. Having established metaphorical continuity

with the *City of Ladies*, the Three Virtues, like the Three Musketeers, become four, and it is the fourth Virtue, "Prudence Mondaine" (or Worldly Wisdom), who becomes the voice of the text. The relationship between the two works is thus one of theory to practice, rather than one of continuity along allegorical lines. Indeed the voice of the work most often lapses into what might be called third person gnomic, dispensing altogether with symbolic representation, except for occasional allegorical flourishes. To a lesser degree, this tendency also holds sway over pictorial representation.

The Galliéra catalogue aptly describes the four illustrations of the Beinecke manuscripts as "précieuses." They are clearly of a different inspiration and style from the miniatures we associate with Christine's artists. An art historian might note such things as the generally richer color scheme, establishing new kinds of relationships between greens and blues; or a new vision of architecture, with a more highly developed sense of perspective and interiors; mention might be made of the round full faces and the downcast eyes, the long flowing hair, the heavy material of the clothing falling in angular folds. Readers of the *City*, however, are more likely to be struck by changes in allegorical attribution which suggest that the artist was more in tune with this work than its predecessor, if indeed familiar with the *City* at all. There can even be some doubt as to the identity of the figures. "Droiture" or Righteousness, with her emblem of the ruler (see illustration), is the only figure consistent with the portrayal of the Virtues in the *City*; she also bears the emblem of the scales, perhaps more readily associated with the idea of Justice. The figure on the left carries a sword, another allegorical attribute of Justice, rather than the measuring cup spoken of in the *City of Ladies*. The third figure, normally in central position, is, by a process of elimination, Reason. She holds a book, sometimes closed, sometimes open, and in one of the miniatures, a heart. Like the other virtues, she has a crown: unlike the others, she has removed her crown, and holds it in her right hand. This may indicate that Reason has descended from the skies to earth, to teach lessons of worldly wisdom. In any event, the book occupies the center of the composition, with the exception of the waking scene. That a book should replace a mirror is surely an interesting occurrence, perhaps alluding to the *speculum* construct, for the work is, as Professor Willard's title suggests—taking a clue from an early Portuguese translation[20]—the work

20. "A Portuguese Translation of Christine de Pisan," *PMLA* 78 (1963): 459–64.

is a *mirror* for women. This is underscored by Reason's audience, for Christine's organization of her material follows the division of society into three Estates: not quite the usual one, for she does not concern herself with nuns. Ladies of the higher and lesser nobility are present in the second miniature before Worldly Wisdom (as fashion and moralists have it, the higher the headdress, the higher one's rank). Book Three is addressed to wives of artisans, dwellers of the towns and valleys, and contains even a noteworthy chapter of advice to "folles femmes," or women of ill repute. We note in this miniature the interesting presence of children, and a dog. Perhaps nothing really should be made of the dog, but one remembers that Christine herself is often portrayed in her study with a dog at her feet: there is possibly some implication that the little girl will carry Christine's message and fame beyond her own time. For the *Mirror of Honor* ends with an invocation to the future, rather remarkable for a medieval book and perhaps more consistent with our ideas of a Renaissance: "Since French is a more common and universal language than any other, this work will not remain unknown and useless but will endure in its many copies throughout the world. Seen and heard by many valiant ladies and women of authority, both at the present time and in times to come, they will pray to God on behalf of their faithful servant Christine, wishing they had made their pilgrimage in this world at the same time as she, and regretting that they should never have met."[21]

1989 has been a good year for Christine's fame, with the edition and translation of the *Mirror of Honor*, with several colloquia devoted to her works, and the foundation of a professional society in her name. The number of scholarly articles on Christine increases exponentially, and there are signs that she is being read, even misread. The topos of feminism in Christine research has offered ample illustration of how loaded words tend to explode in the faces of those who use them without proper caution.[22] Yet the *Mirror of Honor*, although imperfectly known, has usually made for uneasy reading on the part of those who view Christine as a progressive figure. As a companion piece to the

21. The last phrase somewhat more literal than in the Willard translation (202).
22. This was the subject of Professor Reno's excellent contribution to the recent Charlottesville colloquium on Christine de Pizan as a political figure (organizer, Margaret Brabant; proceedings forthcoming). See also Beatrice Gottlieb, "The Problem of Feminism in the Fifteenth Century," in *Women of the Medieval World: Essays in Honor of John H. Mundy*, ed. J. Kirshner and S. Wemple (Oxford: Basil Blackwell, 1985), 337–64, and my own "Discours de la toilette:, toilette du discours: de l'idéologie du vêtement dans quelques écrits didactiques de Christine de Pizan," *Revue des Langues Romanes* 92 (1988): 329–41.

City of Ladies—indeed named *The Treasury of the City of Ladies* since its publication in the sixteenth century—the work looks in many ways like a step backwards. Christine's ideal for women often seems uncomfortably redolent of familiar sexual stereotypes.

That theory and practice should not coincide has always been the ultimate scandal of morals. It is at first disquieting to see how Christine deals with this issue, defending for example the theoretical equality of women while refusing to project the ideal into practice. There is however no sleight of hand involved here, simply the doctrine that what is potentially true need not *exist,* in order to have moral consequences in *other* spheres, for it was other spheres, rather than a program for action, that counted for Christine's audience.

I believe the key word here is *slander.* From the famous Quarrel of the Rose which promoted Christine to the forefront of public life in 1402,[23] through the treatises on politics in the tradition of "Mirrors for Princes" so characteristic of her mature work, nothing seems to have been so important to Christine as lying: lying to women in Matheolus, lying to the prince or princess in countless passages, lying to the people, lying to one's self. I submit that this hatred of lies is in harmony with the kinds of roles and role playing spelled out for virtuous women in the *Mirror of Honor.* True it is that women are everywhere seen as intermediaries—barring those quirks of Fortune which from time to time thrust disastrous and unexpected responsibilities on them, through the calamitous removal of their husbands by death, prison, or circumstance. Otherwise, women *mediate.* Their role is one of communication, as a kind of informational token between men, with the curious property of interjecting noise—so to speak—into the affairs of the world. Christine's woman, in her *Mirror of Honor,* is everywhere, multiplying contacts, stilling lies, intervening on behalf of the poor, on occasion even vying lie against lie (with *pious hypocrisy,* as she puts it) in the interest of the common good. The author's work *mirrors* this role, as a manual for the effective use of words against things, within the framework of things as they are.

Perhaps the artist of Beinecke 427 was closer to truth than allegorical tradition in placing Reason in the center of things, and a book in the hands of Reason.

23. Original documents in E. Hicks, *Le Débat du Roman de la Rose* (Paris: Champion, 1977); English translation by J. L. Baird and J. R. Kaine, *La Querelle de la Rose: Letters and Documents* (Chapel Hill: University of North Carolina [University of North Carolina Studies in the Romance Languages and Literatures 199], 1978).

II. Romanesque Middle Ages?

EUGENE VANCE

Style and Value: From Soldier to Pilgrim in the *Song of Roland*

From Homer onward, great epic poems have often survived incomplete or fragmented. Such fragmentation is obvious at the level of narrative (as in the case of the *Iliad* or the *Aeneid*); however, fracture-lines and patches in epic stories sometimes reflect less obvious crises of discourse which arise when the inherent value-system of a given poetic style falters before a new ethical prospect commanded by some uncodable event.

In what follows I wish to suggest first, that an ethical disjunction arises in the middle of the *Chanson de Roland* when Charlemagne, who is two-hundred years old, replaces his nephew Roland as the poem's central hero; and second, that if we may consider "Roland" the name of a traditional poetic discourse as well as of an individual feudal hero, the intrusion of the king "with the white beard" tests the adequacy of this discourse as it reaches beyond the ethical ground of the poem's first half.

There are other ways of glimpsing this ethical and semantic disjunction,[1] but here I propose to show how it is reflected in the ways that the relic, considered as a type of sign, motivates and serves a divided heroic consciousness in this poem.

Scholars generally agree that, whatever its antecedents in late classical hero worship and funereal practices,[2] the Christian cult of the saints and their relics became a major spiritual force in the Latin West

1. Eugene Vance, *Marvelous Signals: Poetics and Sign Theory in the Middle Ages* (Lincoln: University of Nebraska Press, 1986), ch. 3.
2. Arthur Darby Nock, "The Cult of Heroes," *Essays on Religion and the Ancient World* (Cambridge: Harvard University Press, 1972), 576–601.

YFS Special Edition, *Contexts: Style and Values in Medieval Art and Literature,* ed. Daniel Poirion and Nancy Freeman Regalado, © 1991 by Yale University.

during the late fourth and fifth centuries. Quite early in Northern Italy and especially in Gaul, as Augustinianism took root, the cult of relics won precedence over that of icons as the more potent spiritual paradigm.[3]

An early promoter of the cult of martyrs and of the veneration of relics in the Latin West was Augustine's mentor, Ambrose, Bishop of Milan (374–97).[4] In 396, Ambrose sent relics from thirteen saints to Victricius, Bishop of Rouen, on the occasion of the dedication of a new cathedral. These relics were to reinforce the evangelization of Gaul by endowing it with the protection and prestige of apostolic and martyrial presences. To do so was also to confer upon Gaul an honorable place in salvation history.

A sermon attributed to Victricius evokes with striking clarity many of the doctrines that would characterize the cult of relics during succeeding centuries in Christian Gaul.[5] I shall summarize themes of this sermon to which the *Roland* is an indirect heir.

According to Victricius, the age of martyrdom is now past, but through their relics, the martyrs' presence endures as a celestial army in Rouen, now to be monumentalized in the new cathedral. The resurrected martyrs live in Christ and are therefore spiritually united with God, by whom we are judged. Our sins are shadows, our innocence is light; and light must return to itself. The saints themselves have consented to the translation of their relics to Rouen so as to multiply their good works. Relics are called such because even the smallest bits of blood and dust are parts that disclose the whole. Relics shine with a single invisible light to the faithful everywhere. Thus, even these tiny relics, these bits of blood, shine more brightly than do the sun and the light of day. Relics heal the faithful and bind them into a single community existing in all parts of the world. The martyrs will fight on our side, and with the saints as our brothers in arms, victory is certain. And, as we confess our sins each day, the martyrs are our advocates.

After Victricius, the cult of relics came to serve the different groups of medieval society in ways that corresponded to their ordained ends. In everyday pastoral affairs, the clergy drew above all upon the thauma-

3. André Grabar, *Martyrium. Recherches sur le culte des reliques et l'art chrétien antique.* 2 vols. (Paris: Collège de France, 1946), vol. 2, 356.

4. Ernst Dassmann, "Ambrosius und di Märtyrer," *Jahrbuch für Antike und Christentum* 18: 49–68.

5. Victricius of Rouen, *De laude sanctorum,* ed. and French trans. René Herval, in *Origines chrétiennes de la IIe Lyonnaise* (Paris: Picard, 1966), 109–53.

turgic claims made for relics in order to regulate every aspect of the communal life of the common folk. The administration of justice, the ratification of social bonds, the governance of sexual mores, the cure of the sick, the exchange of property, the management of penitence, the protection of the weak—and even the abundance of crops—were all seen as areas where the cult of relics could play a determining role. Such pastoral concerns best characterize the writings of Gregory of Tours, for instance his *Glory of the Martyrs.*[6] Here, the ceaseless evocation of miracles attributed to the cult of relics is anything but naive, but enhances in precise ways the power of the clergy to govern the pastoral affairs in the daily life of Gaul.

Among the *oratores* of the monastic communities, relics could be venerated with an entirely different emphasis. Monks who saw themselves as successors to the martyrs in ecclesiastical history strove to internalize martyrdom as an *ongoing* death to the world. Among the desert monks of the East, the capacity to identify with the suffering of the martyrs seems to have led the self-mortifying monks to carry relics close to their own flesh.[7] However, in the eighth and ninth centuries, Charlemagne's initiatives as a Christian *bellator* and empire-builder brought a new ideological dimension to the cult of relics in the prosecution of holy wars. In 794 (that is, sixteen years after the disaster at Ronceval), Charlemagne opposed the arguments for the restoration of icons adopted in Byzantium during the Seventh Council of Nicea in 787. The so-called *Libri carolini* were theological statements produced for Charlemagne (probably by Theodulf of Orleans) to refute iconophile positions issuing from Byzantium and from Pope Hadrian I.[8] At the same time, the *Libri carolini* promoted the cult of relics as a vehicle of spirituality. It was argued that relics are holy things and divinely instituted signs belonging to salvation history, while icons are mere artifacts of the hand of man, and are not holy.[9]

Thus, with Charlemagne, the cult of relics became a powerful in-

6. Gregory of Tours, *Glory of the Martyrs*, trans. Raymond Van Dam (Liverpool: Liverpool University Press, 1988).

7. Saint John Damascene, *Barlaam and Ioasaph*, trans. G. R. Woodward, H. Mattingly, and D. M. Lang. Loeb Classical Library (Cambridge: Harvard University Press; London: Heinemann, 1914), vol. 34, xxii. 199.

8. *Libri carolini*, ed. Hubert Bastgen, *Monumenta Germaniae Historica*. Legum Sectio III. Concilia. (Hannover and Leipzig: Hahn, 1924), vol. 2, Supplement. Henceforth cited in text.

9. Celia Chazelle, "Matter, Spirit, and Image in the *Libri Carolini*," *Recherches Augustiniennes* 21 (1986): 168.

strument of imperial ideology opposing the Latin West from Byzantium (*Libri carolini*, III, 16). Moreover, the age of Charlemagne saw new initiatives to inculcate a classical heroic dimension into the semiotics of the reliquary—evident, for instance, in Einhard's silver reliquary in the form of a triumphal arch, or else in the so-called *Écrin de Charlemagne*, now destroyed except for the crest jewel.[10] From the drawing of the *écrin* that remains in the Bibliothèque nationale, we know that it was a five-tiered altarpiece set on a reliquary. Its architechtonics drew the beholder's eye from a base (not original) with eleven arches upward through three tiers of diminishing numbers of arches culminating in a summit of a *single* arch. This progress of the eye upward from the *many* to the *one* led finally to a crest jewel crowning the top arch and containing a Roman effigy of the emperor Titus's daughter, now celebrated as that of Mary.

Especially during the eleventh century, when Roland's legend seems to have reached its apogee, the strengthening ideology of holy war inflected the notion of pilgrimage toward that of crusade.[11] As Bernard McGinn writes, "it was Gregory VII (1073–1085) who did the most to lay the foundations of the Crusades. Gregory went further than his predecessors in forging the alliance between the papacy and the warlike aristocracy of Europe. . . . In Gregory's letters *militia* is less a warfare against vices in the context of monastic spirituality and more the wielding of the material sword against the enemies of the papacy."[12] In the view of Guibert de Nogent, the early twelfth-century chronicler of the First Crusade, the knights of the First Crusade figuratively perfected themselves as monks—not in the cloister, but on the battlefield.[13]

McGinn emphasizes, though, that the crusading ideal not only

10. See Erwin Panofsky, ed. and trans., *Abbot Suger on the Abbey Church of St.-Denis and Its Art Treasures* (Princeton: Princeton University Press, 1946; second ed., 1976), 21 and figs. 24–25. See also Linda Seidel, *Songs of Glory: The Romanesque Façades of Aquitaine* (Chicago: University of Chicago Press, 1981) for relations between these reliquaries and a later romanesque heroic tradition. I wish to acknowledge with thanks my discussions with Linda Seidel on these questions.

11. James A. Brundage, *Medieval Canon Law and the Crusader* (Madison: University of Wisconsin Press, 1969), 128.

12. Bernard McGinn, "*Iter Sancti Sepulchri:* The Piety of the First Crusaders," *Essays on Medieval Civilization*, ed. Bede Karl Lackner and Kenneth Roy Philp (Austin: University of Texas Press, 1978), 42. Brackets mine.

13. Guibert de Nogent, *Gesta Dei per Francorum*, in *Recueil des historiens des croisades*. Historiens occidentaux, vol. 4 (Paris: Imprimerie nationale, 1879), 6. i, 203.

sustained the motifs of pilgrimage as an inward penitential enterprise, but in the end came to be dominated by them:

> If the journey to the historical Jerusalem and worship at its holy places involved a physical *imitatio Christi*, the developing pilgrimage piety made it clear that external imitation was incomplete without internal imitation, the establishment of peace and freedom within the soul. While the full flowering of pilgrimage-crusade as personal reformation was not to be complete until the mid-twelfth century, its seeds were sown by Urban in his appeal of 1095. [42]

As Linda Seidel and Stephen G. Nichols have shown, a heroic dimension of Christian sacrifice would continue to be elaborated in the sanctuaries of pilgrimage routes in France throughout the romanesque period, and beyond.[14]

As the cult of relics gained prominence in the Latin West, so too a theology of resurrection emerged whose model was that of a centripetal *reassemblage*, a gathering up, of the fragmented human body in heaven. This model was compatible with an Augustinian pattern of conversion in which the sinner turns away from the fragmentation of self in the multiplicity of the world to become spiritually reintegrated in God. Augustine writes in his *Confessions*,

> In the bitterness of my remembrance, I tread again my most evil ways, so that you may grow sweet to me, O sweetness that never fails, O sweetness happy and enduring, which gathers me together again from that disordered state in which I lay in shattered pieces, wherein, turned away from you, the one, I spent myself upon the many.[15]

Carolyn Walker Bynum has recently shown how, from the ninth century forward, such a theological model came to prevail over others that had been expressed by Scripture and by early Christianity.[16] However, I would suggest that this model of the fragments-reassembled-into-the-whole became so compelling to those in power because it was homologous not only with an Augustinian model of *individual* conversion (teaching the return of the many toward the One) but also with the

14. Stephen G. Nichols, Jr., *Romanesque Signs: Early Medieval Narrative and Iconography* (New Haven: Yale University Press, 1983). Seidel, op. cit.

15. Saint Augustine, *Confessions*, trans. John K. Ryan (Garden City, NY: Doubleday, 1960), 2. i. 1.

16. Carolyn Walker Bynum, "Metaphors for the Resurrection of the Body," unpublished plenary lecture to the Medieval Academy of America, 13 April 1989.

resurgent ideology of empire advocating a *political* gathering of God's many people into one spiritual community.

Thus, Charlemagne came to be celebrated throughout the high Middle Ages for having established a patronage network, at once spiritual *and* political, based on the distribution of relics to the great religious institutions in his realm. This aspect of the legend of Charlemagne would later be exploited—and exaggerated—by Abbot Suger as he rebuilt Saint-Denis (the traditional burial place of French kings and now the cradle of Capetian ideology) around relics allegedly procured and donated by Charlemagne. And if documents lacked to prove such donations, they could be produced, as in the case of the spurious so-called *Descriptio* produced at Saint-Denis. An extravagant fraud, this document pretended that Charlemagne himself had liberated Jerusalem from the pagans, and that he had received from the emperor of Constantinople the very relics now residing in the treasury of Saint-Denis. Suger claimed that these relics had subsequently been translated from Aachen to Saint-Denis by Charles the Bald, Charlemagne's grandson and first king of the French.[17]

In contrast with the icon, the relic is not a beautiful artifact, not something sublime wrought in vivid colors and precious metals by an inspired human hand, rather, an abject "leftover" (*reliquia*) of a human sacrifice. Typically a dried-up fragment, limb or secretion of an immolated human body, or else some *minutia* metonymically associated with the violation of that body,[18] a relic commonly bears tangible traces of violence dealt by the nail, the stone, the flame, or the sword on the body of a martyr. That the relic was usually concealed in a reliquary (to be occasionally displayed) in no way attenuated its psychological import; rather, the beauty of the reliquary as artifact was a supplement, a secondary semiotic program dialectically declaring the spiritual glory of the saint's body reassembled in heaven.

If the relic and the story accompanying it evinced in the pious soul

17. The full title of this document is *Descriptio qualiter Karolus magnus clavum et coronam Domini a Constantinopoli Aquisgrani detulerit qualiterque Karolus Calvus hec ad S. Dyonisum retulerit,*" ed. G. Rauschen, *Die Legende Karles des Grossen im XI und XII Jahrhundert. Publikationen der Gesellschaft für rheinische Geschichteskunde* 7 (1890): 45–66 and 121–25.

18. The *Libri carolini* hold that the relic is either part of the body of the now resurrected saint, or else is something near (*circa*) martyr's body. Icons have never been "in the body or near the body" (*imagines vero nec in corpore nec circa corpus fuisse,* III. 24).

fantasms of violence wrought upon the human body, so too, the pilgrim's veneration of relics in sanctuaries took form as a somatic *passio*, miming, as Peter Brown suggests, the anguish of a judicial ordeal where a sinner, who is being tortured and judged by God, implores the advocacy of the resurrected martyr.[19]

For generations, scholars have recognized a close link first, between the *Roland* and the crusading ethos of the eleventh century, and second, between the *Roland* and the sanctuaries linked to each other by the pilgrimage routes leading to Saint James of Compostella. I shall not recapitulate here the critical debate on that question. Rather, let us first consider the nature and the role of the relics in the story of Roland's ordeal, understood specifically as that of a chivalric martyr. Then we shall see how, no less specifically, the second half of the *Roland* confers heroic stature upon the *pilgrim* mentality, succinctly orchestrating the spiritual program of the pilgrimage experience itself as it became centered in the veneration of relics. I shall suggest that during the early decades of the twelfth century the difference between the martial ideals of the *militia Christi* and the penitential quest of the pilgrim had become crucial, and that in the *Chanson de Roland* the exaltation of the latter paradigm renders the memory of the former one tragically equivocal.

One will recall that Roland and the rearguard go into battle blessed in advance by Turpin and secure in the soldier-bishop's promise that those who will soon die as martyrs will be resurrected as saints in paradise:

> "Seignurs baruns, Carles nus lassat ci;
> Pur nostre rei devum ben murir.
> Chrestientet aidez a sustenir!
> Bataille avrez, vos en estes tuz fiz,
> Kar a voz oilz veez les Sarrazins.
> Clamez voz culpes, si preiez Deu mercit;
> Asoldrai voz pur voz anmes guarir.
> Se vos murez, esterez seinz martirs,
> Sieges avrez el greignor pareïs."[20]

19. Peter Brown, *The Cult of the Saints. Its Rise and Function in Latin Christianity* (Chicago: University of Chicago Press, 1981), 108.

20. *La Chanson de Roland*, ed. J. Bédier (Paris: Piazza, 1960), ll. 1127–35. Unless otherwise indicated, all English translations are mine. Henceforth cited in the text.

> "Noble Lords, Charles has placed us here:
> For our king we must surely die.
> Let us now uphold the Christian faith.
> You will have battle, you may be sure:
> You can see the Saracens with your very eyes.
> Confess your sins, and pray for God's mercy;
> I will absolve you for your souls' salvation.
> If you die, you will be holy martyrs,
> With seats in the highest part of paradise."

Thus, Roland's body and his weapons, as well as those of his peers, may be seen proleptically as a sure source of the very relics that the midcentury pilgrim's guide would indeed extoll as being quite worth the trip: to Blaye, where Roland's body lies, to Bordeaux, where his Oliphant is kept, and to Roncevaux, where a church has now been built on the site of the stone struck by Roland's sword Durendal during the hero's final moments.[21]

Durendal, Roland himself tells us, came into his conquering hands when, through an angel, God himself ordered Charlemagne to bestow the sword on one of his noblest captains. To the extent that this knight has in effect been dubbed by God, Roland's conquests with Durendal in the name of Charles have been predestined by the Lord of all. Thus, the poem that tells of Roland's exploits is nothing less than sacred history. Moreover, the story of Roland would continue to be told and retold as sacred history in the plastic arts of sanctuaries as well, as Rita Lejeune, Jacques Stiennon, and others have shown.[22]

But Roland's sword is already a reliquary in its own right, since it contains a tooth of St. Peter, some blood of Saint Basil, hairs of Saint Denis, and a piece of Mary's clothing. Each of these relics confers its own special value and meaning on Roland's warfaring mission. The relic of Saint Peter guarantees the apostolicity of France as a sacred Christian empire; the blood of Basil the Great, a post-Nicene Byzantine saint, offers two messages. First, it points to Aachen, rather than Constantinople, as the successor to imperial Rome. Second, since Basil was also remembered as the author of an ascetic rule, his *praesentia* in Roland's sword confirms that Roland's ascesis as the vassal of an

21. *Le Guide du pèlerin de saint-Jacques de Compostelle,* ed. and French trans. Jeanne Vieillard. 5th ed. (Paris: Vrin, 1984), 38–56.

22. Rita Lejeune and Jacques Stiennon, *La Légende de Roland dans l'art du moyen âge* (Brussels: Arcade, 1967); Stephen G. Nichols, *Romanesque Signs,* op cit.

earthly lord was consonant with the monk's before the Lord of lords. As Roland himself puts it,

> "Pur sun seignor deit hom susfrir destreiz,
> E endurer e granz chalz e granz freiz,
> Sin deit hom perdre e del quir e del peil.
> Or guart chascuns que granz colps i empleit . . . "[1010–13]

> "For one's lord a vassal must suffer hardships
> And endure great heat and great cold
> And so too a vassal must lose both hide and hair;
> So let each of us deal out great swordblows . . . "

The hairs of Saint Denis assure Roland of the protection of France's own patron saint, while the *brandea* from Mary's clothing (her tunic was allegedly at Chartres) guarantee Roland of Mary's intercession: none could be more efficacious. As for the sword's name "Durendal," in accordance with its Latin root *duro*, it connotes both "being hard" and "persevering," in concordance with the Augustinian notion of the divine "gift of perseverance" that allows martyrs to fulfill their spiritual action through immolation.[23]

The setting for Roland's heroic deeds is resplendent with sunlight and color:

> Clers fut li jurz e bels fut li soleilz:
> N'unt guarnement que fut ne reflambeit . . .
> Sunent mil grailles por ço que plus bel seit . . . [1002–04]

> The day was bright, and the sun was beautiful;
> There is no armor that does not flash.
> A thousand trumpets sound, to make it more beautiful . . .

So too, the Christian steel of Durendal will continue to flash undaunted in the sunlight even as Roland vainly tries to break it on a rock in order to keep it from pagan hands. And at their death, the blood of "our barons" will shine brightly on the green grass. As Victricius had put it, "Light engenders splendor, nor between light and splendor is there any distinction" (137), and "there is in relics the reminder of perfection, and not the harm of division" (135). The pagans, by contrast, emerge from the valleys and shadows and are as black as ink,[24]

23. Saint Augustine, *De dono perseverentiae.*
24. On darkness and shadows in the *Roland,* see William D. Paden, "Tenebrism in the *Song of Roland,*" *Modern Philology* 86 (1989): 339–56.

and no one who has been to Conques can doubt that, after they are artfully bisected by Christian swords on earth, devils will shred them eternally in hell.

The first half of the *Roland* envisions world history as an economy of violence mediated through relics as a divine pledge-money (*pignora*) dispensed by God to the chosen, the strong and the willing. Like the ancient martyrs of Gaul, Alexandria and Palestine, these "modern" heroes (in the sense that Guibert gives to that term) are utterly numb to bodily pain and even joyous at the prospect of their imminent death and resurrection:

> Ço dist Rollant: "Ci recevrums martyrie,
> E or sai ben n'avons guaires a vivre;
> Mais tut seit fel cher ne se vende primes." [Ll. 1922–24]

> Thus says Roland, "Here we shall become martyrs,
> And I know very well we shall not live long.
> But shame to whoever does not first sell himself dearly!"

Roland's resurrection in the hands of two warrior angels, Gabriel and Michael, stresses the perfect commensurability of chivalric martyrdom on earth with the more sublime peerage of the saved in heaven.

SEEING AND BELIEVING

However, Roland's lofty death and resurrection form only one focal point of the *Chanson*, and it is neither the last nor necessarily the most important one. This epic is a diptych, and Charlemagne's perceptions and commemoration of that glorious event will be evoked with no less precision and power. Immediately after Roland's death, Charlemagne arrives at Ronceval, now strewn with the bodies of his best barons. Just as Roland's bravura in arms had earlier inspired the emulation of his warlike companions, so now, in the example of Charlemagne, suffering moves to the fore and is proffered as heroic action in its own right. Roland's boasts had evinced a torrent of swordblows from his peers, but now the emperor's complaint and somatic grief become a contagious force that sweeps across the whole of the French army, who writhe and faint in unison:

> Tiret sa barbe cum hom ki est iret;
> Plurent des oilz si baron chevaler;
> Encuntre tere se pasment .XX. millers;
> Naimes li dux en ad mult grand pitet.

Il n'en i ad chevaler ne barun
Que de pitet mult durement ne plurt;
Plurent lur filz, lur freres, lur nevolz
E lur amis e lur lige seignurs;
Encuntre tere se pasment li plusur. [Ll. 2414–22]

He tears at his beard like a tormented man.
His noble knights weep from their eyes.
Twenty thousand faint to the ground.
Naimes the Duke takes great pity.

There is not a knight or baron
Who does not weep hard for pity:
They weep for their sons, brothers and nephews,
And their friends and their liege lords;
Many faint to the ground all at once.

However, Charlemagne's heroic grief dictates forms of heroic action that are no longer martial, but ritualistic and commemorative in nature. His first practical gesture upon his return to Ronceval is to ensure that the remains of Roland's and the twelve peers' martyrdom not be desecrated by wild beasts or stolen by knaves (a marked concern of twelfth-century religious communities) before they can be properly enshrined. The yet unanswered imperative of avenging Roland momentarily interrupts Charlemagne's heroics of grieving, but Charlemagne vows to God his resolution—hence, his *obligation*—to return to Ronceval, now a sacred place, not as a soldier, but as a pilgrim. In twelfth-century canon law, failure to respect the pilgrim's vow was of course a serious offense:[25]

"Guardez le champ e les vals e les munz.
Lessez gesir les morz tut issi cun il sunt,
Que n'i adeist ne beste ne lion,
Ne n'i adeist esquier ne garçun;
Jo vus defend que n'i adeist nuls hom,
Josque Deus voeille qu'en cest camp revengum." [Ll. 2434–39]

"Watch over the field, the valleys and the mountains.
Let lie here the dead exactly as they are;
Let no wild beast or lion touch them;
Let no squire or young boy touch them;
I forbid that any man should touch them,
Until God ordains that we return to this field."

25. Henri Gilles, "Les peregrinorum," *Le Pélerinage*, ed. Marie-Humbert Vicaire (Toulouse: Privat, 1980), 161–89.

The figures of soldier and pilgrim continue to diverge. The Saracens are quickly routed, and to make their story miraculously short, the poet drowns them all in the Eber River. In the carefully orchestrated events that follow, though, Charlemagne's conduct reverts to the studied paradigm of a heroic pilgrim, and not of a heroic warrior. Thus, following the demise of the Saracens, the emperor and his men collapse in fatigue and grief under the moonlight, too tired to care for their horses or even to take off their armor. Once again, in the name of Charlemagne, human passion—in the root sense of "suffering"— moves to the very center of the poem. The horses are so tired that they must graze lying down:

> Clere est la noit e la lune luisant.
> Charles se gist, mais doel a de Rollant
> E d'Oliver li peseit mult forment,
> Des .XII. pers e de la franceise gent
> Qu'en Rencesvals ad laiset morz sanglenz.
> Ne poet muer n'en plurt e nes dement
> E priet Deu qu'as anmes seit guarent.
> Las est li reis, kar la peine est mult grant;
> Endormiz est, ne pout mais en avant.
> Par tuz les prez or se dorment li Franc.
> N'i ad cheval ki puisset ester en estant:
> Ki herbe voelt, il la prent en gisant.
> Mult ad apris ki bien conuist ahan.
>
> Karles se dort con hume traveillet.
> Seint Gabriel li ad Deus enveiet:
> L'empereür li cumandet a guarder.
> Li angles est tute noit a sun chef.
> Par avisium li ad anunciet
> D'une bataille ki encuntre lui ert:
> Senefiance l'en demustrat mult grief . . . [Ll. 2512–31]

> The night is clear with a shining moon.
> Charles lies down, but he grieves for Roland,
> And was burdened by the fate of Oliver,
> And of the twelve peers and the Frenchmen
> Whom he left in bloody death at Ronceval.
> He cannot hold back his weeping and his anguish.
> And prays for God to protect their souls.
> The king is weary, for his suffering is great.

He goes to sleep, he can do nothing more.
All over the field, the Frenchmen sleep.
Not a horse can remain standing:
Whichever one wishes grass must graze lying down.
He has learned greatly who has known great suffering.

The terms of this scene of nocturnal grief and exhaustion are a precise reversal of the poetic formulas proper to that earlier exuberance in the poem when heroes put on their fine armor in the sunlight to the sound of trumpets, and when Roland himself savored the prospect of the final fight. As Lejeune and Stiennon have shown, the motif of the tired horse is common in the iconography of the Roland legend, but elsewhere, the panting horse stands by a human master still fighting in the fray. Here, by contrast, Charlemagne is on the ground alongside his horse, overwhelmed by a grief that no young warrior (or his horse) could know. This transformation of heroic norms suggested here corresponds to a broader shift from the *saint admirable* to the *saint imitable* in twelfth-century paradigms of spirituality, recently described by André Vauchez.[26] Exalted at the poem's outset as the joyous breaker of cities, the aged Charlemagne is now an inconsolable and politically destitute leader: *"E! France, cum remeines deserte!"* (l. 2928). However during this anguished stillpoint in military history and this moral darkness, a new dimension of tragic understanding suddenly emerges, clearly expressed in Charlemagne's relationship with that supreme relic of Christ's passion on the cross: the tip of Longinus's spear, now encased in his sword Joyeuse. It is important to recall that this relic from the lance that had pierced Christ's side had enjoyed special prominence several decades previously during the First Crusade. It was reported by veterans of the crusade that by June 1098, while they were besieged by the Turks at Antioch, the Christians had fallen into despair. At that moment, the lance was allegedly discovered in a church in Antioch, and its sudden and miraculous presence among the French inspired the crusaders—themselves led by an aging Raymond de Saint-Gilles, Count of Toulouse—to rally from their exhaustion and rout the Turks.[27] Now in the *Roland*, we are told that the lance has caused

26. André Vauchez, "L'Evolution des fonctions de la sainteté dans la chrétienté occidentale aux XIIe et XIIIe siècles: du saint admirable au saint imitable," a talk presented at the Medieval Academy of America, 14 April 1989.

27. Laurita and John Hill, *Raymond IV de Saint-Gilles, Comte de Toulouse* (Toulouse: Privat, 1959), 79.

Charlemagne's sword to be named "Joyeuse" and that "Montjoie" remains the battlecry of the French:

> Icele noit ne se volt il desarmer,
> Si ad vestut sun blanc osberc sasfret.
> Laciet sun elme, ki est a or gemmet,
> Ceinte Joiuse, unches ne fut sa per,
> Ki cascun jur muet .XXX. clartez.
> Asez savum de la lance parler,
> Dunt Nostre Sire fut en la cruiz nasfret:
> Carles en ad la mure, mercit Deu;
> En l'oret punt l'ad faite manuvrer.
> Pur ceste honur e pur ceste bontet,
> Li noms Joiuse l'espee fut dunet.
> Baruns franceis nel deivent ublier:
> Enseigne en unt de "Munjoie!" crier;
> Por ço nes poet nule gent cuntrester. [Ll. 2498–2511]

> This night, he does not wish to disarm himself,
> And keeps on his white, saffroned hauberc,
> And keeps his helmet laced, which is of studded gold.
> He wears Joyeuse, which never had a peer,
> Whose shining colors change thirty times a day.
> We all can talk about the lance
> With which Our Lord was wounded on the Cross:
> Charles has its tip, thanks be to God,
> And has it encased in the golden pummel.
> Because of such honor and such grace,
> The name of Joyous was given to the sword.
> The Frankish barons must never forget it;
> They have been taught "Monjoie" as their battlecry,
> And that is why no people may resist them.

We are told that the supreme relic of Christ's passion embedded in Charlemagne's sword makes the French invincible, but have the French in the *Roland* not just suffered a major catastrophe, both moral and logistical? Clearly, the notion of Christian victory has veered sharply away from that of the soldier's battlefield and toward the inner spiritual struggles of an old king grieving privately in the night. Durendal had gleamed with the sunlight of unequivocal, historical truth; but here, the more mysterious colors of Joyeuse, which change thirty times a day, are no longer those of some material thing gleaming in the common light of the sun. Rather, the "joy" of Joyeuse, like its light,

devolves from *spiritual* illumination wrought through suffering recalling specifically that of Christ on Calvary. Roland's divinely ordained perseverance had been embodied in the steel of Durendal, but now an aged and weakened Charlemagne bears in "the sword of France" the Christological emblem of an equally difficult inward "joy" achieved in a cycle of abjection, penance, and the hope of resurrection.

Although the new plot is once again interrupted at l. 2569 (to include first the Saracen appeal to Baligant and then Marsile's demise), it resumes again at verse 2845, when Charlemagne wakes up on what is clearly the "previous night's" *proper* next day. Despite Gabriel's prophetic signs of the forthcoming war with Baligant, Charlemagne awakens not as a military hero hungry for combat, but as an unarmed pilgrim setting out (as he had previously resolved) on one of the very roads toward Spain later taken by pilgrims addressed by the *Guide du pélerin*. The poet gives special prominence to the emperor's and the army's gesture of laying down their weapons in order to set forth on the road to Ronceval as pilgrims:

> Al matin, quant primes pert li albe,
> Esveillez est li emperere Carles.
> Sein Gabriel, ki de part Deu le guarde,
> Levet sa main, sur lui fait sun signacle.
> *Li reis se drece, si ad rendut ses armes,*
> *Si se desarment par tute l'ost li altre.*
> *Puis sunt muntet, par grant vertut chevalchent*
> *Cez veiez lunges e cez chemins mult larges,*
> *Si vunt vedeir le merveillus damage*
> *En Rencesvals, la o fut la bataille. AOI* [2845–54, emphases mine]

> In the morning, at dawn's first light,
> The emperor Charles awakened.
> Saint Gabriel, whom God sent to protect him,
> Raises his hand and makes his sign above him.
> *The king arises and puts aside his arms,*
> *And so too, throughout the army, do all the others.*
> *Then they saddle up and ride with great speed*
> *On those very long roads and wide ways:*
> *They are going to see the miraculous damage done*
> *At Ronceval, there where the battle was. AOI*

Charlemagne's journey to Ronceval is conspicuously no longer a crusade, but a heroic protopilgrimage where the junk of the battlefield

will be transformed by the Holy Roman Emperor's exemplary spirituality into a treasure of future relics.

However, relics do not signify unless they are encased first of all in a proper *story*. That story will include details of the martyr's deeds and suffering during torture and execution, as well as details about the willed translation of the martyr's relics to the here and now of the local sanctuary. Since trauma is the motor of relic-centered spirituality, the more gruesome and violent the story, the more easily it may be remembered—and the more eagerly miracles will be hoped for. The horror of what Charlemagne will perceive will determine what he, what the epic poet, and what we of the audience will remember. But even Roland, we learn retroactively, has had the good grace not only to fight so hard that memorable epics could be sung about him but to die in a posture such that his own iconography is already halfway composed. Thus, Charlemagne's protopilgrimage brings him to a protosanctuary where the hero's body is already almost a statue, and where blocks of marble (the stone of monumentality par excellence) proffer to the eyes of all the sublime calligraphy of Roland's final swordblows. By dying so sublimely—and so artistically—the Roland of the second half is in a sense the first iconographer and sculptor of his own sanctuary. And, as Charlemagne ascends to Ronceval and spiritually deciphers the relics of Roland's martyrdom, he becomes in effect the first reader of the *Chanson de Roland:*

> En Rencesvals en est Carles venuz.
> Des morz qu'il troevet cumencet a plurer.
> Dist a Franceis: "Segnurs, le pas tenez,
> Kar mei meïsme estoet avant aler
> Pur mun nevold que vuldreie truver.
> A Eis esteie, a une feste anoel,
> Si se vanterent mi vaillant chevaler
> De granz batailles, de forz esturs pleners.
> D'une raisun oï Rollant parler:
> Ja ne murreit en estrange regnet
> Ne trespassast ses humes e ses pers;
> Vers lur païs avreit sun chef turnet;
> Cunquerrantment si finereit li bers" [2855–67]

> Quant l'empereres vait querre sun nevold,
> De tantes herbes el pré truvat les flors
> Ki sont vermeilles del sanc de noz barons!

Pitet en ad, ne poet muer n'en plurt.
Desuz dous arbres parvenuz est. . . .
Les colps Rollant conut en treis perruns
Sur l'erbe verte veit gesir sun nevuld.
Nen est merveille se Karles ad irur.
Descent a pied, aled i est pleins curs.
Entre ses mains ansdous . . .
Sur lui se pasmet, tant par est anguissus. [2870–80]

Charles arrived at Ronceval.
He began to weep for the dead that he found there.
He said to the French: "Lords, ride slowly,
For I myself must precede you.
For my nephew's sake, whom I wish to find.
Once at Aix, during a solemn feast,
My valiant soldiers began to boast
Of great battles, and of great assaults they'd make.
I heard Roland say the following:
Never would he die in a foreign realm
Without going further than his men and peers;
Towards their country he would turn his head
And would die thus, a true conquerer."

As the emperor went seeking his nephew,
He found so many flowers of the plants of the field
Crimson with the blood of our barons!
Pity swept him, nor could he hold back from weeping.
He came beneath two trees. . . .
He recognized Roland's blows on the three rocks.
On the green grass he found his nephew lying.
It is no wonder if Charles grieves.
He dismounted and rushed on at a run.
Between his two hands . . .
He fainted over him, so great is his anguish.

In this sublime moment of the *Chanson de Roland*, Charlemagne sets a hyperbolic example of the pilgrim's piety which is the exact complement of Roland's mighty swordblows: both were to be imitated by their peers and then sung about to their heirs. The sight of Roland's body, with the natural shadows of the valleys now in his vacant eyes, summons from Charlemagne a visionary prayer for his own burial *ad sanctos* and for his own resurrection among the communion of saints,

the holy flowers of Paradise.[28] (Such too, according to Suger, was the privilege sought by "our emperor" Charles Chauve concerning his own burial at Saint-Denis.)[29] As he contemplates the mortal ruins of a hero now resurrected in heaven, Charlemagne recognizes his own guilt—though now solely from within, and no longer through the external mediation of some angel. The emperor's abjection radiates outward among the hundred thousand Frenchmen who have followed him—not as soldiers, but pilgrims:

> Carles li reis se vint de pasmeisuns;
> Par les mains le tienent .IIII. de ses barons.
> Guardet a tere, vei gesir sun nevuld.
> Cors ad gaillard, perdue ad sa culur,
> Turnez ses oilz, mult li sunt tenebros.
> Carles li pleint par feid e par amur:
> "Ami Rollant, Deus metet t'anme en flors,
> En pareïs, entre les glorius!
> *Cum en Espaigne venis a mal seignur!*
> Jamais n'ert jurn de tei n'aie dulur.
> Cum decarrat ma force e ma baldur!
> N'en avrai ja ki sustienget m'onur
> Suz ciel ne quid aveir ami un sul;
> Se jo ai parenz, n'en i ad nul si proz."
> Trait ses crignels, pleines ses mains amsdous;
> Cent milie Franc en unt si grant dulur
> N'en ad cel ki durement ne plurt. AOI. (Ll. 2892–2908, emphases mine)

> Charles the king comes out of his faint.
> Four barons support him by the hands.
> He looks to the ground and sees his nephew lying there.
> His body is robust, but its color gone.
> His eyes are upturned and filled with shadows.
> Charles laments out of loyalty and love:
> Roland, friend! May God place your soul among the flowers,
> In Paradise, among those in his glory!
> *What a bad lord you followed into Spain!*

28. Yvette Duval, *Auprès des saints corps et âmes. L'Inhumation "ad sanctos" dans la chrétienté d'Orient et d'Occident du IIIe au VIIe siècle* (Paris: Etudes augustiniennes, 1988).

29. *Abbot Suger on the Abbey-Church of St.-Denis and Its Art Treasures*, ed. and trans. Erwin Panofsky. Second ed. by Gerda Panofsky Soergel (Princeton: Princeton University Press, 1979), 129.

Never will I live a day without grief for you.
How my power and joy will decline!
None remains to uphold my honor:
I fear that I have no friend under heaven.
I have my clan, but none is so bold.
He tears his hair out with both hands full.
A hundred-thousand Franks feel such anguish
That not one does not weep hard.

The sight of the fresh relics of Roland's passion beget not only bodily turmoil in the emperor, but a prophetic vision of the body politic being broken into pieces by rebellion:

"Encuntre mei revelerunt li Seisne
E Hungre e Bugre e tante gent averse,
Romain, Puillain e tuit icil de Palerne
E cil d'Affrike e cil de Califerne . . . " [Ll. 2921–24]

"Against me the Saxons will rebel,
And the Hungarians, and the Bulgarians,
And so many others who turn from God:
Those of Rome, of Pouille and of Palerne,
And those of Africa and those of Califerne."

Before this prospect of fragmentation in the body politic, Charlemagne acknowledges (l. 2937) his own responsibility for the destruction of his rearguard. One will recall that in the iconography of Charlemagne's legend after the Roland—for instance at Chartres, and at Aachen—the motif of the emperor's penitence would rival, and at times, eclipse his glory as a Christian warrior.[30] Here, the spectacle of the dead martyrs evinces from Charlemagne less his rededication to the ideology of empire than his longing to be buried beside the martyrs until the time of his own resurrection into the community of the saved. Duke Naimes responds like a chorus to the emperor's exemplary and pious grief:

"Si grant dol ai que ne voldreie vivre
De ma maisnee, ki pur mei est ocise!
Ço duinset Deus, le filz seinte Marie,
Einz que jo vienge as maistres porz de Sirie,
L'anme del cors me seit oi departie,

30. Rita Lejeune, "Le Péché de Charlemagne et la *Chanson de Roland*," *Studia Philologica: Homenaje ofrecido a Dámaso Alonso por sus amigos y disciplos con ocasión de su 60° aniversario* (Madrid: Gredos, 1961), vol. 2, 339–70.

Entre les lur aluee e mise
E ma car fust delez els enfuïe!"
Ploret des oilz, sa blanche barbe tiret,
E dist dux Naimes: "Or ad Carles grant ire." [Ll. 2936–44]

"So great is my grief, I do not wish to live,
Since many of my household have died because of me.
May God, the Son of Saint Mary, grant
That before I reach the great gates of Cize,
My soul will have departed from this body,
And have been placed among theirs,
And my flesh buried beside theirs."
He weeps from his eyes and pulls his white beard,
And Duke Naimes says, "Now Charles grieves greatly."

Charlemagne's wish to be buried *ad sanctos* is identical to the preparations made by Louis VI for his own death, as reported by Suger in his biography of the king he served so devotedly.[31] Interestingly, Suger's own dreams of empire were now pinned on an inauspicious Louis VII, and, like Charlemagne in the second half of the *Roland*, Suger too perhaps glimpses the prospect of a kingdom in ruins.

Given the Capetian taste for the cult of relics as a spiritual force shaping the arts and crafts of Empire, we should not be surprised to find that the *Chanson de Roland* promulgates a memory of Charlemagne not only as the founder of a patronage system based on relics, but also, like Constantine, as a builder of stone sanctuaries with written inscriptions to evoke the martyrs' stories. Thus, eager to endow future shrines with the relics of Roncevals, Charlemagne summons forth the clergy from his troops, who suddenly now abound—bishops, abbots, monks, canons, and priests—and who will take charge of the bodies of the twelve peers. Charlemagne orders the bodies of Roland, Oliver, and Turpin opened before his very eyes so that their hearts may be wrapped in silken shrouds and placed in marble sarcophogi: these, future pilgrims, we could be sure, contain authentic relics.

Despite its trajectory from the crusader's to the pilgrim's spirituality, the *Chanson de Roland* does not end with the burial and veneration of its heroes at Blaye. Its poet attempts, rather, to retrieve the discourse of epic heroism from obsolescence with the Baligant episode, with the judicial duel between Pinabel (who defends Ganelon's cause) and Thierry (who defends Charlemagne's) and with the

31. Suger, *Vie de Louis VI le Gros*, ed. and French trans. Henri Waquet (Paris: Champion, 1929), 284.

trial of Ganelon, which ends in Ganelon's being drawn and quartered. Thus, the second half of the *Roland* is torn between two underlying paradigms: on the one hand, that of a centripetal pilgrim spirituality that aspires to a gathering up of fragments in a resurrected whole; on the other hand, that of a centrifugal political vision announcing the breakup of the empire into unredeemable parts. In my opinion, this centrifugal pull is not countered convincingly in the judicial duel by a Thierry, who is small and skinny, as he fights Pinabel, who is magnificent. Since God protects Thierry, the weaker one wins. Nor are we consoled when thirty of Ganelon's relatives are hanged because they were loyal to him, or when Ganelon's own splendid body is torn apart "with marvelous pain" by four thirty horses—begetting not relics but anathemas. Thus, two diverging paradigms—one spiritual, one political; one centripetal, one centrifugal—subtend the final episodes of the *Roland*.

True, the conversion of the pagan Brammimond and her renaming as "Juliane" points to spiritual modes of conquest that the traditional discourse of feudal heroism is inadequate to accommodate. The legend of this north African saint was pertinent not only to the ethos of the Saracens, but to the Christian pilgrim's cult of her relics in northern Spain.[32] Brammimond, one will recall, was a dutiful pagan wife. The intrusion of an alien female subject into a story of purely male piety centered on relics introduces the potential of a new spiritual paradigm. This paradigm invites male fantasies of the woman's body not as some empire to be cut up, but as a pliable, waxlike entity whose boundaries are vulnerable and changing, but whose penetration can also nurture new fulfillments. Such become the fantasies of that awkward, intriguing epic *Fierabras*, but they do not befit the discourse of this epic, where respite from combat can only be momentary. Rather, their proper habitat will evolve with the discourse of romance. Nor does Gabriel's final visitation at the poem's ending bring good news to a tired warrior-turned-pilgrim: rather, Charlemagne is told that he must set out yet again from Aix, a political and spiritual center, to Imphe, in the infinitely marginal land of Bire:

> Li emperere n'i volsist aler mie:
> "Deus," dist li reis, "si penuse est ma vie!"
> Pluret des oilz, sa barbe blanche tiret.
> Ci falt la geste que Turoldus declinet. [Ll. 3999–4002]

32. *The Song of Roland*, ed. and trans. Gerard J. Brault, 2 vols. (University Park: Pennsylvania State Press, 1978), vol. 1, 335.

The emperor does not wish to set forth.
"Lord," says the king, "how painful is my life!"
He weeps from the eyes, and pulls his white beard.
Here ends the *geste* that Turoldus has set down.

Caught in an epic discourse on the verge of obsolescence because it can proffer no alternative ethics, Charlemagne weeps imperial tears. This is a tragedy not only of a fictional consciousness named Charlemagne, but of traditional poetic discourse in which the yearnings of man as a political and as a spiritual animal can no longer cohere.

MARGOT FASSLER

Representations of Time in
Ordo representacionis Ade

INTRODUCTION

The Gregorian reform movement of the late eleventh and twelfth centuries brought numerous changes to the liturgy of medieval France. Many older, more meditative repertories of texts and music, the tropes, for example, and many sequences, ceased to exist.[1] And, in some northern French cathedral-liturgies, one finds evidence of a new emphasis upon preaching and teaching, and upon arts that could bring an understanding of the major themes of exegetical commentary to the laity and thereby encourage conversion. New arts would address a major dilemma of the age: just as the reformers attempted to rid the clergy of lay influence, to promote celibacy within the priesthood, and the holding of property in common, to build massive rood screens or jubes within churches to separate the liturgical action of the cathedral mass and office from the lay people, so too they wished to become better and more effective pastors.[2] What is the effect of reform, ultimately, if not to save souls? Yet, how could the folk be inspired by a clergy and liturgy increasingly removed from view, pure, distanced, and out-of-sight?

The new cathedral art of twelfth-century northern France—late sequences, conductus, rhymed offices, liturgical dramas, and the new

1. The new liturgical "voice" of the twelfth century is described in Fassler, *Gothic Song: Religious Reform and the Victorine Sequence in Twelfth-Century France*, Chapter 1 (Forthcoming from Cambridge University Press, 1990).

2. The paradoxes of this dilemma can be explored in the writings of several twelfth-century thinkers, including Hugh of St. Victor, Ivo of Chartres, Honorius Augustodunensis and Gerhoch of Reichersberg, all of whom were zealous reformers with interests in religious art.

YFS Special Edition, *Contexts: Style and Values in Medieval Art and Literature,* ed. Daniel Poirion and Nancy Freeman Regalado, © 1991 by Yale University.

97

buildings created to contain these—was often the work of reformers, of men who had agendas for the art works they commissioned. The subjects of twelfth-century liturgical art, particularly when designed for cathedrals, are commonly the Church, what it is, how it works to save souls, and the roles of priests and clergy in its work. This art teaches of the sacraments, baptism, communion, penance, and their importance; of salvation history and the place of each individual within it. It brings the complexities of scriptural exegesis with its three- or fourfold systems of interpretation to life in striking new ways. And it is an art with a view of time, a time wherein all events can be seen at once, placed one on top of the other in layers, lined up, focused, and explained through Christ.[3]

The Anglo-Norman *Ordo representacionis Ade*, perhaps the most famous of all twelfth-century religious plays, illustrates how a learned clerical culture attempted to teach an untutored laity the meanings of Scripture and of salvation history through a particular representation of time and a system of exegesis dependent upon it. Erich Auerbach was the first to claim that the seemingly naive disobedience to historical chronology in the play actually points to a sophisticated view of time and history.[4] But Auerbach did not develop this idea nor show how and why it was important to the larger meanings of the play and its structure. Here I will argue that the elegantly realized discussion of time contained in the play is central to understanding both its use of liturgical source materials and its mode of commentary, and that major problems with the play can be solved by studying it from this vantage point.

Difficulties with the *Ordo* have centered upon three issues: 1.) the use of liturgical sources 2.) the play's unity, and 3.) the place of the play in the history of medieval drama.[5]

3. A similar concept of time, called the "eternal today," is described in Karl F. Morrison, "The Church as Play: Gerhoch of Reichersberg's Call for Reform," in *Popes, Teachers, and Canon Law in the Middle Ages* (Ithaca: Cornell University Press, 1989), 114–44.

4. See his *Mimesis: The Representation of Reality in Western Literature*, trans. Willard R. Trask (Princeton: Princeton University Press, 1953; first printed in Bern: 1946), 157–58.

5. The bibliography concerning the *Ordo* is enormous. A fairly complete overview can be obtained by reference to Lynette Muir, *Liturgy and Drama in the Anglo-Norman Adam* (Medium Aevum Monographs, N.S. 3; Oxford, 1973); this can be updated by the notes in M. F. Vaughan, "The Prophets of the Anglo-Norman 'Adam'," *Traditio* 39 (1983): 81–114 and Steven Justice, "The Authority of Ritual in the *Jeu d'Adam*," *Speculum* 62 (1987): 851–64.

Of these three, the use of liturgical sources, most of which have long been identified, has been the most disturbing, and remains a subject upon which there is still a lack of consensus.[6] Virtually all liturgical dramas of the period were written for a specific liturgical occasion: Easter, Christmas, or a saint's day. Thus, beginning with Maurice Sepet in the nineteenth century, a particular feast or season for the Adam play has been sought.[7] But this play contains enough liturgical borrowings and references to associate it with several different feasts and seasons. The play consists of two major parts, each of which borrows its structure from a liturgical source, and the entire work is followed by what may have constituted a third part, a reading in Old French of the *Fifteen Signs of Judgment*.[8] The models for the two major parts of the play are rooted in different sections of the church year. The first part is a kind of matins service. But instead of consisting of readings punctuated by great responsories, the play consists of scenes in the vernacular functioning as readings, and serving as a kind of gloss upon the sung responsories. The chants themselves, however, are taken from matins services of Septuagesima and Sexagesima Sundays (depending upon which service books one consults), feasts which fall at the opening of the solemn prelenten season.[9] The second part of the play is an *ordo prophetarum*, a dramatic rendering of the popular fifth-century sermon "Vos inquam invenio" written "contra Judaeos, paganos et arianos" to demonstrate that proof for Christian mysteries can be found in Old Testament and even in pagan texts. The sermon itself is proper to Christmastide and all surviving prophets' plays are for this same season.[10] But in this play the prophets' scene has been specially designed to create unique associations with the Annuncia-

6. Sepet's "Christmas theory" has been completely supplanted by the "Lenten theory" advanced by O. B. Hardison in *Christian Rite and Christian Drama in the Middle Ages* (Baltimore: Johns Hopkins University Press, 1965). But scholars still argue about exactly when in Lent the play should have taken place.

7. Sepet's theories are contained in his *Les Prophètes du Christ* (Paris: Didier, 1878). Reprinted from *Bibliothèque de l'École des Chartes* 28 (1867): 1–27, 211–64; 29 (1868): 105–39, 261–93; 38 (1877): 397–443.

8. For discussion of this work see William Heist, *The Fifteen Signs before Doomsday* (East Lansing: Michigan State College Press, 1952). Heist (176) states that other versions in Old French are very much like that found at the close of the Adam play.

9. For a comparison of lists of great responsories from these feasts as found in eleventh- and twelfth-century antiphoners, see René-Jean Hesbert, *Corpus Antiphonalium Officii*, Vol. 1 *Manuscripti "Cursus Romanus"* (Rome, 1963), 70–71.

10. For the text of the sermon and extensive commentary on the plays, see Karl Young, "Ordo prophetarum," *Transactions of the Wisconsin Academy of Sciences, Arts and Letters* 20 (1921): 1–81.

tion and with Old Testament readings of the Easter Vigil Mass as well.[11] Thus the Adam play has strong links to the three most important seasons of the liturgical year: Christmastide, Lent, and Eastertide, and, through its Prophets' play, looks to the Annunciation as well. What sort of play, then, is this?

The author of *Ordo representacionis Ade* uses liturgical sources to create a nonlinear sense of time, an "all time," wherein the beginning, the middle, and the end of human history can be viewed at once. Attempting to implant it within some particular feast or season, then, may well be a futile exercise. Representing time in the fashion found here—as an encapsulated "all time"—is rather a major work of the play. And although the utilization of liturgical sources is the most obvious indication that the usual, linear view of time expressed through the liturgy has been altered, the Scriptural exegesis of the play works to create an "all time" as well. In the exegesis, the historical, allegorical, and tropological levels of meaning are repeatedly expressed in every major scene. But they work here on temporal levels too. The historical level represents Old Testament time, the allegorical level represents New Testament time, and the tropological level is found within present time, as the characters behave within the structures of feudal society, using contemporary language and mannerisms.[12] And the structure of the work as a whole, with its emphasis on themes of judgment and penitence, points to the end of time at the last judgment.

To substantiate this thesis, the play will be approached from two directions: through its use of liturgical sources, and through its scriptural exegesis. It will be seen that the uses of liturgical sources and scriptural sources combine to present a strongly unified view of time, one directly linked to the author's ultimate purpose of inspiring reverence for the church and devotion to its sacraments (Steven Justice, "Ritual," 187). Thus the view of time created by the liturgical sources is directly underscored by the particular exegetical techniques used consistently throughout the play. When these aspects of the play are studied together, it emerges as a powerfully unified work, a work that,

11. See Kenneth Urwin, "The 'Mystère d'Adam': Two Problems," *Modern Language Review* 34 (1939): 71–72 and M. F. Vaughan, "The Prophets," 107–14.

12. Auerbach emphasized the appeal to contemporary audiences in the use of the vernacular and the development of characterization, but he cast this argument within a discussion of "sublimitas" and "humilitas," rather than referring, as I will, to the commonly employed techniques of scriptural exegesis.

although unique in structure, has a well-defined place within the history of twelfth-century religious art.

THE OPENING OF THE PLAY
AND ITS SIGNIFICANCE

The very opening of the play states its view of time and establishes the framework for the entire work. This opening introduces the main characters: Adam and Eve, on the one hand, and Figura and his church, on the other. From the outset, this is a play about the creation as found in Genesis; but it is also a play about Christ and the Church. Adam and Eve are first instructed by the Savior, who is subsequently always called "Figura." He comes and goes always from the church building in front of which the play takes place, and he is always vested in liturgical garments. The opening stage directions make the point:

> Then shall come the Saviour wearing a dalmatic, and Adam and Eve shall take their places before him, Adam wearing a red tunicle, but Eve, white female attire, with a white silk headdress. And they shall both stand before Figura, Adam however nearer, with a calm expression and Eve more humbly.[13]

The savior as "Figura" is, as Robert Kaske pointed out, "essentially a dramatic device through which God the Father, and by implication the triune Godhead, could be presented without loss of theological accuracy under the image of the Son, Who is in turn visible to mortal eyes only as Christ."[14] Thus Figura, dressed throughout the play in clerical vestments, represents the Son, the agent through which all things were made. Because he comes from and returns to the Church constantly, the building itself becomes a second major "Figura," form-

13. The edition of the text used throughout this paper is *Le Jeu d'Adam (Ordo representacionis Ade)* by Willem Noomen (Paris: Editions Champion, 1971). Line numbers are those in the left-hand margins. Translations are taken, with occasional emendations, from Lynette Muir, *Adam: A Twelfth-Century Play translated from the Norman-French* in *Proceedings of the Leeds Philological and Literary Society: Literature and History Section* 13 (1970): 153–204.

14. "The Character 'Figura' in *Le Mystère d'Adam*," in *Mediaeval Studies in Honor of Urban Tigner Holmes, Jr.* (Chapel Hill: 1965), 107. Kaske used as his central proof-text a passage from the twelfth-century exegete Hervé of Bourgdieu: "the image [of God the Father] is placed before the eyes of our mind, in that when we truly strain toward the Father, we behold Him—insofar as we do perceive Him—through His image, that is, through the Son." *PL* 181, 1522–23.

ing the backdrop for all the action. As the dwelling place of Christ, it represents the Holy Jerusalem of future time; but as a physical building with a high priest, it also represents the Church on earth, God's agent for the saving of souls.

The time here, as throughout the entire play, is Old Testament time, time before the Incarnation of the Lord. But this time is ever drawn forward so that each minute is pregnant with the future, making that future present and explaining it. Even from the very beginning, the Old Testament God of Genesis appears in the guise of the Christ to come. It is he who instructs the first humans; and, after they sin, they are ejected from Paradise by the very hand, ironically, that will buy the land back for them. And they are dragged by demons to their only available home after death, the smoking Hell's mouth standing nearby, outside the church.[15]

This opening depicts a stark and simplified view of time. There is God; there is humankind; there is the Church, on earth and in heaven; and there is Hell. Further analysis will show that all time is informed only by these; and that, as Augustine believed, "all time," with its multitude of events, can be discovered in the beginnings of things.

The opening circumstances of the play and their meanings can be used to explain many problems frequently found with the work and to justify its structure. It is outside the church, not because it falls into some Youngian progression from altar to porch to open field, or from ceremony, to liturgical drama, to play, but rather because it is situated in Old Testament time.[16] These characters are outside the Church, even though they encounter Christ as the active agent of the Trinity. Their office resembles that of the actual Divine Office, but it does not have the proper structure, deliberately, to separate it from offices and ordos to come. This is a play put outside the church, so that those who see it will yearn to be inside, just as ultimately, the Old Testament

15. The stage directions describing the Hell's mouth appear just before the Cain and Abel scene of the play. Not only are the devils to speak with loud and jeering voices as they beat upon their pots and kettles, they also are charged to run through the square (1002–17).

16. Karl Young said of the Adam play and other twelfth-century works employing the vernacular, "Transitional pieces of this sort were eventually succeeded by vernacular religious plays of increasing scope, and often of prodigious length." *The Drama of the Medieval Church*, (Oxford: Oxford University Press, 1933), vol. 2, 424. In a passage well-known to students of medieval drama, Hardin Craig said that the Adam play was "caught in the very act of leaving the church." See *English Religious Drama of the Middle Ages* (Oxford: Oxford University Press 1955), 64.

characters themselves will. For the paradise they lose, built alongside the church building, has this building for its earthly counterpart. There are few feasts for Old Testament characters in the Roman rite (Michael the Archangel, the Maccabees, Elijah [in the Carmelite liturgy], among the exceptions) as there are in some Eastern Christian rites. This play creates a service for Adam, a new and different thing, but with a standard twelfth-century purpose.

The opening of the play, its setting, the presence of Figura, the powerful backdrop of the church building and the Hell's mouth, the opening reading and responsories, all these establish the time as "all time." Here are Old Testament figures who are predestined to commit their "felix culpa" and predestined to lend their flesh to God for the coming of Christ. The exegesis contained within the next play clarifies the representation of time even further, and establishes Eve as the prototype of the Virgin Mary. In discussion to follow, I will show how Eve's character becomes central to the play and will offer reasons for the author's emphasis upon her. Three scenes from the first part of the play will be examined: the establishment of Adam and Eve in the Garden, the seduction scene, and the aftermath of the Fall.

IN AND OUT OF THE GARDEN

Figura's first interaction with his creations is based predictably upon Genesis 2:15–17.

> And the Lord God took man, and put him into the paradise of pleasure, to dress it, and to keep it. And he commanded him, saying: Of every tree of paradise thou shalt eat: But of the tree of knowledge of good and evil, thou shalt not eat. For in what day soever thou shalt eat of it, thou shalt die the death.[17]

This short text is expanded in the play through a series of short scenes, each of which is punctuated by a Great Responsory with a text from Genesis. These very long and ornate chants serve, as they would in a Matins service, as points of repose, times to meditate upon the readings and the summary of the readings they provide. In this "ordo," however, the usual relationship between readings and responsories is transformed, the dramatic material in Old French becoming the commentary upon the Scriptural texts of the responsories. The major re-

17. All Biblical quotations are from the standard Douay-Rheims translations of the Vulgate.

sponsibility of the scenes is to advance the Old Testament time of the responsories to New Testament time, present time, and future time.[18]

The Genesis account in the play is not like the Bible story in many key ways, offering, instead of a literal reading, allegorical interpretations borrowed from other scriptural passages (both Old Testament and New) and from exegetical traditions. Figura's description of Paradise and his instructions for living, for example, are long and detailed compared to the original passage from Genesis. And he concentrates upon Eve as well as Adam: in the Bible, she is created only after God gives Adam his instructions. But in the play, she is present to hear the orders. In God's first instructions to Adam and Eve, three subjects are addressed and explained: the relationships both between Adam and Eve, and between Adam and God, and free will.

The greater emphasis is placed upon Eve. She is the subject of Figura's first speech to Adam; she herself is then addressed. And when Figura speaks to Adam he asks that Eve hear too for if she does not she will commit folly (line 166). Eve is to Adam as wife to husband. If she obeys him, according to the laws of marriage, she will dwell "with him in glory" (line 144). Figura emphasizes that both Adam and Eve are to live by the laws of marriage. He is to rule her by his reason, and there is to be no strife between them. She is to be obedient, to serve and love him from her heart and not to go against his laws. Figura states that he has put both good and evil within them so they will not be fettered.[19] Eve is to be the faithful wife; Adam is to be true to his liege lord, Figura. Thus, Adam and Eve have free will to choose good from evil, and the models for their choices are the very relationships binding humans together in twelfth-century feudal society. Right from the beginning, the Old French glosses upon the chant texts have the function of drawing the Old Testament story into the context of the twelfth-century present.

Thus within this opening scene, the Old French action glossing the Old Testament chant texts operates on three levels of time, just as it operates on three exegetical levels. Figura instructs before the Fall with the words he will use after the Fall, in Genesis 3, and these words resonate with Pauline discussions of marriage as well. Even when Fig-

18. The Responsories, given only by brief incipit in the manuscript, are expanded in Noomen's edition.

19. En vostre cors vus met e bien e mal:
Ki ad tel dun n'est pas liëz a pal. (171–72)

ura speaks in Old Testament time, of course, he has full knowledge of events to come. And the author of the play instructs his audience on this view of time by an emphasis on free will. Adam and Eve can still choose freely, even though the results of the temptation are foreknown by God.[20]

In the seduction scene, themes established at the outset remain central: the Devil tries to get Adam to betray his lord, and Eve to betray her husband. Adam's attempted seduction by Satan, not in the Bible at all, is as long as Eve's and creates a balance in the discussion of the two sets of laws introduced in the beginning. Paradise, as Adam thinks of it, is his "chasement" (or "fief") (line 246). Satan calls Adam God's "provender," a vassal provided with a benefice (line 397). And according to Satan, the benefice includes the forbidden fruit. The eating of the apple becomes equivalent to doing Satan's will. At the very end of the scene, Satan gestures to Paradise with his hand and says that Adam will rule and be God's equal if he will but eat. Adam replies: "Fui tei de ci, tu es Sathan!" [Get thee hence, you are Satan!, l. 424]. The scene makes a parallel between the temptation of Adam and the temptation of Jesus in the desert as described in Matt. 4 and Luke 4. Adam is the historical figure, a type of Christ, and a representative of twelfth-century feudal society all at one time, and he moves in three planes of time all at once, Old Testament time, New Testament time, and the twelfth-century present.

Eve's seduction concentrates on getting her to violate the laws of marriage and be unfaithful to her husband. Easy prey to Satan right from the beginning, she counters his attack on Adam's boorishness with the admission that he is "a bit rough" (line 476). The scene is heavily ironic, filled with allusions to Eve as the Mary-to-be and to the fruit as the Christ of the womb. Satan seduces her through flattery, first of her mental powers, but then, immediately of her beauty and her desire for power. Central to his seduction is the promise that she will be queen of all the world, above and below (lines 529–30), and wear the

20. Hugh of St. Victor (*De Sacramentis Fidei Christianae*, I, vi, 15) provides a twelfth-century explanation of foreknowledge and free will. Adam and Eve cannot know the precise consequences of sin, otherwise they would not be free. "On this account, therefore, it is judged more proper that the first man, indeed, had received knowledge and precept regarding those things which he had to do, but of those which were to be he had not foreknowledge, so that his will remained free for either choice." (Translation from Roy Deferrari, *Hugh of St. Victor on the Sacraments of the Christian Faith* [Cambridge, Mass., 1951], 104.)

"crown of Heaven" (line 547).[21] She is "fresher than a rose; more white than crystal, than snow which falls a brilliant ice to the ground" (lines 488–90).[22] His description of her anticipates Mary as the Queen of heaven and refers, although more obliquely, to the white roses and lilies of popular Marian imagery (perhaps glancing sidelong at the Song of Songs as well). But this rose of Sharon has the wrong lover, and because Satan seduces her at last into doing his will by promising the crown of heaven, he, too, is fooled, on the spot. Eve is both the type of Mary and initiator of the lineage of Christ. Satan knows not of what he speaks: that Eve *will* have the honors he has described, indeed, but bought at the greatest price. And yet this Eve is not only a Mary-to-be, she is also a simple twelfth-century woman about to betray her husband.

The heavily moralistic message of this scene is more powerful than a finger-wagging sermon could be. The Old French scenes would reverberate through the minds of the audience as the long, ornate chant with its text from Genesis was sung. And the people, who may have known Genesis only sketchily, have had it explained in context. Through the play's dialogue, Eve is situated both within Old Testament and New Testament time. Yet in the present, she betrays us all. The fruit she eats, described unwittingly by Satan as having "a gift of life" (line 520), will need to be remade within her very flesh.

In the aftermath of the fall, both Adam and Eve, having eaten of the fruit, know instantly the consequences of their sin.[23] Even before Figura seeks him, Adam has removed his solemn vestments, knowing, as in the Bible, that he is doomed. But this Adam has a foreknowledge of future events that his Old Testament counterpart does not, saying only "the son who is born of Mary" (line 720) will be able to save him. Yet, in spite of understanding that Christ will come, he speaks primarily of death and raises his fist against Eve, cursing her and blaming her

21. This image of a heavenly crown also refers to Apocalypse 12:1. Genesis and Apocalypse depict the two great struggles between womankind and Satan, the one at the beginning and the other at the end of time.

22. This striking image refers to Ezekiel 28:13–16. Here God described the fall of the King of Tyre, a type of the Fall of Satan. This king is bedecked in crystalline jewels and can walk amid red-hot coals. But, because of his pride, he is thrown down to a fiery death. The cold beauty of the jewel is an ironic description in the mouth of the prince of Hell.

23. According to Hugh of St. Victor (*De Sacramentis*, I, vii, 10), although both were equally to blame, Adam's sin was less than Eve's because he sinned "only lest by resisting her will and petition he might offend the heart of the woman who had been associated with him through the affection of love . . . " (See Deferrari, 125). The touching scene of Adam's fall in the *Ordo* clearly follows a similar interpretation.

throughout the scene. It is she who has sinned, "and he will be late in coming who will change it" (line 968). Adam, now no longer the trustworthy and appealing fiefholder of the opening scene, is angry in his loss, and directs the blame more to his wife than to himself. Adam thinks about how his sin will be recorded in history, how time will judge him: "Li mien pecchie' iert en estoire escrit!" (line 941). He is a cuckholded husband, smarting with the pain of personal loss.

Eve, however, becomes even more the image of Mary, but in a far more compelling way than before. Here, she is not a tarnished mirror of Mary's queenship as in the earlier scene, but rather a reflection of the humility that will make salvation possible. Adam is without hope; Eve has it. Adam's final curse, the last words we hear him speak, is powerfully counterbalanced by Eve's ending statement: " . . . nonetheless in God is all my hope, for this our fault will one day be redeemed. God will restore me to his grace and sight, and by his power free us from dark night." Now a good mother, Eve worries too, earlier in this speech, about the people who will come after and their sufferings rather than about her own reputation in time-to-come. Both Adam and Eve are deeply concerned with the future and both know, having eaten of the fruit, the consequences of their actions, the differences between good and evil, and the single purpose of unfolding time.

CAIN, ABEL, AND THE PROPHETS

Eve's inspired lament before being taken to hell leads masterfully to the final scene in the long first section of the play. Eve is gone, yet now we witness the sufferings of her son, Abel, interpreted throughout the Middle Ages as the first martyr. Eve was the Mary who wept for Christ, and Abel is her son. Critics who have seen no reference to Christ's passion in this play have clearly misread this scene, for here Abel becomes both the lamb and the high priest, offering the only acceptable and pleasing sacrifice to God. That Abel is meant to represent both Christ the victim and Christ the priest can be demonstrated by comparing the play to its scriptural source. In Genesis, Cain offers "of the fruits of the earth" and Abel "of the firstlings of his flock." Just after accepting Abel's sacrifice and rejecting Cain's, God comes to counsel the older brother: "Why art thou angry? and why is thy countenance fallen?" He says, "If thou do well, shalt thou not receive? but if ill, shall not sin forthwith be present at the door?" (Genesis 4:7).

In the play, both the sacrifice and the counselling have been altered

to create a new emphasis. In the first place, it is Abel who counsels Cain at the beginning of the scene, taking up the function of God in the Bible. Cain recognizes Abel as a preacher, and speaks sneeringly of his doctrine. During the sacrifice, Abel offers his first fruit with incense, creating a liturgical parallel to the offering of the host during the communion service, and a picture of the sacrifice unique to medieval plays.[24] Abel is Christ, but he is also the clergy who preach and offer sacrifices in His place within the church. Cain, however, resembles an unbelieving French peasant who kills Christ again through his unbelief and dooms himself as well. Once again, a strong moral has been presented in this Old French gloss to the text of the Great Responsory, and its ultimate purpose is to defend the importance of the Church and its sacraments in the history of human salvation.

Cain and Abel also exist on three planes of time, Old Testament time, New Testament time, and present time, when they are arguing brothers. This scene is not only carefully linked to the action before it, it also anticipates the Prophets' play to follow. Adam has remembered how long it will take for Christ to come; Eve has trembled for her lineage in the time to come; and now Cain and Abel have set in motion the long struggle between those who will believe in Christ to come and those who will not. The author of this play was well aware of descriptions of Abel in the New Testament: he is twice interpreted as the first of a long line of upright persons in the Old Testament, both in Matt. 23 and in Luke 11.

Because the emphasis in these synoptic passages rests on unbelief, Abel forms an excellent introduction to the *ordo prophetarum*, which has unbelief as a major theme. But, as M. F. Vaughn has pointed out, and as others have recognized as well, the prophets of the Adam play defy the conventional order and selection of texts established by the sermon and the tradition it engendered.[25] Indeed, this is a very different prophet's play, one designed to emphasize the lineage of Mary and to foretell the Annunciation and conception of Christ, the central event in the history of time.

These prophets, through their position after the Creation scenes and with their emphasis upon the Annunciation, form a literary picture of the Jesse tree, similar to those found in twelfth- and thirteenth-

24. See Hebrews 11:4 for a view of Abel as faithful and upright and therefore pleasing to God.

25. A useful comparative table of the several prophets' plays and their scriptural sources is found in Lynette Muir, *Liturgy and Drama.*

century annunciation portals—at Poitiers, for example, and Laon.[26] In fact, the idea that the play was presented in front of such a door is not a far-fetched one. The prophets, too, work on three levels of time. They are Old Testament characters, but of a certain sort, the only ones who will be taken to Paradise, along with Adam, Eve, and Abel at the Harrowing of Hell. Thus, they point to what will essentially be the first judgment of humankind: the saving of Old Testament believers from the pains of Hell. But they also represent the lineage of Mary. The unique arrangement of the Adam *ordo* emphasizes family connections, especially within the house of Judea: Abraham mentions Isaac, his son; Moses and Aaron are brothers; David and Solomon are father and son.

And the prophecies, found only in this play, have been chosen to emphasize Annunciation themes by referring to the canticle of Mary, the Magnificat, Luke 1: 46–55, the liturgical text most powerfully and fully associated with Mary, and sung in the Office at Vespers services throughout the church year. Although the prophets' play has been much-discussed here, its dependence upon the Magnificat has not been realized before. Abraham's opening prophecy, found only in the Adam play, is extracted from Genesis 22:17–18: "Your seed will possess the gates of their enemies and through your children will all peoples be blessed." This text refers to the Annunciation[27] as readily as it does to the prophecies of the Holy Saturday Vigil, where it is one of the twelve texts read.

Solomon is also unique to the Adam play, and he speaks words from the Wisdom of Solomon (6:5–7) for his prophecy:

> Because being ministers of his kingdom, you have not judged rightly, nor kept the law of justice, nor walked according to the will of God. Horribly and speedily will he appear to you: for a most severe judgment shall be for them that bear rule. For him that is little, mercy is granted: but the mighty shall be mightily tormented.

These words also parallel part of the Magnificat, in both phrasing and meaning: "He hath shewed might in his arm: he hath scattered the proud in the conceit of their heart. He hath put down the mighty from their seat, and hath exalted the humble."

Both David and Jeremiah appear in other prophets' plays, but in the

26. M. F. Vaughn has described the connections between iconography of the Jesse tree and the Adam play in "Adam," 90–98.

27. Luke 1:55, "As he spoke to our fathers, to Abraham and to his seed for ever."

Adam play they speak different prophecies. David's words (here Psalm 85:12–13, rather than Psalm 71:11, as found in the Sermon and other Ordines) provide imagery reminiscent of Christ's conception, with an emphasis upon fruit imagery which is extended in the Old French gloss.[28] And in the gloss, the fruit of the womb becomes the communion bread as well. An antiphon for the Second Vespers of the Annunciation also refers to the promise of David contained in the Adam play.[29]

Jeremiah's prophecy (here Jeremiah 7:2–3, instead of Baruch 3:36–38, as found in the Sermon and other ordines) focuses on the lineage of Judea: "Hear the word of the Lord," he announces in Latin, "all ye of Judah that enter in at these gates to worship the Lord." For the medieval audience watching the play, this charge from Jeremiah must have been a highly dramatic moment, for at this point in the play, the stage directions read that the prophet is to point to the doors of the church ("et manu monstrabit portas ecclesie") (line 1466). He then glosses his prophecy in Old French, speaking to his twelfth-century audience as if they were Jews in Old Testament time: "Hear, . . . great lineage of Judah," and asking if they seek "to pass this gateway and go into our Lord to worship." Jeremiah draws the audience into his Old Testament world, yet points tenderly to their own estate when he charges these would-be worshippers to "Prepare ye, and make good the paths; let them be straight as furrows." Of course he quotes Isaiah 40:3 (who is the prophet to follow him in the ordo) here, but he also looks ahead to John the Baptist who offered this same cry as a call to repentance in all the Gospels. And, to make sure the New Testament context is not missed ("Do penance: for the kingdom of the heaven is at hand" Matt. 3:3), Jeremiah charges his people "to let all your hearts be cleansed . . . to let your intentions be all good and no evil-doing in you." He then offers promise of the Harrowing of Hell and the Christ to be offered for ransom.

Thus the prophets speak in Old Testament time, but with a strong anagogical emphasis on time to come. But their time to come is the New Testament Annunciation, the coming of Christ, and His Resurrection. They push the time of the play ever forward, toward the mo-

28. David's gloss: "From the earth will come forth fruit and justice, too, and majesty; God will pour out blessing on us. Our earth will bring forth her corn, of its grain will come the bread which will save the sons of Eve. . . . "

29. Other connections made in the Middle Ages between this text and the Annunciation are cited in M. F. Vaughan, "Adam," 105, n.51.

ment of their own salvation at the Harrowing, and thus toward the time of the second salvation of the rest of humankind as well at the last judgment.[30] They are the long line, described by Honorius Augustodunensis, that began with Adam and Eve and has Christ for a hook at the end, to spoil the jaws of the Devil (Cf. *Speculum ecclesiae,* PL 172, col. 937). But this final victory does not take place in Old Testament time, or in New Testament time. It is yet to come. And it may well be represented in the play by the reading of the *Fifteen Signs of Judgment.*

CONCLUSION

The play of Adam represents all time, both in its use of liturgical sources and in its exegesis. It challenges its audience members to position themselves within this time, to be ready for the inevitable judgment that they were created to face. Another crucial difference between the prophets' play of the Adam and others of its type is that it ends with the prophecy of Nebuchadnezzar. It is he who forms the link between the prophets' play and the final reading of the *Fifteen Signs of Judgment.* His description of the three boys in the fiery furnace is not only the last reading in the Easter Vigil service prophecies, but it also contains the imagery appropriate to discussion of last things and the hell of the final judgment. But within his words, as within the desolation of the entire play, one always finds the fourth man who looks like the Son of God.

Although there are carefully drawn references to several feasts and seasons, the play actually focuses upon the numerous parallels believed to exist in time between the creation, the expulsion from the garden, the Annunciation, the death, and resurrection of Christ, and the end of time. There was, in fact, a great body of medieval myths related to this cosmic lining up of the most important events of time. Not only did they all occur in the same recycled moment, but they were also interconnected by the lineage of Mary, of the house of David, the lineage forming the Jesse tree. The twelfth-century commentator Honorius Augustodunensis described this view of time in his sermon for the Annunciation (as well as in his brief treatise on the six days of creation, "Hexameron"):

30. The idea of the two salvations was suggested to me by Professor Charles D. Wright.

> It is said that on the same day and in the same hour that the first man was formed in paradise, the Son of God, who is the new man, was conceived in the womb of the Virgin. . . . It has also been said that the hour which Adam ate of the forbidden fruit is the same in which Christ, suspended from the cross, drank vinegar mixed with gall; and that hour in which God expelled men from Paradise, is that in which Christ led the thief with him into paradise. [*Speculum ecclesiae*, "In Annunciatione Sanctae Mariae, PL, 172, cols. 902–03]

Such an understanding of time finds room even in liturgical calendars, with their ongoing successions of feasts and their linear view of time. An early thirteenth-century Parisian calendar, for example, states on the feast of the Annunciation, 25 March, "Christ was crucified and Adam was formed."[31] And this view of time is complemented by the ancient Christian belief, so well expressed by Augustine in his Vigil sermons, that Christ will come again on Easter night, that the night of the harrowing and the night of the second coming will line up in parallel across what are to humans long stretches of time, and to God, an instant.

The break between the Old Testament time of the prophets and the future time of the *Fifteen Signs of Judgment* seems abrupt and unconnected to the main body of the play. But if the *Fifteen Signs* was actually intended as some sort of closing gesture for the play, it now seems to form a consistent and appropriate end.[32] By positioning the Last Judgment here, the compiler of this part of the manuscript may have completed a statement about time with the Second Coming, the true end of time. Thus the beginning and the end are present, and the play, through its scriptural exegesis and liturgical sources, recreates the major events falling between these points. All events, those of the past, those happening in the present, and those of the future, are discovered within the first four chapters of Genesis and the words and glosses of Old Testament prophets. The liturgical sources work to undermine a simple, linear sense of time, and the exegesis demonstrates how all time has but one meaning, one singular purpose, the redemption of

31. See March in the calendar of Paris, BN lat. 14605, fol. 262r. The calendar was prepared for the Abbey of St. Victor in the late twelfth century.

32. Disagreement remains about the relationship between the *Fifteen Signs* and the *Ordo* immediately before it. The sole surviving copy of the Adam play is in Tours 927, (which also contains the famous [but defective] Tours Easter play), a manuscript ripe for paleographical and codicological study. Although the manuscript contains a variety of hands, the same or very similar hands seem to have copied both the *Ordo* and the *Fifteen Signs*.

humankind from the powers of sin. Thus the carefully wrought representation of time underlying the entire work makes the play capable of standing on its own. It now seems less important to create a new ending for it, or to force it into being the first of some sort of incipient cycle play.

This reading of *Ordo representacionis Ade* offers new evidence for understanding the development of twelfth-century religious art. The play's emphasis on the Virgin Mary stems from an interest in the connection between the human and the divine, a connection she was believed to have experienced more intimately than any other mortal. She is the best representative of a morally perfect human, and her popularity with religious reformers, in part, depends on this. Yet she is, of course, fully and solely human, and therefore an apt representative of our condition.

More importantly, the play demonstrates how the vernacular could function within a religious art based upon well-established exegetical and liturgical traditions. In the *Ordo* the vernacular operates on the tropological or moral level of exegesis and it relates to the depiction of present time. The chant, the intoned Latin readings, Figura and his Church, resonate with the musical sounds of eternity; Adam, Eve, and their children speak in the vernacular, and thereby interweave their cosmic actions with the fabric of daily life.

SANDRA HINDMAN

King Arthur, His Knights, and the French Aristocracy in Picardy

> And all those who travel the road can still see the story there, sealed
> in parchment.
>
> —Manessier, Continuation of *Le Conte du graal (Perceval)*[1]

Manessier's concluding verses to the last continuation of Chrétien de Troyes' *Perceval* serve as a metaphor for a study of the reception of Chrétien's romances through an analysis of the actual manuscripts. In breaking open the seal in order to "see the story" of some of Chrétien's romances, my interpretation relies on the illuminated copies.

Notwithstanding their continued scrutiny by literary historians, manuscripts of Chrétien's romances have been virtually ignored by art historians, who have commented primarily on their paucity of illustration.[2] My reexamination of this material suggests that such published accounts are misleading. Ten of the thirty-two extant manuscripts of Chrétien's include illustrations, even if these sometimes take only the modest form of historiated initials.[3] The largely incorrect view that

1. W. Roach, ed., *The Continuations of the Old French 'Perceval' of Chrétien de Troyes,* vol. 5, *The Third Continuation by Manessier* (Philadelphia: The American Philosophical Society, 1983), 343, ll. 42666–68: "Encor le puet on veoir la, / Tot seellé en parchemin, / Cil qui errent par le chemin."

2. The standard work remains that of Roger Sherman and Laura Hibbard Loomis, *Arthurian Legends in Medieval Art* (London: Oxford University Press/New York: MLA, 1938). See also, especially on the prose romances, Alison Stones, "Secular Manuscript Illumination in France," in *Medieval Manuscripts and Textual Criticism,* ed. Christopher Kleinhenz (Chapel Hill: University of North Carolina Press, 1976), 83–102; idem, "Sacred and Profance Art: Secular and Liturgical Book-Illumination in the Thirteenth Century," in *The Epic in Medieval Society: Aesthetic and Moral Values,* ed. Harald Scholler (Tübingen: Max Niemeyer, 1977), 100–12; and idem, "The Illustration of the French Prose Lancelot in Belgium, Flanders and Paris, 1250–1340," (unpublished Ph.D. dissertation, University of London, 1970–71).

3. For an overview of the manuscript tradition, including notes about the illustration, see Alexandre Micha, *La Tradition manuscrite des romans de Chrétien de Troyes* (Paris: Champion, 1939; Geneva: Librairie Droz, 1966). Terry Nixon has expanded

YFS Special Edition, *Contexts: Style and Values in Medieval Art and Literature,* ed. Daniel Poirion and Nancy Freeman Regalado, © 1991 by Yale University.

Chrétien's romances are sparsely illustrated comes, I suspect, from their comparison with the contemporary tradition of prose romance, such as the prose Lancelot cycle, of which many de luxe manuscripts, some with hundreds of miniatures, were made over three centuries.[4] Yet, comparison of manuscripts of Chrétien's romances with those of other verse romances—*Athis et Prophilias, Flore et Blancheflor, Claris et Laris,* as well as the entire group of the so-called *romans réalistes,* the romances by Gautier d'Arras, and the lais of Marie de France, to name only a few examples—reveals that Chrétien's manuscripts were much more frequently illustrated. Most thirteenth-century manuscripts of verse romances, apart from those by Chrétien, are entirely devoid of illustration.[5] The question may thus be asked: how do the illustrations of the manuscripts inform us about the reception of the text?[6]

This study of the reception of Chrétien's romances takes as its point of departure an analysis of the manuscripts, the material forms of which tell us something about the audience: where and when they lived, who they were, and how they read. "Where and when" are easily addressed. Because the majority of the manuscripts are written in the Picard dialect, we can assume they were read in Picardy, even though we cannot identify with certainty the original owners of any of the manuscripts. It is striking that no manuscripts were made for the royal court. Although none of the manuscripts is precisely dated, it is nevertheless possible, on the basis of script, decoration, and illumination, to

Micha's list of 31 manuscripts and 9 fragments to 43 manuscript and fragments. Among these, illustrated manuscripts include: Paris, Bibliothèque Nationale, MSS fr. 794, 1376, 1433, 1453, 12576, 12577, 24403; Montpellier, Bibliothèque de la Faculté de Médecine, MS H. 249; Mons, Bibliothèque Municipale, MS 331/206; Princeton, New Jersey, University Library, Garrett MS 125. See also Keith Busby, "The Illustrated Manuscripts of Chrétien's *Perceval,*" *Zeitschrift für französische Sprache und Literatur* IIC-98 (1988): 41–52.

4. Many of these manuscripts were also made for families in northern France and Flanders; see Stones, "Secular Manuscript Illumination," 84–85. For a useful list of the dates and localization of the illustrated manuscripts of the *Mort Artu,* see Alison Stones, "Aspects of Arthur's Death in Medieval Illumination," in *The Passing of Arthur. New Essays in Arthurian Tradition,* ed. Christopher Baswell and William Sharpe (New York/London: Garland Publishing, Inc., 1988), 52–101. Hereafter cited in text.

5. Benoît de Sainte-Maur's *Roman de Troie* is an exception, since a number of thirteenth-century copies are illuminated (e.g., Paris, Bibliothèque Nationale, MSS fr. 783).

6. On the reception of Chrétien's manuscripts, see Beate Schmolke-Hasselmann, *Der arthurische Versroman von Chrestien bis Froissart,* Beihefte zur Zeitschrift für romanische Philologie, Bd. 177 (Tübingen: Max Niemeyer, 1980).

date most of them in the second half of the thirteenth century. "Who and how" are more problematic. Since most of the manuscripts are on stiff, often mended, and sometimes ill-prepared parchment, which has become well-thumbed, soiled, and rubbed over time, we might at first assume they were made for a low-end audience. However, their lavish illustration with azure and gold, which were the most costly materials, provides assurance of an aristocratic readership. Readers of thirteenth-century verse romance read the stories often in large compilations. These observations on the manuscripts point to their manufacture and use in a predominantly oral culture in a milieu where books were relatively uncommon. It would seem thus that we are confronting an aristocratic audience in a provincial area.

To understand how the manuscripts functioned in Picard society we need to determine what they could have meant for their thirteenth-century readers. My thesis concerning the function of illustrated verse romance is developed along two lines. First, I believe that illustrated romance attempts to shore up the image of a regional feudal society, whose identity is threatened by the encroachment of the centralized Capetian monarchy. In this respect, my argument develops directly from the thesis presented by Köhler and refined by Bloch and Boutet.[7] None of these individuals, however, tested the thesis in the Picard context, nor did they consider the illustrated romances. Second, I believe that illustrated romance responds to social and political needs specific to the Picard nobility in the latter half of the thirteenth century, when they confronted a crisis of considerable magnitude, which shook the very fabric of aristocratic culture.[8] In developing my argument, I will consider briefly two examples, manuscripts of *Yvain* and *Perceval* that both date from the latter half of the thirteenth century and are both localized in Picardy (Paris, Bibliothèque Nationale, MSS fr. 1433 and 12576). These two examples present for their readers alter-

7. Erich Köhler, *L'Aventure chevaleresque. Idéal et réalité dans le roman courtois* (Paris: Editions Gallimard, 1974); R. Howard Bloch, *Medieval French Literature and Law* (Berkeley: University of California Press, 1977), especially 228ff., where he argues that the focus on the individual in romance fosters an ethic that plays into the hands of the central monarchy intent on undercutting the power of the nobility as a self-conscious group; and Dominique Boutet, "Carrefours idéologiques de la royauté arthurienne," *Cahiers de civilisation médiévale* 23 (1985): 3–17.

8. On the geographic delimitations of Picardy, which is not an administrative unit in period, see R. Fossier, *La Terre et les Hommes en Picardie jusqu'à la fin du XIII siècle*, 2 vols. (Paris: Beatrice-Nauwelaerts, 1968), especially 11–13, 103–07. Hereafter cited in text.

native agendas for dealing with certain dilemmas internal to the feudal system.

The first example includes eleven miniatures for *Yvain* and five miniatures for the *Atre perilleux* or "The Perilous Cemetery," the anonymous Arthurian romance with which it is bound.[9] In *Yvain*, Chrétien recounts the story of an Arthurian knight, Yvain who, challenged by his cousin Calogrenant's account of a disastrous visit to a magical storm-producing fountain, attempts to slay the defender of the fountain, Esclados the Red. Yvain mortally wounds Esclados, whom he pursues to his castle. Thanks to the match-making of a lady-in-waiting, Lunette, Yvain eventually marries Esclados's grieving widow, Laudine, in a lavish ceremony. Following a celebration of the marriage, Yvain requests permission from his new wife to go off on tournaments, and she acquiesces on the condition that he return in a year. But Yvain forgets himself, a year passes, and Lunette comes to reclaim her lady's ring and to inform him that he has lost her love. Grief-stricken, insane, and amnesiac, Yvain loses himself in the forest, and recovers, thanks only to the ministrations of a hermit and a lady. Upon recovery, he saves a lion from an attacking serpent, assumes a new identity, "the knight with the lion," and sets off on a series of quests, rescuing ladies in need. He slays the giant, Harpin of the Mountain, rescues falsely accused Lunette from being burned alive, and in the so-called Pesme or "evil" Adventure frees three hundred maidens destined to a lifetime of servitude weaving golden textiles. Returning to the court of Arthur, he fights with Gawain, and his true identity is at last revealed. He only then seeks and gains reconciliation with his wife, Laudine.

In a sequence of well-placed miniatures that break the text at appropriate junctures, we can follow the main events of the narrative as I have just outlined them: Calogrenant's battle with Esclados at the fountain (Fig. 1); in a three-part miniature, Yvain's battle with Esclados

9. On Paris, Bibliothèque Nationale, MS fr. 1433, see Loomis, *Arthurian Legends*, 100–101; Micha, *La Tradition manuscrite*, 44; W. Foerster, *Der Lowenritter (Yvain)*, in *Samtliche erhaltene Werke* (Halle: 1887), vii; P. Jonin, *Prolégomènes à une édition d'Yvain*, Publication des Annales de la Faculté des Lettres, Aix-en-Provence, Nouvelle serie., no. 19 (Aix-en-Provence: 1958), 15; J. Porcher, comp., *Les Manuscrits à peintures en France du XIIIe au XVIe siècles* (Paris: Bibliothèque Nationale, 1955), 29; and B. Woledge, *Commentaire sur Yvain (Le Chevalier au lion) de Chrétien de Troyes*, 2 vols., PRF, 170–71 (Geneva: Librairie Droz, 1986), vol. 1, 4. With the exception of Porcher, who based his analysis on the illustrations, all scholars localize the manuscript in Picardy on the basis of its dialect. I thank Alison Stones for informing me that she believes the manuscript might be localized in Tournai.

2. Yvain Battles Esclados, Yvain Conspires with Lunette, Funeral of Esclados the Red, *Yvain*, Paris, Bibliothèque Nationale, MS fr. 1433, fol. 69v.

1. Calogrenant Battles Esclados the Red at the Magical Fountain, *Yvain*, Paris, Bibliothèque Nationale, MS fr. 1433, fol. 65.

3. Funeral of Esclados, *Yvain*, Paris, Bibliothèque Nationale, MS fr. 1433, fol. 72v.

4. Tournaments at Arthur's Court, *Yvain*, Paris, Bibliothèque Nationale, MS fr. 1433, fol. 80v.

5. Lunette Claims the Ring from Yvain, Yvain's Lovesickness, Yvain's Cure, and Yvain Rescues the Lion, *Yvain*, Paris, Bibliothèque Nationale, MS fr. 1433, fol. 85.

6. Lunette in Prison, Yvain Battles the Giant, Yvain Rescues Lunette, *Yvain*, Paris, Bibliothèque Nationale, MS fr. 1433, fol. 90.

7. The *Pesme* Adventure, Yvain Battles Two Sons of the Devil, Yvain Fights Gawain at Arthur's Court, *Yvain*, Paris, Bibliothèque Nationale, MS fr. 1433, fol. 104.

8. Reconciliation of Yvain and Laudine, *Yvain*, Paris, Bibliothèque Nationale, MS fr. 1433, fol. 118.

and his entry into the castle, Lunette's conspiracy with him, and the funeral of Esclados (Figs. 2 and 3); the tournaments after the marriage (Fig. 4); in a four-part miniature, Lunette's return of the ring, Yvain's madness, his cure, and his rescue of the lion (Fig. 5); in two four-part miniatures the various quests, Harpin, Lunette, the Pesme Adventure, and the revelation of Yvain's identity at Arthur's court (Figs. 6 and 7). A final sequence of four scenes in one miniature depicts the reconciliation (Fig. 8). These miniatures are unproblematic: they echo the text closely, and they do not lead us to reinterpret it in any significant way.

I am most concerned with the cycle of illustrations as it functions in three other ways: when it includes miniatures of episodes we would *not* expect to find depicted; when it does not include miniature of episodes we *would* expect to find and which seem, therefore, conspicuously absent; and when it includes a subject for a miniature that either overturns an earlier convention or implies a clear process of invention in creating a new convention.

An example of a miniature we would not expect to find is the second large miniature in the cycle, of Yvain, who on his way to challenge Esclados the Red stands before a vavassor and his beautiful daughter, whom he asks for lodging. We know from medieval literature, including other romances by Chrétien, that the vavassor is a vassal who is usually aged, poor, and of the lesser nobility; a good host, he is always ready to welcome and lodge the wandering knight.[10] The event, taking up only sixteen lines of verse in *Yvain*, permits Chrétien to pause and comment on "the sum of all the qualities you find in men and women good and kind."[11]

Related examples are the miniatures of the funeral of Esclados the Red (Figs. 2 and 3). It is surprising to find the funeral illustrated twice, when other episodes that seem equally important in the unfolding of the narrative, like the marriage of Yvain and Laudine, are conspicuously absent. As in the case of the miniature of Yvain and the vavassor, the funeral fills the entire space of a large picture instead of "sharing" its space with another episode on an adjoining register. Be-

10. B. Woledge, "Bons vavasseurs et mauvais sénéchaux," in *Mélanges Rita Lejeune*, 2 vols. (Gembloux: Editions J. Duculot, 1969), 2, 1263–1277. In royal fief-lists, the vavassor appears at the very base of the feudal hierarchy; see John Baldwin, *The Government of Philip Augustus. Foundations of French Royal Power in the Middle Ages* (Berkeley: University of California Press, 1986).

11. Chrétien de Troyes, *Le Chevalier au lion (Yvain)*, ed. Mario Roques, CFMA, 89 (Paris: Champion, 1982), 24–25, ll. 785–87: "qu'an ne puet pas dire la some / de prode fame et de prodome, / des qu'il s'atorne, a grant bonté."

9. Knight on Horseback, *Yvain*, Paris,
Bibliothèque Nationale, MS fr. 1433,
fol. 61.

10. Knight on Horseback, *Chevalier des
deux épées*, Paris, Bibliothèque
Nationale, MS fr. 12603, fol. 1.

tween the funeral and the tournaments at Arthur's court (Fig. 4), the marriage is, we might say, suppressed.

An example of a miniature that establishes a new convention is the small illumination of a knight on horseback that introduces the first words of the romance (Fig. 9). Similar miniatures, often as historiated initials, preface many Arthurian romances, for example in the *Chevalier des deux épées*, so we can conclude that, at some point, this subject came to signify this type of romance (Fig. 10). The presence of these miniatures at first was puzzling, not so much because their subject is jarring but because other solutions to the opening of the romances were so clearly possible and must have been rejected. In earlier manuscripts of the *chansons de gestes* or in contemporary copies of the *Fables* of Marie de France, a singing jongleur or a writing scribe—both types of author portraits—open the text. But no Arthurian romance adopts this convention. Nor is the type of opening used in the "Guiot" manuscript for *Lancelot* ever repeated: Marie de Champagne tells the story of Lancelot to Chrétien, giving visual form to a literary topos that is frequent in verse romance, the poet taking his inspiration from a lady (Fig. 11). Even where such a pictorial convention is appropriate, in the *Atre perilleux* in our manuscript, for example, where the opening lines evoke the same topos of a lady who "or-

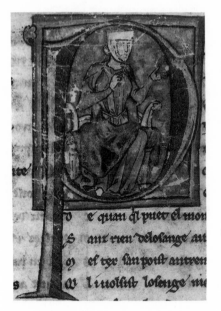

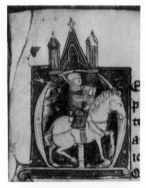

12. Knight on Horseback, *L'Atre péril-
leux,* Paris, Bibliothèque Nationale, MS
fr. 1433, fol. 1.

11. Marie de Champagne, *Lancelot,* in
the "Guiot" Copy of the Collected Ro-
mances, Paris, Bibliothèque Nationale,
MS fr. 794, fol.

dered and begged me to recount the story,"[12] the image of a knight on
horseback recurs (Fig. 12). It is obvious that other solutions might also
have been used and were not: for example, two knights in combat or a
lady and a knight.

The distinctive features I have described in the illustrations of
Yvain can be explained in part by certain changes that took place
within the feudal system as analysed by Georges Duby.[13] By around
1100 the approved pattern of inheritance for the aristocracy favored
primogeniture, with the result that there was a problem of how to take
care of the younger sons. Since it was not desirable to fragment the
family's wealth by cutting off even small pieces of the patrimony,

12. *L'Atre périlleux,* ed. B. Woledge, CFMA 76 (Paris: Champion, 1936), l. 11, i.

13. See especially Georges Duby, "Les 'jeunes' dans la société aristocratique dans la
France du Nord-Ouest au XIIe siècle," and "Remarques sur la litérature généalogique en
France au XIe et XIIe siècles," in *Hommes et structures du moyen age,* (Paris: 1973), 213–
25, 287–98; and idem, "The Transformation of the Aristocracy in France at the Begin-
ning of the Thirteenth Century" and "The Diffusion of Cultural Patterns in Feudal
Society," in *The Chivalrous Society,* trans. C. Postam (Berkeley/Los Angeles: University
of California Press, 1977), 171–85.

the younger sons (called *juvenes* or "youths" in the Latin literature of the period) had nothing to offer in a marriage. So, they frequently remained bachelors and became wandering knights, participating in tournaments, going on crusades, seeking their living as they roamed aimlessly about the countryside. During their adventures, they might hope to meet an eligible woman, either a widow with her own lands and money or a vavassor's daughter, wealthy though not herself an aristocrat.

Several other changes around 1200 profoundly altered further the character of noble society in Picardy. The old distinction between the lord (*dominus*) and the knight (*miles*) blurred, as the two groups came to form a single juridical *ordo* with common customs, including primogeniture.[14] At the same time, in some parts of Picardy and Artois, the smallest portion of the patrimony—as little as one-fifth as opposed to one-third elsewhere in France—was reserved for the younger sons and the daughters.[15] Setting aside the implications of these statistics for Picard women, its implications for the younger sons are clear. The resulting dramatic increase in the number of these "youths" or bachelors particularly in Picardy in the thirteenth century created an unstable, violent fringe group within the society, a group who robbed, raped, and plundered.

With this background in mind, we can now understand the sequence of miniatures in *Yvain* as advocating a social agenda for the youths. Wandering about the countryside engaged in adventure, Yvain, as well as the other knights of the round table, is a bachelor or a youth. When Yvain encounters the vavassor, if he behaves himself and addresses him courteously, he might hope for the hand of his beautiful, wealthy daughter (Fig. 13). Erec in *Erec and Enide* does marry a vavassor's daughter. In marrying a widow with a landed fortune, Yvain fulfills one of the fantasies of all youths. The importance the funeral assumes in the cycle of illustration derives in part from the emphasis on death not only in creating a state of widowhood but in making remarriage necessary "Por le besoing que il i voient" [since we need protection badly] the text explains. (*Yvain* 63, l. 2046). Parenthetically, it should be noted that documents show that widows with large inheritances remarried for precisely the same reason as Laudine (Hadju,

14. Ibid.; R. Fossier, *Histoire de la Picardie* (Toulouse: Privat, 1974); and idem, *La Terre et les hommes*, vol. 2, especially 657–65.

15. For these statistics see R. Hadju, "The Position of Noblewomen in the Pays des Coutumes, 1100–1300," *Journal of Family History* 5 (1980): 122–44, especially 133.

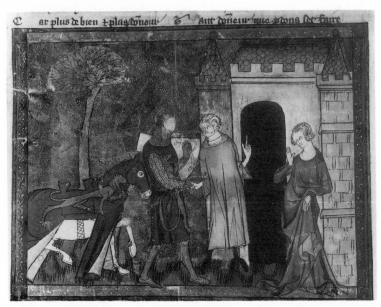

13. Yvain Greets the Vavassor and his Daughter, *Yvain*, Paris, Bibliothèque Nationale, MS fr. 1433, fol. 67v.

"Position of Noblewomen," 122–44). The simultaneous suppression of the marriage at this point in the cycle serves to "rewrite" the romance so that Yvain's, or the youth's, integration in a stable social order only follows a series of quests or adventures; in a sense, he remains a bachelor until the reconciliation miniature.

The structure of the cycle of illustrations in the accompanying romance, the *Atre périlleux*, confirms this interpretation (Woledge, op. cit.). The Arthurian knight, Gawain, seeks to avenge the kidnapping of a cupbearer at Arthur's court and sets off on a series of quests which, like those of Yvain, revolve around doing good deeds, especially rescuing ladies in distress. Joined by two bachelors who accompany him, he eventually succeeds in rescuing the cupbearer, and they each marry women they have met in the course of their adventures. Between the opening double frontispiece, which sets up and develops the crucial episodes of the narrative, and the end of the romance there is only one generalized miniature before a large miniature of the triple wedding ceremony that concludes the story (Figs. 14, 15, 16). The reward for the model well-behaved youth is thus integration in the stable, domestic social order in spite of his lack of a patrimony.

14. Frontispiece, *L'Atre périlleux*, Paris, Bibliothèque Nationale, MS fr. 1433, fol. Av.

15. Frontispiece, *L'Atre périlleux*, Paris, Bibliothèque Nationale, MS fr. 1433, fol. Br.

16. Marriage of Cadres, Espinogre, and Raguidel, *L'Atre périlleux*, Paris, Bibliothèque Nationale, MS fr. 1433, fol. 60.

The model well-behaved youth is *undoubtedly* also the figure pictured in the opening initials of Arthurian romances. The idea of the knight as a metaphor for the reader coupled with the idea of the road (*chemin*) as a metaphor for the book (*parchemin*) is underscored by the sequence of double frontispiece and historiated initial that open the *Atre périlleux*. At the lower right in the frontispiece a knight breaks through the frame of the miniature, out of which he walks as he directs his gaze upwards. Where the text begins on the next page, the knight reappears again not only facing but imbedded in the opening words of the story (Fig. 12). In both cases the horses are caught in midstep. My interpretation understands this figure of the knight in part as a reader of romance.

The second example includes twenty-eight miniatures for *Perceval*, two miniatures for the appended texts, and two moralizing poems by the Recluse of Molliens, a Picard writer.[16] In *Perceval*, Chrétien and his four continuators tell the story of the making of a knight. Growing up in ignorance of chivalry in the Welsh forest, young Perceval encounters five knights, whom he mistakes for angels, "the fairest beings that exist."[17] From then on, Perceval has only one desire: to become a knight. Leaving his mother grief-stricken, he rushes off to Arthur's court. Charmed by the simplicity of the youth, Arthur dispatches him to do combat with the villainous Red Knight, whom Perceval, using his crude Welsh javelins, quickly defeats, helping himself to his armor. These four episodes, in which Perceval becomes a knight, are depicted in the frontispiece of the manuscript (Fig. 17).[18] After his victory, Perceval is then befriended by an older knight, who is also a vavassor, Gornemant of Gohort, who teaches him the use of weapons, as well as a few social niceties (such as don't talk too much). Naturally skilled in combat, Perceval quickly distinguishes himself, defending the castle of Beaurepaire, where he falls in love with its mistress, Blancheflor. Gawain later finds Perceval musing over Blancheflor's beauty as he regards three drops of blood in the snow, the subject of another mini-

16. Micha, *La Tradition manuscrite*, 46–47; Loomis, *Arthurian Legends*, 90–91, fig. 204; A. Hilka, ed., *Der Percevalroman (Li Contes del graal)*, in *Samtliche erhaltene Werke*, ed. W. Foerster (Halle: Max Niemeyer, 1935), 6; and Busby, "Illustrated Manuscripts," 44.

17. W. Roach, ed., *Le Roman de Perceval ou le Conte du graal*, TLF, (Geneva: Librairie Droz, 1956), 1. 138, 5.

18. For an analysis of the frontispiece, which misidentifies the subjects represented in the second and third compartments, see Roger Dragonetti, *La Vie de la lettre au Moyen Age. 'Le Conte du Graal'*, (Paris: Editions du Seuil, 1980).

17. Frontispiece, *Perceval*, Paris, Bibliothèque Nationale, MS fr. 12576, fol. 1.

18. Perceval Contemplates the Three Drops of Blood in the Snow, *Perceval*, Paris, Bibliothèque Nationale, MS fr. 12576, fol. 19.

ature (Fig. 18). One day, Perceval sees a crippled nobleman fishing, the Fisher King, receives from him a sword as a gift (which he breaks on the first blow), and is entertained lavishly at his house. During dinner, Perceval observes a young man carrying a bleeding white lance and a beautiful maiden carrying a gold bejeweled grail, but, remembering the advice of Gornemant (don't talk too much), he fails to ask two crucial questions: Whom are they serving with the grail? Why does the lance bleed? He learns from a wise hermit, the subject of another miniature (Fig. 19), that he did not ask these questions because he sinned, causing the death of his mother; in other words, Perceval has not learned to be a good *Christian* knight, in spite of his prowess at weapons.

Perceval's attainment of Christian virtue is the theme of the rest of the long poem. MS. fr. 12576 is the only illustrated manuscript that includes Gerbert de Montreuil's markedly Christian interpretation of the poem. As Gerbert de Montreuil has the hermit explain to him, "a knight's cutting sword has two edges . . . Holy Church's edge is broken, while the earthly edge cuts indeed. A knight who carries such a sword is deceiving God; and if he does not mend his ways, the gate of Paradise will be closed to him."[19] Although Perceval eventually marries Blancheflor in the third continuation, he never consummates the marriage, preferring to remain chaste. Parenthetically, Perceval is only illustrated once with Blancheflor, when he leaves her to seek the grail and the lance; that the marriage of the hero is never illustrated is all the

19. *Gerbert de Montreuil: La Continuation de Perceval*, 3 vols., ed. Mary Williams and Marguerite Oswald (Paris: Champion, 1922, 1925, 1975), vol. 1, ll. 2764–86, 86.

19. Perceval and the Hermit, *Perceval*, Paris, Bibliothèque Nationale, MS fr. 12576, fol. 25.

20. Perceval Takes Leave of Blancheflor, Gerbert de Montreuil's Continuation of *Perceval*, Paris, Bibliothèque Nationale, MS fr. 12576, fol. 180.

more striking since the marriage of Ysave and King Carados is illustrated (Fig. 20). Perceval goes on to mend his sword, which symbolically makes him worthy of learning the secrets of the grail and the lance. As the Fisher King's nephew, he succeeds him, is crowned (an event illustrated in only one of the Perceval manuscripts, Paris: Bibliothèque Nationale, MS. Fr 1453), and rules for seven years. But, in the end, turning away from the material world, he relinquishes his throne and takes religious vows.

Perceval's rejection of the material world is the subject of the last miniature, the theme of which is further reinforced by the two miniatures that accompany the poems by the Recluse of Molliens. In a large picture that comes after the explicit, Perceval, dressed in clerical garb, kneels before a woman, symbolizing the Church, who holds the grail, which she receives from an angel, while another angel waves a censer above her (Fig. 21). Dressed in a different, short garment, Perceval, holding the burning lance, appears a second time on the far right, as though he were walking out of the picture. The miniature illustrates the conclusion of Manessier's continuation. It depicts Perceval who, because of his great devotion to the grail, was made a clerk and an acolyte, then a subdeacon and a deacon, and finally a priest. But it also depicts Perceval as a generalized reader/knight, who, like the knights in the opening miniatures, "travels the road [and] can still see the story there, sealed all in parchment" (Roach, *Continuations*, 5:343). Far from

21. Perceval Kneels before the Holy Grail, Manessier's Continuation of *Perceval*, Paris, Bibliothèque Nationale, MS fr. 12576, fol. 261.

being primarily an illustration of the two forms of chivalry, spiritual and military, which is often considered to be one of the themes of the text of *Perceval*,[20] this miniature is an advertisement for the spiritual life.

The merit in Perceval's final choice is underscored by the Recluse, who in his texts deplores the uncharitable, sinful ways of aristocratic society.[21] The first miniature, illustrating the *Roman de Carité*, depicts a group of people distributing bread to the poor (Fig. 22). The second miniature, illustrating the *Miserere*, depicts a scene of the Last Judgment (Fig. 23). Recalling the advice to Perceval of the hermit, who used the metaphor of the double-edged sword, we can read this last miniature as a final gloss on the Perceval story: having fully understood the value of the spiritual life, Perceval can rest assured that the gate of Paradise will open for him.

The distinctive features of the text and illustrations of *Perceval* can be explained by the same dilemma in the feudal system discussed earlier: the consequences of primogeniture for the prospects of the younger sons. Not every son left without a patrimony became a bach-

20. Jean Frappier, "Le Graal et la chevalerie," *Romania* 75 (1954): 165–210.
21. A. G. Van Hamel, ed., *Li Romans de Carité et Misere, du Renclus de Moiliens*, 2 vols., (Paris: Bibl. Ec. Htes Et., 61, 62 1985); and C. V. Langlois, *La Vie en France, d'après quelques moralistes du temps*, (Paris: Hachette, 1925), 113–52.

22. Distributing Bread to the Poor, Ren-
clus de Moliens, *Miserere*, Paris, Bibli-
othèque Nationale, MS fr. 12576, fol.
263.

23. Last Judgment, *Roman de Carité*,
Paris, Bibliothèque Nationale, MS fr.
12576, fol. 275v.

elor or wandering knight—like Yvain. Many of them became clerics—
like Perceval. Although entrance into the clergy was not cost-free,
because religious foundations expected a monetary gift to accompany
inscription, it had several advantages: it did not necessitate fragmenta-
tion of the lands and it prevented the lateral branches of the family
from multiplying and, through marriage and childbearing, overwhelm-
ing the main branch. Besides, a small monetary gift to a religious
foundation, along with the inscription of a son or two, brought with it
not only prestige to the seigneury but burial rights within the founda-
tion, which became the family necropolis. In the twelfth century
Picardy was especially well populated with collegiate churches, and it
had the largest number of episcopal sees (Fossier, *Histoire*, 154–59).
There, as elsewhere, the secular and religious clergy were of noble
blood. By the latter half of the thirteenth century with the devaluation
of landed capital, many of these foundations faced liquidation and, so,
they stepped up recruitment (Fossier, ibid., 154–59). The increased
number of younger sons from the recently expanded nobility and the
more acute needs of local religious foundations, which had long en-
joyed seignorial sponsorship, thus coincided. Understood against this
background, Perceval becomes another kind of model for the integra-
tion into society of the younger son devoid of a patrimony.

Interpretation of a manuscript as putting forward a didactic message nearly always raises the same question: who really read the manuscript? For this reason, the manuscript of *Perceval* is of special interest, because it evokes the seignorial milieu for which it must have been written and used. On the first folio, a note reads: "This book belongs to the Sire of Hargerie, who loans it to Madame de Contay, who promises to return it to him." These individuals can be identified as François de Rasse (d. 1557), *chevalier* and *seigneur* of La Hargerie, and Françoise de Contay (married 1507), wife of Jean, *seigneur* of Humières.[22] Although these individuals are later owners of the manuscript, the note (and the proximity of the two domains, in Bersée and Le Forest in the Artois) suggests that romances were passed around the seigneury, a phenomenon that undoubtedly accounts for their sometimes shabby condition. The note also calls attention to the existence of noble women as readers of romance.[23] At the end of this manuscript, between *Perceval* and the *Roman de carité*, directly following a short prose account of the death of a local count,[24] there is a carefully written record of obligations: "I owe Adam Du Blanc Fose (on the territory of Blancfosse, not far from Amiens, cf., Fossier, *La Terre*, 1:302; 2:512, n.194; 686, n.241). 1 capon from the kitchen of the great house at Noel. To Sire . . . Lerous 6 falcons from the great house at Noel. . . . And to Amaroie Bonavele 3 falcons and 5 capons . . . behind the house of Adam. . . . And to the priest of Saint-Germain 5 falcons at Noel and 4 at Easter." Written by the lord himself, or perhaps by his head servant, this list conjures up a vivid picture of a feudal domain, the names of the people, the relative locations of their houses, and their daily needs. It also suggests that the romance was a book left lying about the house, read and used by more than one reader, instead of hidden away on the shelves of a library. Read in such a milieu, romances offered not only leisure entertainment but a social agenda relevant to the times.

There remains the larger question: why was romance so popular in Picardy? Or, what was it about Picardy that promoted a literature of feudalism? Two answers to this question are interrelated. The first explanation can be sought in Picardy's special relationship with the

22. See P.-A. du Chastel de la Howardries-Neuvireuil, *Notices généalogiques tournaisiennes dressées sur titres* (Tournai: Vasseur-Delmee, 1887), vol. 3, 250 [F. de Raisse]; and A. La Morlière, *Antiquitez, histoires et choses plus remarquables de la ville d'Amiens* (Amiens: S. Cramoisy, 1642) [de Contay].

23. See Roberta Krueger, "Desire, Meaning, and the Female Reader: The Problem in Chrétien's *Charette*," in *The Passing of Arthur*, 31–51.

24. *La Mort du Conte de Henau*, 261v–62 ff.

monarchy and the impact that that relationship had on its society.[25] Because of the geographic position of Picardy bounded by Normandy to its west, Flanders to its north, and the Ile-de-France to its south, it presented a potential threat to the Capetian kings, who were eager to guard against an alliance of the Picards with the stronger Flemings and Normans. Beginning with the Treaty of Boves in 1186, in which Philip Augustus and the Count of Flanders split Picardy between them, the Capetians sought to strengthen their control over the area. This process did not proceed without resistance. During the minority of Saint Louis between 1229 and 1236, Picardian nobles joined with the Count of Ponthieu in a revolt against royal authority. Ultimately, such resistance was unsuccessful, however, perhaps because Picardy was made up of hundreds of relatively small counties and seigneuries in contrast to Champagne, Normandy, and Flanders, where there was a strong single count or duke. Between 1250 and 1260 during the reign of Saint Louis, royal administration of Picardy was fully in place: officials appointed by the king replaced the authority of the sires in all administrative affairs.

Coincidental with the establishment of royal authority came the revised conditions of aristocratic life in Picardy in the latter half of the thirteenth century. The ongoing presence of a population whose economic and social needs were not served by the feudal domain fostered the growth of towns, which resulted in the steady increase of a powerful bourgeois class. While an administrative and merchant class grew up around the towns, there was a marked increase also in the ranks of new knights. (Fossier, *La Terre*, 657–65). The charters reveal simultaneously the overindebtedness of a number of lords and sires, who took to selling off their lands to the bourgeoisie (ibid., 598ff.). At the same time, documents in Picardy reveal an unprecedented preoccupation with feudal customs, rituals and rights, which is all the more striking considering that, when compared with Normandy and Flanders, what distinguishes Picardy in the twelfth century is the relative paucity of references to chivalry (Fossier, *Histoire*, 160; *La Terre*, 663–77). What emerges is a picture of feudalism at a moment of consider-

25. For an interpretation of the writing of history motivated by related sociopolitical circumstances, see Gabrielle Spiegel, "*Pseudo-Turpin*, the Crisis of the Aristocracy and the Beginnings of Vernacular Historiography in France," in *Journal of Medieval History* 12 (1986): 207–33, and idem, "Social Change and Literary Language: the Textualization of the Past in Thirteenth-Century Old French Historiography," *The Journal of Medieval and Renaissance Studies* 17 (1987): 129–48.

able crisis. In its conspicuous denial of the power of the monarch, who is an ineffectual, even cuckolded king, coupled with its exaltation of the knights, whose invincible deeds set them off from the monarch as potent forces, Arthurian romance is surely a last-ditch defense of a faltering feudal system.

STEPHEN G. NICHOLS

Marie de France's Commonplaces

In the prologue to her *Lais*, sometime in the third quarter of the twelfth century, Marie de France outlined a poetic agenda based on the assertion that vernacular poetry could derive as much poetic value from indigenous subject matter as from translating classical Latin sources.[1] In a well-known and much-discussed passage, she stressed the concept of the poet's obligation to create a value-added poetry. Taking for granted the preexistence of the subject matter, she situated the poet's contribution squarely in the domain of style and value. The poet achieves a *"grevose ovre,"* or weighty work, by transposing subject matter from one domain to another. Marie tells us that she might have translated from Latin into Romance. In that case, the act of supplementation that would be the vernacular poet's contribution would consist in the adaptation of figurative language, philosophy, and interpretation.

In an uncommon glimpse into the twelfth-century literary marketplace, Marie says that she rejected the notion of translation from Latin into Romance because it would not have enhanced her stature: too many others were already doing precisely that.

> Pur ceo començai a penser
> D'aukune bone estoire faire
> E de latin en romaunz traire;

1. I would like to thank my mentor, Daniel Poirion, and colleague, Nancy Regalado, for inviting me to give this paper at the Yale Colloquium on Value and Style in Old French Art and Literature. Under the same title, I read an early and very different version at the Comparative Medieval Studies session of the Modern Language Association meeting at San Francisco in December 1987.

YFS Special Edition, *Contexts: Style and Values in Medieval Art and Literature,* ed. Daniel Poirion and Nancy Freeman Regalado, © 1991 by Yale University.

Mais ne me fust guaires de pris:
Itant s'en sunt altre entremis! [Pr 28–32][2]

For that reason I began to think of translating some good story from Latin into Romance; but there would have been little reward for me in that, so many others have done it!

With this disarmingly frank avowal, Marie rejects the high cultural route to poetic value. By espousing instead the low culture of Breton folk tales, she makes the first explicit canon revision in European literary history. At the same time, she valorizes indigenous oral popular tales over a written tradition that belonged to the ruling cultural elite represented by the State and the Church whose defining texts were written in classical or Church Latin. These would have been the texts that provided normative models of rhetorical style and poetic value which poets were meant to master in order to qualify for the recognition she so candidly says she seeks.

De lais pensai, k'oï aveie.
Ne dutai pas, bien le saveie,
Ke pur remambrance les firent
Des aventures k'il oïrent
Cil ki primes les comencierent
E ki avant les enveierent.
Plusurs en ai oï conter,
Nes voil laissier ne oblïer
Rimé en ai et fait ditié,
Soventes fiez en ai veillié! *[Pr 33–43]*

I thought of the lais that I had heard, I didn't doubt and knew very well that those who first began them had made them to remember the adventures that they had heard [recounted]. I had myself heard several that I did not want to forget nor ignore, I rhymed them and made lyric narratives *(ditié)*, many's the night I stayed up late working.

Ever since Leo Spitzer's ground-breaking article, "The Prologue to the *Lais* of Marie de France and Medieval Poetics,"[3] where he called

2. *Les Lais de Marie de France,* ed. Jean Rychner. Les Classiques français du moyen âge, 93 (Paris: Champion, 1966). All References will be to this edition.
3. *Modern Philology* 41 (1943–44): 96–102, Reprinted in *Romanische Literaturstudien* 1936–56 (Tübingen: Max Niemeyer Verlag, 1959): 3–14. See also, Mortimer J. Donovan, "Priscian and the Obscurity of the Ancients," *Speculum* 36 (1961): 75–80. Kristine Brightenbach, "Remarks on the 'Prologue' to Marie de France's *Lais,*" *Romance Philology* 30 (1976): 168–77. Alfred Foulet and Karl D. Uitti, "The Prologue to the *Lais* of Marie de France: A Reconsideration," *Romance Philology* 35 (1981): 242–49.

Marie "a clerc, a *poeta philosophus et theologus,*" on the basis of the
erudition she displays, discussion supporting and countering Spitzer
generally views the "Prologue" as emphasizing Marie's relationship
with classical learning thereby creating, at least unconsciously, a di-
chotomy between the reference points of the prologue: classical and
vernacular, high cultural and low culture, writing versus orality. Far
from authorizing such a dichotomy, the prologue demonstrates how
the *Lais* will combine techniques of classical rhetoric from the written
literary tradition with oral popular narrative to make the lay a powerful
dialectic aimed at attitudes towards women and sexuality, marriage
and property as these attitudes were expressed in canonical Latin po-
etry, particularly Ovid's *Heroides.*

For if the ethnographic material she chooses as the subject for the
poetic lay comes from the low cultural oral milieu, the style and value
that she will add to this material result from a bold program in which
the notion of the commonplace, a staple of classical Latinity, takes on a
variety of meanings and nuances, from the literal to the wildly meta-
phoric. She will use the commonplace to juxtapose the dominant Latin
cultural milieu against an indigenous vernacular culture to produce a
pointed critique of social and familial practices condoned, indeed sup-
ported, by the dual authorities of Church and State.

But what is Marie's conception of the commonplace that plays so
important a role in her poetics? Ernst Robert Curtius, the most avid
proponent of topos scholarship in the midtwentieth century, defined
topos in *European Literature and the Latin Middle Ages,* with refer-
ence to its historical meaning as a codified unit of thought belonging to
the classical tradition of rhetoric.[4] *Loci communes* belonged originally
to the oratorical, rather than the purely literary, art of political or legal
argumentation. Quintilian (5, 10, 20) calls commonplaces "store-
houses of trains of thought" (*argumentorum sedes*). During the Roman
Empire, legal and political oratory, in Curtius's words, "disappeared

4. E. R. Curtius, *European Literature and the Latin Middle Ages,* trans. Willard R.
Trask. Bollingen Series 36 (New York: Pantheon, 1953). " . . . every oration (including
panegyrics) must make some proposition or thing plausible. It must adduce in its favor
arguments which address themselves to the hearer's mind or heart. Now, there is a whole
series of such arguments which can be used on the most diverse occasions. They are
intellectual themes, suitable for development and modification at the orator's pleasure.
In Greek they are called *koinoì tópoi;* in Latin *loci communes;* in earlier German,
Gemeinörter . . . About 1770, *Gemeinplatz* was formed after the English 'com-
monplace.' We cannot use the word, since it has lost its original applications. We shall
therefore retain the Greek *topos.*" 70

from political reality, and took refuge in the schools of rhetoric. Conse-quently, "rhetoric lost its original purpose [of legal persuasion] . . . [and] penetrated into all literary genres. Its elaborately developed sys-tem became the common denominator of literature in general" (70).

While retaining the idea of the commonplace's roots in oral rather than written discourse and its purpose as juridical or political persua-sion, we might question Curtius's insistence on seeing the topos as a universal principle of sameness, an invariant which might be used to explain the transhistorical and transsubjective nature of poetry. Let us look, instead, at the commonplace as an example of the pathology of the poetic signifier. Rather than viewing the commonplace as an invar-iant, i.e., a term "whose presence is the necessary condition for the presence of another term with which it is in relation and which is called variable",[5] I would argue that the commonplace is itself, at least as Marie uses it, a transgressive instrument. The commonplace allows Marie to use poetic license, in Donatus's and Priscian's understanding of the term, as an instrument of transgressive appropriation and trans-formation.

In sum, Marie uses the commonplace as an instrument not of tradi-tional thought but as a deviation from norms of conventional wisdom. Classical and postclassical grammarians had a term for poetic license. Donatus—the most influential classical grammarian for the Middle Ages—called it metaplasm, from the Greek meaning to mold differ-ently or remodel. Although sometimes viewed simply as ungram-maticality indulged to satisfy metrical requirements,[6] metaplasm raises the broader issue of the pathology of the poetic signifier. By referring to barbarism in poetry, metaplasm invokes hierarchies of discourse (sermo): high style versus low or demotic style, marginal and foreign (barbarous) speech, in short, the discourses of alterity. It points to the possibility of a speaking subject divided.

Barbarism was one of the connotations of metaplasm in classical grammarians[7] for whom it meant deviation from the correct norm of speech (sermo) or also "incorrect" transformation of individual terms

5. A. J. Greimas, J. Cortés, Sémiotique, dictionnaire raisonné de la théorie du lan-gage (Paris: Hachette Université, 1979), 195.

6. So, for example Curtius, European Literature . . . : 44: "Metaplasm is a deviation from the grammatical norm which is permitted to poets in consideration of the demands of meter: "licentia poetarum" (Isidore, Etymologiae 1, 35, 1). It is thus a special case of "poetic freedom" which is frequently discussed by antique authors.

7. Louis Holz, Donat et la tradition de l'enseignement grammatical (Paris, CNRS, 198), 170.

of expression. Pliny stressed both the transgressive and transformative function of barbarism and metaplasm as well as their effect on common speech: "Barbarismum esse sermonem unum, in quo uis sua est contra naturam" [Barbarism is discourse whose force is against nature].[8] "Metaplasm is a transformation which, either for metrical necessity or to embellish the style, gives a different appearance to a simple, prosaic expression."[9] In seeking an exact Latin form for the Greek metaplasm, grammarians chose *transformatio*. But at least one grammarian suggested that *metamorphosis* would serve equally well, referring his readers to Ovid and Apuleius.[10] Marie de France realizes the full range of these meanings.

From the viewpoint of the high cultural tradition of Latin, indigenous vernaculars such as Anglo-Norman and, *a fortiori*, Breton, constituted a double barbarism as commonplace languages—vulgar tongues—as well as languages without a high cultural literary tradition. True, Anglo-Norman was acquiring one in the twelfth century and was at least derived from Latin, but Breton was thoroughly demotic, without the vestige of a written tradition. In the same formulation where she boldly asserts the equality of these languages with Latin, indeed their superiority for garnering praise for her own talent, Marie also shows that the poetic and philosophical value of poetry derived specifically from manipulating the pathology of the poetic signifier via metaplasm. What rendered classical poetry valuable was the complexity of the language and thought the supplement (*le surplus*) added by poets.[11] In Marie's formulation, classical literature obtained its poetic value based on veiled meaning, the transformation of

8. Pliny, *Dubius sermo*, fragment 125, quoted by Holz, 142. Holz points out that *natura* for Pliny is the lexical dimension of language as opposed to art: "Pour Pline, comme pour Varron, la *natura*, c'est le lexique, l'ensemble de mots dont la masse forme le matériel de base pour une langue donnée. L'*ars*, c'est la systématisation opérée à partir de ce matériel par les techniciens, et qui permet de distinguer l'homme inculte de l'homme cultivé." Holtz, 142.

9. Pliny, *Dubius sermo* fragment 125, quoted by Holz, 171, n. 1.

10. Holz, 171, n. 4: ". . . sed metaplasmus in una parte orationis fit (cf., Don. 653, 2sqq), metamorphosis in omni serie librorum conponitur (*Explanationes* 266, 164 Sch.).

11. I agree with Foulet & Uitti that *lur sen* (l. 16) refers to the ancients ("The Prologue to the *Lais* of Marie de France: A Reconsideration," *Romance Philology* 35 (1981): 246–47). I would go further, however, and suggest that Marie here states that just as supplementation of poetic givens constitutes a major primary poetic task, value will continue to be added to poetry by the interpretation of subsequent generations of readers.

the ordinary by figurative language, what Marie calls "speaking obscurely:"

> Custume fu as ancïens,
> Ceo testimoine Precïens,
> Es livres ke jadis feseient,
> Assez oscurement diseient
> Pur ceus ki a venir esteient
> E ki aprendre les deveient,
> K'i peüssent gloser la lettre
> E de lur sen le surplus mettre.
> Li philesophe le saveient,
> Par eus meïsmes entendeient,
> Cum plus trespassereit li tens,
> Plus serreient sutil de sens
> E plus se savreient garder
> De ceo k'i ert a trespasser. [9–22]

It was the custom of the ancients, as Priscian testifies, to speak rather obscurely in the books they wrote in those days so that those who were to come and who would learn them might gloss the letter of the texts and thereby add to the wisdom [of the originals]. The philosophers knew this and themselves understood that as time went by people would become subtler in their understanding and would better know how to preserve from perishing what was in them.

The passage has been often discussed and I do not propose to comment further except to note that it immediately precedes Marie's rejection of the classical texts as subjects for her *grevose ovre* in favor of the commonplace Breton folktales. It also states that the role of the inheritors of classical texts is not one of paralyzing deference, but rather an active commentary and completion of the meaning of those texts by people whose minds have grown more subtle. Marie hardly expresses here the deferential topos of the moderns as dwarves standing on the shoulders of giants, as Mortimer Donovan suggested.[12]

It should come as no surprise, then, to find that Marie stands on its head the concept of poetic value we have just seen articulated by Donatus and repeated in her description of the classics. She will undertake a running critique, on the order of an exposé, of classical topics by inscribing them *en filigrane* in her *lais*. She then contrasts them by implication with commonplaces drawn from the varied autoch-

12. *Speculum* 36 (1961): 78–80.

thonous languages and settings on which she draws. Marie's *Lais* are truly polyphonic in Bakhtin's sense since they continually juxtapose vernacular indigenous languages—Anglo-Norman, Breton, "English"— with Latin which in this context takes its place as one among several languages. She seems to aim at leveling linguistic hierarchies, so that Breton and Old French appear the equals of Latin. So it is that she derives commonplaces from vernacular registers of these languages, as well as from Latin. Similarly, she will ground her commonplaces in such "vernacular" situations as domestic settings, sexual fantasy, amorous liaisons, jealousy, and other psychological entanglements as common to the indigenous Europeans of the twelfth century as they were to the Romans of Ovid's day. She must establish an equivalence of language and culture not to show sameness, but to make a ground for dialectical comparison, as we shall see.

Let us not forget the repeated references, in the prologues of individual lays, to orality and writing, hearing and reading. Mouth, hand, and ear all play their part in the narratives of individual lays and in the poet's narrative about the origin, creation, and parturition of the poems which, as she tells us, she often spent sleepless nights in birthing. In short, Marie links the commonplaces of the body, the visible orifices and appendages, in the creation of the lays, with the veiled commonplaces of the body in the amorous narrative fantasies we find set in such domestic common spaces as bedroom, garden, dining room, and so on. We find, in short, a politics of the body in Marie that begins with the *Prologue* and continues with each lay all the while exposing a counterpolitics of the body in the classical subtexts she inscribes *en filigrane*, usually by means of an identifiable locus communis.

Space limitations do not permit demonstrating here how this complex polyphony of *loci communes* functions in the *Lais* in general, but we can get an idea of how she initiates her audience in the *Prologue*. We know that the reference Marie makes to the nocturnal labors of adding poetic value to her lais,

> Rimez en ai e fait ditié,
> Soventes fiez en ai veillié [41–42]

became a commonplace in Old French down to François Villon's day, who used it in a theatrical ending to his *Lais* in 1456:

> Je cuiday finer mon propos,
> Mais mon ancrë estoit gelé
> Et mon cierge trouvay soufflé,

De feu je n'eusse peu finer,
Si m'endormis, tout enmouflé
Et ne peuz autrement finer. [*Le Lais:* 307–12.][13]

I tried to finish my task / But my ink was frozen / And I saw my candle
had blown out / I couldn't have found any fire / so I fell asleep all
muffled up / Unable to give it another ending.

Both Marie and Villon evoke a commonplace that had a vigorous
classical Latin existence that seems to have gone unremarked by the
many commentaries on Marie's *Prologue.* "Veillier," from Latin, *vigi-
lare,* translates a topos particularly rich in resonances to the themes
Marie deploys. In the Latin system, variants of *vigilare* connote ex-
traordinary poetic effort in producing the song, *carmen,* whose value
may be measured by its capacity to move its hearer(s) thereby assuring
the value of poet and work.[14] In *Ars Amatoria* 2.285, Ovid says:

His ergo aut illis *uigilatum carmen in ipsas* [285]
 Forsitan exigui muneris instar erit.

and thus to these women *the poem fashioned [by nocturnal labor] in
their praise* will perchance seem like a little gift.[15]

Statius, at *Thebaid* 12.811, offers an apostrophe to his poem that forms
an even closer collocation with Marie's:

Durabisne procul dominoque legere superstes, [810]
o mihi bissenos *multum uigilata per annos*
Thebai? iam certe praesens tibi Fama benignum
strauit iter coepitque novam monstrare futuris.
iam te magnanimus dignatur noscere Caesar,
Itala iam studio discit memoratque iuuentus. [815]

Wilt thou endure in time to come, O my *Thebaid, for twelve years
object of my wakeful toil,* wilt thou survive thy master and be read? Of
a truth already present Fame hath paved thee a friendly road, and begun
to hold thee up, young as thou art, to future ages. Already great-hearted
Caesar deigns to know thee, and the youth of Italy eagerly learns and
recounts thy verse.[16]

13. *Les Lais Villon,* ed. Jean Rychner and Albert Henry. 1: *Textes* (Geneva: Droz,
1977). Translation, Galway Kinnell, *The Poems of François Villon* (Hanover: University
of New England Press, 1983).
 14. I am indebted in this section for the counsel of my colleague, James O'Donnell,
of the Classical Studies Department.
 15. Ovid, *The Art of Love and Other Poems,* ed. and trans. J. H. Mozley. Second
Edition, revised by G. P. Goold (Cambridge: Harvard University Press, 1979).
 16. *Statius* with an English translation by J. H. Mozley (Cambridge: Harvard Univer-
sity Press, 1969), vol. 2.

Commentators on these and other passages in the system—e.g., Virgil, *Georgics* 1.313, *Appendix Vergiliana, Ciris* 46, Juvenal, *Satire* 7.27, Ovid, *Tristia* 2.11, *Fasti* 4.109—point to its character as a tightly self-referential network, in short a self-conscious system of commonplaces within a relatively small corpus of Augustan and post-Augustan poetry (the *Ciris* of the *Appendix Vergiliana* has been dated by Lyne as late as the third century).[17] This makes it all the more significant for our purposes, since the corpus in question was precisely that familiar to the twelfth century.

We may divide the corpus into two subgroups, one that relates generally to Marie's concerns, and a second which may be seen as directly relevant to her text. The most salient examples from the second group are: *Ciris* 46, Statius, *Thebaid* 12.811, and Statius, *Sylvae* 3.5.35. Ovid, *Fasti* 4.109–10 also belongs in this group, but requires more extensive comment than space permits, since it evokes not only themes from Marie's *Prologue,* but also problematizes discursive elements in *Guigemar* and *Bisclavret.*

In considering these classical *topoi,* let's bear in mind the transitional moment in Marie's text where her reference to wakeful nights occurs. The passage links the discussion about the cultural surplus of her poems, that is their claims to philosophical and aesthetic merit beyond the simple oral narratives of the Bretons, to her dedication of the *Lais* to King Henry II. The two-line evocation of her wakeful productivity occurs at a crucial point. With this admission, she makes the transition between poetic activity as philosophical/ethical act and poetry as a cross-gendered expression of heightened emotion. In short, a gift offered to a person of the opposite sex prior to public exposition.

> En l'honur de vus, nobles reis,
> Ki tant estes pruz e curteis,
> A ki tute joie s'encline
> E en ki quoer tuz bien racine,
> M'entremis des lais assembler,
> Par rime faire e reconter.
> En mun quoer pensoe e diseie,
> Sire, kes vos presentereie. [43–50]

In your honor, noble King, / who are so brave and courteous, / to whom joy pays homage / in whose heart all goodness takes root, / I set about

17. *Ciris, A Poem Attributed to Vergil.* Edited with an Introduction and Commentary by R. O. A. M. Lyne (Cambridge: Cambridge University Press, 1978), 56.

gathering together these *lais* / to rhyme and rework them. / In my
heart I thought and said, / sire, that I would present them to you.

The last lines of the quotation associate Henry II both with Marie's
affective life and with the intentionality of the poetic production. We
find something that, at first blush, appears similar in Statius's apos-
trophe to his wife, Claudia, in *Sylvae* 3.5.33–36.

> tu procurrentia primis
> carmina nostra sonis totasque in murmure noctes
> aure rapis uigili; longi tu sola laboris [35]
> conscia, comque tuis creuit mea Thebais annis.

Your wakeful ears caught the first notes of the songs I ventured and
whole nights of murmured sound; you alone knew of my long labor, and
my *Thebaid* grew with the years of your companionship.

This passage forms an interesting contrast with Statius's other one
quoted above (*Thebaid* 12.810ff.). There we found no mention of
Claudia, but instead an apostrophe to his poem coupled with the re-
spectful evocation of *magnanimus Caesar*, and the reverential attitude
towards Virgil and the *Aeneid*. Statius prays not to "rival the divine
Aeneid, but follow afar and ever venerate its footsteps" [. . . *nec tu
diuinam Aeneida tempta, / sed longe sequere et uestigia semper
adora* (816–17)].

The theme here is paradoxically one of respectful distance and
contiguity between Statius and his imperial patron and Statius and his
poetic precursor, Virgil. He is at once close to and removed from
Caesar, in the company of, but respectfully behind Virgil. The *Thebaid*
may approach, but not equal the *Aeneid*. Here we have the phe-
nomenology of political and cultural *auctoritas* clearly articulated.
The passage from *Sylvae* 3 lays out the feminine role in this cultural
paradigm. There, Statius makes his wife, Claudia, a metonymy for this
oxymoronic contiguous distance. Like the poetry itself, she is the
necessary companion of his nights, as he says in line 1—*sociis quid
noctibus, uxor*—but, like the poet vis-à-vis Caesar and Virgil, she
maintains the contiguous distance of respectful audience and witness
to the poet's midnight labor. She has no other role to play but that of
passive companion.

Now look how Marie treats this commonplace. Although the
points of contact are multiple between the Latin system and Marie's
text, hers abolishes the deferential oxymoron of contiguous distance.

For her, the apostrophe offers an occasion to strip away the protocular space between herself and the king, appropriating him not only as her intimate companion through the long nights of labor, but even more, admitting him into her heart, the seat of her poetic invention. Moreover, her heart and the king's are twinned as motors of the poetic effort: in the king's may be found the origin of goodness that marks serious poetry (l. 46); in hers, inspiration, poetic talent, and caritas, the impulse to give (l. 49).

The terms she uses to apostrophize the king—*nobles reis / pruz e curteis*, etc.—are not simply marks of deferential speech by which the subject addresses the monarch. In the context, they become markers of the *bone eloquence*, eloquence of poetic speech, which she cites in the opening two lines as the divine gift to the poet:

> Ki Deus ad duné escïence
> E de parler bone eloquence [1–2]

To whomever God has granted wisdom / and eloquence of speech . . .

The king's presence in the text, his poetic identity, has become the language of *bone eloquence* itself. As *primus inter pares*, the king naturally figures as the persona of the transforming language Marie deploys. This strategy narrows the psychic distance between king and text and thus king and poet from yet another angle. It sets up still another transgressive appropriation and transfiguration of a classical topos. For, as we have seen, the purpose of the rhetorical rapprochement of Marie and her patron is to motivate the value of the *Lais* as her self-presentation, an *acte de présence*. In the amorous vernacular of our day, she may be said to be "hitting on" the king.

Why? for we know that she had ample precedent for a more decorous approach. The answer lies, I think, in the tension between her text and another hitherto unremarked topical subtext, the pseudo-Virgil poem *Ciris*. Lines 46–47 of this poem represent the "working late" topos, in a form closely linked by commentators to the Statius group.

> accipe dona meo multum *uigilata labore,* [46]
> promissa atque diu iam tandem ⟨pagina dicat⟩

. . . accept this gift wrought by me with many a toilsome vigil / a page long promised and now at last declaimed.

In his commentary, Lyne points out the "closeness of *Ciris* 46 to *Thebaid* 12.811" but remarks that "**there is no parallel for the colloca-**

tion with *donum* ['gift']" (121). In other words, the Latin corpus has no other instance of the collocation of poem as gift with the "working late" topos. On the other hand, Lyne reminds us that there is ample evidence of wordplay between the serious sense of wakeful dedication to the composition of poetry, and the lighter connotation of wakefulness caused by the pangs of love: humorous play between the two meanings became a commonplace among the Augustan elegists.[18]

Marie could certainly have known *Ciris;* two of the surviving manuscripts antedate or are contemporary with her own dates: a fragment from the ninth century, and the most complete extant one, preserved in Brussels, from the twelfth. But it is Marie, rather than pseudo-Virgil, who teases out the erotic potential from the conjunction of gift and what Juvenal, in Satire 7.27, called *uigilata proelia,* "the battles that have robbed you of your sleep" (meaning both poetic and amorous struggles).

Unlike pseudo-Virgil, Marie conceives the gift of her *Lais* as a reciprocal give and take. The fourteen-line dedication in which she offers them to the king, divides into two chiastic sections, constructed so that the beginning and end of each contain second-person addresses to Henry, while the first-person self-references (to Marie) occur inside the passages. In other words, the second-person pronoun, *vus* (= Henry), embraces the first-person inflections (= Marie). On the other hand, all but one of the verbs, leaving aside an infinitive *receveir,* and an imperative *Ne me tenez a,* predicate Marie's actions. In short, the aggressive suitor in this encomniastic tryst is Marie. But the one active verb ascribed to Henry signifies the reciprocity of the dedication, a reciprocity emphatically absent from pseudo-Virgil's example. It is a compound verb indicative of that most sensually ambiguous of all courtly expressions *joie*—often used by the troubadours to connote *jouissance:*[19]

18. "Devoted lucubration in the composition of poetry is a conventional assumption in the Callimachean tradition; The Augustan elegists, who came virtually to identify the 'Callimachean' poet with the poet-lover, could humorously play between the ideas of lucubration the product of diligence and lucubration enforced by the cares of love . . . *uigilo* (and compounds) was commonly used to express the Callimachean *topos* and its amatory mate." Lyne, *Ciris,* 121.

19. The grandfather of Henry II's wife, Eleanor of Aquitaine, was William IX, the first troubadour. His songs play upon the ambivalent sense of *joi,* pleasure, delight, and sexual pleasure with sufficient consistency to signal a courtly commonplace. For William IX, love is physical, a means for extending seigneurial power into the domain of personal and private relations. His poetry formalizes a discourse of emotional and psy-

> Si vos plaist a receveir,
> *Mult me ferez grant joie aveir*
> A tuz jurz mais en serrai liee. [51–53]

If it pleases you to accept / you would make me have great pleasure (*grant joie*) / I shall be delighted (= a play on *liee* "bound or tied", and *liee* "delighted") forever

In the *Prologue*, Marie takes language and the commonplaces of language as its rallying point. Latin and its commonplaces of language mark the target not to aim *for*, but to interrogate and transform. The *Lais* also postulate several levels of discourse: a Roman cultural register linked to historical social and political reality in the background and, in the foreground, a Romanesque counterculture based on the liberation of fantasy and desire through the resources of language.

The "official" background discourse reflects real social norms predicated on the Roman high style and hierarchical value system. This register portrays a dystopia of love repressive of female sexuality as given in Roman culture by Ovid's *Heroides* and *Metamorphoses* and in Romanesque culture by the dystopic marriages based on sexual aggression, lust, and the fact of woman as property that form the background of so many of Marie's *Lais*. These vignettes of the *malmariée* are presented as aberrant by Marie, the antithesis of a fulfilling affective life. Yet they portray more or less accurately twelfth-century social and legal norms of marriage.

We might take as an icon of this register the ekphrastic portraits in the tower-rooms of the married woman in *Guigemar*. The portraits, Marie says, were commissioned by the aged and jealous husband to ornament the quarters in which he keeps his young wife locked up. To the extent that they are intended to remind the wife of her conjugal obligations, the paintings suggest the weight of authoritative Latin culture and the social customs it sanctions. They suggest the transhistorical continuity of high culture into Romanesque social institutions.

Against the contextual and background register, marked by the "rationality" of the socially normative, Marie introduces a fore-

chological power of the speaking subject over the beloved, to whom the song is addressed. *Jouissance* is the metaphor for domination in the erogenous zone: "ben deu quascus lo *joy jauzir* / don es *jauzens* [. . . it is right that each one celebrate (*jouir*) the joy / that makes him rejoice (*jouir*)].—*Pus vezem de novel florir*, 5–6 (Guglielmo IX: *Poesie*. Edizione critica a cura di Nicolò Pasero (Modena: S.T.E.M.-Mucchi, 1973.)

grounded narrative that runs counter to the first. The prison tower in *Guigemar*, for example, is a symbol of the bonds of matrimony. None but the husband, his sister, and a castrated priest can gain entry to the tower in which the woman is enclosed, surrounded by the paintings of Venus preaching the duties of love. And yet, this archetypal scene of domestic unbliss becomes the site of a mutually satisfying romance that delivers more than the delight promised by the paintings. Marie achieves this reversal not by following the Latin script, but by introducing a barbarism, a pathological signifier in the form of an element that is both linguistically foreign and foreign to the rationality espoused by the Latin subtexts. This element is the fantastic, the Celtic fantastic. Guigemar, the Breton lover, gains entry to the tower by means of Celtic folk motifs—the boat that sails without a crew, the arrow that strikes both quarry and hunter, the talking white doe with antlers, the words of the dying white doe that wound him. It is the Celtic, translated by Marie, that allows the ekphrastic paintings of the Latin love tradition to take on entirely new connotations that transform the lay from lament to romance.

What is true for *Guigemar* is also true of other lays. Marie introjects in her poems metaplasms or pathological signifiers in the form of the fantastic: hawks that fly through the windows of unhappy women and transform themselves into handsome princes (*Yonec*); werewolves that avenge unfaithful, scheming wives (*Bisclavret*); swans that bear messages (*Milun*), and so on. The Romanesque in Marie comes less from the Roman subtexts than from the *roman*, the vulgar tongues and the romance of the Breton *aventure*. The metaplasm at the center of each of her lays involves code-switching from Roman high style to Romanesque commonplace.

This linguistic code-switching liberates narrative voices recounting parallel versions of love and marriage. So we find the "official" or socially sanctioned dystopic marriage juxtaposed with the competing "voice-over" fantasy where women are free to engage a partner of their choice in a world of sexuality without violence (in the sense of enforced contracts and physically constrained lives). Marie's code-switching literally introduces different languages and invokes different value systems. The utopia of the fantastic appears normal within her narratives: women become pregnant and have babies with men to whom they are sexually attracted, whom they love, while the normal social practices evoked on the contextual margins appear barbarous.

Might one see in the frequent physical transformation of so many

of Marie's characters a diegetic equivalent of metaplasm? For just as metaplasm meant poetic license to transform language norms for the sake of narrative, so physical metamorphosis invoked fantasy to convey the affective and sexual needs of the body as signifier. Metaplasm enacts Marie's counterpolitics of the body to abolish dichotomies of identity and difference in favor of a philosophical anthropology of aisthesis or affective perception where the human is a continuum— like language itself—of complex constructs: that is, varied and contradictory expressions. What Marie shows us by naturalizing the fantastic in her *Lais* is the transgressive appropriation of the extraordinary by the commonplace.

III. Gothic Middle Ages?

MICHAEL CAMILLE

Gothic Signs and the Surplus: The Kiss on the Cathedral

Just as meaning in literary texts is often generated by intertextuality, this paper deals with what we might term intervisuality—a process in which images are not the stable referents in some ideal iconographic dictionary, but are perceived by their audiences to work across and within different and even competing value-systems. One such image that was manipulated by various verbal and visual discourses in medieval society was the kiss.

> Li baisiers autre chose atrait
> Et quant il a la fome plait
> Qu'ele le veut et le desirre,
> Du sorplus n'i a nul que dire [Ll. 129–34]

The kiss leads to other things, and when it so pleases a woman that she wants and desires it, there is no doubt about the rest.[1]

During the Middle Ages the kiss was paradigmatic of the rich potentiality of the sign since it always led directly to something else. This *sorplus*, described here by Robert de Blois in his manual on the behavior of women, *Le Chastiement des dames*, was most often seen as sexual intercourse. Yet the meeting of mucous membranes had associations more complex than those that we now categorize narrowly as

*I would like to thank all those who offered suggestions and ideas at the Conference. This piece is a shortened version of my paper and space allows me to cite only a selection of the relevant sources.

1. Cited in Nicolas James Perella, *The Kiss Sacred and Profane* (Berkeley and Los Angeles: University of California Press, 1969), 103.

YFS Special Edition, *Contexts: Style and Values in Medieval Art and Literature,* ed. Daniel Poirion and Nancy Freeman Regalado, © 1991 by Yale University.

151

the sexual. Like so many other once multivalent social signs, today the kiss has retreated into the finite realm of the private or preys upon our desires for commodities on advertisements and billboards.

During the Middle Ages an equivalent public advertising space in the city of Amiens was the West Front of the Cathedral, constructed during the 1230s. Its vast number of carved representations functioned similarly both to arouse and repress. Beneath the Last Judgment of the closed central doorway, the onlooker saw a static row of twelve female figures with attributes personifying the virtues that he or she should live by, and below them, in vivid scenes of action, the corresponding vices that were to be repudiated. Beneath Chastity ("A virgin whose mouth has never been kissed" according to Alan of Lille) is the scene of *Luxuria*—a couple whose mouths and bodies meet in exactly this (Fig. 1).[2]

During the twelfth century *Luxuria* was depicted as a woman suffering the eternal punishment of having her genitals bitten by serpents and toads in Hell.[3] This change, from depicting the eschatological outcome of vice to enacting its perpetration in the here and now, is best understood in the context of the Fourth Lateran Council of 1215 which instigated confession as necessary for every Christian. Just as these new rules meant that, in Foucault's terms, for the first time "society has taken upon itself to solicit and hear the imparting of individual pleasures" these same forbidden acts had to be represented in order to be recognized.[4]

Canon lawyers of the thirteenth century, in their more systematic definition of the laws of sexual conduct, often equated kissing with the major misdemeanour of fornication (sexual intercourse between an unmarried man and a woman) and the even more serious crime of adultery. Perverse pairs, like that at Amiens, are pictured in illuminated initials to these laws in the Decretals of the period.[5] Gratian, the most influential of the Decretists, even insisted that "extraordinary sensual pleasures" have no place in marriage and refers directly to

2. The relief is discussed in context by Emile Mâle, *Religious Art in France: The Thirteenth Century* (Princeton: Princeton University Press, 1984), 119.

3. For the iconography of *luxuria* see Ellen Kosmer, "The 'noyous humoure of lecherie," *Art Bulletin* (March 1975): 4.

4. Michel Foucault, *The History of Sexuality, An Introduction* (New York, Vintage Books, 1980), vol. 1, 63.

5. Adolf Katzenellenbogen, *Allegories of the Virtues and Vices in Medieval Art* (New York: W. W. Norton, 1964), 78–79.

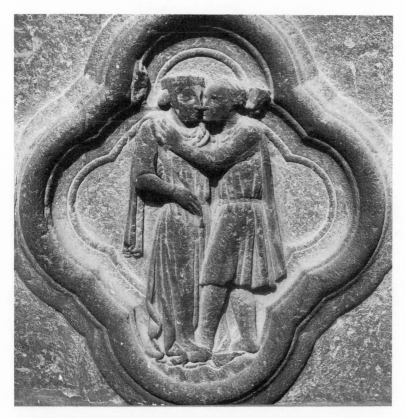

1. The vice of *Luxuria*, Amiens cathedral, West Front relief beneath left jamb figures. (Photo: James Austin).

"whorish embraces" that were more sinful when practiced in the marriage bed than with a prostitute.

According to Georges Duby "the historian cannot measure the role of desire".[6] Michel Foucault's great unfinished project, *The History of Sexuality*, however, attempted exactly this—to assess "the practices by which individuals were led to focus their attention on themselves, to decipher, recognize and acknowledge themselves as subjects of desire" (Foucault, *Sexuality*, 63). When placed within this history of desire rather than the history of iconography, the *Luxuria* image emerges as more than a literal depiction of unlawful sexual relations outside marriage. In its lack of transcendent signifiers it is a radically new type of

6. Georges Duby, *The Knight the Lady and the Priest: The making of Modern Marriage in Medieval France* (New York: Pantheon Books, 1983), 156.

representation precisely because this opens it up to a plurality of inde-
terminate associations. What was to ensure that this sculpture simu-
lating a prohibition would not be used to stimulate a transgression
instead?

This is the problem with image-signs. Once produced they can be
viewed and used for entirely different purposes than those for which
they were designed. Although it had a very clearly demarcated set of
meanings related to the vice of sexual excess, the kiss is an example of
the ambivalence of visual images in which the excess, the *sorplus*—
spills in many more directions than the usual polar opposites of the
sacred and secular. To understand the instrumentality of this Gothic
image fully we have to reject this sacred/profane dichotomy along
with others like spirit and flesh or even form and content; dualisms
which have defined our understanding of medieval culture for too long.
I am not interested in the origins or sources of the *luxuria* design, but
rather its position among a series of contemporary and subsequent
representations of human desire.

THE LECHEROUS KISS

Emile Mâle, who decoded the cathedrals for our century, described the
interdictory Amiens image in the idealist terms of his own nineteenth-
century nostalgia. Compared to the genital-exposing Romanesque per-
sonification of lust, this Gothic image seemed "charming and exceed-
ingly chaste" to him. The male Mâle saw in the costume and postures
of the two figures "an age of chivalry par excellence, an age that deified
woman; artists whose task was to ward against her could not bring
themselves to demean her" (Mâle, *Religious Art*, 120). If the *luxuria*
relief does refer to courtly values, it is surely exactly for the purpose, of
denigration rather celebration.

For the reformed clergy of the thirteenth century, the men who
served at and built Amiens Cathedral, *le sorplus* was out of bounds. To
embrace a woman was to embrace the devil. In an illustrated manu-
script of Guillaume le Clerc's Christian moralization of the behavior
of animals, the *Bestiaire Divin*, the Ybex, a bird which 'cleans its
bowels with its own beak and enjoys eating corpses' is interpreted as
the priest who, instead of partaking of the "*viandes espiritels*," the
spiritual meat of the mass at the right of the scene, prefers the "*char-
nels viande*," or fleshly meat of worldly pleasures (Fig. 2). The rela-
tionship between eating, drinking, and kissing as forms of oral grati-
fication are embodied in the tonsured cleric who is coaxed on by a devil

2. The allegorical significance of the Ybex, Guillaume le Clerc's *Bestiaire Divin*, Paris, Bibliothèque Nationale, fr. 14969, fol. 22v. (Photo: Bibliothèque Nationale).

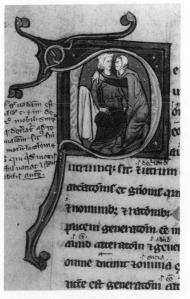

3. Initial to Aristotle's *De Generatione*, Paris, Bibliothèque Nationale, lat. 12953, fol. 166r. (Photo: Bibliothèque Nationale).

to partake of the rich food on the table and to savor the taste of female flesh. Below the feasting scene, the same embracing group repeat their fornication in the flames of Hell. Below the group is an Ybex sucking on a corpse, making the analogy between the woman's flesh and carrion quite explicit.

The woman in the Amiens relief likewise signals death. She seems to stand aloof from the man who kisses her (Fig. 1). Her rigidity approximates her to an idol "the sight whereof enticeth the fool to lust after it" (Wisdom 15:5), a subject I have treated elsewhere.[7] The *'sorplus'* of sex and death is signalled by the vertical alignment of lips coming

7. Michael Camille, *The Gothic Idol: Ideology and Image-making in Medieval Art* (Cambridge Studies in the New Art History: Cambridge University Press, 1989), 298–316.

together directly above the genitals with their hidden, uncontrolled moistenings and movements, a conjunction also made in the accidental etymology of the latin word for kiss, *osculum*, that links *os* (mouth) with *cul* (ass).

In thirteenth-century Parisian manuscripts of Aristotle's *Physics*, which was a set text for students of theology at the University, the book on human sexual reproduction, *De Generatione*, was often euphemistically illustrated by an embracing couple in the first initial (Fig. 3). Like the spiritual glosses added by scholars beside this text, might this image also be a condemnatory pictorial gloss with a message similar to the Amiens relief? Probably not, since the *sorplus* of this embrace (implied in the bedroom setting too) is, in a proper marital relationship, birth and new generation.

Another reason for comparing the Amiens sculpture with the initial to Aristotle's *De Generatione* is that it was in this very treatise that Aristotle defined conception as the mother providing the matter and the father the form of the foetus. "The male provides the 'form' and the 'principle of the movement,' the female provides the body, in other words, the material."[8] Making the male the active and the female the passive partner has its visual equivalent in the initial, where the woman's form is in repose, as compared to the probing arms of the man. As Thomas Aquinas reiterated, "the female alone provides the matter," inserting a flesh/spirit dichotomy between the sexes which had a profound impact on medieval attitudes to the body. For our purposes, in terms of these images of excess and embrace, the key factor is that its power is ascribed to the male in the creative act of coitus.

Sex was deemed necessary only for the multiplication of the species; indeed according to Gratian's *Decretum* it was essential that a marriage be legally consummated. Although the nuptial kiss in the marriage ceremony itself was one totally devoid of erotic overtones and was allied rather with the kiss as a sign of legal union, visually it still pointed to its carnal ratification.[9] Such a matrimonial kiss illustrates Book V of Averroes's gloss on the *Physics* in a manuscript produced in Oxford (Fig. 4). This evokes the more elevated and abstract physical

8. Aristotle, *On the Generation of Animals*, trans. A. L. Peck, (Loeb Classics, London 1913), 111.

9. On legal strictures and kissing see James A. Brundage, *Law, Sex and Christian Society in Medieval Europe* (Chicago: University of Chicago Press, 1987), 204, 247, 303, and 447.

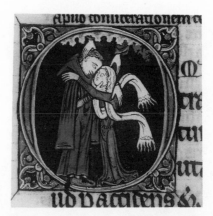

4. Initial to Averroes's Commentary on Aristotle's *Physics*, Paris, Bibliothèque nationale, lat. 6505, fol. 132v. (Photo: Bibliothèque nationale).

fundamentals of movement toward unity. The Deity's hands come down from on high to bring the couple together (Fig. 4). The legitimacy of their embrace is also displayed in the nuptial bands worn by the bride. In marriage the *sorplus*—the act of coitus—was a validating and legally required "movement" to fulfil the agreement. Movement has a quite different status in the Amiens kiss, suggested by the fact that instead of Divine sanction bringing the man and woman together, two devils, now broken-off, once crouched on their shoulders inciting them to defy God in self-defilement. As immobile statues, forever frozen into their guilty positions, they are like the adulterous couple described in an *exempla*, who were found stuck together like dogs and remained so for three days until they received liberation by true penance from a Bishop.

The kiss was seen as especially dangerous to secular clerics and men of learning. A little-known fragment from a secular building, perhaps a school at Reims, ca., 1160 (Fig. 5), makes a parallel between the deadly tongue of the serpent that attacks a young man on the bottom left, with the mouth of the whore who clutches him on the right, both beneath another clash of tongues—the scholarly *disputatio*. But the dialectics of desire suggested in this speaking, biting, kissing image and precursor of the Amiens sculpture is more ambiguous—for the kiss is not only represented in medieval culture to depict the prohibition of desire, but also its fulfillment in other contexts. If materiality was the stepping stone to hell for those who embraced the carnal body, it was the blissful way to heaven for those who sought to kiss Christ's incarnate flesh.

5. Tympanum with figures disputing, man fighting a dragon and a kissing couple, Musée Saint Rémi, Reims (Photo: Archives Photographiques).

THE SPIRITUAL KISS

An embrace and kiss pointing not to Hell but rather to Heaven is pictured in an initial '*O*' to the opening of the *Song of Songs* in a thirteenth-century Bible. (Fig. 6). King Solomon (the supposed author of the work) kisses his Queen in a manner common in such contexts, though usually the two are full-length. In the most orthodox view, the love of the Bridegroom for the Bride represented Christ's love for the Church, but twelfth-century Cistercian exegesis has re-exposed the bodily metaphors of desire and love-longing in order to express the individual soul's love of God. The Christ-*Sponsus* is nearly always shown as the active, kissing partner, the bridegroom's arm encircles his bride here just like his profane peer at Amiens (Fig. 1). But in the latter the kiss is taken, not bestowed. The kiss, like the gift, is a crucial

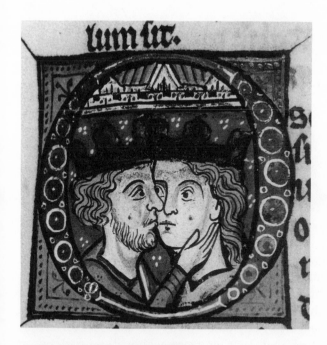

6. Initial to the Song of Songs, Bible.
London, British Library, Royal MS.I.B.
XII fol. 208r. (Photo: Conway Library,
Courtauld Institute of Art).

integer in the symbolism of exchange and social power and in all these images, it is most commonly created by and for men.

Just bringing a male and female head together in the form of this initial normally signalled danger. In medieval manuscripts that focus on the kiss was too explosive and was often erased by later readers, so charged was its negative association. Such effacement occurs on a marginal image of a kissing couple (Fig. 7), on the very first page of a manuscript of the Anglo-Norman *Vie de Seint Aedward le Rei* (ca., 1260). It actually appears below lines in the devout text which refer to the flesh being conquered by chastity [*char vanqui par chastite*] a virtue exemplified by the royal saint King Edward.[10] This is an example of an image of a kiss which explicitly stands for "the flesh" as against "the spirit." Once again the active and passive roles are clearly

10. H. R. Luard, *Lives of Edward the Confessor* (London: 1858), 26.

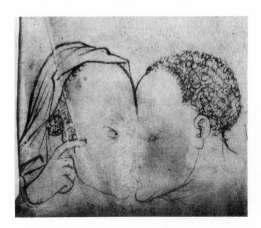

7. Kissing couple in the margin of *La Estoire de Seint Aedward le Rei*, Cambridge University Library, MS Ee.3.59 fol. 3r. (Photo: Cambridge University Library).

signalled. The woman is on the left primary side (the active side if we compare it with the *Song of Songs* initial), [Fig. 6]. Her pointing speech gesture gives her the dominant power of a harlot, her face overlapping that of the man's suggesting euphemistically that she is perversely "on top." It is interesting that another place where illuminations are obliterated in this manner—not where flesh meets flesh in two lovers kissing, but where flesh meets flesh in the meeting of the priest's mouth and the vellum page—occurs at the beginning of the canon of the mass when the Gospel Book was kissed by the celebrant. A result of this practice is that in many medieval Missal manuscripts, the crucifixes beginning the '*T*' of *Te Igitur* have been kissed out of existence.

So far I have been concerned with the kiss from the orthodox viewpoint of those who owned the *Logos* and controlled its decoding. However, even the priests and clerics who erected cathedral sculptures like those at Amiens and read Latin Bestiaries, Bibles, and Aristotelian science cannot be essentialized as constituting "sacred" as opposed to "profane" subjects: men like Richard de Fournival, a Paris-trained poet and scientist who was canon and later chancellor at Amiens cathedral for twenty years from 1240. Clerics like Richard knew and entered into other discourses which existed alongside and in opposition to their own, and where the sign of the kiss was deployed quite differently as an instrument of power. These other systems of thought and expression are implied in the Amiens relief.

8. King Mark kisses Tristram, Chertsey Tile (diam.25.2 cm.), London, British Museum. (Photo: British Museum).

THE LEGAL KISS

The *osculum feodale* was part of the symbolic ritual of vassalage. That given by King Mark to Tristram after he accepts the challenge of the evil knight Morhaut is depicted in the one of the Chertsey Tiles (Fig. 8). In the context of Romance this embrace ratifies and legitimates a feudal agreement. The feudal *osculum* comes in what Le Goff terms the second phase of the ritual, the *foi* or *fidelité*, and unites in perpetuity the two participants. It is a pledge of faith functioning like a seal or document in a semioral culture—a record written with the lips just like an oath spoken with them.

Practices varied so much, that whether it was the lord who bestowed a kiss upon those under his protection or the vassal who gave the kiss to his lord in rendering his due respect, is less important than the reciprocity (it) symbolized. What is crucial is that women seemed to have been exempted from this rite, according to some texts, "for the sake of decency," which not only suggests the way in which the signs were transformed by participation but also that a clear hierarchy of types of *osculum* was understood.[11] Women were the beneficiaries of the kiss only in the bestial sense or as it was bestowed upon them by the active infusing male (either within the soul in the spiritual exegesis on the *Song of Songs*, or in the body in the materialist Aristotelian terms of conception): lacking the kiss, they lacked power. If the active lecherous old woman is so grotesque in the thirteenth-century

11. See Jacques le Goff, "The Symbolic Ritual of Vassalage," *Time Work and Culture in the Middle Ages*, (Chicago: University of Chicago Press, 1980), 256.

drawing (Fig. 7), it is because women were generally subject to the kiss, not its bestower. The exception was the discourse of courtly love where, as lords over their lovers, women wielded the kiss as tactic, shield, and weapon.

THE COURTLY KISS

Le Goff was loath to associate the highly symbolic act of feudal hommage with what he called *"le baiser courtois,"* but I believe we must. The courtly kiss appropriates both the sacred associations of the spiritual *osculum* of the Song of Songs and secular legitimacy from the *osculum feodale* in order to rescue the sign from the deathly kiss of the flesh. Important in courtly love, the lover's goal is to receive a kiss from his beloved—a social inversion of the unusual power structure. He becomes *her* vassal. In a Picard Psalter ca., 1290 we witness the confabulation of spiritual and secular signs in an extraordinary shifting way. In the *bas-de-page* the two phases of the lover's approach to the lady are represented as an inversion of the vassal's *immixtio manuum* whereby he pledges allegiance to his *dominus*, and the kiss of feudal loyalty which usually follows (Fig. 9). The lover similarly swears to the God of Love with the feudal ritual in illustrations to the *Roman de la Rose*, which is also a veritable encyclopedia of kisses.[12] Elsewhere in the poem the legal associations of such acts are inverted when Fair-Welcome refuses to let the lover kiss the rose because "He to whom one grants the kiss has the best, most pleasing part of his prize, along with a pledge for the rest" (l. 3473). On the Psalter page the lady, *domina*, grants the lover her love (Fig. 9). This image doubly sanctions the relationship between man and woman, not only by framing it within the feudal service ritual, but also by the divine text of the Psalms, which on this page speaks of *Dominus* in heaven and His salutation. Courtly love is an ideology constructed, just like this image, out of the fragmented connotational authority of other systems, secular and spiritual. Its visual and verbal vocabulary is a self-conscious inversion, which, like all parody, draws attention to the inadequacy of the systems it has appropriated.

The first clandestine kiss of Guinevere and Lancelot is exemplary

12. For the God of Love kissing the lover see Oxford, Bodleian Library, e. Museo 65 fol. 15v reproduced in *Visual Resources* Vol. 3 (1983) Figure 5. The climactic kissing of the Rose is discussed in Camille, *The Gothic Idol*, 323 and Fig. 173. Jeunesse's kissing her "ami" (vv. 1259–79) is also illustrated in *Rose* MSS.

9. Amorous games in the margins of a Psalter, Paris, Bibliothèque Nationale, lat. 10435 fol. 44r. (Photo: Bibliothèque Nationale).

of the way Romance models itself verbally and visually upon more elevated sacerdotal and feudal images of power. In the prose *Lancelot* the lady Guinevere, as superior being, grants her lover this boon and even grabs her beloved in her hands to gain her kiss, illustrated in a manuscript produced near Amiens late in the thirteenth century (Fig. 10). In image and text the lovers only attain this goal with the help of Lancelot's friend Galehot, who sits between them, making it appear that they are merely conferring. It is Galehot who repeatedly sollicits the Queen to kiss the quivering and timid hero; "Go on, kiss her in front of me to begin your true love" he pleads again and again. Attuned to the oddity of this zealous go-between, the illuminator has painted Galehot's hand curling around her body according to the traditional schema (Fig. 4), not that of her lover's. The Queen finally takes hold of him "by the chin and kisses him in front of Galehaut for quite a long time."[13] The third party is here not only as a witness to their ceremony of homage, but also acts the role of God the Father to their Son and Spirit in a design which has been related to other devotional prototypes, but most closely approximates the three-person Trinity.[14] The reasons for the illustration appropriating such a hieratic sacred

13. E. Kennedy, *Lancelot du Lac. The non-cyclic Old French Prose Romance* (Oxford: Oxford University Press, 1980), 348–49.

14. See the three-headed Trinity type in South French MS Toulouse, Bibl. Mun. M. 19 fol. 121 reproduced by Abbé V. Leroquais, *Les Sacramentaires et les Missels manuscrits des bibliothèques publiques de France* (Paris: 1924, pl. LIX).

10. Kiss of Lancelot and Guinevere, *Lancelot du lac*, New York, Pierpont Morgan Library, M.805–6, fol. 67r (detail).

type is another means of elevating the illicit relationship, making it not an adulterous "whorish" kiss like the one between the pair at Amiens, but a divine union of souls.

Images in books such as this could have an exciting, inciting effect upon those who read them. As the pathetic shade Francesca tells Dante in the Fifth Canto of the "Inferno," it was when

> One day we were reading for pleasure, of Lancelot and how love bound him; we were alone and unsuspecting. Several times that reading made our eyes meet and drained the color from our faces.; but it was one point alone that undid us. When we read of the Queen's longed-for mouth being kissed by so great a lover, this man here, who may never be parted from me, all trembling, kissed me on the mouth. A Galehut was that book and he who wrote it; we read no further in it that day. [Perella, *The Kiss*, 146]

Books and images are go-betweens, instigators of the very acts they represent, damning their readers into endless cycles of duplication. During the Middle Ages, resemblance and repetition made what is represented much closer to what is enacted than we care to think today. No images were more dangerous in this respect that those which

11. The Kiss of Judas, Psalter, Cambridge, St. John's College, K.26 fol. 18v. (Photo: Master and Fellows of St. John's College).

showed evil kisses, like that of lust, and also that inversion of the feudal kiss,—that of treachery.

THE TREACHEROUS KISS

The kiss by which Judas betrayed his master to the Roman guards was a debased and inverted sign. The all-knowing Himself asks rhetorically "Judas, dost thou betray the Son of Man with a kiss?" (John 18:4–5). Gothic artists representing the scene of the Betrayal make much of this dichotomy between act and intention. The two figures have the elegant, attenuated gestures of feudal and courtly lovers (Fig. 11). Indeed, in the garden of Gethsemane they include subtle visual echoes of love-garden images, in the way Judas coyly embraces his object, in strong contrast with the violent and contorted gestures of the guards around them. The one who is kissed stands passive, like the female *sponsa*, but taller than the upward-looking, adoring traitor, whose arm often curls around the shoulder of his beloved as in the erotic examples of such embraces (Fig. 3). The Gothic image of this scene is layered not only with the signals of feudal loyalty/disloyalty, but also with the power relations inherent in erotic osculation.

This is perhaps explained by the fact that in order to oppose the kiss of Judas to the spiritual kiss of breath which Christ gives to his apostles (John 20:21), it has to become profane, debased, sexual. Just as Adam

and Eve sinned through the mouth, *"par boche,"* by eating the forbidden fruit, Judas's great sin was emblematized in this perverted oral gesture. In medieval legends of Judas Iscariot, he becomes an Oedipal monster who marries his own mother, thereby stressing his deviant sexuality. According to James of Voragine's popular account in *The Golden Legend*, the reason why the traitor's bowels gushed out after he hanged himself (Acts 1:18) as depicted in the sculpture on Strasbourg cathedral, was because "He did not want to vomit them from his mouth, because his mouth could not be defiled having touched the glorious face of Christ."[15] The kiss of Judas, the most necessary kiss in Christian history, reverberates with the dark forebodings of death linked to the carnal kiss.

Significant in this respect is the fact that images of homoerotic kissing were not unknown in the thirteenth century. The *Bible moralisée* interprets the pair of angels who visit Lot at Sodom as contemporary Sodomites and heretics—a cleric and layman on the left, and two women already standing in the hellmouth on the right (Fig. 12). Such didactic images equating homosexuality with heresy were part of the increasing repression and representation of sexual transgression. Homosexuals are here represented as an inverted equivalent of the vice of *luxuria* (Fig. 1), even though the visual sign is no different from the same-sex kissing of the feudal *osculum* (Fig. 8). The ambiguity arises partly because the actual *sorplus* of sodomy was even more impossible to picture or portray, except through animal allegories, like the weasel, as occurred in the Bestiary.[16] Just as Christ could become mother and lover in spiritual images and writings of the period, Judas's kiss puts him in the position of the inverted beloved, both in terms of gender and the dynamics of salvation.

THE MYSTICAL KISS

Mystical writers, male and female, following the tradition of the *Song of Songs* and its Bernardine explication, constantly seek His kiss. In an illustrated mystical tract made for Cunegundis, abbess of the Monas-

15. Jacobus de Voragine, *The Golden Legend* (New York: Arno Press 1964), 174; and for the theology of the treacherous kiss, R. B. Halas, *Judas Iscariot: A Scriptural and Theological Study* (Washington D.C.: Catholic University of America Press, 1946), 140.

16. See John Boswell, *Christianity, Social Tolerance and Homosexuality* (Chicago, University of Chicago Press, 1980). Fig. 11 for an illustration of weasels kissing (signifying sodomites) in the margins of the Queen Mary Psalter.

12. Genesis 19:1 and its interpretation, *Bible moralisée,* Oxford, Bodleian Library, MS Bodl. 270b. fol. 14 (Photo: after De Laborde).

13. The Mystical Kiss of Christ and his mother, *Passional of Abbess Cunegundis,* Prague, Bibl. Univ. XIV A 17 II fol. 16v. (Photo: author).

tery of Saint George in Prague between 1312 and 1321, there is a famous image of the Virgin Mary embracing Christ, inscribed *Jesus Christ salutes his mother with the kiss of peace* (Fig. 13). The mother's active embrace of her son, described in the love-language of the *Song of Songs,* expresses a union of her maternal physical body which gave birth, through matter, to his incarnate body. Theologians and mystics used the Aristotelian notion of the female production of matter here to substantiate the physicality of the Savior born from the flesh of a woman. The Virgin Mary, being the Bride, (and also theologically the Church, married to Christ) asks for the kiss—the Spirit—from her husband/Son in order to conceive Him. As daughter, Bride, and Mother of God her kiss is charged with excess; a *surplus* which leads to the incarnation, the passion, and the salvation of mankind. This salvatory trajectory is indicated in the drawing by the clear display of the bloody orifices, the wounds of hands and feet which become lips to so many mystics eager for their moist touch. Excess, which had been exemplified in the vices at Amiens cathedral, was a major component of

the mystic's repertory. Bodily excesses and exudings, in fact a whole language of the body was developed, in which the flesh was not a barrier but a medium for spiritual exploration.[17]

Images were powerful agencies in medieval society not because they were imposed from above or served as "equivalents" for texts, but precisely because they were visible, tangible, malleable forms, capable of transformation. Reversals and inversions were crucial to their effect. The kiss in this sense reveals its valency, not as a transcendent symbol, but as a material sign serving certain groups in society and defining them against others. The one of the couple at Amiens, redolent of Romance and feudal ritual—albeit as a lack—helps relegate them to the murky realms of the flesh, which for some viewers, meant death. Likewise erotic and carnal reverberations make the kiss from the *Song of Songs*, or that of the Virgin for her Lover/Son, deeply meaningful to some Christians.

THE KISS OF PEACE

In his devotional treatise, the *Livre de Seyntz Medicines*, the early fourteenth-century "amateur mystic" Henry, Earl of Lancaster gets caught up in the rapture of signification and we can witness his utilizing some of the very images we have explored as he struggles to embrace Christ. He starts from blood, which he imagines splurting out of the Savior's multiple wounds and trickling down His face into His mouth. Thus he wants to kiss and be healed (spiritually) by that liquid. Demanding a kiss he states that there are three types. First there is the lecherous kiss, (*"uine baiser orde et lecchereuse)* "by which I killed myself as well as her to whom I gave it." Henry is not afraid to admit that he always preferred the kisses of lewd women to those of God-fearing ones. The second is the treacherous Judaslike kiss given to his "fellow creatures while having only ill-feeling towards them." The third kiss is that which he gives Our Lord every day at mass "as a token of peace ending the war between us." This, he hopes, will help heal the wound of his mouth, festering because of the previous two evil kisses (*"malveiste de beisers"*).[18]

17. See Caroline Walker Bynum, "The Female Body and Religious Practice in the Later Middle Ages," in *Fragments for a History of the Human Body, Part One* (Toronto and New York: Zone Books, 1989), 161–219.

18. E. J. Arnould, *Le Livre de Seyntz Medicines* (Oxford: Oxford University Press, 1940), 177–80.

14. "Concordiam in populo," Calendrical Booklet, Oxford, Bodleian Library, MS. Rawl. D. 939. (Photo: Bodleian Library).

Many of the images we have looked at in this text in the mingling of luscious and repugnant liquids, from the polluting carnal kiss to the liturgical kiss of peace, collide. The latter brought the congregation together in the mass and was enacted by a chain of kisses linking each participant with the ultimate mouth.

An image evocative of this kiss of peace, that Henry might himself have seen, appears in a fourteenth-century calendrical booklet among scores of isolated little picture—signs meant to guide the reader through the Church calendar. A crudely drawn formula of a man embracing a blocklike woman, conforming to the type we have seen before, is simply inscribed *concordiam in populo* (Fig. 14). If the image with which we began was meant to convey the sin of fleshly union in general, this one, so close to it in form, represents the values of the social body as a unity.

Such signs became increasingly ambiguous for the Church, however; worried that the mingling of male and female mouths was encouraging the newly defined sin of the *sorplus*, bishops in the midthirteenth century introduced the *osculatorium*, or pax-board. This was a small hand-held panel of wood or metal, painted or gilded with an image of the crucifix, which was passed around the congregation to kiss as an external point of reverence at that point in the service where the kiss of peace had once been shared by all.[19] This location of desire in an intermediary zone—in the individual image—begins the long history of its spectacularization. Expending excess in isolation rather

19. For the kiss of peace see J. Bossy, "The Mass as a Social Institution," *Past and Present* 100, (1983): 55–56; for examples of the pax or kissing board, D. Rock, *The Church of Our Fathers* IV (London: 1905), 187; *The Age of Chivalry*, ed. J. J. G. Alexander and P. Binksi (London: 1987), 240.

than socially, this mass-image can be seen as the prototype for today's "mass-images." The kiss on the cathedral or in the book did not substitute or reflect (like the kissing-board), but ratified and even enacted, desire. Simulating, in a single framed image, a ritual once transferred through and between bodies, the kissing-board might be seen as paradigmatic of the limits, rather than the surplus, of postmedieval representations.

CLAUDE THOMASSET

Toward an Understanding of "Truthfulness" in the French Version of the *Pratique* by Maître Bernard de Gordon

The medical *Pratique* of Maître Bernard de Gordon is an excellent medical book, designed for practitioners. The author wrote it in Latin, finishing it in July 1303. Of this authoritative work, only some manuscript fragments in French remain.[1] This *Pratique,* also entitled *Fleur de lys en médecine,* was edited in this language in 1495.[2] It is based on this text that we have chosen to analyse the way in which the author gives his text the appearance of verisimilitude, how he stages and strategizes the discourse, the main points of which have not been lost in the translation from Latin to French. The translator responsible for the 1495 edition wanted to follow up, and even develop the thought-process of the master. As far as the macrostructures are concerned, the strategy of presentating truth remains unchanged and I believe that this presentation of truth is what directs his discourse.

The *Pratique,* or the type of writing that bears this name,[3] is intended for a group of individuals who saw patients. The myth of a master dispensing knowledge to a disciple, so dear to didactic liter-

1. For a study of the general works of Bernard de Gordon, see Luke E. Demaitre, *Docteur Bernard de Gordon: Professor and Practioner* (Toronto: Pontifical Institute of Mediaeval Studies, 1980). For the manuscripts and the editions, see in particular 171–97.

2. *La Pratique de Maistre Bernard de Gordon qui s'appelle Fleur de Lys en medecine* (Lugduni 1495, in 4°).

3. For the distinction between theory and practice, see for example Nancy G. Siraisi, *Taddeo Alderotti and his pupils—Two Generations of Italian Medical Learning* (Princeton: Princeton University Press, 1981), 109: " . . . medicine was divided into two parts, theory and practice; and surgery pertained entirely to practice. Medical practice was in turn divided into the science of regulating healthy bodies and that of regulating sick bodies." See also 122–23.

YFS Special Edition, *Contexts: Style and Values in Medieval Art and Literature,* ed. Daniel Poirion and Nancy Freeman Regalado, © 1991 by Yale University.

ature, is maintained here through the continuous use of a "Tu" [you], which refers to any individual belonging to the medical profession and likely to be called to the bedside of a patient. This interlocutor must submit to one obligation only, ENTENDRE [TO HEAR], in other words "comprendre" [to understand]. Indeed, "tu dois entendre" [you must hear] is a phrase that scans the rhythm of the text, as is the incitement to SAVOIR [TO KNOW]. But this knowledge, this information, can be verified for it is transmitted through an utterance whose characteristics are already provided in the prologue.

The prologue remains unchanged in the translation from Latin to French. We begin with the notion that the medical *Pratique* is a work whose goal is to tell the truth. And of course to approach truth is to approach God: "Nul ne se peut mieulx approcher a Dieu que en estudiant en verité et pour verité" [No one can better approach God than by studying in truth and for the truth]. The idea is thus to approach God through science; the object of study "in truth" and "for the truth" is the human body. This discourse is authenticated by allusions to the Gospels which aim to deny differences among minds. Indeed, the *Pratique* is intended for the humble: "Je escrips aux humbles" [I am writing for the humble]. The proud, prey to excesses, do not "eat at the common table with the others." By the humble, one must understand the community of practitioners, whereas the proud disdain communication and didactic practice. "And these proud people despise the writings of commoners and are ashamed to say one thing if it has already been said once." Clerical rhetoric had accustomed us to a fiction: that of an esoteric knowledge, parsimoniously imparted in the framework of an economic exchange between a rich patron and a penniless clerk anxious to make money from his compilation. The secret of a science denied to the common person and built on a perishable base is thus guaranteed. In contrast, Bernard de Gordon addresses the humble so that they may profit from his medical and surgical teaching.

The authority of rhetoric requires the repetition of every statement. Indeed, Seneca says that "something is not said too often when it is not said enough" and Horace holds that anything can be "repeated ten times." As for speech, it transmits knowledge, but a type of knowledge that is based on its acceptance by everyone: "Certainement nous ne sçavons nulle chose fors ce que nous disons souvent et ce qui nous est commun et ce que tout homme reçoit" [Certainly we know nothing save what we say often and what is common and what every man accepts]. The issue here is indubitably that of vulgarization of speech,

but at the same time that of the stability, the invariability of discourse: "nous ne sçavons nulle chose, fors ce que nous disons souvent" [we know nothing save what we say often]. Repetition guarantees truth; the vague and obscure are held at a distance. The image of the lily which provides a pattern for the structure of the text and gives it its title requires this: "VI parties seront blanches et transparans pour leur grant demonstrance" [Six parts will be white and transparent because of the proof they provide]. The comparisons chosen are not particularly original, but the object to which this procedure and these considerations apply requires another meaning. The stability of discourse maintained in the *Pratique* allows for constant verification by the practitioners; it thus allows for a rational procedure. The author must consequently affirm assertions he presents as true.

Truth is the goal of didactism is truth in every place, at any time and for any speaker. That is why all diseases and all the varieties of disease call for a definition. These definitions are conceived within the theoretical framework of Galenic thinking which is never questioned and in which any disease is explained by "dyscrasie" [dyscrasia], that is to say the imbalance among the four fundamental humors of the organism. And it is within this mode of thinking that several analytical truths are established, analytic propositions developed according to different modes of thought.

Some of these definitions are founded on a kind of generic predication (for example, monkey→mammal→animals). This is the process of successive semantic inclusion. A list of generic terms which structures thought is thus established. These terms are, in the language under consideration, the conceptual tools that allow for an understanding of disease. One finds, for example: "Pustules, ce sont petites apostumes naissans ou chief ainsi que se c'estoient ampoules petites ou comme petites testes des mamelles ou s'on estoit point de orties . . . " (II,6) [Pustules are little *apostumes* appearing on the face as if they were little blisters or little nipples out of which come nettles . . .] or "Litargie, c'est une apostume du chief en la partie de devant dessoubz le crane" (II,12) [lethargy is an *apostume* of the front part of the head under the skull]. These two examples suffice to show that the generic term *apostume* allows any skin aberration or abnormal swelling to be classified. It will also have been noticed how the description is made by using analogical comparisons. The definition most frequently encountered uses words such as *passion* [passion] and of course *maladie* [disease] (for example: "scothomie et vertigine, ce sont propres

passions de sens commun" [scotoma and vertigo are passions which typically afflict one's common sense] II,11). The word *douleur* [pain] is reserved for the first diagnosis. At first reading it seems that the word most commonly used is *passion* [passion], corresponding to our modern word *affection* [ailment] ("Yvrognie, c'est *passion* du cerveau avec molification de nerfz qui viennent par humeurs resolvee de vin" [Habitual drunkenness is a passion of the brain accompanied by relaxation of the nerves due to debauchery in drinking] (II,20). The most unclassifiable definition, though one often encountered, is that where there is no generic word to describe the ailment: "Alopicie est quant les cheveulx cheent avec ulceres ou scames ou furfures" [baldness occurs when the hair falls out with sores or eschamals or dandruff] (II,1). One might think in terms of tree structures, the generic terms of which would be knots, which would immediately provide a linguistic and conceptual approach to diseases in the vernacular.

Definition by etymology is another means of approaching truth. Etymology is an exercise that permits formulation of analytical propositions: "Herpestiomenes signifie lui mesmes corrodant" [Herpestiomenes itself means corroding] (I,18). This way of thinking is still used by the lexicographers of the *Dictionnaire des termes techniques de médecine*, which proposes for example *herpes*, s.m. ερπειν: to crawl.[4] It consists in justifying a designation by another language, by proposing the meaning of the Greek word which gives a characteristic of the disease. This is how the signifier is verified, since the characteristic of the disease is already included in the etymon and need not be sought through observation, which would only confirm it. Often the technical name of the disease may be followed by a popular equivalent. Thus one finds for *cephalalgia*: "Tu dois entendre que douleur fort agüe avient aulcuneffois en tout le chief et l'appelle on cephalee ou

4. This is also the declaration of the Master to his disciple in the *Dialogue de Placides et Timeo* (ed. C. Thomasset, Paris-Geneva: Droz, 1980), 123: " . . . je vous diray plus parfons secrés, qui ne sont mie a dire fors a son chier cuer et ami, les fleurs des secrés de nature qui ne font a escripre, ce dient les philosophes par leur jugement, fors de menue lettre, petite et soutieue et foible lettre et mal lisant, en parquemin foible et mal appert et peu durant en paroles couvertes, pour ce que cose abandonnee est vile et cose a paines trouvee senee et chiere . . . " [. . . I will tell you deeper secrets which should not be said to anyone except to one's dearest heart and friend: the flowers of the secrets of nature should not be written, according to the philosophers' judgement, except in small letters, tiny, delicate and weak, difficult to read, on poor parchment that is unclear and fading, written in disguised words, for something that is open to all, is vile and something that is found after much labor is good and of great value . . .]. M. Garnier et V. Delamare, *Dictionnaire des termes techniques de médecine* (Paris: Maloine, 1979, 18th edition), 462.

doleur maleate, car il semble que on maille et fiere sur le chief" [you must understand that a very acute pain sometimes overcomes the whole face and one calls it cephalalgia or *hammering pain*, because it seems as if the head is hammered and struck] (II,10). One of the functions of this equivalence is to create an analogy and to make it immediately comprehensible to the practioners, as well as to the sick, because they are one source of information and what they say is one of the elements of the truth of a diagnosis. Translation ensures that the etymological correspondences are not lost. Thus the Latin version of the word *andrac* (anthrax): "et ideo corrodunt et ulcerant et pro tanto dicitur anthrax, quia facit antrum, et carbunculus, quia comburit sicut carbo ignitus, qui postea denigratur" [And therefore they corrode and they make sores, and for this it is called anthrax, because it makes a hole; and carbuncle, because it burns in the manner of burning coal, which thereafter is utterly blackened]. Here is the French version: "et si pourtant on l'appelle *andrac*, car il fait une antre, c'est a dire une fosse et si l'appelle on charboncle, car il art comme charbon ardant et puis se noircist" [and it is nevertheless called *andrac* because it creates a cave, that is to say a pit and thus is called carbuncle because it burns like burning coal and then it blackens] (I,18). To the translator, the word *antre* [cave] seemed to belong to rather elevated language and he felt the need to double it with the word *fosse* [pit], which nonetheless allows the speaker who is not familiar with the learned term to understand the etymological correspondence. Truth is thus approximated by the care taken to motivate the sign, by the good use of the translation, and by the convergence of etymologies.

Even if the etymology is revealed at the price of some verbal acrobatics, it represents a privileged means of approaching truth. It is not surprising that *l'amour héroïque* [heroic love] is an aristocratic ailment, for "Amours qui s'appelle *yreos*, c'est sollicitude melancolique pour amour de femme" [Love that is called *rage* is tender melancholic care for a woman] (II,18), and a few lines later, one reads: "et pour ce l'appelle on *yreos*, car les nobles en sont hoirs et pour leurs grans delices, ilz ont ceste passion" [and therefore it is called *rage*, because the noble are its heirs, and to their great delight they have this ailment] (II,19). This ailment is destined to flourish in an aristocratic milieu and to upset men's capacity for judgment, "la vertu estimative," to such a degree that they may fall in love with an ugly woman. The list of explanatory derivations never ends, and the name *maladie royale* [royal disease] is apparently a recent creation. As concerns the treat-

ment of scrofula, surgery can either cure it or "nous alons aux roys, car les roys les souloient curer en tastant, mesmement le roy de France, et pour ce l'appelle on maladie royalle" [we go to the kings, because the kings used to heal it by touching, especially the king of France] (II,20). Language is thus a source of certainty, of ever truthful assertions. As for Galenism, it provides doctors with a theory whose power of explanation never fails. It is also a tool capable of producing very complex taxonomies. Thus a theory based on the dominant humor in a sickness can explain the different forms that it takes, and everything is always true in a system that can never be proven wrong. Definition of a disease can always be replaced by a statement of the imbalance of humors that provokes it. The theory and its utilisation belong to the domain of the nonrefutable; authority can be questioned only by observation of symptoms.

When judging symptoms, one abandons the realm of certainty revealed by language to address the problem of judgment. One leaves the realm of certainty, seemingly in order to tackle the realm of the probable. The symptoms are in fact carefully indexed according to the degree of certainty they convey. Because this involves probability, there is often redundancy of expression in the formulation of truth: "Vecy *vrais* signes *san faulte* . . . " [Here are *true* signs *without errors* . . .] The concern for not letting truth escape in the linguistic act is accompanied by a methodological procedure that consists in taking only groups of symptoms into account. "Mais par *un* signe nous ne devons pas juger, car ils sont souvent *equivoques*, mais par plusieurs, car adoncques on est plus *certain*" [But we must not judge only *one* symptom for symptoms are often *ambiguous*, but rather by several for then we are more *certain*]. The most important debate that exists in the text is the discussion concerning a sign of leprosy: "Et premièrement vecy une doubte, pour ce que je le vueil sçavoir, s'il peut estre que aulcuns soit parfaictement mezeaux sans avoir nul signe en la face. Et *semble* que oy" [And first, here is an uncertainty for I want to know if it is possible for someone to be a complete leper without having any sign on the face. And it seems that that is possible]. The affirmative answer is based on nothing but appearance. The author gives the example of a man who was seriously afflicted (deformity of the feet and hands, disappearance of discrimination between the joints); it seems that he was a "mezeaux *confermés*" [a confirmed leper] (this is the vocabulary of certainty). The judgment of authority is unequivocal: "Au contraire dit Gallien et Avicenne et tous les aultres acteurs, car quant ilz met-

tent les signes de la lepre, ilz commencent aux signes de la face" [To the contrary say Galen and Avicenna and all the other authors, for when they record the symptoms of leprosy, they begin with the symptoms of the face]. Examination of this problem is preceded by a methodological statement: "de ceste question, je respons: Dieu sçait comment il en est, mais sans prejudice" [To this question I answer: God knows how it is, but without prejudice]. The phrase "Dieu sçait comment" [God knows how] momentarily suspends the truth that is asserted by authority so that the evidence can be freely examined. The objectivity of this examination is guaranteed by the expression "sans prejudice" [without prejudice]. The discovery of truth is subordinated to the development of a *disputed question* which leads us from a first *doubt* to a second *dubitation*, and to a long evaluation of arguments which I will spare the reader. To the doctor-writer the real question is: how does one extricate oneself from a conflict with an authoritative text? One might propose that the symptoms of leprosy may be more apparent in other parts of the body than in the face because of "la force des membres de la face" [the strength of the bones of the face]. But the master stroke, which enables one to reconcile truth with authority, is to declare the diagnosis of leprosy false: "Et a l'exemple de l'omme devant dit je respons que ce n'estoit pas lepre, *ains* estoit une maniere de archetique et de scabie et ulcere des ungles qui corrumpt la forme et la figure des mains" [As for the example of the man discussed earlier, I answer that it was not leprosy, *but rather* a kind of curvature, of scabies, and of sores of the nails which distort the form and shape of the hands] (I,21). We note in passing the argumentative value of *ains* [*but rather*]. An assertion that seems to be drawn from experience leads to a conclusion that purports to be definitive: the man in question has lived for twelve years, and this would not have been possible unless "la face n'eust esté corrumpue" [the face also had become distorted]. The phrase "Dieu en sçait la verité" [God knows the truth about it] puts an end to the debate and gives the odds to the final diagnosis.

In this search for truth, the doctor must be perfectly competent to read symptoms, and the epithets that describe him prove this competence, especially the word *discret* [discerning] in its Latin meaning. If some of the signs are not immediately visible, it is legitimate to turn to the patient, whose statements are never questioned. Equipped with this information, the doctor can enter the debate adequately prepared to reach the truth. Intellectual activity is revealed by phrases such as "je repond" [I answer] or "j'argue" [I argue]. These phrases reflect the

care taken to reconcile authority and professional experience, even on small details. More extensive research would certainly allow me to show to what degree the translators added traces of their observations and reflection to the original version by means of this kind of brief argumentation. These translators, and most particularly Jean Corbechon, have just such a critical mind. When Bernard de Gordon opposes authority, he does so by virtue of his experience: "Item question est de la cure se huyle rosat y compete et semble que non: car elle inflamme et pour ce elle ne compete point en herisipele. La *lettre* dist le contraire: je dy que huyle y compete" [Another question about cure is whether heated oil is adequate, and it seems that it is not, for it inflames and therefore it is not adequate for erysipelas]. Later he says: "Item Avicenne dist que chaulx y compete, je argue contre, car elle fait plus ulcere" [Avicenna also says that heat intervenes, I am against this, for it creates more sores] (I, 29). Analysis of this text shows that scholastic discussion may serve to reestablish the truth of authority which was threatened by appearances or by clinical observation declared inadequate. On the other hand, medical practice opens an area of reflexion in which experience—that is, the effects of remedies—enables the practitioner to share his knowledge with others and to refute the authority on a specific point; but it does not allow him to contest the theoretical principles that structure the certainties of medical science. Bernard de Gordon asserts the possibility of emancipation from *la lettre*, written authority and paradoxically he appeals to Galen to legitimate this freedom: "car selon Galien on ne peut tout demonstrer par lettre certainement" [for according to Galen, one cannot demonstrate everything infallibly by written authority]. This statement arises in a discussion of diet, and clearly reflects the attitude of an open mind concerned with maintaining a place for critical observation.

One should not hasten to conclude from these passages that the *Pratique* uses modern scientific reasoning. Certain words may invite one to do so: they are misleading. Such is the case for the word *experiment* [experiment]. It simply means "recipe." The author prefaces a series of cures to conserve one's vision: "vous ferés ces remedes particuliers qui sont expers en alant toujours du foible au plus fort" [you will use these special remedies which are efficacious proceeding always from the weak to the stronger] (II,5). At the end of the first recipe of remedies, the second one is introduced by "vecy le second *experiment*" [here is the second *experiment*]. The same word also serves to designate a technical procedure that allows one to verify an assertion.

As an example, the following advice specifies the nature of an ear infection: "et vecy ung experiment. Se c'est humidité aquatique fumeuse preng une esponge seche et la chauffe au feu et pren ung drapel double chaufx et le metz sur l'oreille et puis metz l'esponge sur le drapel et fay le patient dormir sur l'aureille. Et au matin tu trouveras le drapel maculé et s'il n'est maculé sans doubte, ce n'est pas maladie d'aureille par humeurs ne par sanie ne par aquosité, ains est par aultres choses" [and here is a procedure. If there is vaporous aquatic humidity, take a dry sponge and heat it up in front of the fire and take a warm folded cloth and put it on the ear and then put the sponge on the cloth and have the patient sleep on his ear. And in the morning you will find the cloth stained and if it is not then certainly it is not an ear infection due to humors nor to bleeding nor to inflammation but to other things] (III,8). The procedure is rather simplistic. It reminds us of the *exempla* that characterize treatises of the thirteenth century.

One cannot blame the author for basing his work on examples that have no true demonstrative value. But one can reproach him for using polemics in order to conceal the absence of reasoning. This is what Bernard de Gordon often does, especially when he tells of his master's death. He succombs to lethargy: in such a case, according to the author and despite the opinion of others, one must attempt to keep the patient conscious by all means, (by pulling his beard, by bending his fingers, by making as much noise as possible . . .) . The author of the *Pratique* commits himself personnally: "et j'en ay veu plusieurs eschaper par telle violance et souvent je ay accusé de homicide ceulx qui les gardoient quant ils ne me laissoient faire" [and I saw many people who were saved by such violence, and I have often accused those who watched the patients of murder when they prevented me from doing what I wanted]. The author does not hesitate to denounce his colleagues violently: "et nostre maistre mourut de litargie et avoit LX ans et estoit colerique adustes et y avoit grant compaignie de maistres" [and our master died of lethargy when he was sixty years old and he was so quick-tempered, and there was a great number of masters around him] (II,12). Hemorrhoids are opened and the patient dies and "affoiblit tant qu'il fust mort" [was so weak that he died]. The author maintains: "et je croy que cela luy greva moult" [and I think that injured him gravely]. We note in his text a surprisingly antifeminist statement: "et y avoit femmes gengleresses qui empeschoit a ouvrer, car a peine peult nul repouser ou femme ont puissance" [and there were many nagging women who prevented the opening of the hemorrhoids, for one has no

peace and quiet where woman take over]. Translation itself can be seen as a whole strategy of truth being concealed. For this is the path of demonstration: I propose a way of treating the patient, they do not follow through, the patient dies, thus I am right. An entire strategy of discourse, where the setting is distracting and which is based on the nonverifiable, is at work. The demonstrative strength of the whole lies in the position of the author as an eyewitness. There is a striking analogy between this type of writing in the medical practice and the thought process of Commynes in his *Mémoires*. The witness, always well positioned, takes a critical look at the events and raises in the reader's mind the possibility of another sequence of events. Unfortunately the reader will never know more than that, for this rewriting between the lines belongs to the realm of fiction. Hypothesis replaces a system of causality but, it is a hypothesis guaranteed by the witness. Rational truth has no place in this procedure.

For the demonstration to be persuasive, conviction must give way to reasoning. This is the case when observation reasserts its rights at the outset. The *Health Diet* is indeed a privileged ground for diagnosis. It is within this framework that the author places a fundamental debate between *nature* and *custom*. Under the authority of Aristotle, *custom* is defined first as another *nature:* "Et nous veons l'experienmce que aulcuns mengent .IIII. fois le jour et ne leur fait nul mal" [And we see by observation that some people eat four times a day without ill effects]. But the doctor must choose. And this is all the more difficult in that the authorities disagree on this question: "Et pour ce dit Avicenne que experiment vainquist raison, car male viande vault mieulx acoustumee que bonne non acoustumee, mais Constancius dit le contraire de toutes ces choses qui dist que ceulx qui usent de male ne se doyvent point esjouyr, car s'ilz ne sont blecés de present, ilz ne eschapperont pas la percucion ou temps advenir" [And on this issue Avicenna says that experience wins over reason, for a bad meat to which one is accustomed is better than a good one to which one is not accustomed. But Constantius says the opposite of all this and maintains that those who eat bad meat should not rejoice, because if they are not hurt yet, they will not escape the consequences in the future] (V,8). Here again truth must be sought in appearance and Bernard de Gordon strives to find a means of reconciliation: "Et pour ce je respons aux bons aucteurs que coustume a grant force, je dy que c'est bien verité se elle se concorde avec les choses naturelles" [And to this I answer the good authors that custom has a great impact, I say that it is

truth if it agrees with natural things] (V,8). With this last attempt to reach the truth of the natural man who is the object of medical science, closes our survey of the various means used to reach truth, the only value capable of giving the final, intangible structure for the act of writing about knowledge.

Our overview based on a translation could only address the macrostructures of the text, those put forth by the author to assert the truth-value of his definitions, of his diagnoses, and of his intellectual choices. There also exist microstructures which define the truth-value of a proposition (for example, the adverb *communement*, which means that everyone acknowledges the proposition, but that there exists at least one dissenting opinion). These microstructures can be studied only within the framework of a strict comparison between the Latin text and its translation. As I have noted in the prologue, the entire strategy to delimit truth in the *Pratique* lies in the stability of the written text. And observation must in turn be tested by authority of written tradition. This explains why the entire discourse of the *Pratique* is ruled by *je dy* [I say] (*dico*), which is transformed from a declarative verb to a shifter leading to truth. It is thus that this form of writing hopes to affirm its progression toward truth.

Translated by Sahar Amer

BEVERLY J. EVANS

Music, Text, and Social Context: Reexamining Thirteenth-Century Styles

Perhaps the first feelings we experience at present upon undertaking to examine the relationship of art to literature to society are those of gratitude, on the one hand, and relief, on the other. The gratitude is directed toward the host of historians and specialists of both literature and the fine arts who have, over the past couple of decades, made the effort to situate against a societal backdrop the rich artistic production of the Middle Ages. The relief comes with the realization that they have, by and large, done a pretty good job. As concerns text and music, the subject of this study, we might, for example, look to Paul Zumthor's *La Lettre et la voix* for a recent reminder of the extent to which the twelfth and thirteenth centuries constituted an "époque chaude": a period characterized by extremely complex movement, constant transformation, and, above all, by the "dynamismes conflictuels" associated with the encounter and eventual interplay of the oral and the written.[1] In music and poetry, this dynamic interaction voiced itself most vigorously in the polyphonic repertory, the field upon which conflict was translated into harmonic motion.

It would be difficult, if not inadvisable, to embark upon any commentary concerning music and text in the thirteenth century without first indicating the direction in which analysis has proceeded thus far. As pertains to literature, to date, any number of studies have dealt in detail with the intertextual relationships inherent in a given group of what would have been coexistent works. While attention has, of

1. Paul Zumthor, *La Lettre et la voix* (Paris: Seuil, 1987), in particular, Chap. 6, "Unité et diversité." Henceforth cited in text.

YFS Special Edition, *Contexts: Style and Values in Medieval Art and Literature,* ed. Daniel Poirion and Nancy Freeman Regalado, © 1991 by Yale University.

course, been paid to the evolution of the various literary forms over time, "intertextuality" would seem to be more generally perceived as a phenomenon associated with a moment in time. Musicological study, in contrast, has tended to concentrate on the step-by-step evolution of one style into the next. Emphasis has been placed on trying to reconstruct a sequence of stages that, over the course of several centuries, basically led from liturgical monophony to all of thirteenth-century polyphony via the Magnus Liber. Thus, a fundamental difference in approach can be cited, which accounts for the fact that musical analysis and literary analysis have, for the most part, proceeded along nonintersecting paths.

The state of affairs upon which we have just been focusing strongly bespeaks the necessity of subjecting the polyphonic repertory to reexamination. A perspective must be adopted that will allow musical and textual studies to reach some common ground. This brings us to the purpose of the current exposition: to arrange an encounter by effecting a slight shift in orientation with regard to the approaches just summarily described. The texts of a specific group of two-, three-, and four-part works will be reconsidered, following Zumthor's lead, in terms of their "intervocality" rather than what would seem to be their more limited "intertextuality" (Zumthor, 161–62). As musical compositions these pieces will be viewed as having strong synchronic value in addition to their already recognized diachronic value. Concluding observations will seek to relate the synchronous, "intervocal" nature of polyphonic music to the social context of the thirteenth century.

In attempting to distinguish, for the purposes of getting under way, one musical-textual "style" from the other, we discover, not unexpectedly, that neither the texts nor the music of the polyphonic repertory can be divided up neatly into categories according to "type."[2] It has become commonplace to cite the motet, in particular, as showing little regard for the boundaries of register, even within the individual text. Likewise, the musical forms of the thirteenth century often appear to us as being hybrid in nature, to the point that we have seen fit to use compound terms, such as "conductus-motet," in reference to them. Be that as it may, one natural line of demarcation has served a somewhat

2. The most ambitious undertaking whose goal is to establish a typology is Pierre Bec, *La Lyrique française au moven-âge (XIIe et XIIIe siècles): contribution à une typologie des genres poétiques médiévaux*, Publications du Centre d'Etudes Supérieures de Civilisation Médiévales de l'Université de Poitiers, 6 & 7 (Paris: A & J Picard, 1977–78). Henceforth cited in text.

useful end in enabling us to organize the field of study into two more manageable lots. Let us see if it seems worthwhile to continue using this natural boundary to organize our own commentary, or if it might not be better to reorient our thinking.

The line of demarcation whose usefulness we need to reassess here is of a linguistic nature: polyphonic compositions exist, of course, in both Latin and French. In general, the Latin, liturgical repertory has been examined apart from the French repertory, a practice which has produced nonintersecting paths of its own. Ironically enough, nothing about the polyphonic corpus of the late twelfth and early thirteenth centuries suggests that considering the Latin forms apart from the French ones stands to increase substantially our understanding of either. As a matter of fact, it would seem that those compositions whose musical structure and textual content achieve a successful melding of the two traditions, a skillful blending of the two voices, deserve closer scrutiny, as a group, than they have so far received.

One of the most remarkable features of a significant number of compositions that involve simultaneous enunciation of two, three, or four texts is their juxtapositioning, or more often, their superposition-ing of lines of both Latin and French verse. These pieces allow the voice of the cleric to be raised in chorus with that of the courtly lover, the shepherdess, and the others of secular poetry. Thus, they provide the most interesting examples one might hope to find of the dynamics of intervocality. The Latin/French interaction can occur, in its least elaborate form, as a simple, refrainlike insertion of a Latin phrase into an otherwise French setting. However, this sort of interaction characterizes only a minority of cases. Much more frequent is the association of lengthier passages in Latin and in French with one and the same musical composition. This manner of interplay can be divided, for the sake of study, into two main varieties, as follows:

1. two-text compositions of which one voice is entirely in Latin and the other is entirely in French;
2. multiple-voice compositions which survive in some manuscripts in an entirely Latin version and in other manuscripts in an entirely French version.

Each of these will be examined separately.

As we look to pieces that present simultaneously texts in two different languages, it is hardly inappropriate that we should wonder what logic, if any, governs this combination of material. Granted, the treat-

ment of rhythm and harmony, as concerns the musical dimension of these works, is certainly nothing out of the ordinary with respect to the polyphonic repertory overall. However, the principles underlying potential unity of text are less than obvious: greater value seems to be placed on contrast and diversity. Nevertheless, in view of the intricacy and subtlety of the art with which we are dealing, we must seriously entertain the notion that compositions involving both Latin and French texts are not, first and foremost, examples of gratuitous intervocality. Surely, these voices have been joined to each other for some reason. The task before us is to determine, by surveying a representative group of pieces, what that reason might have been.

The search for a set of compositions suitable for examination with regard to the mixture of Latin and French leads rather quickly, as is so often the case in studies of this sort, to a specific section of the Montpellier Codex.[3] Fascicle 3 of this largest extant collection of Northern French thirteenth-century polyphony consists of eleven three-voice motets in the style under consideration. Each of these uses a preexisting Gregorian melody in the lowermost voice, or tenor; a Latin text in the middle voice, or motetus; and a French text in the uppermost voice, or triplum.[4] It is worth noting at the outset that, in over half of these compositions, the Latin word or words associated with the tenor show a definite connection to either the exact words or at least the sense of the Latin motetus. This relationship, which is reminiscent of prosula technique, thus sets the motetus text upon a base whose solidarity was established in a deliberate way. What remains to be seen is whether or not the triplum text is the product of equally deliberate intent.

Initial surveillance of Fascicle 3 does, as per expectation, reveal what might be interpreted as evidence of strong incongruity or incom-

3. Bibliothèque Interuniversitaire, Montpellier, France, Section Médecine, MS H 196. This codex, which will be referred to subsequently by the siglum "Mo," was first edited by Yvonne Rokseth. Her monumental work, *Polyphonies du XIIIe siècle: le manuscrit H 196 de la Faculté de Médecine de Montpellier*, 4 vols. (Paris: Oiseau-Lyre, 1935–39), continues to be an indispensable research tool. Hans Tischler has produced an updated edition of the Mo music, *The Montpellier Codex*, Recent Researches in the Music of the Middle Ages and Early Renaissance, 2–7 (Madison: A–R Editions, 1978), which is intended to be used in conjunction with Rokseth's vols. 1 & 4. *The Montpellier Codex*, Recent Researches, 8, presents the French and Latin Mo texts translated, respectively, by Susan Stakel and Joel C. Relihan. Their edition and translation of the texts will be used in this study.

4. The term "duplum" is sometimes used in place of "motetus." Rokseth uses "teneur," "double," and "triple."

patibility between the subject matter in Latin and the accompanying subject matter in French. Looking first to the Latin texts, we are not surprised to find that over half of them, eight, to be precise, are Marian poems replete with the stock expressions we have all come to associate with devotion to the Virgin. Of the remaining texts, one serves as a warning against having faith in false brothers. Another is a meditation on the Holy Cross. The last is based on the Biblical theme, "I shall not abandon you an orphan."

As concerns the eleven French texts that accompany the Latin ones just inventoried, we discover that the overwhelming majority, with the clear exception of only two, evolve on no such elevated plane. Curiously enough, one exception is the moralizing "L'estat du monde et de la vie," which concludes by criticizing the "Jacobins" and the other minor orders. The other exception is a *fin'amor* lament. If we were to label the nine poems that constitute the majority as belonging to one "type" or another, we would observe that all of them develop along the lines of the "reverdie" and the "pastourelle."[5] How, then, can these texts of more "popular" flavor be seen to relate to the Latin devotional texts with which they are synchronized in music?

The most direct approach to discerning the manner in which Latin and French texts interact is to pay brief attention to a specific work. Any of the compositions in Fascicle 3 would be of interest as an example. However, only one will be considered here. (See Figure I, below.) The piece which appears as Mo number 44 must first of all be recognized as having a rich, although not atypical, set of concordances.[6] The tenor, a melisma on the syllable "re" of "regnat," is drawn from the change "Alleluya. Hodie Maria virgo celos ascendit gaudete quia cum Christo regnat in eternum," which was used for the Feast of the Assumption. This melisma, with an added voice also singing "regnat," forms a two-part clausula in the Florence manuscript and in W_1, one of the Wolfenbüttel sources.[7] In three other sources, this same music appears with a different text, "Flos de spina rumpitur," in the upper

5. A concise study of the pastourelle is Michel Zink, *La Pastourelle: poésie et folklore au moyen âge* (Paris: Bordas, 1972).

6. The most recent inventory of concordances is Hendrik Van der Werf, *Integrated Directory of Organa, Clausulae, and Motets of the Thirteenth Century* (Rochester: NY, 1989). Information on earlier inventories can be found in this volume. The compositions in question here are listed on pp. 64–65. (Henceforth cited in text).

7. Florence, Bibl. Laurenziana, Plut. 29,1, fol. 126 (siglum "F"); Wolfenbüttel, Herzog August Bibl. 628, fol. 51.

Mo number 44

TRIPLUM:	MOTETUS:
Quant repaire la verdor	Flos de spina rumpitur;
et la prime flourete,	spina caret
que chante par grant baudour	flos et aret,
au matin l'aloete,	sed non moritur.
par un matin me levai,	Vite florem
sospris d'une amourete.	per amorem
En un verger m'en entrai	flos complectitur,
por cueilli\<e\>r violete.	cuius ex solatio
Une pucele avenant,	sic reficitur
bele et pleisant,	in vigore proprio,
junete,	quod non patitur.
esgardai	*Virgo* de Iudea
en un requai	sursum tollitur . . .
delés une espinete . . .	

Upon the return of greenness and the early buds, when the lark fills the
morning with joyful song, I got up one morning captured by sweet love.
I entered an orchard to gather violets. I saw there a comely maiden, fair,
pleasing, and young, sitting all alone in a corner beside a thorn bush . . .

The flower is plucked from the thorn; the flower without the thorn
withers, but does not die. In love, the flower embraces the flower of life;
in this solace it so refreshes itself in its own strength that it does not
suffer. The virgin from Judea is lifted up . . .

Figure I

voice.[8] Returning to Florence, we find, once again, the same music
expanded into a three-voice conductus-motet of which the two upper
voices both sing "Flos de spina rumpitur" (fol. 393v.–394v.). Finally, in
Mo, the two voices of the clausula occur with yet a different third voice
that has its own text, "Quant repaire la verdor."[9] Thus, the Mo com-
position carries with it all of the associations just listed, while manag-
ing to introduce a new variety of interaction. The nature of the interac-
tion is two-fold, as we shall now see.

Beginning with the more straightforward of the connections be-

8. Madrid, BN MS 20486, fol. 126v.–127v. ("Ma"); Wolfenbüttel, Herzog August Bibl.
1099, fol. 147–48 & fol. 180–80v. ("W₂"); Munich, Bayerische Staatsbibl. lat. 5539, fol.
75v.–76v. ("MuC"). Next cited in the text.

9. For a comparative display of the music of these concordances, see Hans Tischler,
ed., *The Earliest Motets (to circa 1270): A Complete Comparative Edition*, 3 vols. (New
Haven: Yale University Press 1982), motet no. 29, 1:205–16 (music) & 3:69 (notes).
(Henceforth cited in text).

tween "Quant repaire" and "Flos de spina," we notice a strong bond on the level of lexical field. The element "flos," and a related form, show high frequency of iteration in the opening lines of the text: "flos" itself appears three times, while "florem" appears once. The initial statement of the coincident French text introduces the word "flourete," a word we would expect to encounter in the pastoral setting. A second lexical connection is evident in the mention of thorns in both texts. The Latin poem opens with the image of the flower plucked from the thorn; the French poem situates the "amourete" next to a thorn bush. The use of these two items in both the motetus and triplum texts serves to ensure a lexical bond to which the composer, if not the performer or the listener, would certainly have been sensitive. Another important function of the flower and thorn imagery is its creating a bond between the feminine presence of the Latin text, the Virgin, and the feminine presence of the French text, the maiden. This connection is reinforced by the explicit reference to "love" in both texts: "ameraiaim/amorem." It has, of course, long been recognized that the languages of devotion to the Virgin and to the Lady constitute, in reality, one and the same language. We shall, however, find it necessary to return to this notion presently with respect to other texts.

The second major type of interaction that occurs in the mixture of Latin and French is probably the more interesting as concerns the study of movement and textual dynamics. As already mentioned, it does, at first, strike us as odd that the most frequent combination of material involves simultaneity of a devotional poem to the Virgin and a pastourelle. The logic of this situation can perhaps best be explained if we stop to consider that, in addition to being characterized by a certain lexical field and by other linguistic traits, such as the use of diminutives, the pastourelle distinguishes itself through reliance on direct discourse to effect an interaction of its masculine and feminine players.

> Triplum:
> Quant je vi la tousete
>
> .
> si la saluai,
> puis li ai dit itant:
> "Bele, cuer et moi
> vos otroi et present.
>
> .

>Ele mi respont doucement:
>"Sire, oiés ma pensée
>. .

When I saw this young girl. . . . I greeted her and spoke thus: "Fair one,
I surrender and give to you my heart and my soul. / She answered me
sweetly, "My lord, listen to my thoughts. . . .

We might, therefore, interpret the function of the pastourelle within
the Latin and French composition as being to sensitize us to the dy-
namics of a dialogue, in this case, a social dialogue in which two major
artistic traditions, the religious and the secular, enjoy harmonious
interplay as voices of the same three-part composition. It is from this
perspective that we shall now consider the other broad category of
works in which the Latin and French textual repertories encounter
each other directly.

From the information on concordances with "Quant repaire / Flos
de spina / Regnat," it was evident that any polyphonic composition we
might single out for analysis exists simultaneously in a multitude of
different forms, the result of a process of perpetual transformation. The
permutations of both music and text seem infinite: the more one stud-
ies any given set of related pieces, the more one discovers details that
attest to the diversity of the corpus and the individuality of each musi-
cal/textual construct. However, a significant number of motets do
have a "Latin version" and a "French version," a circumstance which
has obviously fueled studies whose goal has been to date with preci-
sion the various styles of composition popular in the twelfth and thir-
teenth centuries. One proceeds from the assumption, or in some in-
stances, the certainty, that the Latin came first; the French came next.
Therefore, one often neglects the fact that, even if that were the case for
all works, the supposedly later French texts still evoked the memory of
their Latin forebears. In many cases, French texts do appear to gloss, in
the broadest sense, their Latin counterparts. However, even those
French texts which show no direct lexical or other obvious connection
with the Latin need to be interpreted as exhibiting interplay with
them. This is especially clear with respect to the piece we shall exam-
ine next (see Figure II) as an example of the second major composi-
tional variety mentioned earlier.

A particularly interesting four-part motet occurs as Mo number 20,
in Fascicle 2, and in a number of other sources as well [Van der Werf, 57;
Tischler, no. 184, 2:1098–1106 (music) (158–59 (notes)]. As concerns
the different polyphonic structures which make use of the same music

Mo number 20

QUADRUPLUM:

Celui en qui je me fi,
qui de fi
sai, qu'ele est a mi,
requier de vrai cuer et pri
d'amour, car en li
cuer et cors ai mis sanz retor;
souffrir s'ele osast la dolor
et la tres loial amour,
dont mes cuers, qu'ele a seisi,
sovent se reclaime:
Mes fins cuers n'est mie a moi,
ainz l'a, qui bien l'aime.

TRIPLUM:

La bele estoile de mer,
qui amer
doit on sans fauser,
vueil servir et henorer,
de cuer reclamer.
Virge pucele, en qui je croi,
roïne del mont, aidiés moi!
Proiés vostre fil, le roi,
qu'il me deigne conforter
et geter de paine.
Nus ne doit joie mener,
se bien ne voz aime.

With a true heart I beg and lovingly beseech the one in whom I trust, who I in truth know is mine, in whose care I have irrevocably placed heart and soul, that she dare to feel the pain and the most loyal love which often prompt my captured heart to cry out: My true heart belongs not to me but rather to the one who loves it well.

The lovely star of the sea whom one should love without deception is the one whom I desire to serve and honor and entreat from the depths of my heart. Virgin maid, in whom I believe, queen of the world, help me! Beg your Son, the King, that He deign to comfort me and take away my pain. No one should be joyful unless he love you well.

MOTETUS:

La bele, en qui je me fi,
merci cri,
qu'ele son ami
ne mete mie en oubli;
car, voir, je l'aim si,
que point ne m'esmai de dolor
souffrir ne de languir nuit et jor,
mes que ne perde l'amor
de li, par qui tout deffi.
mes cuers se reclaime:
Mes fins cuers n'est mie a moi,
ains l'a, qui bien l'aime.

To the fair one in whom I trust, I cry for mercy so that she forget not her sweetheart, for in truth I love her so much that i in no way dread suffering pain or languishing night and day as long as I lose not the love of her on account of whom I abandon all else. My heart cries out: My loyal heart belongs not to me but rather to the one who loves it well.

Figure II

and/or text, the list of concordances reveals two versions of a two-part motet and three versions of a three-part motet, one of which happens to be in Mo Fascicle 8. The group of concordant compositions all belong to the family of works generated by the chant for the Feast of Saint John the Baptist, "Alleluya. Inter natos," and are thus all based on the tenor "Iohanne." Fascinating interrelationships are discernible throughout the entire network of two-, three-, and four-part works. We shall first look to the two-part and three-part pieces and then turn to the four-part piece.

The two-part members of the family just described both occur in the other Wolfenbüttel source for this repertory, usually referred to as "W$_2$." One motet shows in its upper voice a Latin text typical of the repertory, "Ave plena gratia." The other, whose music is, for all intents and purposes, the same, uses the French text "La bele, en qui je me fi" in its upper voice (fol. 178; fol. 236v.). Both of these texts also appear in three-part motets, although their usage does not involve a combination of Latin and French in the same work. The Munich B manuscript combines "Ave plena gratia" in the motetus with the text "Psallat vox ecclesie" in the triplum (Bayerische Staatsbibl. lat. 16443, no 6 [fragment only for "Psallat vox ecclesie"]). The Bamberg manuscript and Mo combine "La bele, en qui je me fi" in the motetus with another French text, "La bele estoile," in the triplum (Bamberg, Staatliche Bibl. Lit. 115, fol. 34v. ["Ba."]). What, then of the Latin devotional poem do we find in the French version? "La bele estoile" is, of course, "La bele estoile de mer," the "Virge pucele," the Blessed Virgin.

The four-part motet, also in Mo, achieves a striking effect of balance by adding a quadruplum text, "Celui en qui je me fi," to the other two French texts already mentioned. The quadruplum and motetus texts are closely related to each other in several ways. They both emanate from opening lines that are semantically identical: "Celui / La bele en qui je me fi." They both have exactly the same rhyme sounds which are sung simultaneously. A number of crucial words, such as "dolor" and "souffrir," are common to both. Finally, both end with the same refrain text, which is set to two different melodies: "mes fins cuers n'est mie a moi, ainz (ains) l'a, qui bien l'aime."[10] It should be noted that the

10. The standard repertory of refrains is Nico H. J. Van den Boogaard, *Rondeaux et refrains du XIIe siècle au début du XIVe: collationnement, introduction et notes*, Bibliothèque française et romane, série d: initiation, textes et documents, 3 (Paris: Klincksieck, 1969). Normally, lines of refrain are given, as here, in italics. It is wise to keep in mind, however, that not all of the material listed by Van den Boogaard is likely to

refrain is announced, as is often the case, in a way that introduces direct discourse. This is, naturally, the same technique that operates in pastourelle dialogue.

Now that the quadruplum and motetus texts have been compared, we can determine how they interact with the triplum text in their midst. The relationship of these two secular love texts, which are basically laments with a twist of the popular at the end, to what we might call the French "chanson pieuse" between them is analogous to the relationship we found in pieces that use Latin in one voice and French in the other (Bec, 142–50, on the "registre pieux"). All three texts hold many points in common on the level of auditory effect. They also reflect the same overall structure. "La bele estoile de mer" even closes with direct discourse, as do the accompanying texts. We have, then, the strong sense that, in the four-part version of this motet, the voices of religious and secular devotion have reached a state of maximum assimilation. Their relationship is not simply inter-textual. It is truly inter-vocal.

The stated purpose of the analysis we have just pursued involved two related, equally important objectives. The first was to reexamine a specific group of compositions in a way that would allow musical and textual studies to orient themselves along coincident, rather than non-intersecting, paths. The second was to interpret, if possible, the dynamics of polyphonic art with respect to the social context of the thirteenth century, that "époque chaude" characterized by complex movement and constant transformation. Concluding remarks will, therefore, focus on each of these objectives in turn, hopefully, bringing the current exposition to a state of synthesis in harmony with that apparent in the subject matter it has examined.

As concerns the first of our two main goals, it is probably less desirable to engage in painstaking summary than it is to indicate in just a few words the manner in which we have succeeded in uniting conceptually the approaches to music and text described at the outset of this presentation. Our observations in reference to the encounter of the Latin and French traditions within the polyphonic repertory bring

represent "true" refrain. A great many of his attributions have no concordances. They have been designated "refrain" with respect to criteria that are difficult, if not impossible, to delineate with certainty. See Eglal Doss-Quinby, *Les Refrains chez les trouvères du XIIe siècle au début du XIVe,* American University Studies, 2/17 (New York: Peter Lang, 1984), for more information on refrain characteristics and placement within texts.

to light a process of assimilation whose importance to the study of the aesthetic in question should not be underestimated. By applying the concept of assimilation to analysis of thirteenth-century musical forms, we come to appreciate the degree to which any polyphonic composition has absorbed its past. We recognize that a three-part motet, such as "Quand repaire / Flos de spina / Regnat," is thoroughly imbued with the Gregorian melody from which its tenor is derived. We also note that it maintains close connections with a host of other compositions that stem from the same chant. This constitutes a useful perception of a complex repertory, for it allows us to conclude, as the step-by-step chronological perspective cannot, that each work *is*, in a sense, its own past: it enjoys a synchronous relationship with all of the concordant, and in some cases antecedent, pieces whose essence it preserves. An analogous movement toward preservation is, of course, discernible with respect to the textual dimension of polyphony. Examination of the relationship between French and Latin poems associated with the same music reveals that a like process of assimilation serves to unify the voices of religious and secular devotion. Each is absorbed into the other. The principle in evidence is that of intervocality, a concept which will now help us to situate polyphonic art against its societal backdrop.

The opening remarks of this study made reference to the thirteenth century as being a period of "dynamismes conflictuels," which implies movement characterized by both lively energy and diversity. Certainly, the movement of polyphonic art can justifiably be viewed in these terms. We need, however, to consider carefully whether or not the dominant movement in art and society was toward maintaining the conflict in all of its diversity, or if the dominant movement might not have been more toward achieving a state of equilibrium, a unity of sorts. Based on our examination of the interaction of voices, the intervocality inherent in multiple-part musical compositions, it would seem more useful to explore concordances rather than discordances, the coming together rather than the moving apart. Polyphonic music, by definition, the music of "many sounds," captured the multiple voices of its age with a vividness and accuracy unsurpassed by contemporaneous forms of artistic expression. For this reason, it presents the most compelling record of a society in which new encounters among the old orders were stimulated by a drive toward the broadening of both geographic and mental horizons. The polyphonic corpus, meeting place of the voices and the traditions, emerged as a privileged locus, at

the same time repository of the collective memory and proving ground of dreams. Its "intervocal" style appealed for a coming together of the religious and the secular, the written and the oral, "*les* lettres" and "*les* voix." All were invited to rejoice in a lively, dynamic art, just as we are still, by the first line of a motet that sings, "Gaude chorus omnium!"

CLAIRE NOUVET

Dangerous Resemblances:
The *Romance of the Rose*

> Now the Sirens have a still more fatal weapon than their song,
> namely their silence. And though admittedly such a thing has never
> happened, still it is conceivable that someone might possibly have
> escaped from their singing; but from their silence certainly never.
>
> —Kafka

We are all too ready to believe in the existence of a radical difference
between a "true" dream and a literary, fictional dream. We consider a
dream to be "true" when we can remember it as a past event. According
to this definition of the dream, the *Romance of the Rose* cannot be read
as a "true" dream since few readers will believe that the dream it
narrates was ever really dreamt. The *Romance of the Rose* would then
have to be considered as a "literary" dream, that is, as a text which uses
the dream as a mere fiction, as a literary device. But can we and, above
all, should we accept this restricted definition of the dream as the more
or less faithful transcription of a memory? I will suggest that the first
question that a literary dream raises is precisely the problem of defin-
ing what a dream is. Let us admit that the *Romance of the Rose* invents
the dream that it pretends to transcribe. We must then remember that
it defines the dream as being itself an invention, a fabulation. Inventing
the dream, the *Romance of the Rose* thus invents an invention, it
reinvents this invention that the dream already is. A "literary dream,"
it asks us to read *as* a dream that *might* not have been dreamt but *could*
have been dreamt. It asks us to read the invention of the dream as a
"true" dream. According to this text, then, the notion of "dream" must
be expanded to include that which cannot be remembered and must
therefore be invented. It must be expanded to include "the dream of the
dream."[1]

1. I borrow the expression of "dream of dream" from two writers who used it in two
different perspectives which are related to the problem that I am trying to articulate here.
Maurice Blanchot in *L'Espace litteraire* (Paris: Gallimard, 1955) suggests that the dream

YFS Special Edition, *Contexts: Style and Values in Medieval Art and Literature,*
ed. Daniel Poirion and Nancy Freeman Regalado, © 1991 by Yale University.

How then does the *Romance of the Rose* dream the dream? And, above all, what can we learn from this dream? As I will here suggest, this dream dreams speech. Dreaming speech, it calls us to question the status of the speaking subject by positing a peculiar play of resemblance between speech and song.

Let us begin with this remark: the *Romance of the Rose* defines the dream as a work of citation. The dream cites. More precisely, it does not cease to cite and to reorganize the clichés of lyric poetry. Among these clichés, one in particular will call our attention: the cliché of the birds. I will briefly recall that the lyric *Chanson* is characterized by its codified opening. If the Chanson ends with the "envoi:" "Chanson . . . go . . , " it also begins with an "I" listening to birds singing. This codified opening imparts to the birds what seems to be a simple metaphorical status: they figure the lyric voice which, in like fashion, sings the poem. This reading of the birds as the metaphor of the lyric voice does not entirely account for the part they play at the beginning of the Chanson. Placed at the beginning of the Chanson, the birds sing before "I" can sing, they thus figure a certain anteriority of speech in relation to the speaking subject. In order to begin singing, or to state, "I am singing," the lyric "I" must posit that singing has already begun. Moreover, even though the singing of the birds does not address anyone in particular, he hears in their song a "provocation" in the etymological sense of provocation: a calling forth. Singing calls forth singing. As soon as "I" hears singing, he hears a call to which he is compelled to respond: "il m'estuet chanter," "I must sing." Addressed to no "I" and coming from no "I," the song of the birds functions as a

"as such" is of interest to literature to the extent that its "content" is its very "form," that it dreams its own possibility: "Perhaps one could say that the dream is all the more nocturnal in that it turns around itself, that it dreams itself, that it has for its content its possibility. Perhaps there is no dream except of the dream. Valéry doubted the existence of dreams. The dream is like the reason for this doubt, and indeed its indubitable confirmation. The dream is that which cannot "really" be." In an entirely different context, we should remember that Freud in Chapter Seven of his *Interpretation of Dreams* enjoins us to read as a dream the narrative which is "improvised," invented in order to fill the lacuna of a forgotten, unavailable dream. Commenting on this invented narrative, Jacques Lacan in *Seminar II* (Paris: Seuil, 1978) uses the expression of "dream of dream": "Just when Freud once again puts into question all the constructions built up in the preceding chapters, in relation to the dreamwork, which constitutes the bulk of *The Interpretation of Dreams*, he all of a sudden says that all objections can be answered apropos of dreams, including that the dream may perhaps be only the dream of a dream." This dream of the dream, this "improvisation arbitraire, édifiée à la hâte et dans un moment d'embarras," must nevertheless be read as a dream, as a "sacred text."

pure address and at the same time as an imperative order to which "I" can only submit. Speech, it seems, calls speech. "I" can begin speaking because Speech, under the figures of birds, has already addressed speech to me.

Transferred in the oneiric context of the *Romance of the Rose*, the birds seem to function in a very different manner. I say "seem," for, as we shall see, far from forgetting their function of address, the *Romance of the Rose* literalizes it. The song of the birds "transports" the protagonist of the dream, and this in two ways. It "transports" him since it exerts on him an entrancing effect. But it also "transports" him in a much more prosaic manner. As soon as he hears the song of the birds, he decides to leave the closed space of his room and walk toward another closed space: a garden.

This garden (in which the entire dream narrative is going to unfold) belongs to Deduit, that is, Pleasure. "Transported" by the song, the protagonist is thus literally "transported," displaced from one place to another. And we should note the verb which designates this transport in Old French: the verb "addresser."

The *Romance of the Rose* thus defines the dream as a peculiar movement of address. The dream stages a figure that I have called for convenience' sake the "protagonist of the dream." This protagonist is indeed a figure; he figures in the dream the dreamer, this dreamer who, now awakened, tells us the dream. A figure of the dreamer, and by extension of the Narrator, this figure addresses itself, walks toward birds which themselves figure the lyric voice, birds which in fact figure the voice that the Narrator adopts to tell the dream. What, then, does the dream do when it puts into play this double figuration? First, it represents the subject as distanced from his voice. Secondly, it represents this subject as going toward an uncanny encounter with this voice. Finally, since this voice is the voice with which the Narrator speaks the dream, it represents a subject who, in a dream, walks toward the voice which will enable him to tell the dream. The dream, as the *Romance of the Rose* invents it, does not lack in strangeness under its apparent simplicity. The dream is a singular address. It addresses the subject toward speech. It calls him to meet the voice with which he will address to us the narrative of the dream.

At this point of our reading, it seems essential then to decipher as precisely as possible the analogical relation that the *Romance of the Rose* posits between the song of the birds and this voice. We now understand that our very voice, our ability to address speech, are at

stake. How, then, can speech be "like" a song? How can speech resemble music?

Let us examine the first description given of the song. This description seems at first relatively innocuous. It is nevertheless designed to explain why the song of the birds "transports," both literally and metaphorically, the protagonist. By way of an explanation, the text claims that the birds are[2]

> si lié qu'il mostrent en chantant
> qu'en lor cuers a de joie tant
> qu'il lor estuet chanter par force. [Ll 71–73]

have become so gay in May, in the serene weather, that their hearts are filled with joy until they must sing.

In the very act of singing, the birds show the abundance of joy that fills their hearts and compels them to sing. Singing shows the joy in the heart, and by doing so, brings joy to the heart of the listener. I will point out, first of all, that the song "shows." But how can a song *show* joy? This representation has little to do with a mimetic representation. The song shows joy because it is a *sign* of joy. In other words, the song functions as the sign of an ultimate signified. How, then, does this sign signify this signified? The song does not signify joy by *saying* joy. It signifies joy in the very act of singing, of creating a "douce melodie," a "bele accordance". In other words, Joy is not represented in the semantic structure of the song but in its melodic structure. This explains why a song can indulge in pathetic declarations of pain and suffering and still "show" joy. The semantic of pain is not incompatible with the representation of joy.

To say that the melodic beauty signifies joy does not mean, however, that "joy" simply signifies "melody." And we must pay attention here to the distinction of two spaces; on the one hand, the space of the song and on the other hand, this other space from which it originates and where joy resides: the heart. This "heart" is presented as the "elsewhere" of the song, a secret place, unreachable and beyond any perception. This "elsewhere" provides the figurative "place" where joy "takes place" in all its assumed plenitude. In order to signify this radiating joy beyond perception, the song must therefore effect a translation. It translates in a melodious form a joy which does not coincide

2. I am using Félix Lecoy's edition (Paris: Champion, 1970). All further references are to this edition. All translations are taken from Charles Dahlberg (Princeton University Press, 1971).

with this sensorial translation. We can now begin to understand why a beautiful song is always described as "clear." Only by achieving clarity can it pretend to come from a place of radiating joy. Its sensorial clarity "translates" an unseeable center of clarity, promises this ultimate clarity and thus opens the difference between "here" and "there;" it is not "here" in this clear or audible form, but "there" that joy "takes place." Presumed to come from a secret and inaccessible "heart," translating in an audible form the plenitude and clarity of meaning, the song opens an infinitely seductive and attractive difference: the difference between the Here of the song and the There of joy and meaning (terms by the way which seem interchangeable: joy is meaning and meaning is joy). Because of the opening that it posits between joy and song, the song calls out. (Any song is, in that sense, an "Invitation au voyage.") It calls us to traverse the song, to move beyond the Here of the song in order to go toward this There, this Elsewhere, which it signifies without thereby making it accessible. It calls us to go beyond its formal manifestation toward a plenitude of meaning and joy that its melody can only indicate. A sign of joy, the song signals.[3]

Transported with "joy," the protagonist enters the garden in order to see, and not only hear, the joy promised by the song. He then discovers that this garden contains a multitude of birds of different species. Although such a gathering of birds threatens to create an unbearable cacophony, the different sounds manage to fuse in a harmonious melody. We should take note here of the tension between the multiplicity of the birds and the singularity of the song. In spite of their plurality, the birds do not produce several songs but only one song. Let us note, moreover, that each species is assigned a different "corner" of the garden. Scattered to the four corners of the garden, the birds are *spaced* apart. Looking for the place from which the song of joy originates, we must then recognize that this song does not, precisely, proceed from one place but many; no single place can be pointed to as the "here" from which it could be said to spring forth. The song takes place, indeed, but it takes place in this nonplace, in this pure and nonlocalizable difference that a spacing is. This topographical spacing figures, it seems, another kind of spacing. It reminds us that in order to

3. The cliché of the song coming from the heart is central enough to have become the more or less explicit model for any analysis which tries to account for the melodic quality of a lyric Chanson. One of the best examples of this type of analysis is undoubtedly Paul Zumthor's study of the *Grand Chant Courtois* which explicitly models itself on the heart/song polarity: *Essai de poétique médiévale* (Paris: Seuil, 1972).

hear the notes of a song resonate, a system of differential marks, an inaudible spacing, is required. It is this spacing (which gives a purely differential value to each note) which constitutes what we call "music." It is in this sense that speech can already be said to be like a song. Like a song, it is constituted by an inaudible relation: the relation of difference and of spacing set up between sounds.[4]

What happens then to the subject who speaks such a speech? According to the analogical reading proposed by the *Romance of the Rose*, I speak like the birds sing. I must then recognize myself in the disquieting image of these birds scattered at the four corners of the garden. This image indeed scatters the image of the subject as one whole entity, as a point identical to itself which could be located and said to be "here." Believing myself to be the "carrier" of speech, I am in fact traversed, and more precisely, "spaced" by it. "I" am the spacing which articulates sounds in a purely differential system where each sounds exists only as different from other sounds. A musical subject, I am no more than a spacing, a system of differences to which the personal pronoun "I" gives a deceptive singularity.

The "joy" that the protagonist sees when he penetrates in the garden corresponds then to a certain spacing of both song and speech. The vision, or rather the reading, of this spacing compels us to reassess retroactively the potential deception embedded in the call voiced by the song. The song posits joy as a plenitude of meaning. It also posits a radical disjunction between this meaning and its audible manifestation. Inaccessible to the senses, joy would be radically distinct from its manifestation. It would in fact constitute that which is beyond the audible. It is in the position of an inaudible plenitude, of a beyond the audible, that the ultimate attraction of the song resides. It is there also that its greatest deception resides. By pretending to transport us toward the inaudible beyond of joy, the song makes us forget the silent and imperceptible spacing which constitutes and articulates its music. The evocation of that which is beyond the audible enables us to forget the silence which inhabits music or, the muteness which inhabits speech as well. Far from being a beyond of signifying plenitude, joy

4. The speaking voice is indeed like music if we remember, as Andrzej Warminski reminds us, that music is not to be confused with the audible: "Just as speech is not a matter of sound, what we hear, but the (inaudible) relations *between* sounds, the joints or articulations—that is, precisely what we do *not* hear—so music is a matter of the order of sounds, their jointing or articulation, a system of differential markings that cannot be perceived (heard or seen)." Andrzej Warminski, *Readings in Interpretation* (Minneapolis: University of Minnesota Press, 1987), iii.

must therefore be reread as this silent spacing which articulates the song. Joy would only be an articulation, a difference.

To "entendre" joy and to take joy in this "entente" might then not be the unmitigated "pleasure" which we assumed it to be. Contrary to all appearances, when it invites us to listen to a song of joy and to take joy in this listening, the *Romance of the Rose* does not invite us to a pure aesthetic rapture. It invites us, I believe, to another kind of reading, a reading which does not transport us into any paradisiacal beyond. In that sense, to read a medieval text would not consist of making it "speak," in rendering it audible for us. If, as the *Romance of the Rose* suggests, we must read a text as we read music, we must cease to take pleasure in its audibility in order to read the articulations, the relations, the inaudible spacings that it inscribes.

Proceeding from a spacing, the song that fills the garden of Deduit is also characterized by its supreme beauty. The effect of this beauty is nevertheless rather surprising. The song which blends different sounds into one melodic flow is said to be so beautiful that it too does not resemble itself: "qu'il ne sembloit pas chant d'oisiaus" (l. 668) [it did not seem the song of a bird]. We can understand this curious formulation in two ways. A first reading will invoke the explanation that the text itself provides a few lines later. The song does not resemble itself because it seems to be an angelic song. It does not resemble itself because its sensorial beauty succeeds in evoking a beyond of another order, the spiritual beyond of paradisiacal joy. By an appeal to the senses, it would have succeeded in transporting us beyond the senses, in the joy of the spirit, in the joy of pure sense. Although the text uses this explanation, I will suggest that the function of this interpretation is both to point out and cover up a problem of nonresemblance that the recourse to a spiritual transport does not suffice to explain.

The beauty of the song has been described on several occasions. Each description provides an added refinement in a continuous progression. First, they sing "chant piteus," then "dances d'amors," and finally "lais d'amors et sonoiz cortois" "en lor serventois." From the indeterminate "piteus" which could still refer to a natural sound, we move to specific and elaborate lyric forms ("dances," "lais" and "sonoiz.") Parallel to this progression in formal sophistication, we note an equivalent progression in their musical competence. We move from "noise" ("feire noise" l. 75) [make this noise], to "sons" ("des oisiaus les sons" l. 95) [to hear the sound of birds], to "acordance" ("mout estoit bele l'acordance / de lor piteus chanz a oïr" ll. 482–83) [The harmony

of their moving songs was very good to hear], to "notes" ("et les notes / plesanz, jolives et mignotes" l. 494) [melodies that were sweet, courteous and charming], to "melodie" (l. 675 and l. 705) [melody], and at last to a specific musical reference when they are said to sing "li un en haut, li autre en bas" (l. 705) [one high, the other low]. Having read this double progression, we will observe that, indeed, the song of the birds does not resemble itself. But if it does not resemble itself, it is not because of its spirituality, it is because it resembles another song too much: the lyric song.

It seems that the *Romance of the Rose* falls into an excess of resemblance. In order to make explicit the figural status of the birds, in order to leave no doubt that they indeed figure the lyric voice, it accumulates resemblances to the point of rendering the so-called natural song perfectly identical to the lyric song. This excessive resemblance leads the analogical reading that we undertook into a disturbing tautology. We were ready to learn how the lyric song resembles a natural song which was in this very gesture posited as the natural model of the lyric song. However, after carefully examining the resemblance between these two songs, we can only utter the following tautology: the lyric song is like the song of the birds which is itself like the lyric song.

What happens when we are led to such a tautology? First of all, by giving to the natural song the properties of the lyric song, the *Romance of the Rose* calls into question the natural model on which our reading relied, at least implicitly. When we wondered how the lyric song could resemble the natural song, we posited this natural song as the model of the lyric song. The lyric song is said to resemble the natural song in order to achieve, thanks to this resemblance, a certain measure of naturalness. It is this originary naturalness that the *Romance of the Rose* calls into question. In this text, the natural song does not resemble itself precisely because it resembles the song for which it is supposed to be the natural model. Resembling the song of birds, the lyric song then resembles a song which does not resemble itself because it resembles a lyric song.

I will say that for having played the game of resemblance too much, the *Romance of the Rose* does not play it anymore or, at least, does not play it according to the rules of the game. The rules of the analogical game require, indeed, that an analogy be established between two terms which are supposed to be identical to themselves. One term can resemble another term as long as it is "itself" not a resemblance but an identity. Curiously, however, the formula "the song does not resemble

itself," leads us to read a tautology such as: "the lyric song resembles the song of the birds which, itself, resembles the lyric song." By forcing us to read this tautology, the *Romance of the Rose* forces us to say or, rather, to stutter: "the song resembles the song which resembles the song." There is here only an apparent contradiction: the song does not resemble itself precisely because it resembles itself. For the song to be a song that we recognize, the song must indeed be identical to itself, there must a song "as such." When the song is defined as a tautological resemblance, it is this identity to itself which is lost. The song does not resemble itself because it resembles itself, because this resemblance to itself has introduced a difference in the song, a spacing. Resembling itself, the song is therefore at a distance from the song.

Thanks to this complex play of resemblance, the *Romance of the Rose* calls us to consider the possibility that the song, and with it speech, might only be a resemblance. The song would be its own resemblance. Or speech would resemble speech. These are still enigmatic formulas that the text will later give us occasion to clarify. Let us note for the time being that it forces us to consider their possibility.

It is at the point where the song does not resemble itself because it resembles a song so much that it is judged supremely beautiful. So beautiful that it ceases to resemble itself, it can be compared to the song of the Sirens:

> qui por lor voiz qu'eles ont saines
> et series ont non seraines. [Ll. 671–672]

who have the name *siren* on account of their clear, pure voices

With this ultimate resemblance, the movement of the Protagonist toward the song of the birds takes on a threatening connotation. We belatedly learn that, "addressing" himself to this song, the Protagonist was in fact walking to an encounter with the most seductive but also the most dangerous voices (a word which appears here for the first time in the story). But why does the song of the birds deserve to be compared to the dangerous song of the Sirens? The answer to this question has already been evoked. The voices of the birds deserve to be compared to the voices of the Sirens because they pretend to represent the joy coming from the heart. Any song of joy, that is, any song which posits a secret locus beyond representation, resembles the song of the Sirens since it calls into being the fatal desire to see a "beyond" which is precisely a beyond-seeing, since it calls to go beyond the song, the

form, toward that which is forever "there." By pretending to transport us to the inaudible beyond of joy, this song makes us forget the silent and imperceptible spacing which articulates it. The evocation of a beyond is deceptive to the extent that it enables us to forget the silence inscribed in music or the muteness inherent to speech, a silence which would explain that one can say, for example, that speech can only resemble speech.

With the mention of the voices of the Sirens, the whole episode of the birds finally draws to a close and the narrative voice makes its first entrance in the dream. In a direct address to "you," the Narrator declares his intention to tell the whole story, the whole "afeire":

> Des or mes, si con je savrai
> tot l'afeire vos conterai.
> Primes de quoi Deduiz servoit
> et quel compaignie il avoit
> sanz longue fable vos voil dire,
> et dou vergier trestot a tire
> la façon vos redirai puis.
> Tot ensemble dire ne puis,
> mes tot vos conteré par ordre,
> que l'en n'i sache que remordre. [Ll. 689–98]

From now on, I shall recount to you, as well as I know, how I went to work. First I want to tell you, without any long story, about what Diversion [Deduit] served and about his companions, and then I will tell in a full and orderly way the appearance of the garden. I cannot speak of everything together, but I will recount it all in such order that no one will have any criticism to make.

It seems that the voices of the Sirens, as well as those of the lyric birds, have been quickly forgotten. The voice of the Narrator resembles very little a seductive singing. His voice does not promise a musicality but a logical and coherent narrative order. However, how do we account for the "des or mes" [from now on] which opens the passage? "From now on" emphasizes the fact that the voice which promises a sequential ordering is itself part of a specific sequential order. "From now on" suggests that the Narrator can speak only after "they" have sung, as if the song of the Sirens had *provoked* him, called him to speak. The passage allows in fact two different readings. A first reading can insist on the relation of resemblance (and therefore also of difference) posited between the narrative voice and the voice of the Sirens. If the Narrator possesses a voice as "they" do, his voice does not promise a harmo-

nious and melodious flow, but rather an intelligible and coherent ordering. A second reading can insist on the relation of cause and effect suggested by the "des or mes." It is not "by chance" that the Narrator begins to speak after the Sirens have sung. He can speak because they have sung. The voices of the Sirens would have given him the voice with which he addresses us. What both readings leave unquestioned, however, is the assumption that the Sirens (or for that matter the birds) indeed have a voice which the narrative voice can resemble and from which it can differ, from which it can even originate. But do they?

The passage already cited ends with a rather ludicrous explanation of the name "Seraines" itself. The Sirens are called "Seraines" because their voices are "saines" (pure) and "serie" (serene, harmonious.) This obviously constitutes an example (rather frequent in medieval literature) of etymological invention. Let us, however, examine more closely this etymological derivation. Its stake is clear: to prove that the noun "Sirens" signifies the purity and serenity of the voice. In order to impose this meaning, the text has recourse to the phonetic resemblance existing between three signifiers: "seraines," "serie" and "saine."[5] Moreover, it evokes a particular play of letters. Split in two, ser/aine resembles, with a difference of only a few letters, ser/ie and s/aine. The *Romance of the Rose* is thus playing with the signifiers in order to elevate a noun such as "Seraines" to the privileged status of signifying the voice in all its melodic beauty and seductiveness. This play of letters is, however, potentially dangerous. The signifier "serie" that the text uses in order to exalt the serenity of the voice can also propose another and much more disturbing resemblance. "Serie" does mean "serene," "harmonious," "calm," but it is also dangerously close to the adverb "seri" which, coming from "serein," means not only calmly but also "without noise." This unexpected resemblance confers to the harmonious beauty of the song the serenity of silence. By establishing a resemblance between "serie" and "seraines," the text has thus opened an unpredictable reading possibility: it is possible that a serene and melodious voice might have the calm of the most complete silence. The play of resemblance which likens the lyric voice to the song of the birds and then likens this voice to the voice of the Sirens

5. Commenting on this play of signifiers, Arthur Knoespel in his *Narcissus and the Invention of Personal History* (New York: Garland, 1985), 71, notes that although the Sirens were given a positive connotation in Macrobius's *Commentary on the Dream of Scipio* (93–94) where they are related to cosmic harmony, medieval mythographies give them a predominantly negative connotation by linking their name to the Greek word for "betrayal," (Cf., *Fulgentius the Mythographer*, ed. Whitbread), 73–74.

finally points, and this thanks to a last resemblance at the level of the signifier, to the silence of the voice. At the precise point where the voice seems to assert itself in all its beauty and seduction, it seems to be discreetly and quite elegantly cut off.

First indicated in a play of signifiers, this cutting off of the voice is later marked in a more explicit and more easily readable manner. Following the mention of the Sirens, the birds that we had been hearing for so long seem finally to fade away; but only to appear in a way which retroactively puts into question the assumption that they too had a voice. The narrative voice which promised to tell us "first of all about Deduit" fulfills its promise. We are at last allowed to see Pleasure itself, this Pleasure which created the garden and hung allegorical portraits on its walls, the function of which is to represent, and thus exclude, all "ire" from the garden. Although pleasure is thus made to depend on the pictorial exclusion of all ire, Deduit's description begins, strangely enough, by likening him to a portrait. Deduit is so beautiful that he resembles a portrait:

> il resembloit une pointure,
> tant estoit biaus et acesmez
> et de toz menbres bien formez. [Ll. 810–13]

he was so elegant and full of grace, so well formed in all his limbs, that he looked like a painting.

Again supreme beauty is defined as a peculiar play of resemblance. To be beautiful is to be "like" oneself. As the beautiful song resembles the song (thus ceasing to resemble itself), the beautiful Deduit resembles his portrait, that is, his own resemblance. Deduit resembles himself. Deduit's beauty turns Deduit, Pleasure, into the likeness of a likeness.

If this first implication is already disconcerting, the rest of Deduit's description is no less disturbing. Resembling a portrait, Deduit wears a dress on which birds are "portrets" [painted]:

> D'un samit portret a oisiaus
> qui estoit toz a or batuz,
> fu ses cors richement vestuz. [Ll. 818–20]

His body was richly clothed in samite decorated with birds and beaten gold.

In a final twist, the singing birds are turned into mute pictures. The entire narrative of the birds ends up by cutting off their voice in a last

representation, in a last resemblance. It is this cutting off that the elegant incisions of Deduit's dress seem to signify:

> Mout fu la robe deguisee,
> s'estoit en maint leu encisee
> et decopee par cointise. [Ll. 821–23]

His dress was highly ornamented; in several places it was cunningly slashed or cut away.

We could say that by turning the birds into portraits, the *Romance of the Rose* at last explicitly acknowledges their figural status. The birds do not really have a voice, they are only a representation of the voice, an impossible representation therefore, the voice being precisely that which cannot be represented. Thanks to their portraits, the *Romance of the Rose* would also indicate the proximity of two terms: "dream" and "allegory." In dream, the dreamer believes he hears birds sing. This song, or this voice, is only the semblance of a song and of a voice. The dream makes figures speak and sing. It gives a fictive voice to mute portraits, thus exemplifying the allegorical gesture which confers voice, figure, and movement to a noun as mute as "Deduit." However, when we claim that, thanks to the portraits of the birds, the text finally acknowledges that these birds are mere images of the voice, we presuppose the possibility of maintaining a clear separation between the mute sign and the voice that it signifies. On the one hand, we would have the muteness of the sign, and on the other hand, the pure audibility of the voice. This reading is reassuring since it assumes that the voice can be posited in all its audible presence before its gets cut off in its representation. It is this reassuring representation that Deduit's dress, and especially its incisions, calls into question. The incisions imposed on his dress seem to signify the cut inflicted to the voice as soon as we undertake to represent it. These incisions, however, are qualified as "disguises," a qualification which suggests that the so-called cut inflicted by representation might merely be a fashionable way to cover up and forget another and more radical cut. In other words, it may be that the muteness of the representation indicates, and at the same time conceals, a more radical muteness, a muteness inherent to speech itself. This muteness befalls any speech whenever a seemingly gratuitous play of signifiers such as "serie/saine" intervenes.

As we saw, the text posits that the name "seraines" means "serie" and in order to impose this meaning invokes a phonetic resemblance.

However, "serie" is itself a polysemic signifier. Because of this polysemy, the resemblance between "serie" and "seraine" can signify the exact opposite of what it meant to signify. Because of this polysemy and of the divergence of meaning that it induces, a serene voice can become a mute voice. What I will call the "muteness" inherent to speech names the always open possibility of such a divergence of meaning.[6] This possibility (open as soon as we speak) makes it forever impossible for us to "really" say what we mean to say or even to know what we "really" mean to say. In this sense, any voice is mute as soon as it speaks, since in the very process of saying what it means to say it loses a control that it never had and is condemned to say something other than (or even opposite to) that which it intended to say. It is therefore possible that speaking, we have not yet truly begun to speak. It is possible that, speaking, we are speaking a speech which only resembles this "true" speech, forever future, which would at last say what it means to say. In this case, speech would be indeed, as the *Romance of the Rose* suggests, an infinite movement toward speech, toward the possibility of addressing speech. In this case also, it is not sure that we are awakened or can ever awaken from the dream of address that the *Romance of the Rose* summons us to dream.

6. This is a possibility that the allegorical portraits, placed at the very threshold of the garden, exemplify. These portraits are supposed to represent the "uncourtly" qualities judged undesirable in the garden. In order to fulfill their representational function, they must represent an invisible signified, such as Vieillesse, in a visible signifier such as a wrinkled face. These wrinkles "signify" by giving a perceptible form to an invisible signified: the passing of time. The possibility of such a successful representation hinges on the possibility of creating a convincing resemblance between sign and meaning. Although the "I" claims to be able to see the resemblance between the image and its meaning, the descriptions of the "ymages" show, however, only one thing: the impossibility of representing with the desired certainty the meaning that they pretend to represent. The image of Tristece, for example, could as well signify Poverty. The image of Papelardie could as well signify Devotion, that is, the exact opposite of what it is supposed to signify. Confronted with an allegorical sign, the reader is then confronted with a sign which opens several reading possibilities by suggesting resemblances pointing in different and even opposed directions, a sign which therefore proposes divergent meanings.

ANNE BERTHELOT

The Other-World Incarnate: "Chastel Mortel" and "Chastel des Armes" in the *Perlesvaus*

Clarity is, without a doubt, the essential characteristic of the *Perlesvaus*:[1] unlike other later prose romances, its different levels of enunciation are apparently clearly distinguished and its narrative logic is restrictive enough that adventures which could be described as heterogeneous come together in a harmonious whole. The very size of the work makes it a romance on a comfortably human scale, "à visage humain": one which the reader can master without being overwhelmed by the proliferation of tales and the intermingling of "branches," as will be the case with later works. This is not to say, however, that there are not structural irregularities or—even more important—that an unquestionable "senefiance" [signification] is established by the text: on the contrary, it remains rather enigmatic. Even where the categories of enunciation are concerned, the internal and external double reference to a "bon clerc" [good cleric] called "Joseph" suggests that the distinction made between different moments of enunciation is perhaps only an illusion which snares the reader in a Moebius's strip whose secret is ultimately unsolvable. However, if the basic order which governs the *Perlesvaus*, that of illusion and wandering, is all the more radical for apparently being held in check by a solid binary system, then the careful construction of the work's rational facade is only greater as a result.

If one dates the *Perlesvaus* from the 1210s, then there are no models

1. *Le Haut livre du Graal, Perlesvaus*, ed. William A. Nitze (Chicago: University of Chicago Press, 1932–1937), 2 vols. All quotations from the Old French are taken from this text and will be referred to by line numbers.

YFS Special Edition, *Contexts: Style and Values in Medieval Art and Literature*, ed. Daniel Poirion and Nancy Freeman Regalado, © 1991 by Yale University.

yet for the Château du Graal; or rather, it is the direct successor of that described by Chrétien de Troyes, with perhaps a detour taken through the embellishments added by the *Continuation Perceval*. That is to say that little is known about it. The paths leading to it, the defenses which protect it, its internal structure and the characters who gravitate around the Holy Grail, are still unknown; and as for the nature of the Grail and make-up of its cortège, no definite answers are available. The Grail is still young enough to be in great need of stabilization, in a manner of speaking. And that is what the *Perlesvaus* does, by means of two complementary procedures of exceptional simplicity. First, multiplying views of the castle by several different visitors, each of whom, by definition, has a different perspective on things, as one might say of a modern literary work. Second, it establishes a counterpoint to this eminently positive site, a malefic castle whose negative value permits a better evaluation of its divine homologue. Somewhat later, the *Queste del Saint Graal* uses, to a certain extent, the same artifice, but without going so far as to put an actual bipolar system into place.

In the *Perlesvaus*, moreover, the Holy Grail is not yet completely redefined by allegorical interpretation. On the contrary, one could argue that allegory, perfectly functional in and of itself, actually serves the mystery of the Grail. The multilayered reading of the different places and edifices visited by the succession of heroes furnishes a possible grid for deciphering the Château du Graal and its dark counterpart, the "Chastel Mortel," without exhausting either its meanings or its potential. For example, the hospitable hermit of the well-named "Chastel de l'Enqueste" proposes a very orthodox reading of the "Noir Hermite" [Black Hermit] as none other than Lucifer. This allows for both the knights errant and the reader to "recognize" the King of "Chastel Mortel" as a new figure for the devil and, consequently, to see his castle as a new representation of Hell. This then naturally leads to the assimilation of the Château du Graal with Paradise—the "Château des Ames" or "Castle of Souls" as Lancelot insists on calling it—or at least with a celestial Jerusalem. The knights and the reader can then allow the characters of the tale to carry on with their own private business quietly: the King of "Chastel Mortel" merely invades his brother's castle because of ordinary family quarrels and not for any theological motive. The interpretation is proposed, but not imposed; more precisely, it is placed at the disposition of the reader, serving to some extent as an intertextual testimony before the fact (since no thematic reservoir of tales about the Holy Grail yet exists). It does this,

however, without diminishing the pleasure to be found in the adventure. In the *Queste del saint Graal,* the reader quickly realizes that the naive pleasure to be found in the story of a tournament or battle must be overcome and sublimated through theological interpretation. The *Perlesvaus* does not deprive itself of allegoresis, but rather treats it as an extra ornament to the narrative: one path among others in a forest full of adventures, a possibility which does not exhaust the "senefiance" of the text.

Although the *Perlesvaus* is undoubtedly one of the most Christian of the romances of the Holy Grail, it nevertheless provides a perfectly coherent series of secular adventures. In fact, it is the only tale which justifies the changing topography of the Arthurian world in the name of God's will, which is of particular importance for the pleasure of the knights errant. Thus it explains casually that the "illes de mer" [sea islands] change location and appearance so that the same adventure does not occur twice:

> Josephes nos tesmoigne que les samblanches des isles se muoient por les diverses aventures qui par le plaisir de Deu i avenoient, e si ne plot mie as chevaliers tant la queste des aventures se [il nes] trovasent diverses, car quant il avoient entré en .i. forest e en une isle o il avoient trové aucunne aventure, se il i revenoient autre foiz si troveroient il recés e chasteau[s] e aventures d'autre maniere, que la paine ne li travax ne lor anuiast, e por ce que Dex voloit que la terre fust confermee de la Novele Loi. [Hitze, vol. 2, ll. 6615–22]

> Josephus bears witness that the islands changed appearance because of the bizarre adventures which came about by the will of God. And indeed, the quest for adventures would not have been as much to the knights' liking if they had not found them strange; having entered some forest or island and having found an adventure, if they came back they would find strongholds, castles, and adventures of another sort. This so that the suffering and toil might not wear on them, and because God wanted the land strengthened with the New Law.

One cannot resist questioning the relationship between the "confirmation" of the New Law and the variety of adventures: if the enthusiasm of the knights diminishes in proportion to their interest in the adventures proposed to them, would their Christian and Evangelical enthusiasm then diminish as well? Whatever the case may actually be, this solution is infinitely more satisfying for the romantic imagination than that of the "museum" adopted by most of the later great romances, including the *Grand Palamède.* On the other hand, this solu-

tion does defy all narrative logic and threatens the very notion of the Quest of the Holy Grail, for in this non-Aristotelian space, no knight has the least chance of ever returning to the castle where he failed to ask the right questions. . . . In any event, as is shown in the *Perceval* of the contemporary prose trilogy by the pseudo-Robert de Boron, the place where the Holy Grail appears is not of this world and, cannot therefore be definitively stabilized in the actual realm of castles to be found, one way or another, on a map of the Kingdom of Logres. Nevertheless, not only do Perlesvaus, Gawain, and Lancelot each make their own way to the Castle of the Fisher King under the auspices of a fictional series of adventures that one could qualify as normal, but the path which leads to this castle seems to be the most frequented in an unstable world. This belated topographical stability, however, ultimately serves no great purpose.

In fact, even when the hero seems to be in a position to pass the test—to ask the right questions—he soon realizes that the givens of the situation have been changed: it is no longer a question of undergoing a complex rite of initiation, but of taking up arms to avenge the Grand Master of this Secret Order, put to death by his evil brother. Perlesvaus's victory is chivalric, bearing no direct relation to the Holy Grail. Furthermore, the one and only King of the Holy Grail is dead, and he cannot be replaced by Perlesvaus. After the recapture of the "Chastel des Ames," the Grail reappears nowhere but in the chapel where it takes its place as a liturgical object or relic: no more corteges, no more "miracles" smacking of paganism. "My Kingdom is not of this world": such is, undoubtedly, the lesson of the *Perlesvaus*. Ultimately, Joseu, the Young Hermit, and his successors preside over a defunct abbey, a "Sleeping Beauty's Castle" whose partial survival in the physical world bespeaks undescribable events which no longer have a place in the present of the narrative.

Here the dangerous originality of the *Perlesvaus* surfaces again: the time of the tale rejoins that of the writing. The Château du Graal, as it appears to Gawain, its first visitor in the space of the romance, may still be endowed with all the glamour of Arthurian magic, more or less discreetly and more or less deftly Christianized. But since it is highly improbable that a place so saturated with the supernatural should pass unperceived in the "contemporary" universe supposedly shared by the telling of the tale and the reader, it is appropriate to neutralize it so as to integrate it into a purely nostalgic and commemorative topography. The days of miracles are over: Guinevere's tomb can still be seen at

Glastonbury and the Château du Graal is not close by, but they are no more than empty shells now, tourist sites lacking in "senefiance." And yet . . . the Château du Graal is not completely deconsecrated. Most of the Castle's imprudent visitors—who see no difference between a Walt Disney imitation and a place where the spirit, if no longer present, once did walk—these tourists simply disappear. This is a wise precaution taken by a text which limits itself to just one source, one very precious and very skilled at smoothing over inconsistencies of time and space. It is also, however, a way to avoid the complete demystification of the Château du Graal: even in ruins, and even emptied of its inhabitants, the site retains something of its prestige or aura. Its two sole survivors take up its mystical flame and become Holy Hermits— they who were so far from holy before, having undertaken their visit there as a challenge and in the spirit of *gabois* [boasting].

The well-known opening passage of the *Perlesvaus* symbolizes the principal difficulty encountered by all prose romances, and especially by those dealing with the Holy Grail, caught as they are between the truthfulness required by their formal vehicle and the ties of their material to the "vain and pleasant" fable. The squire, Cahus, has an adventure as serious—and as conclusive—as does any knight errant. But it is in a dream that he leaves the court, and in a dream that he meets his destiny; he wakes only to confess his sins. In one sense, this is a transparent allegory: the life of an adventurer is a dream from which Christian death awakens penitent souls, before it is too late! Yet Cahus is to be pitied more than the innumerable victims of the Red or Black Knights who perish throughout the romances, for he never even gets a chance to really prove himself. (He is only a squire, he lives therefore in a state of latency, a sort of daydream, relative to the only honorable position for a hero.) His situation, however, is not fundamentally different from that of numerous other allegorical "dreamers," and the fact that Cahus's dream ultimately proves to be true attests to the veracity of other dreams and visions brought on by some exterior circumstance in the semiconscious state of "dorveille" [waking dream]. But this argument is a two-edged sword: practically no one questions the significant weight of an allegorical vision but, by the same token, nobody makes the case that in reality Reason personified or the God of Love meander about the everyday world giving out advice! What, then, are the differences of degree or of nature which separate Cahus's "male aventure" from the adventures regularly described throughout a romance, or, more precisely, throughout the romance that we are now in

the process of reading which opens with the instructive and highly symbolic episode of a dream come true? If Cahus is dreaming, and wakes only to die, then how do we know that the other heroes aren't dreaming as well, but have neither the opportunity nor the desire to awaken? The analogy obviously is never more evident than in the case of Lancelot, who confesses his sins but refuses to rejoin the real world of penitence and pardon and remains in that of illusion, that is to say, for him, the world of "adventure and love."

In fact, what the romance tells us about Lancelot as well as Cahus pertains to the realm of dreams. Reality remains to be found in the realm of religion or, more precisely, in that of a religion wholly oriented towards penitence and death of the body which, by renouncing worldly passions, may perhaps save the soul. It is also the death of the romance which leads all of its heroes to the tomb or to paradise, or to each in turn. But the problem of the Château du Graal, and in general that of the Grail itself as a fictional motif, is clearly more difficult to resolve. Do the adventures of the Holy Grail spring forth from the life of the spirit or from the letter (of the text) which kills the soul? A priori, the Grail is not as different from the other wonders of the Kingdom of Logres as one might hope; even in the best of lights, there is always a touch of a pagan "marvelous" which contaminates even the episodes most easily recuperated by the allegoresis of the most orthodox of hermits. In Chrétien de Troyes's work this enigmatic object written about so often over the course of the next century and a half appears as only one element among others forming a cortege to which the term "Christian" cannot be applied without exaggeration. Moreover, the scene takes place in a "château-mirage" that presents all the characteristics of a supernatural site of the Celtic Other-World. Although the *Perlesvaus* does veer off on an aesthetic tangent towards the proliferation of a supernatural macabre, it is also, and above all, structured by an almost impeccable theological framework. Taken in this light, the Holy Grail must then be "fished out" of the troubled waters of the pagan Other-World and reconciled with both Christian orthodoxy and reality, in the sense that the frame for the enunciation of the work can be taken for the reality of the world. Both the reduplication of the approaches to the Château du Graal, on the one hand, and the invention of the fratricidal war between the two kings on the other serve that very purpose.

A unique status is reserved for both the King of Chastel Mortel and for his Castle. Unlike the Château du Graal, this castle, it should be

noted, is never described nor is it visited by any of the various heroes of the romance who, nevertheless, journey extensively throughout the Kingdom of Logres and its neighboring islands. The castle functions as a logistical base for the deeds of a wholly negative, "black," character who is designated only by this malevolent title, contrary to the pattern established by a text which makes a point of giving names to even the most minor of secondary characters. This special treatment is immediately noticeable in the genealogy of the First Branch, which gives the names of Perlesvaus's mother, sister, and of one of his maternal uncles, as well as his complete paternal lineage, including his father's eleven brothers: an innovation without precedent in the tales of the Holy Grail, and subsequently never repeated! The only two characters who are not explicitly named at this moment are the Fisher King and the King of Chastel Mortel:

> . . . li Rois Peschierres fu ses oncles, et li Rois de la Bassefent, qui fu nomez Pelles, e li Rois du Chastel Mortel; en celui ot autretant de mal com il ot en cez .ii. de bien, o il en ot molt . . . [Ll. 37–39]

> . . . the Fisher King was his uncle, . . . as was the King of Castle Mortal; in this last one there was as much evil as there was good in the other two, where it abounded . . .

This passage establishes a privileged relation between them and suggests that they are incarnations of metaphysical principles rather than normal characters. Subsequently, mentioning the King of Chastel Mortel serves to identify the different members of the family who wander in search of each other. And though he is only mentioned in a wholly negative manner, it remains a rather abstract negative—that is to say that it is his evil nature which is evoked so fundamentally opposed to that of his brother—until the moment when he becomes an active force in the romance, attacking the Château du Graal and, therefore, all of those who are allied to it. It is the Château du Graal itself which, after Gawain's visit, first informs the reader of the state of siege under which the forces of Good labor:

> . . . Missire Gavains ot le cor soner autre foiz, et ot une voiz huchier molt en haut: "Qui de çaienz n'est, si s'en aut, quex que il soit; car li pont sont abessié et la porte overte, et li lions est en sa cave, et après ce covendra les ponz relever por le Roi du Chastel Mortel, qui gerroie cest chastel. Et ce est l'achaison par quoi il morra sanz faille." [Ll. 2482–87]

> . . . Sir Gawain again heard the horn sound, and he heard a voice shout, "Who is not of this place, let him leave, whoever he may be; for the bridges are lowered, the gate open, and the lion in its den. Afterwards

the bridges must again be raised on account of the King of Castle Mortal, who is making war on this castle. For this he will suffer certain death."

The Château—for this disembodied voice, taken straight from Celtic legends and "tales" can be attributed to no particular human character—the Château, then, is remarkably well aware of the current situation; more so, it seems, than the Fisher King himself, who made no allusion to this conflict during his conversation with Gawain the evening when the Grail appeared. And yet, many other subjects were brought up then, in particular, that of the "disinheritance" of Perlesvaus's mother, for whom his sister is searching everywhere. But it is to be noted as well that the threat which hangs over the Château du Graal is still purely theoretical at this point. The principles of Evil and of Good are at war but actually, in a concrete military sense, the Château du Graal is not under siege. In structural terms, the role reserved for the King of Chastel Mortel is not yet clearly defined; the groundwork for his intervention, essential for the anchoring of the Grail in reality, *and* in the past, is simply being laid more and more precisely. The voice of the Château du Graal loosely traces the lines of the plot to follow, but at this point in the narrative no speaker is in a position to go into further detail.

A little later, when Dandrane visits the Chapelle Périlleuse, she, too, hears a mysterious voice tell her of the death of her uncle, the Fisher King, of the fall of the Château du Graal, which has since disappeared. Or rather has not reappeared, this suggesting a choice in the potential ties of the magical object. Having fallen into the hands of Evil, the Holy Grail does not use its own power to fight against it, nor does it become evil itself; it just goes away: a horn of plenty providing terrestrial nourishment when needed but in no way an instrument of war. . . . In the *Perlesvaus*, the nature of the Holy Grail is perhaps not so clearly fixed as to require a definition of its attributes and powers. The next item denotes a further step in the direction of Evil (although the death of the Fisher King is not explicitly tied to the attack led by his brother. On the contrary, what we have is not a fratricide but an attack begun at an opportune moment when the defenders of the Holy Grail are in a state of disorganization following their leader's death). The return of the King of Chastel Mortel to the "Old Law" is revealed and, thus, to his heretic nature or even as the anti-Christ:

> . . . car li Rois del Chastel Mort[el], qui la terre a sesie et le chastel, a fet crier par tout le païs que tuit cil qui voudront maintenir la Viez Loi et

> guerpir la Nouvele avront sa garantie et sun conseil et s'aide, et cil qui
> fere nel voudront seront destruit et essillié. [Ll. 5420–24]

> . . . for the King of Castle Mortal, who has seized the land and the
> castle, has proclaimed throughout the land that all those who would
> keep the Old Law and abandon the New will have his protection, his
> counsel, and his aid. Those who refuse will be decimated and exiled.

After two or three insistent calls to return, Perlesvaus finally arrives at
the Château du Graal, after dispatching a certain number of highly
picturesque adventures on the way. These adventures are entirely in
the spirit of the romance, which is by far one of the most original of all
those dealing with the Grail. They are also, it seems, infinitely more
central to it than the recapture of the Château, whose defenses appear
quite modest and commonplace. The very road to the Château has lost
its spectacular appearance. From the point of view of Christian numer-
ology, the seven bridges defended by the enemies of the Faith have,
doubtless, a great symbolic value; but odds are that Gawain's halluci-
nations are more enticing to the reader. Moreover, the whole episode
takes place with a laughable rapidity, the only element somewhat out
of the ordinary being that of the white lion whose thoughts Perlesvaus
reads in order to learn what course of action ought to be taken.

Just as the Fisher King dies discreetly, without slowing the text, and
that the Château du Graal was taken *in absentia* by the evil brother,
the reader only informed of it by rumor and allusion, the King of
Chastel Mortel, enemy of God and man, suddenly disappears from the
scene in just a few lines. To be sure, he takes his own life, thereby
committing the worst crime imaginable for a Christian. The homily
delivered by "Josephes" on the black sheep who spoils the best of
families, however, constitutes an obvious anticlimax to the event, as is
confirmed by the bewildered attitude of Perlesvaus and the hermits
once in control of the castle. All returns to normal, a mass is sung in
the chapel, everybody goes home . . . there's not much else to say!

Perlesvaus's mission is complete: he recaptures the Château du
Graal and assures the reestablishment of the New Law. But this victory
does not constitute a return to the good old days. The Fisher King
rightfully belongs to the world of fiction. The wonders of the Holy
Grail disappear with him, never to return again. Contrary to what
occurs in the *Parzifal* of Wolfram von Eschenbach, or even, to a lesser
degree, in the prose *Perceval* of the pseudo-Robert de Boron, the "Good
Knight" does not take his uncle's place as the King of the Grail. Or

rather, if he does become King, it is on very different terms: the magic which ruled the Château in the time of the Fisher King no longer prevails. The castle itself tends to become confused with the chapel where the hermits march in procession, and at this point the only wonders to be found there are the bell and the chalice which Arthur decides to use regularly in liturgical ceremonies. A very edifying miracle to be sure, but one whose impact is far from essential! From then on, the Holy Grail is removed from the sphere of romance to rejoin that of spiritual truths which, as everyone knows, are better kept secret. Beyond the simple announcement of the perfections of the "chastel que Perlesvaus avoit conquis" ["the castle that Perlesvaus had captured"], all that remains, all that the "estoire" (l. 7205) ["story/ history"] can supply, is a brief encyclopedic entry listing the different names of the castle: and even this etiological explanation is cut short:

> Por ce ot i a non Chastel des Ames, ce dist Josephez, que onques nus n'i devia que l'ame n'alast en Paradis. [Ll. 7206–08]

> For this it was called the Castle of Souls, says Josephus, for no one ever died there whose soul did not go to Paradise.

The imagination of the Count, or of "Joseph", seems to be idling! One need only compare the quick listing of the appearances of the sacred object during the mass to the description given of its different "passages" before Gawain. In the first case one has, successively, a candle in the Grail, "donc in n'ert gaires a icel tens" [so there were hardly any in those days] (a pleasant comment that excuses the apparent banality of this first "semblance" of the Grail); then "enmi le Graal la forme d'un enfant" (l. 2439) [inside the Grail the shape of a child], and then, inside the Grail, suspended midair "un home cloufichié en une croix, et li estoit le glaive fichié eu costé" (ll. 2449–50) [a man nailed to a cross, with the lance thrust in his side]. These different "muances" [symbolic metamorphoses] which explicitly link the Grail to the life and passion of Christ are accompanied by hallucinations on a lesser scale. Lesser insofar as Gawain sees two or three angels where others only see young girls, and as he is fascinated by three drops of blood on the table, which form an obvious counterpoint to Perceval's three drops of blood on the snow in the *Conte du Graal*. In the *Perlesvaus*, Gawain is not yet anything like the failed knight so absorbed in the beauty of the Grail's carrier that he thinks of nothing else! In any event, the scene of the cortege itself, preceded by those of the entrance into the Château du Graal and of Gawain's reception by the Fisher King, occupies a respect-

able number of lines. In the second case, after Perlesvaus's victory, the scene is quickly conjured away:

> Li Graaux s'aparut eu secré de la messe en .v. manieres que l'on ne doit mie dire, car les secrees choses dou sacrement ne doit nus dire en apert, se cil non a qui Dex en a grace donee. Li rois Artus vit totes les muances. [Ll. 7223–26]

> The Grail appeared during the Secret of the mass in five ways which no one should reveal, for no one should tell the secrets of the sacrament, save he to whom God has given that grace. King Arthur saw all the changes.

And a lot of good it does him! The reader, however, remains particularly frustrated. This silence about the mysteries of the Faith is entirely praiseworthy, but it does constitute the death of any tale, and of any romance. It is not at all surprising, then, that the tale begins to prattle on, calling on the wisdom of nations before finding a second wind in the telling of undoubtedly profane, independent "stories," such as that of Gawain's birth or, more generally, that of the conflict with Briant of the Isles. In fact, just as the *Queste del saint Graal* and the *Mort le roi Artu* form a diptych of profane adventures and "heavenly" chivalry, the episodes in the *Perlesvaus* that are connected to the betrayal of Keu and the revolt of Briant of the Isles form a purely chivalric plot, devoid of any metaphysical dimension and which becomes more important in the latter branches of the tale than the theological epic.

The Château du Graal is in fact reduced thereafter to the castle where the Grail "appears." In its broadest definition, it is a convent where Perlesvaus hopes to establish his mother and sister, once and for all. For all its label of "saintisme," (l. 9242) [most sacred] it is described as a relic, for it is surrounded by other relics of almost equal worth. Ultimately, the "wonder" moves away from this all too domesticated site too close dangerously to an Isle of Avalon which is easily confused with historical Glastonbury despite the artificial distinctions between them in order to take root in a Beyond inherited from the travels of Saint Brendan and from hastily Christianized Celtic legends. In fact, the "Isle Plenteürose" of which Perlesvaus will be King after he has accomplished his present mission, presents all of the characteristics of Earthly Paradise. Similarly, the "Isle Souffroitose," with which the white-garbed hermits threaten him if he fails in his duty, is a new avatar of Hell ruled, as is fitting, by the Black Hermit whose existence

has been somewhat forgotten since the allegoresis proposed to Gawain by the Hermit of the Château de l'Enqueste. . . . This idea of knightly adventures no longer terrestrial but maritime, as is found in the prose *Estoire dou Graal*, is connected to the imagination of an Otherworld as nothing less than Christian, in which all the wonders are found in one island after another. Interesting resurgences of this legendary corpus are to be found, for example, in the innocent mention made of the "Chastel de la Balainne" ["Castle of the Whale"].

On the whole, the author of the *Perlesvaus* finds himself confronted by a magical heritage from which he can free himself only by using techniques of displacement and allegorization. The untouched wonders concerning the object of the Grail as such are first allowed into the space of the text at the time when the narrative focuses on Gawain, the character most closely tied to the world of romance, in the sense of fiction. As the theological message connected to the Holy Grail is salvaged little by little, in the text, the flamboyant traits of the literary Grail are debunked and eliminated from representation. The story of the Grail, as it was conceived by Chrétien de Troyes, is never finished: there is no second meeting between the Fisher King and Perlesvaus; no questions to which the correct answers could finally be given; no transmission of powers. The "King" of the Holy Grail is replaced by a monastic or even hermitic structure. The Castle which was the Grail's remains a concrete place which can be located and eventually visited—though to do so the adventurer faces risks and perils, and obviously does so against the wishes of the speakers in the narrative. It has lost its magical and fictional value and become a historic "witness" to events just as marvelous but also, and more importantly, as *true* as those of the Incarnation. The "marvelous" survives elsewhere, in the dust of the islands whose disposition and content vary with God's will and which are pushed back to the outer boundaries of the human world: that is to say, paradoxically, to the boundaries of the divine world where at least faith can find itself on safe ground.

The creation of a second castle to counterbalance that of the Holy Grail allows, in fact, for the separation of the latter from reality, insofar as the Chastel Mortel and its King remain simple designations void of meaning. The bipolar structure put in its place tends to reduce the Fisher King and the Château du Graal to simple allegorical figures, rhetorical "loci" upon which a more or less allegorical reading, but not a fictional text can be based. The meeting of these two principles, Good

and Evil incarnate, has an effect similar to that between matter and antimatter: nothing remains afterwards but a greyness that cannot be compared with the former sacred place of wonders. Ultimately, the Château du Graal remains accessible, anchored in the time and space of the enunciation of the romance rather than relegated to the other side of the impenetrable barrier which separates truth from fiction. Unfortunately, what remains is no more than a deceptive silhouette. All that was specific to it is eliminated and displaced to other magical places. The Holy Grail itself is not definitively removed from sight—as it is in the *Queste de saint Graal*, the ending of which is satisfying at least in terms of aesthetic structures even if frustrating on the level of narrative content—it just "moves out," as does Perlesvaus himself. The Grail settles down in the famed "Ile Plenteürose" which serves as a substitute for the Castle of the Fisher King and which, because of its paradisiac quality, is more apt than its "prototype" to bear the name of "Chastel des Armes." As one of the celestial voices casually appearing in the *Perlesvaus* calmly informs Perlesvaus:

> "e li sainz Graauz ne s'aparra plus ça dedenz, mes vos savroiz bien desq'a cort terme la o il iert." [10138–39]

> "and the holy Grail will no longer appear in this place, but you will soon learn where it will be."

The set remains the same, such as it is described in this "estoire" faithfully passed on by Josephes, whoever he may be. But all the signs which contributed to the establishment of the "senefiance" of the "Haut Livre du Graal" have gone through to the other side of the looking glass. Nothing remains but the letter, the letter of the text, the letter of the edifice inscribed on the world; if any and everyone can see Guenevere's tomb in the "Isle d'Avalon en une sainte meson de religion" (l. 10189) [on the Isle of Avalon in a holy house of religion], the Holy Grail continues to "appear" in another Avalon which blends a dream of Heaven on Earth with the "Isles Bienheureuses" of Celtic legend.

Translated by Amy Reed

Translations from the Old French by John Jay Thompson

IV. Baroque Middle Ages?

JACQUELINE CERQUIGLINI-TOULET

Fullness and Emptiness: Shortages and Storehouses of Lyric Treasure in the Fourteenth and Fifteenth Centuries

Two activities, trivial in appearance but recurring, frequently commented upon by the poet, run throughout the lyrical works of Jean Froissart like an enigma: making garlands of flowers, crowns, wreaths—and enclosing poems in boxes.

In the *Espinette amoureuse,* young women collect violets and toss them onto the knees of the poet and his lady; Froissart then remarks:

> Ma dame si les recoelloit,
> Qui bellement les enfiloit
> En espinçons de grouselier,
> Et puis le mes faisoit baiser.[1]

My Lady gathered and artfully threaded them onto gooseberry thorns, then offered them to my lips.

In the *Plaidoirie de la Rose de la Violette* the action reappears, explained and justified:

> Par usage on voit moult de gens
> Qui en biaus rainsiaus vers et gens
> De grouseliers ficent et boutent
> Les violettes et aroutent
> Pour mieuls veoir et oudourer.[2]

1. Jean Froissart, *Espinette amoureuse,* ed. A. Fourrier (Paris: Klincksieck, 1972, 2nd edition), ll. 3520–23. Hereafter cited in the text as *EA*.

2. Jean Froissart, *"Dits" et "Débats",* ed. A. Fourrier (Geneva: Droz, 1979), *Plaidoirie de la Rose et de la Violette,* ll. 67–71. Hereafter another title from this work, *Dit dou Florin,* will be referred to in the text as *DF*.

YFS Special Edition, Contexts: Style and Values in Medieval Art and Literature, ed. Daniel Poirion and Nancy Freeman Regalado, © 1991 by Yale University.

Many are seen, as is the custom, setting and arranging bunches of violets on lovely green gooseberry branches, to better see them and catch their scent.

The gesture is of an aesthetic order: "Pour mieuls veoir et oudourer"; it creates a work that arouses adoration: "Et puis le mes faisoit baisier." This adoration is in fact transferred; though directed at the lady, it is addressed to the flowers, which the lady has just made into an object of art.

The second manual activity concerns the poet. In the *Prison amoureuse* (*PA*), small caskets are made for the keeping of poems, in this instance a virelay:

> Je le mis en une laiette
> Que j'avoie proprement fete
> De danemarce bien ounie,
> (Car moult volentiers m'ensounie
> A passer le tamps sur tel cose).[3] [*PA*, ll. 1248–52]

I put them in a little coffer which I had carefully made of smooth Danish leather (for I gladly keep myself busy with such things).

The act of enclosing lyrical pieces in coffers punctuates the work. What is this gesture which, from flowers to poems, holds on by a thread, sews on with a thorn, ties with a branch, assembling and encloses in a case or jewel box, that which by its essence is immediate and unique—a flower, a poem? A gesture of collection? An aesthetic of fullness and emptiness?

Jean Froissart's *Prison amoureuse*, typical of poetic experiments of the fourteenth century, tells the story of its own writing. It offers no other narrative frame or argument. The *Prison amoureuse* is the art of writing as an act unfolding before our eyes, a reflection on writing itself. The great model here is Guillaume de Machaut's *Voir Dit*. Jean Froissart uses Guillaume de Machaut's formula of inserting a correspondence, not between the lover and his lady, but between the poet Flos and his friend and patron Rose. The names of the two protagonists identify them as flowers in a bouquet in a relation of the generic (the poet) to the specific (the patron), from Latin (the scholar, Flos) to French (the prince, Rose). The patron asks the poet for advice in mat-

3. Jean Froissart, *Prison amoureuse*, ed. A. Fourrier (Paris: Klincksieck, 1974), ll. 1248–52. Hereafter cited in the text as *PA*.

ters of love as he asks for samples of poetry. In this way their correspondence, the poems and the mythological inventions accompanying it, that are their commentaries, are assembled in one volume. The patron urges the poet to finish this compilations in these terms: "mes che m'i moet et fait faire le grant desir que j'ai de veoir che livret rassemblé et volumé ensi qu'empris l'avons vous et moi." (*PA*, Letter XI from Rose, 168, ll. 11–14) [. . . but the great desire I have to see this book gathered and bound, just as you and I have agreed, spurs me to do it.].

What is the meaning, then, within this context of reflection on the composition of a work, of the careful gesture that preserves poems in safety by enclosing them in a coffer?

> J'avoie a dont de cuir bouli
> Un coffinet bel et poli,
> Qui estoit longés et estrois,
> Ou les balades toutes trois
> Mis, car ensi user soloie [*PA*, ll. 2114–18]

I used to have a little chest, pretty and polished, made of boiled leather. It was long and narrow and I placed, as was my wont, all three ballads in it.

The gesture is banal, or can seem so to a modern eye. What is remarkable, after all, in seeing a poet lock three ballads in a box, when he has described this activity in such simple terms? This "meadow manufacture," as Ponge says, is quite prosaic; but the discourse of the writer on the act of writing is part of a historical process. In describing a gesture that only seems familiar, Froissart actually represents the emergence of writing as a profession.

Let us note the similarities between this act and the making of floral wreaths that delineate a paradigm. In both cases, the activity is described at length with painstaking attention to detail. The activity is noted as being habitual, associated with a collective use for flowers, *"par usage,"* reflecting an individual practice for the poems, "car ensi user soloie." In each case the activity is justified, but for a different reason. It displays the flowers to their advantage; the poems are preserved and amassed as capital. It has a practical purpose: to avoid dispersion and loss (*PA*, ll. 2119–2121).

A complex act with many implications, this activity indicates, first of all, an anxiety about poetic creation. The poet fears failure from two perspectives. For himself, he fears missing opportunities for composition; since composition is, and must be, related to a *sentement*, that is,

lived experience, what has been felt. The poet vigorously reaffirms it. He thus sets forth the conditions for the three ballads he will keep in reserve:

> Jusques a trois balades fis,
> Selonc le matere et l'avis
> Que j'avoie lors pour le tamps
> Et dou quel je sui bien sentans. [*PA*, ll. 2030–33]

I made three ballads out of my thoughts of the moment—and this according to my feelings.

The term "to feel" (*sentir*) is capital; it expresses the idea of a convention linking the order of experience to the order of writing. The poet makes the same remark in regard to the lay he has undertaken but is unsure of finishing, a project for which he would like to take advantage of the immediate state of his *sentement:*

> Encores entrepris a faire
> Un lay, quoi que fust dou parfaire,
> Selonc le matere et le tamps
> Le quel j'estoie adont sentans. [*PA*, ll. 2122–25]

I again started to compose a lay, however long it might take, following my thoughts and feelings of the moment.

By this alone he indicates the difficulty of his position as a commissioned writer and of the risks of writing in response to an inner need and also to an outer commission.

For Froissart's second fear of failure falls within the perspective of his patron; the poet is afraid of not being able to respond immediately to a request:

> A fin que, je les voloie
> Envoiier, donner ou proumettre,
> Tost peuisse sus le main mettre. [*PA*, ll. 2119–21]

So that, when I wanted to send, give, or promise them, I could have them on hand straightaway.

The poet feels the need to be *pourveü* [supplied with] poems, completed pieces, perfected objects. Here Froissart is original: for Guillaume de Machaut, to be *pourveü* was to desire to receive from Nature and Love the qualities and the disposition necessary for composition. Thus Guillaume de Machaut responds to Nature in his Prologue,

which is his *ars poetica:* "Qu'avis (variante qu'amours) n'autre chose
soutive / N'ay ne n'aray, se ne m'en pourveez"[4] For I have not, nor will I
have, any thought (variant: any love) or any subtle thing, / save you
provide me it].

and Love announces to him:

> Pour ce t'ameinne en pourvëance,
> Pour toy donner matere a ce parfaire,
> Mes trois enfans en douce contenance:
> C'est Dous Penser, Plaisance et Esperance. [Ballade III, ll. 7–10]

So I am providing you with the stuff you will need to finish this: my
three children, delightful to behold: Sweet Thoughts, Pleasure, and
Hope.

For Froissart, to be *pourveü* no longer refers to the conditions of cre-
ation but to its results. The poet writes to his patron: "Rose, tres chiers
compains et grans ami, vous m'avés escript que aucun dittié nouvelle-
ment fet et ordonné je vous vosisse envoiier. Sachiés que au jour que
vostre lettres me vinrent, je n'en estoie point pouveüs" (*PA*, Letter VI
from Flos, 103). [Rose, dear companion and friend, you have requested
that I send you a poem, newly written and rhymed. But on the day your
letter arrived, I had none on hand]. Or again: "Je vous envoie trois
balades faites assés nouvellement, en l'absence d'un lay, car je n'en sui
pas pourveüs tant qu'en present" (*PA*, Letter IX from Flos, 155) [I am
sending you three recently composed ballads, instead of a lay, for at the
moment I have none on hand]. On the contrary, the poet, having re-
ceived letters and poems from Rose and having sent some to him in
return, states, referring to the messenger:

> Il se parti et je remés,
> Bien pourveüs et bien armés
> D'amoureus et de biaus escrips,
> Tant par moi que d'autrui escrips,
> Ou je m'esbatoie alefois. [*PA*, ll. 1049–53]

He took his leave and I remained, well provisioned and well armed with
beautiful words of love, written by me and by another, in which I took
pleasure.

4. Guillaume de Machaut, (*Oeuvres,* ed. E. Hoepffner (Paris: Firmin-Didot, 1908,
S.A.T.F.), vol. 1, Ballade 2, ll. 16–17. Hereafter cited in the text.

Poetry is that which arms, it is a stock pile. The poet wants to have at his disposal something he can make use of in a relationship of exchange. There are two related gestures here: to accumulate (the reference is to three ballads) and to enclose. To be *pouveü* is to have a stock.

Jean Froissart, at the beginning of the *Joli Buisson de Jonece* (*JBJ*), recalls that as a young man he wished to try his hand at commerce. It was a failure:

> Si me mis en le marcandise,
> Ou je sui ossi bien de taille
> Que d'entrer ens une bataille
> Ou je me trouveroie envis![5]

So I went into buying and selling, which suits me about as much as going into battle, the last place I would want to be!

No more than arms is trade the work of a scholar. But the temptation was, it would seem, profoundly compelling for Froissart, since it left its trace even in Froissart's conception of his poetic activity: *li mestiers gens* (l. 162) [the noble craft]. The poet desires to manage his creation as one manages a business. To be *pouveü*, in terms of lyrical poems, to have them *en pourvëance*, is to speculate what has been postponed, what is foreseen. Within this desire we can grasp Froissart's fundamental anguish, his fundamental wager against time. The fear is of missing an opportunity: one must collect what one sees and feels at the moment (and what others see and feel: we need only think of the *Chroniques*); the fear is of keeping someone, the prince, waiting. Thus, a propos of the lay that had been commissioned but never finished:

> Mes ains que je l'aie acompli,
> Trop poroie le messagier,
> Qui chi se sejourne, atargier;
> S'est bon que son chemin avance. [*PA*, ll. 3452–55]

But before I can do the finishing touches, the messager, retained here, could be held up too long, so it is better that he continue on his way.

One must be prepared. Referring to the ballads, Froissart says: "Cestes vorrai presentement / Envoiier" (*PA*, ll. 3458–59) [I should gladly send these now]. The idea that this fear is that writing can struggle against loss, time, and oblivion. Wondering if he should continue the lay he has

5. Jean Froissart, *Joli Buisson de Jonece*, ed. A. Fourrier (Geneva: Droz, 1975), ll. 94–97.

already begun, the poet concludes: "Oil, di je, il est bons repris, / Anchois que le mette en oubli" (*PA*, ll. 3450–51) [Yes, I said, it is better taken up again, before I forget it]. Writing, unlike speech, also allows for the anticipation of a demand; it changes one's perspective on time.

Until very recently, literary critics tended to represent Froissart as a *janus bifrons*. The poet was set against the chronicler; the former praised, the latter denigrated. It is striking to see that the same forces run throughout the entire work: from one section to another, Froissart's essential activity is that of collecting.

The storing up of poems, an activity of the commissioned poet, is mirrored in Froissart's text. Like many lords of the fourteenth and fifteenth centuries, the prince, Rose, wishes to pass for a poet and emulates their attitudes; for example, he asks Flos:

> Je vous suppli chierement et fiablement que, se vous avés riens fet de nouvel, que vous le me voelliés envoiier, et par especial, se de tant je vous osoie cargier que d'un petit dittié amoureus, qui se traistast sus aucune nouvelle matere qu'on n'aroit onques veü ne oÿ en rime, tele com, par figure, fu jadis de Piramus et de Tysbé, ou de Eneas et de Dido, ou de Tristran et de Yseus, car j'en ai esté requis par plusieurs fois en lieu ou bien me fuissent venu en point, se j'en euisse esté pourveüs, et feront encor, se je les ai. [*PA*, Letter V from Rose, 82]

> I kindly and sincerely request, if you have some new composition, that you send it to me; and especially (if I dared burden you with so much as a little love poem), one which deals with new material never before seen, or heard in rhyme, as were the characters of Piramus and Thysbe, or of Eneas and Dido, or of Tristan and Isolde. For I have had them requested several times in situations where they would have been just the thing, if I had had them on hand. And they still can work, if I have them.

The enclosure of poems thus plays both upon the postponed and the transferred. It refers to a poetry which has its effect not in presence but in distance. This process had already been sketched by Guillaume de Machaut. In the *Fonteinne amoureuse*[6] (*FA*), the poet, through a partition, overhears the poetic lament of a lover; the poet's reflex, typical of the movement of the fourteenth century, is to write down this "dolereuse complainte" (l. 214), to preserve it. The poet insists upon this scribal activity:

6. Guillaume de Machaut, (*Oeuvres, Fonteinne amoureuse*, ed. E. Hoepffner (Paris: Edouard Champion, 1921, S.A.T.F.), vol. 3, ll. 229–32. Hereafter cited in the text as *FA*.

> Si que je pris mon escriptoire,
> Qui est entaillie d'ivoire,
> Et tous mes outils pour escrire
> La complainte qu'i voloit dire. [*FA*, ll. 229–32]

So I took my pen-case, carved from ivory, and all my instruments in order to write down his lament.

In this way the poet, who is later asked by the prince to write "ou lay ou complainte" on the subject of his suffering, can present him immediately with the prince's own composition, written down the night before:

> Ma main mis a ma gibessiere,
> S'ataingni sa complainte entiere
> Et dis: "Sire, vostre requeste,
> Tenez; vesla ci toute preste." [*FA*, ll. 1517–20]

I reached into my game-bag and brought out his entire lament and I said, "Sire, you have your request; here it is all set."

The *gibecière* [game bag] is the first figure of the coffer to appear; but this figure still refers to chivalric values through an allusion to hunting. Moreover, by his staging of the scene between poet and prince, Guillaume emphasizes the idea of exchanging gift for countergift. His poetic notation, his hoarding of poetic treasure [*thésaurisation*] are not deliberate, they are simply the fruit of an opportunity taken. The poet merely returns to the prince what is already his: poetry. For within this conception of the world, and of the role of each of its different conditions, the prince figures as the primary lover. Guillaume de Machaut, in the *FA*, insists on the respective roles of knight and scholar (ll. 132–38). For the prince, arms and love, that is, in terms of Guillaume's poetic art, *material*; for the scholar, writing, that is, *form*.

The conditions of exchange between poet and prince evolve from Guillaume de Machaut to Jean Froissart. In the *FA*, Guillaume evokes, in the character of Jean de Berry, a prince who knows how to give, in accordance with his role, makes wealth circulate. In one example, at the beginning of the text, this is explicitly stated; the prince receives *une haguenée* [a sparrow hawk] from one of his neighbors:

> Le don prisa moult hautement
> Et le reçut courtoisement
> En disant: "Vesci riche don.
> Bien est dignes de guerredon." [*FA*, ll. 1141–44]

He greatly esteemed the gift and accepted it graciously saying, "This is a gift of great price, worthy of much recompense."

He thanks the messenger, giving him twelve florins. Immediately afterward, "tout en l'eure" (l. 1148), he sends "le chien, l'oisel, la haguenée" (l. 1149) to a woman. At the beginning of the *Prison amoureuse*, Jean Froissart echoes this praise of generosity:

> Certes, c'est une bonne tece
> Que uns grans sires puet avoir
> D'estre larges de son avoir. [PA, ll. 54–56]

Indeed, generosity is a good quality for a great lord to have.

The words *dons* [gift] and *guerredons* [recompense] reappear (l. 77–78). The prince he chooses as an example, Jean de Luxembourg, embodies the traditional chivalrous values. But while Jean de Luxembourg was Guillaume de Machaut's protector, he was never Froissart's, who was just nine years old when the sovereign died—symbolically enough—at Crécy. For Froissart, largesse, as represented by the king of Bohemia, is only a memory.

Why then, when the riches are brought out of coffers, must poetry be put back in? What does this dialectic of fullness and emptiness signify for the scholar? The time, in fact, is one of frugality; generosity is praised only because it is no longer honored. The satiric texts of Froissart's day repeat it time and again; we need only listen to Eustache Deschamps. And if the great—the lords, the prelates—lack generosity, what can the poet hoard? Riches? Certainly not in Froissart's case; the poet evokes this impossibility in the *Dit dou Florin* (*DF*). The image of a prison reappears obsessively: a prison-purse which, however well *pourveüe* it is (l. 105), cannot keep money.

> J'avoie acheté en ce jour
> Une boursette trois deniers
> Et la, comme mes prisonniers,
> Les quarante frans encloÿ.
>
> .
>
> Or avoi je mis mon avoir
> Et la boursette, tres le soir,
> En une aultre bourse plus grans.
> Quant je cuidai trouver mes frans,
> Certes je ne trouvai riensnee. [DF, ll. 396–99 and 403–07]

That day I had bought a little purse for three pennies and I shut in there my prisoners, the forty francs.

...

When I went to look for my francs, indeed I found nothing at all; and the night before I had put my belongings and the little purse inside another, larger, purse.

The endless insertion of the purses into one another cannot prevent loss. If Froissart knows how to "argent desfaire," [to go through money] he does not know how to "refaire (argent)," [make money] "le rapiecier ne remettre ensamble," as he says at the opening of the text (ll. 1–3); but to redo, patch up, put back together, is precisely what makes writing. Since the exchange of gifts (*don* and *contre-don*) and generosity, (*spartio*), [largesse] are dead, what the poet will stockpile, in order to bring it back again, if need be, into a mercantile exchange, is poetry.

The gesture of enclosing poems in coffers marks a fundamental change in lyric poetry. It marks a passage from a poetry of *énonciations* [utterings] to a poetry that is a reserve of *énoncés* [utterances]. Voice has fallen silent; poetry can exist independently of music, whose place is now taken by writing. The lyrical poem becomes an object that must be seized at the right moment and is available for the taking. It has the various characteristics of an object; it is given a title circumscribing it, isolating it, establishing its autonomy. The poem is *built:* the image appears frequently in Froissart. Lyrical pieces are finely wrought. There is an emphasis on the time required for their composition; the lay is interrupted, then taken up again. By this alone the poet indicates the difficulty of realizing such a piece (*PA*, ll. 2199–2203) and emphasizes the fact that the moment of its composition is no longer unique; the lyrical piece is no longer song but writing. The poet goes so far as to hand over sketches, outlines, rough drafts. Thus Rose writes to Flos (let us note that it is the prince, the amateur poet who writes): "Je vous envoie d'un virelay che que j'en ai fait" (*PA*, Letter XI, 169). [I am sending you what I have written of a virelay]. The virelay produced contains, in fact, only one stanza. The unfinished composition of a lyrical piece is already featured in Guillaume de Machaut's *Voir Dit;* but there it referred to the psychological state of the author of the piece, the lady, also an amateur poet:

> Hé las, la douce debonnaire
> Le tiers ver ne pot onques faire,
> Tant estoit lasse et adolee,

> Triste, dolante et esplouree;
> Mais les .II. vers qu'avez oÿ
> Dedens ceste lettre encloÿ.[7]

Alas, the sweet good-natured lady could not compose the third stanza,
she was so weary and distressed, saddened, pained, and teary-eyed. But
the two stanzas you have heard she enclosed in this letter.

This is not the case with Jean Froissart: the incompletion of a piece is
meant to show lyrical objects in a state of being wrought; the reader is
made to participate in the process of writing.

It is understandable, then, that the poet insists on evoking not only
the act of writing in its materiality, "Je pris dou papier et del encre" (*PA,*
l. 741) [I took paper and ink.] an act already mentioned several times by
Guillaume de Machaut, but also the making of objects: from the fabri-
cation of the *laiette* [the little chest] out of Danish wood, at the begin-
ning of the *Prison amoureuse* (ll. 1248–52), to the various manual
activities of Pynoteüs, who works with wood or earth. The mythologi-
cal example invented by Froissart is, in fact, a *mise-en-abyme* of the
entire work; Pynoteüs is a figure of the poet:

> Et de lettre fu moult bien duis,
> Car tel l'edefia Nature
> Qu'il congneut plus de l'escripture
> Que nuls poëtes a son tamps,
> Car il fu les .VII. ars sentans,
> Bien lettrés et bien *pourveüs.* [*PA,* ll. 1319–24 (emphasis added)]

And he was well versed in letters, for Nature had formed him such that
he knew more about writing than any poet of his time: he was sensitive
to the seven arts, learned and well endowed.

Thus Jean Froissart shows Pynoteüs, in his prime, having "maçonné et
fet" a goblet from the bark of a cherry tree (ll. 1371–73): fabrication of a
goblet, an open receptacle, a source of life. Nephtisphelé once dead,
Pynoteüs is a new Pygmalion:

> Oevre une ymage a grans bracies:
> D'aige et de terre muiste et mole
> Ordonne et taille et fet le mole,
> Dou long, dou large et del estroit,

7. Guillaume de Machaut, *Le livre du Voir Dit,* ed. Paul Imbs (forthcoming), ll.
8488–93. Hereafter cited in the text as *VD.*

> Dou clos, del ouvert, dou destroit,
> Tele que fu jadis au monde
> Neptisphelé qui tant fu monde. [*PA*, ll. 1717–23]

With great energy he fashions an image. Using water and damp soft earth he forms and shapes the mold: it had length, width and girth; places closed, open, and narrow, just as the pure Neptisphele had while she lived.

The words are identical, from the sculpture of the statue to the writing of the lay by the poet, to the prince's writing of his lament (l. 3008): *ordonne* et *taille*. Neptisphelé's mold is described in terms that will be used later to describe the small chest enclosing the ballads: "Un coffinet bel et poli, / Qui estoit longés et estrois" (*PA*, ll. 2115–16) [A pretty little polished chest, which was long and narrow]. It is this lifeless mold which Phoebus, the god of sun and poetry, brings to life through the intermediary of a laurel leaf (l. 1739). It is noteworthy that this role is no longer assigned to Venus, as it was traditionally from Ovid to Guillaume de Machaut. This evolution must be taken into account: the *coffres* [coffers] of the twelfth century, enclosing still warm and palpitating bodies (the nightingale of Marie de France's *Laustic*, laid in the tomb still singing, the lady mistaken for dead in Christian de Troyes's *Cligès*), become the *coffins* [caskets] of the fourteenth century containing a body of poetry: ballads to be reactivated by the poet when their time has come. Poetry is an object, but an object that can be animated. Its visible form is the book, in its two manifestations: *livre*, the closed book that encloses, the open book *recueil* [that collection].

An anecdote recounted in the *dit dou Florin* indicates this new attitude. The poet arrives in the court of Orthez, the court of Gaston Phoebus, with a finished book: *Meliador*. Froissart had been commissioned to write this romance of the "chevalier au soleil d'or" (l. 296) by Winceslas of Brabant, who died before seeing the completed work:

> Et le livre me fist ja faire
> Par tres grant amoureus afaire,
> Comment qu'il ne le veïst onques. [*DF*, ll. 307–09]

And as a gesture of great friendship he had me write the book, although he never got to see it.

Winceslas could not settle his account with the poet. For nearly three months, Froissart reads seven pages of *Meliador*, every night at mid-

night, to Gaston Phoebus. When the reading is finished, Gaston Phoebus pays the poet: he renumerates him for the entertainment but fails to purchase the book. Froissart is disappointed, as he shows in a passing remark:

> Et mon livre qu'il m'ot laissié,
> (Ne sçai se ce fu de coer lié),
> Mis en Avignon sans damage. [*DF*, ll. 387–89]

... and my book, which he had left me (I do not know if he did so gladly), I stored in Avignon without incident.

The leftover wine he is given ("Le demorant me faisoit boire" (*DF*, 1. 374), the paid performance, lower the poet to the rank of minstrel. Froissart's book was not recognized by Gaston Phoebus as an object worthy of possession. Gaston Phoebus is not a modern prince.

The poets' desire to preserve and to treasure poetry designates their new social situation. Henceforth their duty is not to serve but *pouveoir* to supply, the princes. In this way a new aesthetic is created which I will call the aesthetic of the book.

A strange scene from the *PA*, a scene that has always been interpreted as merely a refreshing depiction of reality, furnishes the key to this kind of writing. A group of women, during an outing in the country, steal from the poet the contents of his *aloiiere*, the small purse he wears attached to his belt (reminding us of Guillaume de Machaut's *gibecière*), which contains letters from Rose. The poet is determined to take back his property; a fight ensues in which not even his clothing is spared (1. 1136). The poet's lady concludes:

> Je conselle, ançois qu'on l'efforce,
> Que nous le mettons a renchon
> De la plus nouvelle canchon
> Qu'il ait fait ou que d'autrui sace. [*PA*, ll. 1150–53]

I suggest, before he is done violence, that we ask him ransom: the newest song he has written or learned from someone else.

It should be noted that in Guillaume de Machaut, the poet is held and made to pay ransom in the form of a lay on Hope (ll. 4289–94, *PP*, ll. 4956–61); Christine de Pizan was made to pay a fine that takes the form of the *Cent Balades d'Amant et de Dame* (prologue to a ballad, ll. 19–21). Poetry has become currency in the relation of exchange. Once the poet has accepted the price for his ransom, his lady then receives the letters from the hands of the young women; she opens them and discovers their contents, a ballad and a virelay. She then releases the

poet on condition that he leave the lyrical pieces with the women as booty; but the poems are written on the same parchment as the letters. Thus the lady removes, with the diamond from her ring, "de casune lettre . . . les cançons" (ll. 1187–89). The poet concludes this *aventure:*

> J'eus les lettres, et les cançons
> Cheirent en leurs pareçons.
> La furent monstrees et dittes
> Et copiies et escriptes
> En grant joie et en grant revel,
> Car tout plaist quanqui est nouvel. [*PA*, ll. 1193–98]

I got the letters, and the songs were the ladies' share. With great joy and revelry they were shown and recited, copied and written down, for "every new thing looks fair."

The anecdote illustrates the two phenomena that seem to be characteristic of this new aesthetic—on the one hand, the crisis of invention: there is a paucity of poems, since theft, ransoming, and fines occur; on the other, the mode of composition of the lyrical book. The poems are inseparable from the material of the letters, themselves enclosed within a *loiiere,* a pouch, which is also a tie (*lien*), as indicated by the etymology of the word. The composition of poems implies the opening of bags and the cutting of ties; but as soon as the poems are spoken, the poet is quick to copy them, transcribe them, while awaiting a new poetic composition.

The aesthetic of the book in the fourteenth and fifteenth centuries is an aesthetic of the coffer, the chest. Both book and chest are objects whose material fabrication is of some importance: chests are made of boiled leather, wood, ivory; books of paper, parchment. It would be surprising, then, that in the *Espinette amoureuse (EA)* the name *Papirus,* a mythological character invented by Froissart, "really lead nowhere", as the editor believes (introduction, 38). Papirus, as the name indicates, is an ancient image of the poet, blacksmith, and magician in accordance with Virgil's model (*EA,* ll. 2710–14). Like the chest, the book is a form concealing a content: it is a volume. Thus we see lyrical pieces move readily from the boxes containing them to the book enclosing them:

"Je vous renvoie la laiette que vous me baillastes au partir de vous et tout ce qui estoit dedens," [I am returning the little coffer you gave me when I left, and everything it contained,] writes Guillaume de Machaut to his lady in the *Voir Dit,* "car tout est mis par ordre dedens

vostre livre" (*VD*, letter XXXI, the lover) [for all of it has been put in proper order in your book]. This external form that informs the content illustrates the new composition of anthologies.

The composition has two aspects to it. It is collective, associating different parts and linking them together in a certain order; Guillaume de Machaut emphasizes this. The poet fits the elegant etymological definition given by Dante in the *Convivio:* "Et en tant qu'"auteur" vient et descend de ce verbe (auieo), il se prend seulement pour les poètes, qui par l'art musaique ont leurs paroles liées"[8] [And in so far as the word "auteur" derives from the verb *auieo*, it refers only to poets, who string their words together through the art of mosaic].

The poet is also, for the authors of the fourteenth and fifteenth centuries, one who folds. This is the other aspect of the composition: it enfolds (*enchâsse*). The gesture is obsessively repeated in the *Prison amoureuse:* "Les lettres pri et les ploiai / D'un fil de soie les loiai" (*PA,* ll. 1272–73) [I took the letter, folded it, and tied it with a silken thread]. "Et si tost qu/elle fu ploiie / Et saielee et bien loiie" (*PA,* ll. 2016–17) [And as soon as it was folded, sealed, and well tied . . .] and again: "Et escripsi sans plus d'atente / Les balades trestoutes trois / Et puis en petis plois estrois Les ploiai" (*PA,* ll. 3464–67) [And without delay I wrote all three ballads, and folded them into little narrow pleats]. Lyrical poems are enclosed in letters, letters enclosed in books, the books enveloped in linen cloth—*kamoukas*—and placed in chests. The setting of objects one within another is an image of the possibilities writing offers: the endless insertion of forms, but also of meanings: *mise-en-abyme,* superimposition. And what is proper to this kind of writing—a writing of collection—is the image through which it suggests this enfolding or embedding (*enchâssement*): the poet no longer turns to metaphors borrowed from the natural world such as the nut, for example; the figure is one of *emboîtement* [settings, embeddings]. It refers to objets fabricated by human hands. Meanings are no longer engendered in a mode of germination, of continuous growth, as they are in Chrétien de Troyes, where meanings arise from seed and grain: they unfold in an objective mode. Chests have locks, locks require keys; the moment for anagrams has come.

The chest is a figure of the book in terms of its form, but also in terms of its functions. Literally, the book makes poems circulate, as it is in the *Espinette amoureuse* where the poet places in a book he lends

8. Dante, *Banquet,* trans. A. Pézard (Paris: Gallimard, 1965, La Pléiade), IV, VI, 450.

to his lady, the *Baillieu d'Amours* by Mahieu le Poirier, a ballad of declaration proclaiming: "Pris me rench en la prison / La belle que tant pris'on" (*EA*, ll. 931–32) [Captured, I give myself up to that beauty of such great price]. Like the chest, the book protects. It brings through time whatever it encloses; in doing so, it is memory. Froissart frequently returns to this theme in the *Chroniques:* "car il n'est si juste retenue que c'est d'escripture"[9] [For no memory is as accurate as writing]. He also notes: "car il n'est si bel ne si grant memoire comme est d'escripture." (*Chroniques,* volume 12, 237) [For there is no memory so beautiful or so great as writing]. The chronicle is the coffer of time.

But as we see from the meaning the word has taken on in English—and which is one of its medieval meanings—the *coffin* [casket] is also a sarcophagus. Does the writing of collected pieces inaugurate, for lyricism, a time of contemplation, distance, reverence and death? *Coucher par écrit* [lay out in writing]? The voice has fallen silent, to be sure, but the letter is alive and the texts express this. The seals must be broken, the letters unfolded, the chests opened. This is the other meaning of enclosing: chests and books are made not so much to hide their contents as they are to be opened, and read by whoever must read them. What they protect, and what they offer, is a *trésor* [treasure], storing gold of the highest quality.

The *Prison amoureuse* proposed to us by Jean Froissart—a title he reflects upon at length—is at once an image of the emprisonment of the duke of Brabant, a traditional metaphor for *la vie amoureuse,* but above all an image of the lyrical book. An image appropriate to writing, whose numerous material enclosings, offered by the text, are its mirror. *Laiette, coffre, escrin, forgier, forcier, estui, huche,* an entire semantic field associated with writing, with memory, articulates the new lyrical experience of the fourteenth and fifteenth centuries. The experience is lived through imprisonment: the crucible of prison made many of these poets write. A literary experience of stockhousing: the book, be it a literary work or an object, collects and encloses lyricism. Solitude becomes one of the conditions of writing: interiorization, reflection on fullness and emptiness.

<div align="right">Translated by Christine Cano</div>

All translations from the Middle French by John Jay Thompson

9. Jean Froissart, *Chroniques,* ed. L. Mirot (Paris: Société de l'Histoire de France, 1931), vol. 12, 65. Hereafter cited in the text as *Chroniques.*

SYLVIA HUOT

The Daisy and the Laurel: Myths of Desire and Creativity in the Poetry of Jean Froissart

In vernacular poetry of the fourteenth century, one often finds a certain tension—or fascination—with the conflicting identities of scholar-cleric and lover. This can be expressed, on the one hand, as an anxiety about writing love poetry; or on the other, as a tendency to make love poetry into a learned medium. One thinks, for example, of Machaut's careful distinction between the clerk and the knight, and of the humor to which he subjects his unsuccessfully amorous persona, especially in the *Voir Dit*; and at the same time, of his designation of himself as an inspired poet and composer of love, endowed by Nature for that very purpose with intellectual, rhetorical, and musical skills.[1] Froissart, ordained as priest and increasingly committed to his project of chronicling military and political history, stages a literal and figurative awakening in the *Joli Buisson de Jonece*, at the end of which he abandons the composition of love poetry and produces a *Lay of Nostre Dame*.[2] And the fourteenth-century Italian tradition is marked by

1. See Kevin Brownlee, *Poetic Identity in Guillaume de Machaut* (Madison: University of Wisconsin Press, 1984); Jacqueline Cerquiglini, *"Un Engin si soutil": Guillaume de Machaut et l'écriture au XIVe siècle*, Bibliothèque du XVe Siècle 47 (Paris: Champion, 1985); Daniel Poirion, *Le Poète et le prince: L'Évolution du lyrisme courtois de Guillaume de Machaut à Charles d'Orléans* (Paris: P.U.F., 1965), 192–205.

2. See Michelle A. Freeman, "Froissart's *Le Joli Buisson de Jonece*: A Farewell to Poetry?" in Madeleine Pelner Cosman and Bruce Chandler, ed., *Machaut's World: Science and Art in the Fourteenth Century*, Annals of the New York Academy of Sciences, 314 (New York: 1978): 235–47; my *From Song to Book: The Poetics of Writing in Old French Lyric and Lyrical Narrative Poetry* (Ithaca: Cornell University Press, 1987), 316–23. On Froissart's concern with the potential follies of love, see also William W. Kibler, "Self-Delusion in Froissart's *Espinette amoureuse*," *Romania* 97 (1976): 77–98. I cite Froissart's works in the following editions: *The Lyric Poems of Jean Froissart: A Critical Edition*, ed. Rob Roy McGregor, Jr., North Carolina Studies in the Romance Languages and Literatures, 143 (Chapel Hill: University of North Carolina Department of Romance

YFS Special Edition, *Contexts: Style and Values in Medieval Art and Literature*, ed. Daniel Poirion and Nancy Freeman Regalado, © 1991 by Yale University.

Petrarch's extended meditation on his own identity as scholarly poet of love.[3] The conflict was not, of course, invented by the fourteenth century. No doubt the most remarkable example of learned love poetry in the medieval French tradition is the *Roman de la Rose*, where scholarship and erotic love are opposed as two possible sources of pleasure and profit alike, at the same time that they are fused in the fabric of Jean de Meun's text.

It is against this backdrop of an increasingly intellectualized vernacular love poetry that I wish to examine the works of Froissart. My focus here will be not the conflict between amorous *matière* and clerkly identity but rather their fusion, the elaboration of a poetry at once learned and secular. In particular, I wish to examine Froissart's technique of establishing a mythographic basis for his poetic identity and love psychology. This strategy, forging a link between vernacular love poetry and the Latin tradition, is not a new one; indeed, it is a well-established aspect of medieval vernacular literatures. But if Froissart was firmly rooted in tradition, he nonetheless altered those traditions to fit the context in which he wrote and to suit his own expressive needs.

Froissart's adaptation of Ovidian myths—both his use of known myths, sometimes transformed, and his creation of new ones—implies an audience with some knowledge of the *Metamorphoses* and its commentary tradition.[4] We know that Froissart composed his poetry

Languages, 1975); *Le Dittié de la flour de la margherite* (*DM*), in *Oeuvres de Froissart: Poésies*, ed. Auguste Scheler, vol. 2 (Brussels: Victor Devaux, 1871), 209–15; *L'Espinette amoureuse* (*EA*), ed. Anthime Fourrier, Bibliothèque Française et Romane, Série B: Editions Critiques de Textes, 2 (Paris: Klincksieck, 1972); *Le Joli Buisson de Jonece* (*JB*), ed. Anthime Fourrier, Textes Littéraires Français (Geneva: Droz, 1975); *Le Paradis d'amour* (*PA*), ed. Peter F. Dembowski, Textes Littéraires Français (Geneva: Droz, 1986); *La Plaidoirie de la rose et de la violette* (*PRV*), in *"Dits" et "Débats"*, ed. Anthime Fourrier, Textes Littéraires Français (Geneva: Droz, 1979), 191–203; *La Prison amoureuse* (*PrA*), ed. Anthime Fourrier, Bibliothèque Française et Romane, Série B: Editions Critiques de Textes, 13 (Paris: Klincksieck, 1974).

3. Much has been written concerning Petrarch's attitude towards love and towards his identity as poet; see, for example, Robert M. Durling, "Petrarch's 'Giovene donna sotto un verde lauro'," *MLN* 86 (1971): 1–20; John Freccero, "The Fig Tree and the Laurel: Petrarch's Poetics," *Diacritics* 5, i (Spring 1975): 34–40; Sara Sturm-Maddox, *Petrarch's Metamorphoses: Text and Subtext in the "Rime sparse"* (Columbia: University of Missouri Press, 1985).

4. On Froissart's use of myths, see my *From Song to Book*, 303–23; Kevin Brownlee, "Ovide et le Moi poétique à la fin du Moyen Age: Jean Froissart et Christine de Pizan," in *Modernité au moyen âge: Le défi du passé*, ed. Brigitte Cazelles and Charles Méla (Geneva: Droz, forthcoming); Douglas Kelly, "Les Inventions ovidiennes de Froissart: Réflexions intertextuelles comme imagination," *Littérature* 41 (Feb. 1981): 81–92; Michel Zink, "Froissart et la nuit du chasseur," *Poétique* 41 (1980): 60–77.

for an aristocratic, not a clerical, audience.[5] A certain level of literary sophistication among the aristocracy is possible with the existence of texts like the *Ovide moralisé,* which made Ovid's myths—both text and gloss—available in the vernacular. The popularity of the *Roman de la Rose* with its adaptations of such authors as Ovid, Cicero, Boethius, and Alain de Lille is a further index of lay interest in the Latin tradition, as is the growing number of translations of both classical and medieval Latin texts.[6] Evrart de Conty's encyclopedic commentary on the *Echecs amoureux,* written around 1400 for aristocratic patronage, indicates a strong interest in secular readings of myth, turning on love psychology, social morality, and natural science.[7]

This fascination with literary interpretation is not limited to texts grounded in the classical tradition. Already in the thirteenth century, the proliferation of allegorical visions and adventures in the *Queste del Saint Graal* suggests a public interested in both chivalry and exegesis.[8] The lapse of time between a knight's puzzling experience and its explication by a hermit allows the audience to formulate its own reading of the episode. The interpretive process becomes explicitly literary in the *Roman de Perceforest,* dating from the second quarter of the fourteenth century. One episode in this long prose romance offers a love poem replete with obscure imagery, the "Lai Secret," and invites the audience to unravel the ways in which it reflects the love stories of three knights; then rewards our efforts as each knight in turn meditates on the stanzas relevant to him and explicates the text.[9] Vernacular literature had always allowed for a certain element

5. Froissart frequently foregrounds his relationship with his aristocratic patrons. See Peter F. Dembowski, *Jean Froissart and His* Meliador: *Context, Craft, and Sense,* Edward C. Armstrong Monographs on Medieval Literature, 2 (Lexington, Ky.: French Forum, 1983), 32–59; William W. Kibler, "Poet and Patron: Froissart's *Prison amoureuse,*" *Esprit Créateur* (1978): 32–46; Daniel Poirion, *Le Poète et le prince,* 205–18.

6. See Peter F. Dembowski, "Learned Latin Treatises in French: Inspiration, Plagiarism, and Translation," *Viator* (1986): 255–69; Robert H. Lucas, "Medieval French Translations of the Latin Classics to 1500," *Speculum* 45 (1970): 225–53.

7. See Françoise Guichard-Tesson, "La *Glose des Echecs amoureux:* Un savoir à tendance laïque: comment l'interpréter?" *Fifteenth Century Studies* 10 (1984): 229–60.

8. See Laurence de Looze, "A Story of Interpretations: The *Queste del Saint Graal* as Metaliterature," *Romanic Review* 76 (1985): 129–47.

9. The *Roman de Perceforest* is as yet only partially edited. The performance of the "Lai secret" appears in *Perceforest: troisième partie,* ed. Gilles Roussineau, Textes Littéraires Français (Geneva: Droz, 1988), vol. 1, 275–78; Lyonnel explicates the strophes referring to himself, 280–82. The explication of the remaining strophes will appear in the second volume of Roussineau's edition of Part 3 of the *Perceforest* (forthcoming). I

of audience interaction with the text. But whereas Thomas d'Angleterre, writing in the twelfth century, invited his audience to judge the emotional content of his various characters' experiences, the anonymous author of the *Perceforest* proposes an exercise not in psychological but in textual analysis.

Clearly, a growing element of the lay public had an interest in literary interpretation, in mythology and mythography, in metaphor and allegory; and this interest was secular, revolving around love poetry, chivalric adventure, and aristocratic social values. When Froissart portrays himself in the *Prison amoureuse* in the service of Wenceslas of Brabant, his work is by no means limited to the composition of love songs. He additionally composes a long pseudo-Ovidian myth, that of Pynoteüs and Neptisphelé, and glosses it in some detail as an allegory of love; a similar commentary is provided for his patron's dream, shown to be a recasting of the same story in different imagery. The patron's letters indicate that both he and his lady not only study but even expand on Flos's commentary. It is Rose who first requests a gloss explicating the dream and the story of Pynoteüs as parallel constructs; the lady then finds the gloss incomplete:

> car elle les a examinees et sus ymaginé une nouvelle matere, qu'elle dist qui y faut, selonc l'ordenance dou livret de Pynoteüs et de Neptisphelé. . . . et est li ymaginations de li tele qu'il li samble que li exposition de mon songe ne fet nulle mention de Phebus, de Pheton, ne de la grant poëtrie qui dedens est contenue. Si dist ensi que une comparison, de vous fete et figuree sus ceste matere, seroit bien seant . . .
> [*PrA*, Lettre II, 168]

> for she has examined them and come up with a new topic, which she says is lacking, in the arrangement of the story of Pynoteüs and Neptisphelé. . . . and her idea is such that it strikes her that the explication of my dream makes no mention of Phoebus, of Phateon, nor of the great poetry contained therein. Thus she says that it would be good to have a comparison made and elaborated by you on this matter.

While the account in the *Prison amoureuse* is no doubt at least somewhat fictionalized, it surely does reflect a social reality in which aristocratic men and women sought to exercise their powers of interpretation on vernacular texts. Such an attitude on the part of the

have consulted that portion of the text in the MS Bibl. Nat. fr. 347, fol. 141–42 (explication of strophes relating to Estonné) and fol. 143v–144v (explication of strophes relating to Le Tor).

aristocratic patron is part and parcel of the growing status of vernacular poetry as literature, as a written art form worthy of learned explication; and of the vernacular versifier as a *poète*, a writer, a figure of literary authority.[10]

This constellation—a public interested in the secular uses of myth and literary interpretation; poets interested in establishing themselves as learned authors of the vernacular, exploring the possible conflict or resolution of this identity with their amorous subject matter—coincides with a resurgence of interest in the god Apollo as a literary figure. The regal associations of the sun make Apollo an appropriate figure of identification for the aristocratic reader; one of Froissart's patrons, Gaston, Count of Foix, even took the nickname "Fébus." And as the frequently amorous god of wisdom, music, and poetry, Apollo lends himself well to the newly emerging figure of the learned author of love poetry. Apollo is not especially prominent in the twelfth and thirteenth centuries, which favored other mythological figures: Narcissus, Pyramus and Thisbe. But he does appear in a fairly widespread interpolation in the *Roman de la Rose*, dating from the late thirteenth century.[11] Here, Apollo's musical contest with Marsyas is recounted by the God of Love, who seeks to identify himself with Apollo: certainly an appropriate association for Jean de Meun's patron deity. Machaut repeatedly identifies himself with Apollo as poet-musician; in the *Voir Dit*, he compares his situation to the tale of Apollo and Coronis. And of course, Machaut's Italian contemporary, Petrarch, returned almost obsessively to the myth of Apollo and Daphne throughout his lyric corpus, making of it the paradigm for his own unending pursuit of the elusive poetic lady. Apollo provides a figure of wisdom conquered by love; of desire eternally frustrated, resulting in the possession of the leaves that represent Daphne while marking the finality of her absence. Such a figure is readily applicable to the situation of the poet who, through writing, creates and prolongs his own desire, communing with the written page but not with the lady of whom he dreams and writes. Like Apollo with the laurel, such a poet appropriates the visual sign of his own loss and of his own unfulfilled desire, making of it an instrument of victory, of prowess, of poetry. The interest in Apollo can

10. On the vernacular *poète* figure, and on the vernacular poet as a writer, see my *From Song to Book;* Cerquiglini, *"Un Engin si soutil";* Brownlee, *Poetic Identity,* op. cit.

11. The Apollo interpolation appears in Ernest Langlois's edition of Guillaume de Lorris and Jean de Meun, *Le Roman de la Rose,* Société des Anciens Textes Français, vol. 3 (Paris: Champion, 1921), note to ll. 10830–31.

be associated both with an intellectualization of vernacular love poetry, and with the greater sense of the vernacular poet not as a maker of ephemeral song, but as a writer of books.[12]

Froissart, writing in the second half of the fourteenth century, inherits this rich tradition. His indebtedness to the *Rose* and to Machaut are obvious; given his travels to Avignon and to Italy, it is possible that he had some knowledge of Petrarch's poetry, although there is no evidence that he knew it well. In any case, Froissart's use of Ovidian mythology is extensive, and Apollo plays a prominent role in his writings. His first major dit, the *Espinette amoureuse,* opens with a replay of the Judgment of Paris, incorporated into a larger scheme—explained at greater length in the *Joli Buisson de Jonece*—whereby human life is divided into periods governed by a series of deities. Froissart's young protagonist, having been trained in eloquence by Mercury, is now presented with the choice of Venus, Pallas, or Juno; he chooses Venus. Departing from the example of Machaut, for whom Pallas represented *clergie,* Froissart identifies Pallas as goddess of war; the acceptance or rejection of learning does not enter into his decision.[13] If anything, one might feel that the young man, having learned to "parler par soutieueté" [speak subtly (*EA:* 404)], is selecting his poetic *matière.* Later, having fallen unrequitedly in love and found his poetic voice, Froissart's protagonist chooses the myth of Apollo and Daphne as the paradigm for his situation; he recounts the story at length in a *complainte,* expressing a wish that his own lady might become "[u]ns biaus loriers vers et foillus" [a beautiful laurel, green and leafy (*EA:* 1784)]. Such a transformation would allow him greater access to his recalcitrant beloved: "Aumains, je ne seroie plus / En doubte de moi traire ensus / De sa veüe" [at least I would no longer be afraid to come into her sight (*EA:* 1785–87)]. In a subsequent dream, he beholds his lady in a mirror. The dream lady—a pure projection of the lover's desire—welcomes the figuration of herself as a laurel, and promises to live up to that image of steadfast loyalty: in effect, to become a poetic image. And in the *Prison amoureuse,* Froissart recasts the Pygmalion story in his tale of Pynoteüs, who fashions a statue to replace the dead

12. I have discussed ways in which the myth of Apollo and Daphne is appropriate to the identity of the poet as writer in *From Song to Book,* 307–10.

13. Margaret J. Ehrhart discusses the motif of the Judgment of Paris in the works of Machaut and Froissart in *The Judgment of the Trojan Prince Paris in Medieval Literature* (Philadelphia: University of Pennsylvania Press, 1987), 130–51. Ehrhart points out that, unlike Machaut, Froissart makes Pallas goddess of war (146), but does not comment on the significance of this fact for Froissart's poetic identity.

Neptisphelé and prays to Apollo that it be given life. It is thus Apollo rather than Venus who presides over the transformation of art into life; the miracle takes place through the agency of a laurel leaf placed in the statue's mouth. Pynoteüs's prayer, largely devoted to an account of the fall of Phaeton, also refers to Apollo's love for the laurel and to his creation of the frankincense shrub from the body of Leucothoë. In both the *Espinette* and the *Prison*, the lady has become a reified image, a work of art: laurel, frankincense, reflection, dream, or animated statue. And we are shown that the lover-poet's only real contact is with the poetic image, not with the actual lady. Apollo provides Froissart with a figure for the poet who creates a monument at once enduring and beautiful, commemorative of love, yet at the same time embodying the eternal prolongation of desire, the absence of the beloved, the experience of loss. Such, for Froissart, is the power and the limitation of poetry.

The tale of Pynoteüs and Neptisphelé is not Froissart's only original myth. The most frequently recurring Froissardian myth is that of the daisy, or *marguerite*. The fourteenth century witnessed a vogue of poetry in honor of the daisy, as reflected in the works of Machaut, Froissart, Deschamps, and Chaucer.[14] The virtues attributed to the daisy, based on its shape and colors, its ability to bloom in wintertime, and its habit of turning its face to the sun by day and closing its petals at night, do not vary greatly from one poet to another; but Froissart was unique in his consistent use of the daisy and the name Marguerite, and in his invention of a myth explaining the origins of his favorite flower. We will probably never know whether or not Froissart had in mind one or more real women named Marguerite. What concerns us here is not his motivation in choosing the daisy as his special emblem, but rather the ways in which he used it and the mythological context he created for it.

The daisy appears in many of Froissart's dits; a brief overview of this motif allows us to view, in microcosm, the evolution of Froissart's literary career. In his earliest dit, the *Paradis d'amours*, the daisy functions as a love token: the protagonist receives from his lady a garland of daisies and composes a ballad, "Sur toutes flours j'aimme la margerite" (*PA:* 1627–53). From the beginning, then, the daisy is closely associated with the lady and already tends to replace her: possession of the

14. See James I. Wimsatt, *The Marguerite Poetry of Guillaume de Machaut*, Studies in the Romance Languages and Literatures, 87 (Chapel Hill: University of North Carolina Press, 1970).

garland is the closest the protagonist comes to winning her. In the *Espinette*, Marguerite appears to be the lady's name: just as she has proclaimed herself a laurel, so also she has acquired the identity of this other poetic image, has been subsumed by the love token she offered in her earlier manifestation.[15] Or is Froissart perhaps hinting that his real love is a poetic flower and not a real lady at all? In the *Prison*, where Froissart's identity as lover all but disappears, the daisy is the seal that he uses for his correspondence with Rose, the visual representation of his pseudonym, Flos. As the laurel to Apollo, as the laurel crown to Petrarch, so the daisy to Froissart: from being the sign of the beloved lady, source of poetic inspiration, the daisy has now become the sign of the poet himself, in his capacity as adviser, versifier, commentator, and compiler. In the *Buisson*, a dit that culminates in the transition from erotic to sacred poetry, the daisy does not appear: instead, the marguerite has become Sainte Marguerite, to whom the protagonist offers a prayer every morning, an activity from which he is distracted by the arrival of Venus (*JB:* 1106–12). The object of the poet's devotion has passed to a spiritual plane, conflicting rather than coinciding with the pursuit of erotic love. And in the *Plaidoirie de la rose et de la violette*, Froissart, turning from the poetry of love to the chronicling of military and political exploits, proclaims a shift from the court of Imagination to that of the fleur-de-lis (*PRV:* 276–87). The marguerite is mentioned briefly as a figure in attendance at the fleur-de-lis's court, perhaps with reference to one or more women at the French court (*PRV:* 333–36). In the course of Froissart's oeuvre, then, the marguerite alternately takes on associations with the expression of love; with the beloved herself; with the love poet; and finally with both sacred and political figures. The daisy proved a potent image, adaptable to the various phases of Froissart's poetry.

The myth that Froissart created to explain the daisy appears in three places: in the *Dittié de la flour de la margherite*; in a pastourelle, "La margherite a la plus belle" (ed. McGregor, #17); and in the *Buisson*. Each text gives somewhat different details. The *Margherite* contains the longest version of the story, which here falls into two

15. Froissart tells us (ll. 4183–88) that his name and that of his lady appear in four lines located between ll. 3338 and 3426. Fourrier has identified these as ll. 3386–89: from the first two of these one can extract the name "Jehan Froissart," while the fourth contains the words "violettes" and "marguerites." Given Froissart's predilection for the marguerite, one can assume that he means to draw our attention to this as the name of the lady, although, as Ehrhart points out, the possibility remains that "Violette" could be the intended name as well (*Judgment*, 143–44).

parts: the creation of the daisy, and its discovery by Mercury. The first part of the story is additionally treated in the other two sources. I will begin with this part, and then move on to consider the significance of the episode with Mercury.

In the *Margherite* and the pastourelle, as in Froissart's other earlier dits, the daisy is associated primarily with the lady. The heroine, variously named Hero or Herès, is weeping over the grave of her beloved, Cepheüs; in recognition of her grief, Jupiter causes daisies to grow where her tears have fallen. In the pastourelle, Jupiter is aided by Zephyrus, who gives the daisy its scent; in the *Margherite*, Zephyrus is not mentioned, and Jupiter performs the miracle "[p]ar le pooir de Phebus" [through the power of Apollo (1. 78)]. As in the *Paradis*, then, the daisy is an emblem for the lady's love, for her mercy. At the same time, since it arises from the body of Cepheüs, it does also represent the absent lover at whom her love is directed. One can discern here traces of several Ovidian myths. That of Venus and Adonis comes to mind, along with various myths involving Apollo, five of whose loves—Daphne, Clytie, Hyacinthus, Cyparissus, and Leucothoë— metamorphosed into trees or flowers.

Froissart has constructed a myth that stands up to the scientific mode of interpretation favored by his contemporary, Evrart de Conty, in the commentary on the *Echecs amoureux*. That Jupiter, working through Apollo, causes the daisies to grow is entirely logical: plants do come into being through the combined effects of sunlight and rain.[16] The substitution of Zephyrus for Apollo might be explained as an allusion to the effects of the mild west wind on spring flowers. But Froissart's myth must also be read in its immediate context, that of love poetry, composed in part as an expression of personal experience— such, at least, is the fiction that Froissart maintains—and in part for the sake of, and even in collaboration with, an aristocratic patron. In the *Prison* Froissart glosses Apollo as a figure for the god of love; combining his various associations, Apollo can be seen as the god of love poetry. Jupiter, king of the heavens, might be seen as the all-powerful patron whose good will and motivating force, filtered through the medium of amorous and poetic inspiration, stimulates the

16. Jupiter was commonly associated with the sky and with storms or other manifestations of weather. Evrart de Conty's explication of the various myths and mythological figures alluded to in the *Echecs* frequently includes a "scientific" reading, turning on astronomical, meteorological, or botanical interpretations of the pagan deities.

transformation of affective experience into new verse.[17] As a poetic image, the daisy functions very much like the laurel: it is a marker of absence and loss, of memory and desire. Like the laurel, green even in winter, it is a figure of eternal vigor: Froissart repeatedly states that the daisy blooms even in the most inclement weather, when no other flowers are to be seen. With this myth Froissart shows that the heart-felt sentiments of a loyal lover, under the aegis of aristocratic direction working through the power of poetry, can produce a living monument. If poetry does not have the power to materialize the lost beloved—and Froissart shows us repeatedly that this is so—it can nonetheless trans-form the experience of loss into a beautiful artifact, can give shape and eternal life to memory and desire.

The associations with the laurel and with the reification of desire are strengthened in the added episode appearing in the *Buisson* where, concomitant with Froissart's growing concern in his later dits with the roles of male patron and poet rather than with the lady, the focus of the myth shifts to Cepheüs. Here we learn that Cepheüs and Hero had the habit of meeting in a garden. Impatient when Hero failed to arrive, Cepheüs climbed a laurel tree to look for her; his growing anx-iety when he could not see her coming caused him to fall to his death. The tale of Cepheüs's death is embedded in a series of mythological exempla: it is preceded by the stories of Apollo and Daphne, Or-pheus—here linked with Proserpine—and Pygmalion, and followed by those of Tibullus, Narcissus, Paris, and Achilles. Tibullus would have been known to Froissart not only through Ovid's elegy (*Amores* 3, 9), but also through the midpoint passage of the *Roman de la Rose*, where Tibullus is associated with Guillaume de Lorris, another poet who wrote of his love for a flower in a poem that ends on a note of unfulfilled desire. Appearing in this context, the figure of Cepheüs takes on asso-ciations with the famous lovers and love poets of antiquity. Perched in a laurel, scanning the horizon for his missing beloved, Cepheüs is entirely determined by figures for desire, absence, and loss. Without a favorable response from the lady, the love poet experiences a sort of death. But her answering desire, her favorable reading, generates from this death a new life, a new poetic flowering.

Within the *Buisson*, Froissart does not mention the various mirac-

17. On the importance of the patron, see the works cited in note 5 above and, more generally, Douglas Kelly, "The Genius of the Patron: The Prince, the Poet, and Fourteenth-Century Invention," *Studies in the Literary Imagination* 20 (1987): 77–97.

ulous transformations: of Daphne into a laurel, of Cepheüs into daisies, of Narcissus—here presented as searching the waters for the image of his lost beloved, Echo—into a narcissus. Orpheus now goes to Hell in search of Proserpine; here too, Froissart neglects to mention that the rescue of Proserpine allows the world to flower for half of every year. But given the social and intellectual context in which he wrote, he could have expected his audience to supply the missing details. The three Ovidian myths offer three different perspectives on the botanical motif. In the case of Daphne, it is the fleeing, unattainable beloved who becomes a tree, eternal marker of desire and loss. In the case of Narcissus, it is the grieving lover himself who, overcome with the pain of desire, becomes a flower. And in the case of Froissart's tale of Orpheus and Proserpine, the flowering of springtime is the sign of reunion, of presence, of desire fulfilled—albeit temporarily.

All three of these perspectives on love and desire are reflected in Froissart's myth of the daisy. Like Narcissus, Cepheüs dies of desire in the attempt to catch a glimpse of his beloved, and eventually metamorphoses into a flower. At the same time, the creation of flowers from Cepheüs's body, in response to Hero's grief, parallels the creation of the laurel with which Apollo, forever denied contact with Daphne, must content himself. And the daisy functions to conjoin, as a sign of reciprocal love, in its capacity as love token. We have already seen it so used in the *Paradis d'amours*. This function is represented in the myth as well, as it appears in the *Margherite*. Here Mercury discovers the daisies miraculously growing in the snow and sends a bouquet to Serès; impressed by this gift, she grants him her love. The episode with Mercury figures the poetic reappropriation of this already poetic image. On one level, Mercury represents Froissart: the god of eloquence, trainer of young poets, appropriates the mythical emblems of past lovers, using them for his own purposes. On another level he could be associated with the patron, like Rose in the *Prison*, who uses the poet's works in his own love affair.

Thus the daisy, reworked and redefined throughout Froissart's poetic career, becomes a multifaceted emblem of desire and absence, of memory and creativity, of death and life. At its origin lie both masculine and feminine love and loss; it can point either to conflict, frustration, and grief, or to harmony, reciprocity, and bliss. The daisy represents perfection: "le flour des flours" [flower of flowers (*DM:* 2)], miraculously created without the intervention of either natural or human agency, "sans semence, et sans semeur aussi" [without seed,

and also without a sower (l. 66)]. In its divinely ordained generation from sunlight and tears, the marguerite is the botanical counterpart of the jewel of the same name, the pearl, believed to be generated through the agency of moonlight and dew. Ultimately, Froissart's marguerite carries resonances with the *margarita pretiosa*, the Biblical pearl of great price (Matthew 13:45–46): an image of absolute desire, of absolute perfection, by definition unattainable in this life, and nameable only metaphorically.[18] Such is Mercury's recognition at first seeing the marguerite: "Lors dist en soi: Or ai mon desirier!" [then he said to himself: "Now I have my desire!" (l. 100)].

In this way Froissart created a new myth of love and creativity, one appropriate to the social context in which he wrote. It responded to his audience's taste for secular and amorous readings of myths. It plays on various myths of Apollo, a figure in whom Froissart's predecessors had already found a mythographic basis for an intellectualized love poetry, a vernacular literature in the fullest sense of the word. More than a century later, Du Bellay would propose a new botanical figure for the beloved lady: the olive, an image charged with associations of political origins, of power struggle, of competition for artistic preeminence.[19] But clearly he was not the first French poet to found his literary project on a carefully chosen image, to exploit the power of myth to express the mysteries of love, of desire, of poetry.

18. For medieval readings of the "pearl of great price," see Stephen L. Wailes, *Medieval Allegories of Jesus' Parables* (Berkeley: University of California Press, 1987), 120–24. Wailes discusses the allegorical use of pearl imagery in the *Psychomachia* and the Middle English *Pearl*, 28–33.

19. I refer of course to the myth of Athena's creation of the olive in her competition with Poseidon at the founding of Athens, and to her portrayal of this scene in her artistic competition with Arachne, in *Metamorphoses* 6: 1–145.

MARGARETE NEWELS

From Narrative Style to Dramatic Style in *Les Moralités*

Some preliminary remarks on literary criticism, choice of method, and the question of truth and liberty, inspired by recent events and developments.

The literary critic or historian who intends to judge the *style* or *value* of a text from a period prior to his own can choose from at least two approaches. The first would be to measure the work by those means that are familiar to him and that stem from the tastes and fashion of the day or from methodological innovations. The history of criticism shows us that such an approach is quite common, unfortunately, often for reasons of ideology and political bias.

The second approach would be to base a judgement on knowledge of the principle of literary creation that prevailed at the time the work was written, without however neglecting what contemporary criticism offers us in the way of well-founded hermeneutic tools. It must be agreed that this second approach is the only legitimate and reliable one for the literary critic or historian.

Ultimately, we must decide: which path to follow? This is, in fact, the recurrent question in the medieval *Moralités*, and it is no less relevant today. To the medieval man it imposed the responsibility of choice, thus introducing into all aspects of life an element of morality and responsibility.

I will be presenting a group of the *Voies d'Enfer et de Paradis* here. These texts have remained unknown and I am now editing them for publication. They represent the origin or at least the cradle of the

YFS Special Edition, *Contexts: Style and Values in Medieval Art and Literature,* ed. Daniel Poirion and Nancy Freeman Regalado, © 1991 by Yale University.

medieval "Moralités," at least for those that constitute the nucleus of the genre. One might cite as examples the plays numbered 18, 19 and 22 of the *Recueil Trepperel*: the *Moralité très bonne et de grant conséquance à VII personnages*; the *Moralité du Lymon de la Terre* and the *Moralité des éléments à XV personnages* in which "Confession" and "Pénitence" make their appearance on stage. One must also cite the plays numbered 51, 52, 53, and 64 of the British Museum Collection that are entitled: *Moralité nouvelle des Enfants de maintenant; Moralité nouvelle: comment envie aux temps de maintenant fait que les frères sont ennemis; Moralité nouvelle d'un Empereur qui tua son neveu*, and the *Moralité nouvelle de Charité*.

What is the style and the value of these *Voies*? As literary creations they are "original" only in the sense given to this term by Christine de Pizan, who said that a work is constituted of well-known elements joined together in a uniquely personal manner. This is a definition of style that emphasizes the author's contribution, that is, his personal style. One must not, however, forget that this concept stems from Aristotle's thoughts on the role of nature. From the moment that "the Philosopher," as he was called in the Middle Ages, became the main reference for medieval philosophy, nature served as the principal image by which poetic creation was explained.[1]

The *Voies d'Enfer et de Paradis* to which I refer here are literary transformations that are based, as fictions, on the manuals of confessors and of confession. These manuals proliferated and increased in importance from the thirteenth century onward. It is from them that spreads the genre of the *moralité*, which developed in response to the necessity of popularizing pastoral teaching. Later on, we find the *moralités* expanded by several thousand lines, of amplification, one of the stylistic means that was put at the disposal of clerics by rhetoric. The title of these *moralités* indicates that the authors intended them both for reading and for theater. They characterized them as treatises and, through modifications in the writing style, gave them the appearance of scientific texts. Thus, dramatic play and theological commentary were united.[2]

1. W. Erzgräber, ed. *Kontinuität und Transformation der Antike im Mittelalter*, Kongreßakten des Freiburger Symposiums des Mediävistenverbandes (Jan Thorbecke Verlag: West Germany, 1988); Margarete Newels, "Natur in der Spätmittelalterlichen Poesie," ibid.

2. W. Helmich, ed. *Moralités françaises*, Facsimile reprint of twenty-two allegorical plays printed in the fourteenth and fifteenth centuries (Geneva: Slatkine, 1980), vol. 1.

Returning to our reflections on the principles of the work of critics or historians, we would like to propose an image from the medieval period that might serve as an example and as a "figuration," as it was then called.

The medieval code of Christian morality advised princes and clerics, above all, to combat pride with the virtue of humility. The etymological sense of *virtus*, still very much alive at the time, must have suggested that the individual, through practice of the virtue of humility, would become strong rather than weak. The act and the attitude were considered as a sort of preparation of the soil, prior to receiving the seeds of wisdom or of knowledge, necessary for those who ruled and for those who taught. Approaching these high functions by way of humility might seem paradoxical to us today, as the word has come to connote weakness.

Yet, with more reflection and a closer look, we see that humility does indeed heighten the value of wisdom or of knowledge, and also that of the process of governing. We hold men and things in respect only when they are truly authoritative. During the fourteenth and fifteenth centuries we see the beginnings of a merging between authority and grandeur. Princely splendor and show which served to underscore the importance of the nobility, were a staging, a spectacular representation taking the place of what we might call the truth of authority.

If only we might apply this image to the work of the critic and the historian! Should we not approach our research by assuming an attitude of humility before the historical event? Such an attitude gives us patience we need, enables us to avoid choosing methods that basically only serve to confirm our biases or support our ambitions. What do we do with the Word in this context then? Václav Havel, in a speech read on the occasion of the receipt of the literary prize awarded him in Frankfort, evoked respect for the Word, that is, for the Truth of the word. Ironically, Havel was forbidden by the Czech government to attend the award ceremony, and his speech had to be read by a substitute.[3]

Other methodological questions can arise. What is to be said of those critics who doubt strongly whether research can succeed in re-

3. Václav Havel, Text read by Maximilian Schell 15 October 1989 in Frankfort, West Germany; *Frankfurter Allgemeine Zeitung* 16 October 1989.

flecting the literary reality of a period as distant as the Middle Ages? Is this not paying too much heed to a certain psychological reasoning, that asserts that man is the prisoner of his time and its ideology, in short, of his quite subjective individuality? Are we then incapable of dealing with historical phenomena without distorting them? Are we to believe that all historical phenomena are inevitably transformed by the needs or the fashions of the day? The consequence of this thought is that phenomena are ineluctably perceived only as a function of the style and the need of the moment. Is it not, in fact, one of the responsibilities of the critic to attempt to steer around such potentially destructive obstacles and to set a straight and clear course toward historical truth?

The profound implications of this question have been brought to light quite recently in Europe. The moral and political reflections on free will [la franche volunté], so frequently referred to by medieval theologians, has been revived. The arguments of these theologians, which establish the liberty and nobility of men, are repeated in many of the moralités. Let us turn once more to current developments. Because of the nature of present-day media coverage, we are living proof that the comparison of the facts of divergent ways of life has led hundreds of thousands of people to seek both intellectual and material freedom. Is it not by comparing facts, in the diachrony as well as the synchrony of texts and the periods in which they were written, that literary critic and historian, these so-called prisoners of their time, find the way to free themselves?

It seems almost superfluous to evoke this here, as the method was already well-known to the medieval cleric. The essential point is that this method is the one that must be employed, despite the patience required to sustain it through to the end. It is not at all surprising that political dictatorships are fearful of its application. The proof of this is presently staring us in the face. In thinking of literary criticism, we must consider the question of knowledge. If we are to interpret the literary facts of the Middle Ages, is it really sufficient to be content with a so-called "typical" example as the basis upon which we judge an entire genre or even the style of a period?

If I understand correctly the position of the author of the colloquium, he is not among those who have chosen the voie soueve [easy road] that inevitably leads to hell. Rather, he has conceived it as a means by which we might add to those tools, already quite numerous,

which allow us to comprehend the literary reality of the Middle Ages more accurately, and which function, like the media, as mediators of the literary fact or event.

The Voies d'Enfer de Paradis, *the literary system, and the creative role of the author who, by focusing on the effect, gives form to the material.*

With reference to the article by Daniel Poirion: "*L'Epanouissement d'un style: Le Gothique littéraire à la fin du Moyen Age,*"[4] I would say that the manuscripts that I am considering contain works that belong to the "Gothic style."

They are certainly not the works of a master. In all fairness, we must say that the author clearly did not intend to create a work of art but rather, a practical one that would meet the needs of pastoral instruction. These texts, as well as many others, abound in allegory and personification and were thus considered of little value by critics devoted both to a naturalist esthetic in literature and to classical rules for the definition of genre.[5] This tendency prevailed until it was realized that the understanding of the facts of medieval literature depended precisely and essentially on the understanding of this style of writing. The broadening of the concept of "literariness" (*littérarité*), accords these texts a place (and I quote from the aforementioned article): "au large inventaire des textes du XIVe et du XVe siècles au prix duquel on peut rééquilibrer nos jugements sur les valeurs et les styles" [in the large inventory of texts from the fourteenth and fifteenth centuries on the basis of which we can form better balanced judgments of value and style] (Poirion, 30).

These *Voies d'Enfer et de Paradis,* of which Antoine Thomas gives a few examples in *L'Histoire littéraire de la France*—where he even mentions his own intention to edit them for publication, (though he has not realized this project)—do not belong to what we customarily call literature in the modern sense of the term, nor are they purely instructional texts. They do, however, provide interesting material for the history of the "literary system" (cited by Poirion, 29–44). As sug-

4. Daniel Poirion, "L'Epanouissement d'un Style: le Gothique littéraire à la fin du Moyen Age," in *Grundriß der Romanischen Literaturen des Mittelalters, GRLMA,* ed. Winter (Heidelberg, 1988), vol. 8/1, 30.

5. Charles-V. Langlois, *La Vie en France au moyen âge* (Geneva: Slatkine reprint, 1984), vol. 2, introduction, vi.

gested by Jacques Le Goff in his book *L'Imaginaire médiéval*,[6] they are of interest to the historian as well as to those concerned with the history of the language. For, among many other representations of daily life, our texts frequently refer to the trades and to the depravity of those who ply them seeking only their own profit.

What is so striking is the realism of the examples cited in the copies of the *Voies*, which date, approximately, from the time of Jacques Legrand and Christine de Pizan. In the *Livre de Bonnes Meurs* and in *La Cité des Dames*, the criticism, in contrast to that of our texts, is entirely academic [*universitaire*]. They draw their examples from the texts of antiquity known at that time, from the Bible and from the saints' lives.

If the content of the six manuscripts (a seventh was discovered later) is for the most part similar, there remains, however, one distinguishing element, which is that the story of the *Voies*, the voyage, is presented in the form of different genres. It would be relevant to ask why the copyists departed from the narrative form of the original to adopt that of a *par personnages* text ["with characters"], and of a stage director's book in which choreography and directions for actors' movements were added in Latin.

In applying the very criteria for creation that were customarily employed in that period, I will present the *Voies* according to the scholastic divisions of "auctor," "materia," "forma," and "effectus."

Materia

The choice of material must be understood in the context of the practice of confession, which became significantly more widespread after the fourth Lateran Council in 1215. The Council's decree, that an annual individual confession was obligatory brought with it not only the proliferation of writings in Latin on doctrine as well as the translations of these writings such as the *Somme le Roi* 1279, of Frère Laurent for Philippe III, le Hardi [Philip III, the Bold]. This work was not unique. Other texts, in French, inspired by the new code of Christian morality, would, from the beginning of the thirteenth century onward, be addressed directly to the laity. At that time, the monastic orders, whose importance increased in the thirteenth century, became involved with pastoral instruction and, above all, with confession. According to the

6. Jacques Le Goff, *L'Imaginaire médiéval* (Paris: Gallimard, 1985).

text of the *Voies*, the Franciscan friars, apparently more adept than the secular parish curates whom they replaced, were able to accumulate a fair number of the fortunes of the penitent and dying. It is well known that this was a cause of conflict between the orders and the secular priests. The *Voies* are not uncritical of the clergy. In fact, none of the estates escaped scrutiny.

The effect envisaged by the author is to familiarize the faithful with the practice of the sacrament of penitence in order to induce them to recognize the necessity and the religious and spiritual value of confession. The role of spiritual advisor became increasingly important, but it also created an intense rivalry between the orders, especially when the monks became confessors to the king.

While the decree of the Council of 1215 obliged theologians to renew their reflection on the doctrine of penitence and, consequently, on the vices and virtues, there was also added in the thirteenth century interdependence between the pastoral doctrines and the new philosophy. This renewal was the inevitable result of the introduction of Aristotelian ethics into the university. Ethics was henceforth one of the subjects of study. The canon of vices and virtues were organized in the great "Sommes." In most of these writings the vices and virtues are reduced to seven. There is new order indicated by the series of initials s.i.i.a.a.g.l., which stands for *superbia, invidia, ira, avaritia, accedia, gula, luxuria* [Pride, Envy, Anger, Avarice, Sloth, Gluttony, and Lust]. This order is also respected by our author. In order to explain the vices to the faithful, it was necessary, through the use of examples, to give meaning to what is, at first, only a name or a category. Even a change in this order could produce meaning and give a special significance to the text.

Forma

The preparation for confession necessarily involved the presentation of all the vices. These became the basic material of the author who could use his imagination in selecting an appropriate form of presentation. According to Aristotle, it is the life-giving breath of form that gives matter a soul. Aristotelian form, or esthetics and style, the bringing together of matter and form, is just as much a creative function in nature as it is in poetry.

The author of the *Voies* chose an already familiar literary form: the dream, where a voyage is undertaken whose itinerary leads once to hell

and once to paradise. The choice of this framework reduces the narrative to a very simple construction: one need merely follow the path travelled. The history of the genre shows that this structure allows free rein to the imagination.

In the history of narrative genres the *immrama* and then the Quest endure as basic narrative structures: it is therefore possible to witness changes in writing each time there is, from one period to the next, a transformation in discourse. Our *Voies*, for example, have all the elements of scholastic theology and thus may be compared to the *Pelerinage de la vie humaine* of Deguilleville. In contrast to the *Voies*, in which the narrative is quite restrained, Deguilleville's work has a baroque quality: it is a Christian epic of the life of man. The narrative version of the *Voies* predates it by a good number of years, but these two works have in common the integral presentation of catechism to which Deguilleville adds an explanation of the problem of transsubstantiation in the Eucharist.

The *Pélerinage* and the *Voyage de saint Brandan* share the metaphor of the ship [*le nef*] which sails on "the ocean of life" most probably inspired by the pilgrimages to Jerusalem, which, in the fifteenth century, take up where the crusades left off. Somewhat later in the history of literature, at the end of the fifteenth century, Sébastien Brant fills that "ship" with fools; and in Rabelais's sea voyage, the characters seek only the answer to the very earthly question of paradise in marriage.

The author of the *Voies* has his protagonist proceed on foot through a symbolic landscape, but this setting is inspired by observations on the architecture of his period and even on nature. Just as in a pilgrimage to Saint-Jacques-de-Compostelle, the rests and the meals are taken at stops (seven of them) that correspond to the seven vices and virtues. Each stop constitutes a chapter in which *doctrine* is taught by the vice itself. Precepts about vice are addressed to all the Estates of the social hierarchy. The rhetorical figure of irony allows the author to explain the vice in the form of counsel, that is, as advice concerning the "path to take." The protagonist in the story is a cleric who is looking for the way to hell, and later, once converted to virtue, for the way to paradise. The two ways are conceived symmetrically. The *Voie de Paradis*, whose material is more difficult to render in a form that maintains the attention of the reader or listener, culminates in a description of earthly paradise and scenes of justice in heaven.

In the tradition of allegory and personification (those rhetorical "colors" which, in the thirteenth century, and influenced by the *Ro-*

man de la Rose, begin to pervade literary works) the *Voies* present personified forms of the vices and virtues, or, as was said in the Middle Ages, the vices and virtues in a figurative style. Personification not only allowed for a more vivid presentation of abstract teachings; it also permitted the transformation of those teachings into dramas. One of the copyists undertook such a transformation. The authors of the *moralités* thus profited from a stylistic method familiar from biblical exegesis as well as the widespread diffusion of the *Roman de la Rose*.

The story in the *Voies*, whether it is rendered in narrative or dramatic form, or presented par personnages, is told in octosyllabic rhymed couplets. The author and the copyists do not insert poems into the story, but they do add rhymed prayers at the end. The author of the narrative text wanted to create a "book" conceived along the lines of the religious treatise.

The Date of the Manuscripts: Our author whose name is unknown must have written his text shortly after the death sentence of Enguerrand de Marigny, the favored minister of Philippe le Bel [Philip IV, the Fair] and executed in 1315 under Louis le Hutin.[7] The fate of this powerful man is cited as an example by Envy who boasts that she can provide more protection than the king or even the Pope. The chapter dealing with Avarice presented as an unkempt and poorly dressed character, forever counting money and providing only meager meals to guests) involves the question of abolishing the tithe in France. With the promise of a crusade, which is never undertaken, the Pope goes along with the French king's position. These historical facts are not mentioned in the "par personnages" text nor in the dramatic version, which probably both date from the time of Christine de Pizan and Jacques Legrand.

Auctor

The author wishes the reader to take what he tells us in his Prologue quite literally: the two dreams he has had during the night struck him as so extraordinary and made such an unforgettable impression that he must, as he says, share with others their lesson for the salvation of other people's souls. It is thus in a pure spirit of duty and responsibility that he renders in written form these visions of the beyond.

7. Armel Diverrès, *La Chronique métrique* attribuée à Geoffroy de Paris (Paris: Les Belles Lettres, 1956).

In the "par personnages" text the author appears in three roles. When the account of the first dream begins, he becomes one of the personifications in the text and calls himself "Acteur." At the same time he is transfigured as the *Clerc* [Cleric], the protagonist of the adventurous voyage. This in no way prevents him from reappearing from time to time as the narrator of the dream.

The Cleric is overcome by the desire to travel to hell. Is he impelled by the curiosity for adventure, or by the very human desire to transcend his natural limits, a theme that had engendered so many dream-inspired works in this period? While the Cleric experiences this burning desire, along comes a guide, "une demoiselle moult viguereuse et moult ysnele" [a vigorous and agile damsel] named *Désespérance* [Despair]. She promises to lead him to hell in seven days. When he arrives at the threshold of his destination, the spectacle of the reeking valley and of the devils, those repulsive figures of evil, so terrifies him that he confesses and converts just in time to escape the suffering of hell. He then awakens, but the ordeal experienced in the dream has ("*bien travaillé*") [has had an influence on him] as he says.

The Cleric then mentally recapitulates the content of the dream. Fatigued by this effort, he once again falls asleep, but this time his sleep and his dream are sweeter. *Espérance* [Hope], one of the three divine virtues, along with *Foi* [Faith] and *Charité* [Charity], leads him to Paradise. Although his dream-voyage takes him to the earthly Paradise and to the very gates of true Paradise, he remains a living inhabitant of the earth and so is likewise awakened from this second dream. He then takes pen in hand in order to transmit the religious experience he has undergone in the dreams to his audience and readers. Thus, in a Christian manner, he will benefit his fellow man.

Pedagogic effect: When he has the Cleric think back on the events of his first voyage, the author attempts to demonstrate once again the valuable pedagogical effect of repetition. He thus aids the memory of his public to whom he wants to teach the practice of confession. We find numerous other examples of this pedagogical tendency in the text. Viewed from the vantage point of today's standards, the esthetic value of the text suffers considerably as a result. However, in comparison with the confessional manuals that proliferated during the thirteenth century, our story is more interesting to read or listen to. Following Horace's precept, the text combines the useful and the pleasing as it leads the Cleric and his companion, "Dame Désespérance" forth from the parental castle in quest of the right doctrine leading to hell, or, in

the second dream, to Paradise. There are many courtly exchanges when the couple introduce themselves and greet their hosts. Even the lesson of confession contained in the *Ménagier de Paris*, dating from the fourteenth century, could not have been better received or appreciated than these *Voies*.

As far as the pedagogical efficacy of style is concerned, does Gerson not suggest that one can profitably employ theater in pastoral teaching? The idea was not original: one need only think of the surviving manuscripts of the *Sponsus*, of the *Passion de Clermont*, of the *Ordo representationis Adae*, *La Vie de saint Nicolas* etc. . . . Likewise, the *Voies* respond to the need for pastoral instruction destined for a lay-public. Their structure is simple and they are as interesting for their closeness to real life, for the selection of examples and for description of the voyage. There is no question that the text of the *Voies* fully reflects the intention of the manuals, but its literary value is not inferior to "The Parson's Tale" in Chaucer's *Canterbury Tales*, which appeared some sixty years later.

The Ideology of the Voies: The meal scene that takes place in hell in the *Voie* of Raoul de Houdenc has no equal in the medieval literature of the infernal vision. It is a presentation of the vices that is intended to inspire fear, just as in the *Voies* of Rutebeuf and many other visions from the Middle Ages. On the other hand, our *Voies* focus the believer's attention on the absolution of sins, and highlight the mystery of the redemption of humanity through the death of Christ.

The echo of the narrative structure of the *"immrama"* and of the Quest found in our *Voies* blends with the ideology implicit in the image of life as a path to follow. This ideological structure points to the biblical source from the New as well as the Old Testament. "I am the Way," said Christ, and the priest in the *Canterbury Tales* begins his teaching by quoting Jeremiah 6:

> State super vias, et videte, et interrogate de viis antiquis que sit via bona, et ambulate in ea . . .

Situating the "way" [*la voie*] within the context of a dream is not specific to the Christian literary tradition but corresponds to certain psychological truth. It is difficult for man, an individual or for mankind, to acknowledge the limits imposed by nature. Transcendence of the confines of the human condition has been an endless dream since the beginnings of humanity. The exploration of the beyond is an element of this dream.

This is one of the reasons why the reception of antiquity remained alive throughout the Middle Ages, as is evidenced, for example, in the *Romans d'Alexandre*. The Middle Ages gives us, in parallel to this other type, a religious novel: *Le Voyage de saint Brandan*. The *Visio sancti Pauli* and the *Purgatoire de Saint Patrice* are also well-known works from that period. In addition, there is the group of visions of hell brought together in *Speculum morale*, a *Somme* attributed to Vincent de Beauvais. If the intention of these visions was political, as in the case of *Visio Caroli Calvi*, in which the king sees his parents condemned to hell, the *Speculum morale* serves to explain that the devils or hideous beasts of the vision are to be taken for what they are: pure personifications of evil; they have no real life. There are also dreams and visions that fall into the category of prophetic literature, as is the case with the *Romans de Merlin* and the *Sibylles* of the *Chroniques*. *Le Roman de la Rose*, must also be included within the tradition of visions.

All these works were very well known and they continued to be read at the time that the narrative version of our *Voies* appeared. The choice of the dream as narrative framework is explained not only by literary tradition, but also by a narrative method that respects reality. For no man, during his lifetime, has as yet entered hell or paradise. The vision of God is possible only for the dead. While remaining faithful to the reality of human life, the story suggests a religious reality that escapes rational proof and experience. It is a question of faith. This is what the *Voies* have in common with Dante's *Commedia*, which was probably written during the same years as our narrative text.

Allegorical Writing: Nothing is left to the haphazard wanderings of the fanciful imagination. The eternal truth of faith imposes its limits on the genre's esthetic of the imaginary.

According to Church doctrine, one of the most serious sins is despair, the lack of faith in God's grace. This explains why the personification, "Despair" (*Désespérance*), accompanies the Cleric on the road that leads from one vice to another. Despair does all she can to serve the Cleric. She does so in the hope of leading his soul to Lucifer, the supreme figure of evil. The psychological bonds of the vices are characterized by a parental relationship. Lucifer is the father of evil and Despair is the mother who has long participated in the typical works of vice. Literature presents the vices either through the image of the family line or through that of a tree with branches and leaves. In this case it is the family line. We make the rounds of the kin. The most

beautiful castle belongs to Pride; the poorly maintained and dilapidated houses are inhabited by Greed; and Sloth.

At the very moment when the Cleric is repelled by the consequences of evil, God's grace has already entered the scene in the figure of Hope. It is she who provokes the Cleric's internal struggles that recall the well-known and widespread model of *Psychomachia*. The *Voies* are compared with each other; their ideological basis is the dualism of good and evil. They exist in opposition and stir up the turbulent waters of psychological struggle in which God's grace, provided one accepts it, brings one safely into port. As for the Cleric, his participation involves the decision freely made (*en franche volunté*) to opt for repentance, and the satisfaction derived from good works. This struggle between good and evil is not limited to the Middle Ages. If I am not mistaken, present-day life continues to show us that the ideologies that attempt to conjure away this dualism are brought back to the truth of reality.

The Cleric's struggle with the vices has all the elements of a drama, and lends itself well to a visual or scenic presentation. A dramatic version of the narrative text does, in fact, exist. The copy of the theatrical version is, however, in a somewhat unfinished state. It appears to have been written in haste and thus allows us to surmise that the two parts of the play, the "Voie d'Enfer" and the "Voie de Paradis," were in fact staged at one time. As in the narrative version, confession and catechism are thoroughly explained. In the liturgical calendar, it would have fit well into the Easter preparations. The dramatic version of the *Voies* adds a scene of devils, which we do not find in either the "par personnages" text, or the narrative version. It is likely that this scene was deemed necessary to amuse the audience. After all, why not offer the titillating spectacle of the mystery of evil?

The following is a short sample of an allegory that is complete in itself. The companions arrive at the first stop, the castle belonging to Pride:

> Je demanday moult bellement
> A la dame qui me menoit
> Et compaigne me tenoit,
> Se le chastel sçavoit nommer.
> "Ouïl, dist elle, et sournommer.
> Orguilleux toutes gens le nomment
> Et moult vantoux ilz [le] sournomment.
> Si te diray pour quel raison,

Car en tout l'an il n'a saison
Que la dessus grant vent ne vente.
Orgueil, ma mere la prisie,
A du chastel la seigneurie."

I asked my companion and guide in a courtly manner whether she knew the name of the castle. "Yes," she said. "The people call it Proud, and they have nicknamed it *blowhard*. I'll tell you why. No year goes by when great winds do not blow upon it. It is reputed that Pride, my esteemed mother, is its mistress."

Here, the architecture itself expresses the immoderation, haughtiness, and vanity that characterize Pride.

The "par personnages" text contains a beautiful miniature of the castle of Pride who is portrayed surrounded by courtly ladies. The Cleric kneels in front of this sumptuously dressed princess. Despair stands behind her, with her hand placed on her shoulder. The illustration in this manuscript must have been rendered by a Parisian atelier around 1430.

In all the manuscripts the text is the same. One of the elements of the "Forma," which entails esthetic inspiration and application, is imagination. (I am thinking of Guillaume de Machaut's *Prologue*). Imagination engenders the image, which might be in the form of writing, painting, or dramatization. The narrative text of the *Voies* is one in which word and expressions produce image reinforced in the "par personnage" text, by the use of miniatures; in the dramatic text the image becomes a stage set.

The Three Rhetorical Styles: The division into *stilus humilis, mediocris,* and *gravis* concerns the *ornatus,* or decorum, that is to say, the appropriate representation of men and things according to their importance, rank, value, utility, etc. . . . The *rota Virgilii* has already been mentioned in this colloquium. One can understand that the rule of decorum cannot be applied without taking into consideration the sociological and cultural givens of a period. A certain realism in literary presentation is thus preserved, as well as variation in writing according to the period in which the text was created. The three *genera elocutionis: humile, medium, sublime* (it is not a question of "genre" in the sense given the term today) serve to elucidate primarily the works of Virgil.[8]

8. Margarete Newels, "Grands rhétoriqueurs et style dramatique," in *Les Grands rhétoriqueurs,* Actes du Ve Colloque International sur le moyen français (Milan, 1985), vol. 1, 33–47.

Although the rule of decorum does apply to our *Voies*, it does not explain their different "genres" (narrative, "par personnage," or dramatic). Here, distinctions are made according to the character who speaks. Indeed, according to Diomedes, the rhetorical manuals distinguish among the different levels of speech: the *exégématique* where the author alone speaks; the *dramatique* where the characters speak without the author's intervention; and the *style mixte* where dialogue and the author's discourse appear together.

The narrative text of the *Voies* adopts the *style mixte* [the mixed style] where descriptions of landscapes and architecture, portraits, and personification, alternate with dialogue. As the dialogues occur frequently, the copyist of the "par personnages" text did not find it difficult to put into his manuscript, above each speech, the name of the character speaking. The reader's imagination, (and this manuscript lends itself well to a reading), serves to bestow an element of action to the characters. The manuscript is quite beautiful: there are some highly ornate pages, the capital letters are intricately decorated, and the miniatures contribute both to the understanding and to the beauty of the text.

The visual effect of the edition's page layout in three columns (which permits a synoptic reading of the narrative text, the "par personnage" text, and the dramatic text) brings out the amendments to the original text. Comparison of the manuscripts enables us to look, as it were, into an esthetic and ideological workshop, thus facilitating the study of stylistic effects. Moreover, the synoptic layout allows us to follow the linguistic changes occasioned by the copyist's language, and by changes over the century during which the manuscript was repeatedly copied.

In his article, Antoine Thomas remarks that these texts might serve to elucidate the development of different genres notably in that of the *moralités*. His definition of genre is the same as that of Petit de Julleville, whose *Répertoire* did not include the text that Thomas found. At that time, the distinctive criterion for the definition of the *moralité* was thought to be in the use of allegory and personification. Although allegory is used in all genres of medieval literature, particularly in the wake of *Le Roman de la Rose*, this criterion continues to prevail up to the present day, as is evidenced by Werner Helmich's[9]

9. W. Helmich, *Die Allegorie im französischen Theater des 15. und 16. Jahrhuderts* (Tübingen: Niemeyer, 1976), 1–18.

thesis that appeared in 1977. As there are also plays from that period that were called *moralités*, despite the fact that they contain no allegories or personification, Helmich finally corrected his definition in 1980 in the facsimile publication of twenty-two pieces that he calls *moralités* without, nevertheless, replacing his first definition by one that would better explain the genre (Helmisch, *Moralités*, "Introduction.").

According to Thomas, the "par personnage" text falls, chronologically, between the narrative and the dramatic versions. Apparently, he supposed that pure dialogue, which is the literary form of the dramatic play, was a belated phenomenon. Now, when medieval rhetorical teaching outlines the three forms of a text's presentation, (the aforementioned *stilus exagematicus, mixtus,* and *dragmaticus* or *dramaticus*), it is referring to a phenomenon of literary presentation which, in the realization of medieval works, is always manifested synchronically. Poetic imagination could make use of these three styles. The commentaries also explain that the exegematic style is more suited to instruction, and that the dramatic style, in and of itself, should not be confused with the dramatic play. If one must speak of genre, and I repeat that the term does not have the same meaning in the Middle Ages as it would subsequently acquire, one would have to say that the "par personnage" text is entirely distinct from the "play" (*le jeu par personnages*), and constitutes a genre in and of itself that stems from a different esthetic concept than does the play.

The explanation of the dramatic style that states that the characters speak alone without the intervention of the narrator is not a definition of the genre. Drama necessarily involves the use of dialogue in order to create a staged work, but the dominant role of rhetorical teaching explains, to a great extent, why many theatrical pieces from the Middle Ages have a narrative quality.

If it is true that the medieval theater does not reach its maturity until the fifteenth century, the reasons are multiple and stem not only from the concept of drama but also from the demographic and psychological evolution of the population, and the material conditions such as the technique of establishing and printing texts. The experience of staging a play, however, is old; indeed, as is that of the transformation of a narrative text into a play. As examples, we need only look to the Mysteries, the Passion Plays, the Saints' Lives, the Miracle plays, etc . . .

The Morality plays are a special case. They originate as the staging

of pastoral teaching with the goal of explaining the practice of individual confession, as already mentioned, become obligatory once a year with the fourth Lateran Council in 1215.

It remains to determine, among many other questions, why the narrative text was transformed into both a "par personnage" text and also into a dramatic version. The answer might be the following: the new forms responded better to new esthetic demands, to a world itself grown more "spectacular," and to the more urgent necessity for religious instruction, for a world that had become increasingly enamored of power and of military, and commercial success.

A concluding remark on style

There is in these manuscripts an abundant use of *topoi* and even of clichés. In the chapter on Lust (*la luxure*), for example, we are told that this vice begins with gaze followed by touch, embracing, kissing and then le *surplus*. (This quotation is taken from M. Camille's excellent article.) Nevertheless, the manner in which pastoral teaching is presented reveals a certain *style* (I quote Daniel Poirion), "ce qui s'ajoute au discours déterminé par son objet comme la marque, la signature d'un sujet, défini par les choix, les attitudes qui prêtent un sens à la vie" [which is added to the discourse determined by its object as the mark, the signature, of a subject, defined by the choices, and attitudes that give meaning to life] (Poirion, 29).

Translated by Joe Breines

MICHEL ZINK

The Time of the Plague and the Order of Writing: Jean le Bel, Froissart, Machaut

For our taste and to our minds, fourteenth-century authors—especially the French—do not speak enough about the plague.[1] If the mirror of writing is supposed to reflect the world, they do not give this scourge space in proportion to its effects on the society of the time. If the mirror of writing is supposed to reflect writing itself, they worry remarkably little about putting their pictures of the plague in the perspective of those offered them in abundance by the literature of antiquity. The Black Death elicits only a few lines from Froissart, whereas he devotes entire pages to the insignificant *combat des Trente* or to some feat of arms, some siege, some abortive enterprise—Geoffroy de Charny's attempt to retake Calais, for example—the importance and consequences of which were negligible or nonexistent.

But the very disproportion between the event and its literary treatment hints at a process of selection in this laconism, as in the diversity of approaches to and treatment of this subject by the different authors. We will attempt here to analyse these choices and to interpret them in relation to intellectual models and imperatives of literary expression, using three famous examples: Jean le Bel, Froissart (the first book of whose *Chroniques*, we know, takes as source and model the work of the canon of Liège—in some places recopying it word for word—), and

1. On the Black Death, see Anna M. Campbell, *The Black Death and Men of Learning* (New York: Columbia University Press, 1931); Elizabeth Carpentier, "Autour de la peste noire: famines et épidémies dans l'histoire du XIVe siècle," in *Annales* E.S.C. Nov.–Dec. 1962; G. G. Coulton, *The Black Death* (London: E. Benn, 1929); Raymond Craxford, *Plague and Pestilence in Literature and Art* (Oxford: Oxford University Press, 1914); Philip Ziegler, *The Black Death* (London: Collins, 1969).

YFS Special Edition, *Contexts: Style and Values in Medieval Art and Literature,* ed. Daniel Poirion and Nancy Freeman Regalado, © 1991 by Yale University.

Machaut, who depicts the ills of the time in the prologue to his *Juge-ment du roi de Navarre.*[2] Jean le Bel and Machaut were actual contem-poraries of the events and evoke them almost as they happen. Froissart, then twelve years old, recounts them much later.

Jean le Bel twice mentions the plague and the events associated with it (flagellants and the massacre of Jews): first in two or three pages (at greater length than Froissart), the second time in a few words. This repetition, occasioned by the outline which he is following, makes it possible to measure what the plague represents to him. He first speaks of it in his forty-first chapter, "How messire Charles de Bohème was crowned king of Germany." The beginning of this chapter recounts the death of the bishop of Liège in 1344, the death of the emperor Louis of Bavaria that same year, and the election of Charles of Bohemia. Since this election was contested for several years by the duke of Bavaria and the marquis of Brandenburg, the author follows the affair up to its resolution by the marriage of Charles of Bohemia to the sister of the duke of Bavaria. This brings him to the coronation of Charles and his wife in August 1349. He then develops the description of the plague which was raging at the same time: "At this time death was rife high and low. . . ." Events in Germany thus lead him to skip over several richly eventful years. He does not turn back to them immediately, but instead pursues in the following chapters the affairs of Flanders in the 1350s. It is only in chapter 46 that he goes back to 1340, at the time of the crisis of the Brittany succession, and from there he follows the French war with the English. We can understand, then, why his plan brings him back twice to the year 1349. The second time, he again brings up the plague in the course of a chapter entitled "How King Philippe [Philippe VI of Valois] and his son were remarried and quite soon afterward the said king died; thus the Duke of Normandy was crowned king [Jean II le Bon]." The chapter is spiteful, not to say ven-imous, toward the two kings, and aims overall to give an unfavorable impression of them: suspicions of having poisoned Bonne of Bohemia, amorous rivalry between father and son, consanguineous marriages which they forced the Pope to support, financial greed and malpractice on the part of Jean le Bon, pressures put on the Pope to obtain the yield of the tithes (Jean le Bel does not say that this was for the purpose of

2. Jean le Bel, ed. Jules Viard and Eugène Déprez (Paris: S.H.F., 1904), vol. 1; Jean Froissart, ed. Siméon Luce (Paris: S.H.F., 1869), vol. 1; Guillaume de Machaut, ed. Ernest Hoepffner (Paris: S.A.T.F., 1908), vol. 1. Hereafter cited in text.

financing the Crusade); his impotence as the English ravaged his kingdom. After having related the double marriages and before recording the death of King Philippe, the chronicler introduces the following sentence:

> In the year of our Lord 1349 began the disease of buboes, which physicians call "epidymie," which caused much death throughout the world, as much among Saracens as Christians, of which you can find the account above; even so the king of the Romans, Charles of Bohemia, crowned his second queen in the month of July, with great pomp.

The purpose of this sentence is to relate to each other the chronological series followed separately by the chronicle. It does this by mentioning the two important events of the year 1349: the marriage of Charles IV and the plague. The plague had a profound effect, as one can well imagine, on the people of the time. It marked them due to its universal character and for this reason constitutes an essential point of reference; one cannot speak about the year 1349, or even simply live through it, without mentioning the plague.

But it is therefore all the more remarkable to see how discreet are descriptions which are made of it. Let us return to the first exposition—detailed enough, to be sure—which Jean le Bel devotes to it. He speaks about the plague, about flagellants and about Jewish massacres, in that order, which is chronological. This seems natural, but Froissart will not follow this order, despite being inspired by the text of his forerunner, nor will Machaut. Jean le Bel presents the sequence of events with vigor and clarity: the plague, its symptoms, its spread, the terror of contagion, and the religious disorder directly resulting from it (the priests refuse to hear confessions for fear of being contaminated); this spiritual disorder is added to the distressing idea that the plague is God's punishment for "the sins of the world"; this idea is a call to penitence; among the manifestations of this collective penitential movement are the flagellants who appear in Germany: their behavior, their arrival in Francophone lands (Liège, Hainaut, Brabant), where they gain imitators, their excesses and the Church's reaction, the accusations brought against the Jews, their massacre and their conduct in the face of death.

Where it is a question of the plague itself, Jean le Bel is of course impressed by the fact that the epidemic strikes the whole world, by the devastating, extremely contagious character of the illness (it is this last point that he emphasizes the most) and by the complete absence of any

effective remedy. On the other hand, he remains very discreet about the symptoms and is content himself to observe that the disease "took some in the left arm, others in the crotch." This disease was however extremely spectacular, peculiarly horrible and repulsive: buboes, blackened flesh, and a putrid odor. In their time, the authors of antiquity had produced countless such descriptions. Does this mean that this vividness, these touches of horror hold no interest for the chronicler? He is quite capable, a few lines further on, of showing the blood of the flagellants which "streams down on all sides". In fact the flagellants, and to a lesser extent the Jews, interest him more than the plague itself—he devotes much more space to them. He points out with attention and penetration the methods of propaganda and intimidation brought into play by the flagellants: their "rhymed composed" songs which their imitators in Liège rush to "put into plain French"; the fact that they foist themselves on good people by inducing guilty feelings (" . . . and each man gave them of his money out of great devotion and all were ashamed who could not lodge them"). He observes that the accusations against the Jews are, like the flagellants, a consequence of the plague and that these two simultaneous phenomena should be seen from the same point of view: "When these flagellants were about. . . . " But the accusations against the Jews are propagated by the flagellants and therefore are also a consequence of their presence: "they were all burned and put to death wherever the flagellants went." Jean le Bel knows therefore how to make the reader feel the combined operation of general and particular causes. He takes no position on the foundations of the accusations (as Froissart and Machaut do, though on opposite sides of the question) but he is extremely struck by the Jews' prophecies and by their manner of facing death.

Thus Jean le Bel is interested above all in men's actions and behavior. To describe these alone is the true object of his chronicle. In his eyes, the plague is less important in itself than as an explanation that reveals the reasons for these actions and behavior, and also as a chronological reference point that allows him to date and measure actions not directly connected with it. Froissart not only shares this point of view, but also draws more radical conclusions from it in the organization of his narrative.

Froissart places his account of the plague and the flagellants at the same point where Jean le Bel briefly reminds us of it: when he relates the coronation of Jean le Bon, his journey to Avignon and to Languedoc,

and the siege of Saint-Jean-d'Angély. Froissart's text is shorter than Jean le Bel's, but it is amplified in the last version of Book I of the *Chroniques* in the Rome manuscript, which on the whole gives us rather an abridged version.

Froissart begins by talking about flagellants, not about the plague. He mentions it only subsequently, and very briefly, as being the cause of the appearance of the flagellants, before returning to the latter and going on to end with the massacres of Jews. In the first editions, he gives, curiously enough, a version of the facts which is favorable both to the flagellants and the Jews. He describes the flagellants' shows of penitence and ceremonies, but not their excesses and extortions. He speaks of them only with praise and turns them into peace-makers:

> And these penances caused many men to repent and die beautiful deaths, something which previously could not be accomplished by any means at all.

From a reading of Froissart, the pope's hostility toward the flagellants is all the harder to understand because his reasons are referred to by preterition: "for many important reasons which he gave, which I will pass over to be brief." The French king's enmity seems dictated this time by an excessive submission to the pope: "The king forbade it due to the pope's correction and prohibition." Perhaps Froissart had been in contact with "holders of preferments or clerics," in his presbytery or his chapter house, who, compromised by involvement with the flagellants, had been obliged to seek absolution at the papal court. As for the Jews—"these poor Jews," he writes—not only does he judge them not guilty; he doesn't even mention the accusations brought against them, even while insisting on the refuge which they find in the papal states—"under the pope's wings." Now the responsibility of the lords who seize the goods of executed Jews is implicitly underlined. But the link between the flagellants and the persecutions of Jews is emphasized very little: it is purely a question of concomitance ("At that time . . . "); the Jews' prophecies, according to Froissart, meant it to be just this way. Finally, he breathes not a word of the legend, to which Jean le Bel gives credence, according to which the Jews jostled each other in their eagerness to be burnt at the stake, and went to their death singing joyously.

The peculiarity of the Rome edition is that it furnishes many more details about the flagellants and is at the same time more severe toward them, even though most of its addenda are not unfavorable to them. It

describes, in the same terms as Jean le Bel, the rods which they used to make themselves "bleed most hideously" and their felt hats, the color of which varied in each company. It emphasizes that they slept on straw, that they could not sleep two nights running in the same place and that their expeditions lasted thirty-three and a half days—one day for each year of Christ's life on earth. It mentions the prayers which they recited on arriving in a place and on leaving. It identifies precisely where they stopped, not going beyond the limits of the Hainaut, nor as far as Cambrai, or Saint-Quentin in France; similarly it gives, at the end of the passage, the list of sovereigns besides the Pope who protected the Jews. It expatiates admiring remarks on "beautiful peaceful deaths" and allows that "in their rules there are many things which are reasonable enough and worthy of discussion." But other remarks are clearly pejorative: "foolish women" collected the blood of the penitents and applied it to their eyes, attributing to it miraculous virtues; their expedition cost them little, since they got others to support them and lived off the land. Finally Froissart gives a reason this time for the Pope's hostility; no one has the right to impose a penance on his own authority. He seems then, in the final edition of the first book, to take a more nuanced view of the flagellants and at the same time to grant them more importance than before.

But the essential fact, for us, does not lie here. It is rather that, in all the editions, scornful of chronological order and the logical linking of events, Froissart begins with the flagellants, not with the plague, and that he remains utterly silent—even more than Jean le Bel, himself already highly discreet—on the nature and symptoms of the illness. Are we to conclude that, being younger than the canon of Liège, he has not like him had direct experience of the pestilence? But Froissart, as we have already pointed out, must have been twelve years old in 1349: old enough to remember, old enough to be affected, and strongly! by dramatic events. The reason for his choices lies elsewhere. It is the same reason which pushed him to begin with the flagellants and to say nothing of the illness itself. Like Jean le Bel, he considers that the subject of chronicles is politics, understood in its largest sense. The plague only becomes part of his material because it is the cause of social movements. By sacrificing chronology to the hierarchy of areas of interest, Froissart translates into his narrative's writing and organization a conception of history which his forerunner shared, but whose consequences he did not pursue in the order of literary organization. Do we need proof of this deliberate political choice? Although silent on

the nature of the illness, Froissart gives a numerical estimate of its ravages, which is absent from Jean le Bel's text and which agrees with the estimates of modern historians: "of which fully a third of the world's people died."

Nonetheless, in both chroniclers, the passages devoted to the plague and to the troubles of the period are placed in a historical narrative which is fundamentally ruled by the order of events. The order of this succession is not in doubt for them. Only that of their presentation varies. The situation is quite different in Guillaume de Machaut's *Jugement du roi de Navarre*. There the plague and the ills of the time are not related to history, but to the poet and his own story. They take their place not in historical time, but in the interior time of the poet who is confronted by historical time. Understanding of these events is governed not by the narration of history, but by the poet's humors, his melancholy. Or rather it is their narration which allows the poet's humors, themselves narrated, to be understood. The reference to the plague and to the troubles which are connected with it is an element of a staging of the poet and of his self-definition, both founded on the interweaving of subjective, historical, calendar, and meteorological time. This is why the long prologue of the poem is constructed on the imbrication of these different times according to a logic and a linking of causalities which correspond, not to the real historical succession of events, but to the flux of consciousness and the poet's awareness.

We must not then be surprised that events are not presented in the order that they occurred, but in a different order, governed not by the story of history but by the poet's story—which we should understand as an objective genitive: the story which deals with the poet, the story of which the poet is the object. Let us briefly recall this order and the organization of the prologue: autumnal beginning—on 9 November 1349 the poet closets himself in his room because of bad weather. Faced with the world's perversity, he is prey to melancholy; Avarice reigns; God is forgotten and the divine order, now overturned, is the object of recriminations. In a serious reflexion on the self, the poet observes that the wise man must resign himself to what he can do nothing about, but new considerations forbid him this serenity. Indeed, the times are exceptional and marked by "horrible wonders." Heavenly signs (the conjunction of stars, eclipses, comets, showers of blood, earthquakes) have announced the ills of the time: wars and the crimes of the Jews who are poisoning the rivers and springs. They have been justly punished and put to death in various ways. At the same time appeared

the flagellants, the disciples of Hypocrisy. Furious at the evil of men, Nature asks Jupiter to unleash the lightning and asks the winds to loose the tempest, causing storms which result in the pollution of the air. This pollution brings on the plague. Seeking vengeance for the world's corruption, God unleashes death; ravages of the plague and economic consequences of the mortality it causes. Terrified, the poet shuts himself up at home; so he knows nothing of the death of his friends, which makes him less sad. End of the epidemic, marked by celebrations, the noise of which brings the poet to his window. Return of the spring. The poet goes hunting in the countryside and meets a lady . . . beginning of the anecdote which serves as a frame for the debate on the casuistry of love.

As we can see, the sequence of events contradicts reality when it assumes that the accusations against the Jews and the appearance of the flagellants occur prior to the plague. The events are subordinate to a cosmological order. They are deliberately brought about by God and Nature, but at the same time their succession obeys the natural effects of those first causes (for example, the storms are loosed following the intervention of Nature, these storms bring about the corruption of the air, which is the cause of the plague, but it is God who sends death). They are inserted into calendar time which is partly responsible for the weather that largely determines them, and framed by the arrival of autumn and the return of spring, which provoke and at the same time echo the poet's moods. This calendar time itself opens onto historical objective time, on the one hand, and on the other hand onto the poet's interior subjective time. Historical time, since this autumn day is dated precisely as the ninth of November in 1349, the year of the plague; in this respect, the reference to the plague fulfills its most obvious if not most important function by grounding the poem and its diegetic contents in historical time and on the poet's subjective time, since there is a relation between the changes in his mood, calendar time, and the weather which corresponds to the season he imagines. But calendar time also creates interferences between historical time and subjective time, and between these two times and that of writing. These interferences are involuntarily emphasized by Hoepffner when his effort to date the poem from internal clues falls afoul of the confusion of times (Hoepffner, *Oeuvres de Machaut*, LXII–LXVIII); the poet's meditation is dated 9 November 1349, but it incorporates at the same time this whole winter's passing into spring; it turns upon the

troubles of the period, especially the plague, but the plague erupts that winter to end only with the spring.

So it is that the order of events in this prologue, represented with disregard for their real historical order, is inscribed simultaneously in the interior logic of the poet as author-actor of the poem, and in the poetic logic which, since Alain de Lille and Jean de Meun, to cite only these two, articulates the works of Nature (tied to mythology by virtue of the association allegory-personification-mythology) with the works of God.

The poet's logic is first of all made up of the commonplaces of deploring the vices of his age and the *laudatio temporis acti*. He consoles himself with stoicism for these vices and for the lamentable spectacle presented by the world. Nonetheless, the true evils of the time, that is, those which are peculiar to the time and which are objective, concrete afflictions, not a judgment of moral decadence, defy stoic consolation and call for another view along with another form of lamentation. But the reflections on afflictions, like the statement of their sequence, are themselves inserted into the poet's winter—his melancholy reverie—as if these scourges, as much as the remarks on the reign of Avarice and the revolts against divine order, were nothing but the product of that reverie. At the heart of the metaphorization of winter, the subjective time, there are only reflections of mood and speculations on the ways of Nature and God. It is a moment of the poet's inner life, which spring and the hunt quickly make him forget. The autumn is thus the metaphor at once of the poet's melancholy and of the troubled times which are the cause of it. And the autumn is literally the time (*le temps*) and the cause of the poet's melancholy, the time when he thinks about the present ills, when these ills erupt, since, according to Machaut, it is bad weather (*le mauvais temps*) which brings on the plague. Spring on the other hand is the metaphor for the end of the plague and the poet's return to high spirits. And it is presented as being actually and literally the moment when the epidemic comes to an end. Set against the closed shutters of winter, against melancholy, solitude, the obsession with illness and the fear of death, are shutters open to the spring, health, and high spirits regained, and the chance of unlimited possibilities, of romantic encounters, of amorous speculation whose discourse can at last be pursued.

In Machaut, the narration of the plague does not therefore aim to make historical time tangible, incarnate it, allow it to be thought

about or simply dated (as when Jean le Bel mentions the pestilence for the second time), but to allow fictional time to be thought about by grounding it at once literally and metaphorically in historical time—that time of poetic fiction which presents itself as the interior time of the self and defines the self.

In the logic of poetic development, the evocation of personified vices brings on that of Nature's intervention, sanctioned finally by God's. Whence comes the upsetting of the historical order of events and of their sequence. The goal of this confusion is to achieve an order by virtue of which we may move from the abstraction of vice to its concrete punishment by way of an intermediate stage: its incarnation in human conduct, that is the description of the evil doings of particular persons or groups. Whence the orderly progression: reign of vice, heavenly signs of evil portent, evils constituted by evil conduct, concrete incarnation of vices (war, Jews, flagellants), punishment of evil conduct (tempests, plague, and finally death).

Thus the fundamental abstraction of the poetic thought of the time, with no regard for a reality which anyone could see for themselves, makes it necessary to disturb the order and the sequence of the facts so as to be able to move from the abstract to the concrete, a passage which personifications, in the form of the *abstractum agens* or mythological figures, help to negotiate. The fact that poetic logic is the logic of the abstract and that the intervention of concrete elements puts its development into disarray is marked almost naively by the pause of ll. 109–42, when the poet states that the teaching of stoicism breaks down against concrete reality.

This is not due to an incapacity on Machaut's part to see or paint the concrete, but to the necessity pure and simple to bow to the habits and forms of poetic discourse. The proof of this is that when he at last takes up the subject of the plague, he describes it with more detail than the chroniclers (ll. 317–46, ll. 367–406). What is more, he is attentive to the economic consequences of depopulation (ll. 407–30), which neither Jean le Bel nor Froissart mention. Yet these, in our eyes, are the preoccupations of a historian, rather than of a poet.

This step from the abstract to the concrete is the opposite of the one taken by all the authors of antiquity in their descriptions of the plague and repeated even in the fourteenth century by Boccaccio, a student of their style. Boccaccio, like Thucydides, starts with a concrete and terrifying depiction of this evil before moving to its moral and political consequences. The ancient authors have a taste and a feel for clinical

description, which often betrays the influence of Hippocratic texts; the details that Lucretius doesn't borrow from Thucydides come from Hippocrates. To be sure, Machaut echoes Lucretius, whose work he could not have known, and Ovid, whom he perhaps remembered, when he sees the source of the plague in bad weather and humidity. But, as we know, in his eyes the bad weather punishes vice, which is thus the cause of the scourge, far from being a consequence connected with the demoralization which it induces. And he keeps almost entirely silent about the symptoms of the illness. So the order of events is subordinated in each instance to the order of narration, according to his choices and his models. Clinical description of the plague, its moral consequences, the divine anger which they provoke: this is the view of a moralist, of a Boccaccio, or a Thucydides. Chronological orientation and connection of effects and causes, the plague's subordination as a medical phenomenon to the political and social movements which it brings about: this is the organization which governs the chroniclers' writing. Evocation of the plague as evil incarnate in lived time, at the junction of subjective and historical time—such is the medieval poet's approach.

These are the imperatives, the laws, the choices of writing that govern not only the different depictions of the plague, but also how it and its relation to the events connected with it are perceived. It would be impossible to conclude from this however that such writing is indifferent to the real, that its models and its effects refer only to itself or to other forms of writing. For in the examples which we have considered, it is chronology and causality, historical time and the experience of time as the frame of consciousness, that is in each case a way of situating oneself in relation to the world, which determines the variations of literary art.

The undoubtedly more complex literary art of Machaut's poem imposes its laws and the artifice of its procedures in a more deliberate and, as it were, more violent manner, in the narrative of the two chroniclers. Jean le Bel and Froissart slice a piece from the indefinite multiplicity of the real and offer to the reader a stylized representation so as to make the chronological succession of events coincide with its effects and causes in a theoretically closed and limited series of events progressing from the beginning of a crisis to the end. In other words, the two chroniclers impose on their narrative the Aristotelian definition of the poetic fable. Machaut is far from discarding this model. But he blurs the composition of the narrative by superimposing and inter-

weaving the points of view and the logical choices which ought to shape it, so as to reflect, together along with his perception of the chaos and the vicissitudes of the world, the confusing and revealing encounter between worldly temporality and the temporality of the self. The comparison of these types of writing shows how true it is that beyond all distinctions of literary genres or distinctions between history and fiction, poetic fiction is elevated to the rank of horizon of reality and historical reality to that of poetic horizon.[3]

Translated by Katherine Lydon

3. Hans Robert Jauss, "L'usage de la fiction en histoire" (trans. Jean-Louis Schlegel), in *Le Débat* 54, March–April (1989): 91.

DANIEL POIRION

Afterword

Quod lingua nequit, pictura fatetur.
 —Alanus de Insulis, *Anticlaudianus* V, 118

The exchange of signs and forms between literature and other aesthetic languages is an important theme of our critical thinking. But if it is easy to pose problems relevant to this topic in modern literature, as in the case of René Char for example, this is more difficult when one goes back to the beginning of European culture, to the time that is conventionally called the Middle Ages. The notions of literature and art were not yet clearly defined then nor used as they are today.

This aesthetic mode of thinking did exist nevertheless and showed itself in various ways: its mark is still inscribed in monuments and on manuscripts that we still consider fundamental works. The essays presented here reveal important aspects of this issue and these were discussed in papers and a roundtable at the end of a colloquium that took place at Yale in preparation for this special issue of *Yale French Studies*. I will summarize here some of the ideas that were discussed and debated at that time.

The exchange of signs is revealed first in the reciprocal inclusion of linguistic and iconographic signs. The literary description of the work of art, or *ecphrasis*, and the scroll in painting both illustrate the exchange between writing and art. The inscription of texts within iconographic works corresponds to the written descriptions of monuments or precious objects. Such descriptions became a traditional exercise in the art of writing. The first great romances, such as the *Eneas*, rely on this motif to structure their story and clarify its moral meaning. Heroes of romance, such as Tristan and Lancelot, resort to painting to tell of their lives and to express their feelings.

YFS Special Edition, *Contexts: Style and Values in Medieval Art and Literature,* ed. Daniel Poirion and Nancy Freeman Regalado, © 1991 by Yale University.

The notion of style that we have chosen as a common perspective in all these papers is not a projection of a modern mode of thinking on medieval works. It appears (or reappears if we look back at antiquity) in treatises that examine in an original way the relation of the system of written works to social reality. At first, style is equated with what we would call genre. The elevated style thus corresponds to the epic genre. And the latter is only gradually distinguished from the hagiographic genre which celebrates the highest value of the sacred. The system that is established in the twelfth century, most particularly in the theoretical treatises written in Latin rather than in works written in the vernacular, corresponds generally to a hierarchical view of society. Both texts and works of art must thus be seen in relation to the system of values of medieval societies. But the confusion of moral and social perspectives tends to replace it by a simple opposition between the sublime (or elevated style suitable to the presentation of models to be imitated) and all the rest.

Minstrels and writers in the vernacular, however, need new values that fit the expectations of their audience. In this perspective, the creation of the marvelous, an aspect of the narrative that must be distinguished from the miraculous, appears particularly significant. The psychological, and even pathological connotations of the marvelous provide some transformations of the story or discursive meaning through rhetoric which is the linguistic base of emotions. Aesthetic forms are thus from the start clearly marked by this particular logic of passion or of feeling, by excess or by lack, sometimes even by madness, but they always remain within a communicative framework that seeks an emotional relation with the anticipated audience. The issue of value in the stylization of reality through writing, painting, and other artistic media is thus raised to a moral and psychological level. The particular accentuation of the text requires a reevaluation; sometimes a devaluation when the goal is to entertain or criticize; often an overvaluation, as in the case of the sublime. Transformation of values in works of art reflect the same processes. There is a kind of rhetoric in the technique of painters and sculptors.

All these strategies characterize technique, craft, in other words, *art*. In the system of liberal arts, what we call literary art corresponds to the three arts of the *trivium:* grammar, rhetoric, and logic, which were taught at first in the Roman schools and later, after the foundation of the universities, in the first years of the *cursus*. What we call *style* can involve grammar, rhetoric, and logic. Figures of speech, the establish-

ment of clichés or commonplaces, the deformation of logic such as sophisms, are also used to some degree in the plastic arts. It is in the use of commonplaces that the relation among all the arts is most evident. Forms and values of the nonliterary arts pertain rather to the *quadrivium* (arithmetic, geometry, music, and astronomy). The sciences of the *quadrivium* are also found in literary motifs, but they constitute the very forms of other arts (this is evident in the case of music, less so for architecture, although it depends on geometry and arithmetic).

However, literary styles, in their very form, also undergo the influence of the arts of the *quadrivium*, for instance music in the case of sung poetry. The function of objects in literary or nonliterary stylization, also seems essential, whether they appear as decoration, allegory, symbolic expression, the representation of a craft, or an activity. Beginning with *La Chanson de Roland*, the bow, which evokes violence more than power, is opposed to the prestige of the sword. The transformations of *mimesis* in all genres, literary or not, are a reference point for the definition of styles. Similarly, the expression of subjectivity needs to be carefully examined, in the case of a Van Eyck just as in that of Guillaume de Machaut. As early as *Le Lai de Narcisse*, or at least Guillaume de Lorris, gazing into the mirror opens reading to subjectivity. But it is through the representation of space and time (bases of a *mentalité* or of a worldview) that one can best apprehend the evolution and localization of the styles and values they express. In the representation of wind, description of animals, construction of landscapes for example, the marvelous serves to differentiate periods: it is widely used in the thirteenth century before yielding to a more naturalistic imitation of reality. In this light, the emergence of perspective in the representation of pictorial space marks the end of an evolution. But forms do not follow a uniform pace in their evolution. A history of forms, of styles, and values must take into account the specificity of the genres and the uniqueness of each work. One could almost say that a history of art omits the essential since what seems always to define art is this very desire to escape from the grip of time.

A historical interpretation remains necessary nevertheless when referring to a society whose context lends or confirms a meaning that can be read in the forms of the works. The gestures, the objects in a painting by Van Eyck take on a special meaning within his period. Religious, moral, or political discourse remains a necessary reference in the works often commissioned by men who play an important social

or political role. But in order to further the analysis of styles, it is necessary to turn to the hierarchy of values that is implicit in the different discourses. The system of values is revealed in the confrontation of various discourses, be they political, religious, juridical, medical, or other. It is in the very nature of art to provide us with a synthesis or a layering of the different discourses, explicit in the case of literary discourse, implicit in the case of the structural and iconographic signification of the other forms of art. A certain degree of rigidity in formulations of different types of knowledge, ideas, and values makes this kind of analysis particularly fruitful with respect to the Middle Ages.

Certain aesthetic phrases thus appear imbedded in repetition. Poetic discourse is ritual, works of art are dedicated to celebration, and hence to repetition. The rectangle where the illustrator sets a novel by Chrétien de Troyes defines the forms of chivalric representation. Likewise, liturgy continues to exert its constraining weight on the *Jeu d'Adam* and controls the inspiration of the romance *Flamenca* while continuing to play on the opposition of two languages, each carving a discourse, one religious and the other profane. Behind the stylization of such bilingualism can be discovered the cohabitation or the confrontation of values. Medieval aesthetic is not monolithic, as one might believe at first, nor is it propelled by a continuous and progressive becoming. It allows us to hear and see a plurality of voices and faces. In this sense it is polyphonic. Definition of style may be broken down into specific areas that are linked to the complexity of the medieval world. The conventional hierarchy of values and styles crumbles under the heterogeneity of its societies. Once we get beyond simplistic overviews, the history of art and literature is caught up into specificity of significant details.

It is, therefore, all the more interesting to identify the places or the milieus in which the works were created. Since a style is also a way of life, the latter tints all forms of literature and art with an original color. Despite their relative proximity, the illuminators of Picardy have a different style from those of Paris, and an even more different one from Flemish painters. For example, the idiosyncratic stylization which draws upon mythology to adorn discourse is not practiced everywhere in the same way. Some kinds of courtly abstraction resist it, perhaps distrusting philosophy as vehicled by stories known through Ovid. Despite the relatively tempered moral interpretation of the *Ovide Moralisé*, some authors such as Charles d'Orléans continue to resist it:

rather than being the effect of a consciously proclaimed distaste or a lack of understanding, I see such resistance as a fear of being compromised by a moral outlook understood all too well that conforms too closely to the conduct of the prince, namely that of the *Ars amatoria* as a gloss to mythological fictions. That could disturb the balance of "courtoisie" and "gauloiserie."

The relation between love and beauty, between erotic and aesthetic thinking is altogether fundamental even in the Middle Ages. The values proclaimed in the works from the thirteenth to the fifteenth century send us back to the problem of desire, because it is desire that constitutes universal economic law. Art plays with our desires, while the marketplace takes advantage of them, thus giving us mere reflection for reality. Thus courtly aesthetic proposes the kiss, instead of carnal pleasure, and privileges the kiss over the famous *surplus*. It is striking to find this motif in Gothic sculpture for it is a dangerous game which seems to tempt one into transgression of moral prohibition.

But a whole human culture was built upon anticipation, upon retreat from pleasure which ends desire—a culture obviously diametrically opposed to that of desire satisfied that our modern economy tends to impose on us at present. The Middle Ages is not indifferent to lovers' joy or even erotic pleasure, but it subjects it to all the strategies of art: ellipsis, transposition, concentration, deprecation, sublimation. To the variety of these combined strategies corresponds the variety of styles that cannot be reduced to an opposition between the sublime and the grotesque, but that corresponds to the diversity of life styles characteristic of particular regions and cultural milieus. A geography of art could thus be substituted for the history of art where time would be subordinated to space, in an effort to locate forms within value systems. Behind the group of clichés which presupposes shared desires, the diversity of ways of life allows the complexity of human mentalities to reappear. Our systems and our schools of criticism attempt to impose an authoritative order on styles to be defined only from the milieus where the works were created.

After the publication of the findings of our research group at the Centre National de la Recherche Scientifique (*Styles et Valeurs. Pour une histoire de l'art littéraire au Moyen Age* [Paris: Sedes, 1990]), it was our purpose in this issue to extend the concept to other forms of art, to iconography in particular. Despite objections and a priori advice, we have not chosen the collaborators of this publication for their method

or their philosophy but for their attention to the meanings and differences of the artistic and literary forms in the Middle Ages. To sum up these differences from our modern perspective, let us say: the works of this time period allow us to explore a world in which human beings had more time and more space to desire and to suffer. Let us measure the distance that separates us from them before we attempt any judgments.

Translated by Sahar Amer

Contributors

SAHAR AMER is a Ph.D. candidate in French literature at Yale University. She is studying the role of Arabic literature and culture in Spain and their impact on French literary production in the Middle Ages, with particular emphasis on the lyric, storytelling, and fable traditions.

ANNE BERTHELOT is Professor of medieval French literature at the University of Connecticut, Storrs. Her new book, *Figure et fonction de l'écrivain au treizième siècle* (Institut d'études médiévales à Montréal), is forthcoming.

JOSEPH BREINES is a Ph.D. candidate in French literature at Yale University.

KEVIN BROWNLEE is Professor of Romance Languages at the University of Pennsylvania. He is the author of *Poetic Identity in Guillaume de Machaut* (1984) and coeditor of *Images of Power: Medieval History/Discourse/Literature, Yale French Studies* 70 (1986). He is currently completing a book on courtly discourse and historiography in the works of Christine de Pizan.

WALTER CAHN, who received his Ph.D. from the Institute of Fine Arts at New York University, is Carnegie Professor of the History of Art at Yale University. He is the author of *The Romanesque Wooden Doors of Auvergne* (1974); *Masterpieces. Chapters on the History of an Idea* (1979); *Romanesque Bible Illumination* (1982), and numerous articles on various aspects of medieval art. He has just completed a three-year term as Editor-in-Chief of the *Art Bulletin*.

MICHAEL CAMILLE is an Associate Professor of Art History at the University of Chicago. His book, *The Gothic Idol Ideology and Image-Making* was published by Cambridge University Press in 1989. Other articles include "The *Très Riches Heures:* the illuminated

manuscript in the Age of Mechanical Reproduction", *Critical Inquiry*, Fall 1990. He is currently working on depictions of the body in thirteenth-century French manuscript illumination.

CHRISTINE CANO is a Ph.D. candidate in French literature at Yale University.

JACQUELINE CERQUIGLINI-TOULET is Professor at the University of Geneva. She is a specialist of fourteenth-century literature, with particular attention to Guillaume de Machaut and Christine de Pizan. She is the author of *"Un engin si soutil." Guillaume de Machaut et l'écriture au XIVe siècle* (Paris: Champion, 1985).

BEVERLY J. EVANS is Associate Professor of Foreign Languages at the State University of New York, College at Geneseo. She has published on text-music relationships of the thirteenth century and is currently writing a book on this subject.

MARGOT FASSLER teaches in the Music Department of Brandeis University. Her publications have appeared in a number of journals including *Speculum, The Journal of Musicology,* and *Early Music History.* Her article "Who was Adam of St. Victor: The Evidence of the Sequence Manuscripts" (*Journal of the American Musicological Society,* 1984) received the Elliott Prize of the Medieval Academy in 1985. Her book *Gothic Song: Religious Reform and the "Victorine" Sequence in Twelfth-Century France* (Cambridge University Press) is forthcoming, and she is now writing a second book on the episcopal liturgy of medieval Chartres.

ERIC HICKS did graduate and undergraduate work at Yale. He holds the chair of medieval French literature at the Université de Lausanne. In addition to research on Christine de Pizan, he has written on allegory, the fabliau, and textual criticism. His forthcoming book is a new critical edition of the correspondance between Abélard and Héloïse.

SANDRA HINDMAN is Professor of Art History at Northwestern University. Her field of interest is the production and reception of illuminated manuscripts and early printed books, on which she has written and edited the following books, among others: *Painting and Politics at the Court of Charles VI: Christine de Pizan's "Epistre Othéa"* (Toronto: Pontifical Institute for Medieval Studies, 1986), and as editor, *Painting the Written Word: The Social History of Books, ca. 1450–1520* (Ithaca, NY: Cornell University Press, forthcoming). She is currently completing a book-length study on the reception of the illuminated manuscripts of Chrétien de Troyes.

SYLVIA HUOT is Associate Professor of French at Northern Illinois University. She is the author of *From Song to Book: The Poetics of Writing in Old French Lyric and Lyrical Narrative Poetry* (1987), and has just completed a study of the manuscript tradition and reception of the *Roman de la Rose* in the fourteenth century.

KATHERINE LYDON is a Ph.D. candidate in French literature at Yale University finishing a dissertation on Montaigne and melancholy.

MARGARETE NEWELS is Professor at the University of Bonn. After publishing two books on poetics in Spanish Literature, she has just undertaken the study of the theater at the end of the Middle Ages in France, particularly the definition of the *moralités*. She is the author of *Los Generos dramaticos en las poeticas del Siglo de Oro*, 1974.

STEPHEN G. NICHOLS is Edmund J. Kahn Distinguished Professor of Humanities and Associate Dean of Humanities at the University of Pennsylvania. His book, *Romanesque Signs*, won the James Russell Lowell Prize of the Modern Language Association in 1983. Among his recent publications are *Boundaries and Transgressions in Old French Literature, The New Philology, The New Medievalism,* forthcoming. A fellow of the Medieval Academy and Senior Fellow of the School of Criticism and Theory, he is currently completing a book, *The Roman in the Romanesque*.

CLAIRE NOUVET teaches French Medieval Literature at Emory University. She has worked on fourteenth-century literature and completed a book entitled *An Open Dream: The Romance of the Rose*. She is the editor of "Literature and the Ethical Question," *Yale French Studies 79*, 1991. She is presently working on a new book: *Abélard and Héloïse: The Evil of Letters*.

DANIEL POIRION is Professor of French at Yale University and emeritus Professor of the University of Paris-Sorbonne, corresponding member of the Académie des Inscriptions et Belles Lettres, and is the director of numerous research projects on Literary Theory, Literary and Esthetic History of the Middle Ages, as well as the editor of editions/translations in the Pléiade and Garnier Collections. He is the author of *Le Poète et le Prince, la Poésie lyrique de Guillaume de Machaut à Charles d'Orléans* (Paris: PUF, 1965), *Résurgences, Mythe et littérature à l'âge du symbole* (Paris: PUF, 1986).

NANCY FREEMAN REGALADO is Professor of French at New York University. Author of *Poetic Patterns in Rutebeuf, A Study in Non-Courtly Lyric Modes* (Yale University Press, 1970). She is coauthor

of a fac-simile edition of the Bibliothèque Nationale Ms. Fr 146 *Roman de Fauvel* (NY: Broude Brothers, 1990) and is completing a book: *Reading Villon's Poetry.*

AMY REID is a Ph.D. candidate in French literature at Yale University. She is currently researching the inscription of women's relationships in nineteenth-century novels.

LINDA SEIDEL teaches art history at the University of Chicago. Her work on twelfth-century French sculpture has appeared in the *Art Bulletin, Women's Studies* and as *Songs of Glory: the Romanesque Facades of Aquitaine* (Chicago, 1981). Her studies of the Arnolfini Portrait are part of a forthcoming book, *Stories of an Icon.*

CLAUDE THOMASSET is Professor at the University of Paris-Sorbonne and, with Michel Zink, the director of research on the History of Literary Art in the Middle Ages, founded at the C.N.R.S. (Centre national de recherche scientifique) by Daniel Poirion. He is a specialist of scientific literature of the Middle Ages, and has recently distinguished himself by his work on medieval medicine and sexuality. He is the author of *Sexuality and Medicine in the Middle Ages,* with Danielle Jacquart (Princeton: Princeton University Press, 1985), and *Une vision du monde à la fin du XIIIe siècle. Commentaire du dialogue de Placides et Timéo* (Geneva: Droz, 1982).

JOHN JAY THOMPSON is a Ph.D. candidate in French literature at Yale University. His dissertation is entitled "Translation and Thirteenth-century French Prose Hagiography: The Work of a Thirteenth-century Translator, Wauchier de Denain."

EUGENE VANCE is Lockwood Professor in the Humanities and Professor of Romance Languages and Literatures at the University of Washington. Author of *Mervelous Signals, Poetics and Sign Theory in the Middle Ages* (University of Nebraska Press, 1986).

MICHEL ZINK is Professor at the University of Paris-Sorbonne and has conducted important research on Predication in the Middle Ages. He is a specialist of twelfth- and thirteenth-century poets, and more recently he has focussed his attention on fourteenth- and fifteenth-century narratives. With Claude Thomasset, he is at the head of research on the History of Literary Art in the Middle Ages, founded at the C.N.R.S. (Centre national de recherche scientifique) by Daniel Poirion. He is the author of *La Prédication en langue romane avant 1300* (Paris: Champion, 1976), and *La Subjectivité littéraire* (Paris: PUF, 1985).

The following issues are available through **Yale University Press,** Customer Service Department, 92A Yale Station, New Haven, CT 06520.

63 The Pedagogical Imperative:
 Teaching as a Literary Genre
 (1982) $15.95
64 Montaigne: Essays in Reading
 (1983) $15.95
65 The Language of Difference:
 Writing in QUEBEC(ois)
 (1983) $15.95
66 The Anxiety of Anticipation
 (1984) $15.95
67 Concepts of Closure
 (1984) $15.95
68 Sartre after Sartre
 (1985) $15.95

69 The Lesson of Paul de Man
 (1985) $15.95
70 Images of Power:
 Medieval History/Discourse/
 Literature
 (1986) $15.95
71 Men/Women of Letters:
 Correspondence
 (1986) $15.95
72 Simone de Beauvoir:
 Witness to a Century
 (1987) $15.95
73 Everyday Life
 (1987) $15.95

74 Phantom Proxies
 (1988) $15.95
75 The Politics of Tradition:
 Placing Women in French
 Literature
 (1988) $15.95
 Special Issue: After the
 Age of Suspicion: The
 French Novel Today
 (1989) $15.95
76 Autour de Racine:
 Studies in Intertextuality
 (1989) $15.95
77 Reading the Archive: On
 Texts and Institutions
 (1990) $15.95
78 On Bataille
 (1990) $15.95

Special subscription rates are available on a calendar year basis (2 issues per year):

Individual subscriptions $24.00

Institutional subscriptions $28.00

ORDER FORM **Yale University Press,** 92A Yale Station, New Haven, CT 06520

Please enter my subscription for the calendar year
☐ **Special Issue (1991)** ☐ **1991 (Nos. 79 and 80)** ☐ **1992 (Nos. 81 and 82)**

I would like to purchase the following individual issues:

For individual issues, please add postage and handling:
Single issue, United States $2.75
Each additional issue $.50
Connecticut residents please add sales tax of 8%.

Single issue, foreign countries $5.00
Each additional issue $1.00

Payment of $ _____ is enclosed (including sales tax if applicable).

Mastercard no. _____

4-digit bank no. _____ Expiration date _____

VISA no. _____ Expiration date _____

Signature _____

SHIP TO: _____

See the next page for ordering issues 1–59 and 61–62. **Yale French Studies** is also available through Xerox University Microfilms, 300 North Zeeb Road, Ann Arbor, MI 48106.

The following issues are still available through the **Yale French Studies** Office, 2504A Yale Station, New Haven, CT 06520.

19/20 Contemporary Art $3.50
 23 Humor $3.50
 33 Shakespeare $3.50
 35 Sade $3.50
 38 The Classical Line $3.50
 39 Literature and
 Revolution $3.50
 40 Literature and Society:
 18th Century $3.50
 41 Game, Play, Literature
 $5.00
 42 Zola $5.00

43 The Child's Part $5.00
44 Paul Valéry $5.00
45 Language as Action $5.00
46 From Stage to Street $3.50
47 Image & Symbol in the
 Renaissance $3.50
49 Science, Language, & the
 Perspective Mind $3.50
50 Intoxication and
 Literature $3.50
53 African Literature $3.50
54 Mallarmé $5.00

57 Locus: Space, Landscape,
 Decor $6.00
58 In Memory of Jacques
 Ehrmann $6.00
59 Rethinking History $6.00
60 Cinema/Sound $6.00
61 Toward a Theory of
 Description $6.00
62 Feminist Readings: French Texts/
 American Contexts $6.00

Add for postage & handling

Single issue, United States $1.50
Each additional issue $.50

Single issue, foreign countries $2.00
Each additional issue $.75

- -

YALE FRENCH STUDIES, 2504A Yale Station, New Haven, Connecticut 06520

A check made payable to YFS is enclosed. Please send me the following issue(s):

Issue no.	Title	Price
_____	_____	_____
_____	_____	_____
_____	_____	_____
	Postage & handling	_____
	Total	_____

Name _____

Number/Street _____

City _____ State _____ Zip _____

The following issues are now available through Kraus Reprint Company, Route 100, Millwood, N.Y. 10546.

 1 Critical Bibliography of
 Existentialism
 2 Modern Poets
 3 Criticism & Creation
 4 Literature & Ideas
 5 The Modern Theatre
 6 France and World Literature
 7 André Gide
 8 What's Novel in the Novel
 9 Symbolism
10 French-American Literature
 Relationships

11 Eros, Variations...
12 God & the Writer
13 Romanticism Revisited
14 Motley: Today's French Theater
15 Social & Political France
16 Foray through Existentialism
17 The Art of the Cinema
18 Passion & the Intellect, or
 Malraux
21 Poetry Since the Liberation
22 French Education
24 Midnight Novelists

25 Albert Camus
26 The Myth of Napoleon
27 Women Writers
28 Rousseau
29 The New Dramatists
30 Sartre
31 Surrealism
32 Paris in Literature
34 Proust
48 French Freud
51 Approaches to Medieval
 Romance
52 Graphesis

36/37 Structuralism has been reprinted by Doubleday as an Anchor Book.
55/56 Literature and Psychoanalysis has been reprinted by Johns Hopkins University Press, and can be ordered through Customer Service, Johns Hopkins University Press, Baltimore, MD 21218.

representations

Number 33 • Winter 1991

The New World
Edited by Stephen Greenblatt

ANTHONY PAGDEN
Text and Experience in the Writings of Bartolomé de las Casas

LOUIS MONTROSE
Ralegh's *Discoverie of Guiana* and the Discourses of Desire

MARY C. FULLER
Reference and Deferral in Ralegh's *Discoverie of Guiana*

INGA CLENDINNEN
Cortés and the Conquest of Mexico

DAVID DAMROSCH
Aztec Poetry Before and After Cortés

SABINE MacCORMACK
Demons, Imagination, and the Incas

ROLENA ADORNO
The Negotiation of Fear in Cabeza de Vaca's *Naufragios*

FRANK LESTRINGANT
Jean de Léry's *Histoire d'un voyage* in the Eighteenth Century

Individuals $24.00, Students $16.00, Institutions $48.00. Outside U.S. add $5.00 postage. Send payment to: *Representations*, University of California Press Journals, 2120 Berkeley Way, Berkeley, CA 94720